THE ART AND CRAFT OF
DRAWING

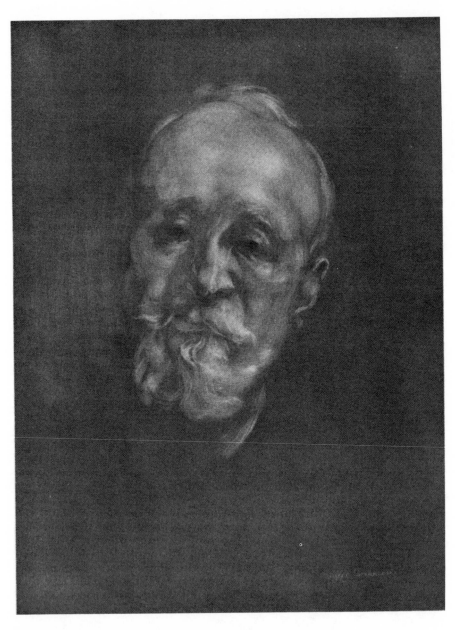

PUVIS DE CHAVANNES

Lithograph by Eugène Carrière

THE ART AND CRAFT OF
DRAWING

Vernon Blake

DOVER PUBLICATIONS, INC.
New York

The primal object of painting is to show a body in relief detaching itself from a plane surface.
Leonardo da Vinci. TREATISE ON PAINTING

The greatest perfection should appear imperfect; it will then be infinite in its effect. *Tao-Tê-king,* 50

The Tao of which one can speak is not the Tao.
Lao-tseu

Published in Canada by General Publishing Company, Ltd., 30 Lesmill Road, Don Mills, Toronto, Ontario.
Published in the United Kingdom by Constable and Company, Ltd., 3 The Lanchesters, 162–164 Fulham Palace Road, London W6 9ER.

Bibliographical Note

This Dover edition, first published in 1995, is an unabridged republication of the work originally published in 1927 by Oxford University Press (Oxford, England) and previously reprinted by Dover in 1951 by special arrangement with Oxford University Press. Some of the figures have now been repositioned in the text and the list of illustrations altered accordingly.

Library of Congress Cataloging-in-Publication Data

Blake, Vernon, 1875–1930.
The art and craft of drawing / Vernon Blake.
 p. cm.
Originally published: London : Oxford University Press, 1927.
Includes bibliographical references and index.
ISBN 0-486-28594-4 (pbk.)
 1. Drawing—Technique. I. Title.
NC730.B52 1995
741—dc20 95-5436
 CIP

Manufactured in the United States of America
Dover Publications, Inc., 31 East 2nd Street, Mineola, N.Y. 11501

PREFACE

ONE of my principal intentions in writing this book was to point out the uselessness of attempting, first, to separate the abstract from the technical aspect of art ; and, secondly, the equal folly of seeking to split up technique into various, but supposititious, compartments. This desire led me to avoid, to a great extent, the method of dividing into chapters and into paragraphs classed according to the compartment treated. If method there be in the composing of this book, it consists in examining any given drawing under all its aspects, however distinct they may be from one another according to accepted tenets. Though such system—or lack of system—may possibly do its work in calling attention to the fundamental homogeneity of artistic expression, it is evident that it is not a form of presentation convenient for reference and for study. In order to palliate this defect to some extent, I have taken considerable trouble with the index or rather with the indexes, for it has been decided to assemble all anatomical terms, together with those dealing with the construction, and allied matters, into a separate list. This decision alone will simplify the finding of any particular point connected with the actual practice of figure-drawing. Again, to further this end I have in many cases indicated, in black Clarendon type, the references to the pages on which the particular subject receives its fullest treatment. It is obviously impossible to carry out such a plan in a strictly methodical way, for it becomes a matter of mere opinion to decide which reference is, and which just fails to be, worthy of heavy type.

At the same time my intention is that this book should be of more use to the student as a general training in outlook

upon art, upon its meaning, and upon its methods, than as a craftsman's book of reference. Indeed, I have more than once in its pages referred the reader to other works should he require more detailed information on any special point. On the whole I have tried to include in these pages information not readily accessible elsewhere, and have omitted such facts as may be found with ease in existing text-books.

The Clarendon Press has not thought fit to fall in with my notions as to the general appearance of the book, hence the text implies one point of view, the appearance of the book belies it. When once attention is called to this fact it becomes of less importance.

I must take this opportunity of expressing my appreciation of the trouble taken by Mr. William Bell in verifying references and in correcting the text.

VERNON BLAKE.

LES BAUX, *October* 1926.

ERRATA

p. 255, lines 13–17. Carrière's daughter informs me that this is an error on my part. Her father was not short-sighted. How careful we must be in controlling our ideas! I have still so clearly in mind his habit of half closing his eyes with the exact gesture of a myopic man. I had so definitely classed him, on this account, as short-sighted, that it never occurred to me that I possessed no *real* information on the matter.

TABLE OF CONTENTS

NOTE: Between Fig. 93. (which immediately follows page 293) and Fig. 94. (which
immediately precedes page 296) are inserted 28 additional plates from Vesalius of interest
to the art student.

LIST OF ILLUSTRATIONS

Figs. 6, 23, 43, 70 and 71 are reproduced from Grosse : *Das Ostasiatische
Tuschbild* by permission of the publisher, Bruno Cassirer, Berlin, and figs. 4 and
123 are reproduced from *Kokka* by permission of the Kokka Co., Tokyo.

I

CERTAIN FOREWORDS OF IMPORTANCE

MANY treatises on artistic anatomy exist ; there exists, it may be, a less number of volumes on figure-drawing. Several of these treatises, of these volumes, I have read, still more have I glanced through ; years ago I consulted with assiduity Marshall's *Anatomy for Artists*. Now, as a draughtsman of the nude myself, as a sculptor, as a painter, I have faults to find with one and all of the books on drawing that it has been my lot to come across. Some of them are practically valueless ; others are fairly good ; some, the artistic anatomies, I mean, fulfil rather too well their allotted task, but unfortunately the task that they have allotted themselves is far from coinciding with the extent of the subject of figure-drawing ; and figure-drawing implicitly contains all other forms of drawing. I forget now which painter of seascapes was once asked what was the best way of learning to paint the sea. The churlish reply came : ' Go and draw the Antique ! ' This answer I would, myself, modify : I would replace the word ' Antique ' by the word ' Nude ' ; why I would do so will appear hereafter.[1] For the moment I will return to my accusation.

Let us examine the case of the anatomists. I must hasten to say that, far from being hostile to anatomical studies, I favour them highly. It is many years since I read the often splendid, but as frequently inconsequent, prose of Ruskin. One thing, however, I remember among others : his denunciation of anatomical study. He named it as the cause

[1] pp. 85 and 164.

of artistic decadence. Whether at some subsequent date (as was often his wont) he contradicted this statement, I know not. At any rate so great was his confusion of thought, that at the same date of writing, he, on the one hand, praised devout study of hill-form or of flower by Turner or by Giotto, eulogized their minute knowledge of natural things, and the while condemned anatomical study, which is naught, after all, but more perfect knowledge and understanding of one part of natural manifestation—the part always to us the most interesting, for it constitutes our very being. I fear Mr. Ruskin would have been sore put to it to point out the exact degree to which he permitted nature study to be carried. What reply would he have made if a curious questioner had asked : ' Why, Mr. Ruskin, do you tell us to study with such intentness the working of the mechanical forces that shape a mountain, that govern the growth of trees, and at the same time do you discourage us from taking even a summary interest in the mechanical economy of the very remarkable machine that is the human body ; to say nothing of the shapes and logical construction of animals ? '

The explanation of this incoherence on the part of Ruskin's teaching is, I believe, threefold. First, he was incapable of concatenated thinking ; he was a rash enthusiast, friend of the fervid and romantic word for its own sake ; the co-ordinate logos was to him anathema ; hence his small praise of Grecian things ; hence his ignoring of a whole side of Italian Renaissance art. From this failing springs, barely separated from it, the second : abstract form was scarcely understood even dimly by him. He would state that French scenery was superior to English, but then he hastened to add that Swiss landscape was as superior to French as French was to English. The appreciation of the formal qualities of French landscape had manifestly escaped him. The question

of Form I will treat later in its proper place. Third, and last, I fear we must place a puritan prudery far removed from the spirit of fair Hellenic days, when the athlete's frame was almost worshipped for the glorious balance of its detailed mass, powerful yet fraught with grace, a bright gleaming symbol of the measure of ourselves, glad vanquisher of things beside a hyacinth sea ; when, too, was worshipped that conjugate meeting of extremes, a woman's form, now flower-like in shrinking frailty, now magnificent as lasting architecture, yet again, glad with light gaiety of youth and Artemisian liberty. No, Mr. Ruskin, you praised unstintedly the mantling tints of Turner, the glory of his evening skies, his fatalist rendering of the steadfast mystery of the Alps ; you did work, even great work, in freeing the people from convention's thraldom ; you were a preacher of better things, but of better things that you yourself understood but dimly. A revolutionist, you had the faults and the qualities of your calling. Erasmus thinks ; the narrower Luther evangelizes.

Ignorance is not an asset of art, nor is knowledge baneful to it, though pseudo-knowledge inevitably is. One of the essential conditions of artistry is : Just and ordered choice. The painter, the sculptor, who does not know how to choose the elements of his intended manifestation in a co-ordinate and balanced way fails. This is true whatever be his artistic tenets, whether he be impulsive or cerebral, romantic or classic ; it is only the nature of the method of co-ordination that varies. The anatomy of Michael-Angelo was at least as masterly as that of his successors ; the latter failed, not because they studied anatomy, as Ruskin would have us think, but simply because they were inferior artists ; simply because they had little or nothing to express by means of their knowledge which was, itself, imperfect. Their knowledge of anatomy may have been—was, especially at Bologna —of a degree quite sufficiently great ; it does not follow that

their knowledge of all the other composing factors of a work of art was equally so. In every masterpiece an unquestionable equilibrium is established between all its parts. If undue stress be laid on the anatomical components, the work will be inferior. Any great work fuses to an integral whole, and the technique (I use the word in its most extended sense) that makes its presence felt is one of low quality. I must not be understood to mean that the work must be so finished up as to render the method of painting invisible ; I have equally in mind certain Leonardo perfections of ' added fact ' and other rapid, nigh on instantaneous indications, masterly in reserve of means, fully suggestive by reason of faultless *choice of the essential.* There lies the difference between the clever running of a water-colour wash, in order to make a vain show of technical address, and the sure noting of a great man dominated, obsessed by the need of transcribing some chance movement of a model, some strange glint of sunlight on a distant sea, some arabesque of his own thought's imagining. Ruskin told us that finish was added fact ; in this he was right.[1] The pity is that he remained content with his aphorism, and sought no further the real meaning of his words. Is anatomy an illusion ? He might well have put the question to himself ; but he did not. Had he done so, and done similarly on every like occasion, the instructive value of his teaching would have been far greater. Ruskin might have said that when artists began to investigate anatomy, they began to render their own task far more difficult of execution. In this there may be some truth ; though it rather tacitly implies that it is easier to be a Giotto than to be a Michael-Angelo ; a proposition that I am

[1] On re-reading I hesitated over this last phrase. Is Ruskin's aphorism applicable to other than representational arts ? is it applicable to the art of primitive peoples ? I think the words still are applicable, though I fear we should sometimes be forced to attach to the word ' fact ' a meaning distinctly different from that which was in Ruskin's mind. See, for example, Chapter XI.

inclined to reject. What is unquestionably correct is that it becomes increasingly difficult to maintain the suggestive and aesthetic value of a work when we increase the number of expressive factors, and thus augment the chances of committing error. On the other hand, the increasing difficulty of execution is to some degree balanced by the increasing difficulty of criticism ; the critic becomes slightly confused in presence of a bewildering appeal to too many separate critical efforts. In the years following on 1500 a decadence of art set in ; this decadence was in no way due to the study of anatomy, but to the mental inefficiency of the artists themselves. The human body was contorted in the ' manner ' of Michael-Angelo ; the light and shade of Leonardo was exaggerated—if possible ; the Italian school then suffered a domination of technique for technique's sake (it will be noticed that I am including even type of pose under the heading of ' technique ') ; a domination quite analogous to the nineteenth-century English abuse of technique and tidiness, in the abuse of carefully careless water-colour blots and slick brush-work, which followed on the valid work of Turner. The knowledge of Turner can hardly be arraigned as responsible for the inefficiency of those who came after him !

If, then, I am favourable to the study of anatomy, why am I discontented with the anatomists ? A short while back I stated that aesthetic transmission of idea was largely based on choice of the essential (and, of course, on proper co-ordination of that choice ; which is really the same thing). This is equivalent to saying that we must judge the relative values of the different elements which we employ in our work ; in other words, we must use them in order. It is this aesthetic order of importance that is so little realized by the greater number of writers on so-called artistic anatomy. The use of a muscle is stated ; its shape is roughly described, as is the mode of its attachment ; but no means is given to the

unhappy student of exactly estimating its artistic importance. The omo-hyoid muscle, the presence of which it is exceedingly difficult to detect, and which may be looked on from the painter's or the sculptor's point of view as literally nonexistent, is described by Marshall with almost the same care as the important mass of the gastrocnemius. Then again the diagrams are the work of undistinguished draughtsmen, who have no care for the real and solid conformation of a bone or muscle, which it is, of course, paramount for an artist to have and hold in mind as a concrete and perfected idea. The anatomical drawings of Leonardo, of Michael-Angelo meet this need ; why are they not employed to illustrate artistic anatomies ? Why is an ' art student ' supposed to learn art from teaching and diagrams from which every trace of art is carefully expurgated, and replaced by tidiness, flatness, and time-tables ?

Why has the knowledge of anatomy failed to endow the world with more complete, more learned figure-work than the Greeks, almost ignorant of the subject, have bequeathed to us ? The primal cause is to be sought undoubtedly in the lessening nearness of art to daily life ; in the relegation of art to a very secondary place in the social order of importance; in the general attempt to thrust it out of sight into galleries and museums ; in the divorce between art and religious beliefs ; in a word, in the conversion of art from a reality into an artificiality. In this way art becomes an unusual thing to be pursued under difficulties ; it ceases to be a natural factor in life and so is executed with less freedom and with less naturalness. The subconscious source, its inspiration, is less sure, less unhesitating. The artist gropes, stops to think ; is not swiftly, unreasoningly productive. Then we must take into account the undeniable inferiority of the northern nations in aesthetic sensitiveness. The centre of European art production has migrated ethnically. True, art has carried with it the Hellenic

tradition ; still the tradition is but a tradition ; the sacred
fire of its inspiration has flickered low and all but died away.

.

Yet with some of us still lingers a pagan joy in the sheer
and splendid beauty of things, in the sheen, in the lithe
rhythm of a young girl's form, in the male massiveness of an
athlete's torso. If, O would-be draughtsman, you fail to
poise high above you an intangible abstract vision, quint-
essentialized from such mystic harmony, leave drawing,
leave art, which is no other than the hopeless striving to
realize unattainable abstraction, leave the exercise of art to
the few who, branded from birth, slave-like, are condemned
to such Sisyphus task.

A new temptation has now arisen, but is already waning
to an end. Ugliness, deliberate ugliness, has momentarily
occupied the throne of beauty. Eccentric accentuation of
the hideous has been the device of recent art ; and in ways
that we have never seen before, unless it be in some of the
more degraded manifestations of savage output. To cut
a definite section through history, to say here begins a certain
development, there just beyond lies its cause, is idle. Cause
and effect pass by indefinite gradations one into the other.
A clear marking of commencement can be but an illusion.
Nevertheless in this, as in other matters, approximation may
serve a practical end. Though arguments may readily be
produced in opposition to the statement, we shall not be far
wrong in saying that the cult of ugliness dates from the work
of Cézanne. But let us be very wary of attributing to him
any such *credo* as those multiple beliefs professed by his
pseudo-imitators. To certain, to many sides of the world's
beauty Cézanne was profoundly alive ; and to him it was
a source of unceasing sorrow that his lack of deftness, his
insufficient knowledge, kept him from transcribing to the
full such beauty in his work. Cézanne may almost be likened

to some uncouth artistic seer to whom came passing visions
of fair form rounded by unmeaning night. He would have
been himself the first to condemn much, if not all, of the
aesthetic chaos that has succeeded to his time. His self-
styled followers have chosen the easier task of imitating his
defects ; they have neglected, in almost every case, to
reproduce his qualities.

A spirit of dislocation, a pseudo-scientific pretence at
analysis has crept during the last three decades into the realm
of art ; faulty ratiocination has ofttimes replaced subcon-
scious aesthetic judgement, for the most part unhappily
absent. To what extent should I take count, in a work such
as this, of the doings of a whole period of artistic history ?
The answer remains to a very great degree a matter of
personal opinion. After consideration, after taking into
account that the present movement (and that of the immediate
past) in art has not yet shown us its definite crystallization,
I have decided not to treat in this volume of the more unusual
theories concerning the use of form. I myself have assisted
at the birth of the many latter-day aesthetic conventions ;
I have myself been profoundly influenced by them. It will
for the moment be enough to allow this influence to mould
subconsciously the making of my thought. What I shall
write could scarcely have been written thirty years ago. The
ineffaceable thought-tendency is there, be it or be it not
openly manifest in a chapter bearing some such title as
' Drawing in Modern Art '. Years ago Eugène Carrière
said to us, his class : ' I do not wish you to paint as I do. I
am here to point out certain facts in the construction of the
figure which I must find rendered in your work ; facts which
I have always found rendered in valid work of all periods.
How you render them is your own affair.' Can I do better
than follow his eclecticism ? Some of my readers may com-
plain that I have not fulfilled the promise of my title-page

when they fail to find indexed a chapter on the ' Art and Craft of (say) Cubistic Drawing '. Let them bear with me ; my subject is already large ; this volume would become unwieldy were I to crowd within its covers every possibility of this kind. I will limit myself to an incomplete statement of what my own artistic experience has taught me to be the essentials of the craft, whatever may be the particular work-shop, in which we elect to work, whatever may be the trade-mark we write above the door. I will leave largely aside the tendencies which as yet are uncrystallized ; I will restrict myself almost entirely in the matter of examples to past and firmly established work ; and if dissident voices reach me, I will content myself with asking : ' Have you noticed how curiously modern Claude Lorrain's drawings appear to us, or how little out of date certain fragments of archaic Greek statuary seem to be ? '

We are all, willy nilly, consciously or unconsciously the artistic children of Cézanne ; or if we are not, we are simply a quarter of a century or more behind the times. To be a child of Cézanne is not, as perhaps too many think, to break with the tradition of the great painting of the past ; on the con-trary, few have been more fervent admirers of the old masters than was Cézanne ; his unceasing desire was to be worthy of taking his place one day in the august assembly of the Louvre.

Nothing is more dangerous than the isolated phrase, than the aphorism that stands alone deprived of all enlightening context. Cézanne once cried out : ' Ces musées ! les tableaux des musées ! nous ne voyons plus la nature, nous revoyons des tableaux.' (Oh, these picture galleries ! the pictures of these galleries ! we no longer see Nature, we re-see pictures.) Thus stated alone this phrase betrays the thought of its author almost completely. So completely did it betray his intention that, but a short time after his death,

a section of his enthusiastic disciples armed with the seeming authority of the master demanded the burning of the Louvre ; a Bastille-like destruction of all *anciens régimes.* Yet the thought of Cézanne is really evident enough.

.

In striking contrast with the vaguely formulated aesthetic tenets of Europe there exists on another portion of the globe a marvellously co-ordinated system of plastic laws, of laws considered inviolable even to-day, although they count some fifteen hundred years of existence ; perhaps it is because they count so great a period of time since their inception, that they are no longer, indeed they never were, a matter of opinion ; they are an essentialized result of the aesthetic convictions, not of a person, but of a whole race to whom art was from the beginning an inherent part of life. Is it needful to say that I speak of the two great nations of the Farther East, of China, and of Japan who borrowed from the former the bases of her artistic *credo* ? Two reasons lead me to develop somewhat at length the position that the Extreme Orient takes up with regard to the plastic arts. The first of these reasons is the more evident one ; it is that I fail to see in what way the general formulae of the Chinese or Japanese aesthetic can be refuted. The second reason is a more subtle one. I would call in the aid of a discussion of this aesthetic —in so many ways so different in its completeness from our own unordered attempts—to create an atmosphere which I would fain conjure up so that it may, in a subtle way, permeate all subsequent explanations that I hope to make. For the moment I must be content with calling attention to the profound significance of this Far Eastern art, to its keen sense of the insoluble junctions that exist between the rhythmic sweep of a brush stroke and the ultimate problems of the universe. Such a view of art, it is hardly an exaggeration to say, is wholly unknown in Europe. I may here be

accused of quitting the ground of practical drawing instruc-
tion to enter on that of metaphysical speculation. If I be so
accused, I must remind my reader that the title of this book
is : ' The Art and Craft of Drawing ' ; now by Art I mean
Art as distinct from Craft ; otherwise my title would contain
a redundancy. Art is essentially an abstract thing ; were my
aim simply to propound recipes for the production of colour-
able imitations of the human or other forms by means of
lead pencil or other media, all abstract discussion would
assuredly be beside the mark. But such is not my aim ;
indeed I would rather take up arms in the very contrary
cause ; I would try in part to suppress the already too great
mass of drab and meaningless monotony of tidy work turned
out by the too numerous Art (?) Schools of England. Now
what concrete differences can we trace between the drawing
of a great master and that possibly more correct one by some
prize student whom a ruthless fate will subsequently condemn
to oblivion ? We are obliged to fall back on abstractions
before we can determine the very evident difference of
artistic value that exists between the two. This book is only
addressed to those who will accept the postulated position that
a mental attitude is at the basis of all artistic production of
worth ; that though one side of art be craft yet the other and
greater element of it, that which inspires the craft itself, is
intellectual, intangible, spiritual. What better way can I find
of creating here and now this atmosphere of transcendent
things than by shortly expounding the secular Chinese doc-
trine of the Tao ? How shall I put it better forth than by
translating into English the short and wonderfully able con-
densation that M. Chavannes has given of it ?

 ' A European intellect but little used to the modes of
thought of the Extreme East hesitates to transpose into our
languages, designed for the expression of other thoughts, the

concise and energetic formulae in which this antique philosophy finds expression. . . . A unique principle reigns over and is realized in the world in relation to which it is at the same time transcendent and immanent. This principle is that which has neither form nor colour, nor has it sound ; it is that which exists before all things, that which is unnameable ; yet it is that which appears among ephemeral beings, constraining them to follow a type, impressing upon them a reflection of the supreme reason. Here and there in Nature we perceive the luminous flashes by which the presence of this principle is made manifest to the wise, and we conceive some vague idea of its consummate majesty. But once these rare heights are attained, the spirit worships silently, well knowing that human words are incapable of expressing this entity that encloses within itself the universe and more than the universe. To symbolize this principle, at least in some degree, we apply to it a term, which if it do not indicate the unfathomable essence of this mystery, does to some extent express the manner in which it makes itself known to us ; we call the principle : The Way ; The Tao. The Way . . . the word first implies the idea of Power in Movement, of Action ; the final principle is not a motionless term, of which the dead perfection will, at most, satisfy the needs of pure . reason ; it is the life of a ceaseless becoming, at the same time relative, because it is changing, and absolute, because it is eternal. The Way . . . again the word suggests the idea of the fixed and certain direction, of which all stages succeed to one another in determined order ; the universal ' becoming ' is not a vain agitation ; it is the realization of a law of harmony.'

Without understanding this vast naturalism by which is governed the splendid hierarchy of Heaven, of Earth, of Mankind, we cannot hope to penetrate to the significance of the Six Laws of Painting formulated by Sié Ho, critic and painter in late fifth-century China. These Laws have

governed Chinese painting from then till now. Of a surety they are worthy of some consideration. They are expressed with that extreme and almost cryptic conciseness in which the Chinese language delights ; hence their transference to an occidental tongue is far from easy.

1st. K'i yun cheng tong : Consonance of spirit engenders the movement (of life).

2nd. Kou fa yong pi : The law of bones by means of the brush.

3rd. Ying wou siang hing : Form represented through conformity with beings.

4th. Souei lei fou ts'ai : According to the similitude (of objects) distribute colour.

5th. King ying wei tche : Arrange the lines and attribute to them their hierarchic places.

6th. Tch'ouan mou yi sie : Propagate forms by making them pass into the drawing.

In the light of the preceding discussion of the nature of the Tao, these cryptic utterances take on shape and significance. The Spirit's consonance or rhythm constitutes the creative element of movement of life. The unstaying flow is naught but a tangible manifestation of this rhythm which permeates all immensity. Harmonious motion of the spirit engenders the perpetual flow of things ; they are the consequence themselves of its action ; they would disappear into nothingness were the flow to stop. The artist should, it follows, perceive, before all things, and over and across the movement of shapes, the rhythm of the spirit, the cosmic principle they express ; beyond appearances he should seize upon the Universal. When Mr. Hatton writes about drawing, he gives us excellent but incomplete advice ; he tells us : ' The drawing must be made in as long lines as possible, there must be no patching together of little bits.' This contains only a small part of the truth. In reality it is not

the length of the drawn line that is important, it is the rhythm
of it that Sié Ho would insist on as being a counterpart of the
rhythm of the Tao. A ' patched ' line will assuredly be void
of rhythm ; on the other hand it is not because we determine
to draw a long line that that line must necessarily be instinct
with rhythmic life. Before we can hope to reproduce such
rhythm we must, so to say, intoxicate ourselves both with the
abstract conception of universal harmony and with the parti-
cular manifestation of it that we have at the moment before
our eyes. Then, and then only, can we hope to create on our
paper some distant, not replica of the universal harmony, but
vague foreshadowing of its ever unattainable perfection. A
few days ago I tried to draw in a London Art School. After
a short time I got up and went out, too horribly oppressed
by the nullity of my surroundings. No spark of aesthetic
intelligence illuminated the thirty faces that surrounded me.
Their owners were there because it had occurred to them to
' take up art '. Right and left of me, pseudo-industry dis-
played itself by temporary sketching in some half-inch of
weak line, as a trial, as an attempt to find if it would ' do '.
It generally disappeared more swiftly than it came, erased by
a most necessary piece of india-rubber. No kind of applica-
tion was evident ; a sad uniformity of unintelligent action
pervaded the room. In vain one sought some sign of that
strained sympathy with the essentials of the harmonious
balance of the model's forms ; some sign of that ' consonance
of spirit ' that ' engenders the movement of life ' ; and truly
the drawings about me were dead, lifeless enough. What was
a discussion concerning universal rhythm to such a crowd of
nonentities ? What, in consequence, was the value of their
drawings ? Neither a long line nor a short line will influence
the value of your work. The laws concerning the use and
shape of dots are complex and very complete in Japanese
teaching of art ; and a dot is essentially a short element.

Dots arranged without rhythm are worthless ; in rhythmic surface-sequence they are valuable aesthetic factors. One is perhaps justified in re-editing the antique maxim of Sié Ho into a first law of draughtsmanship for Europeans : *Strive to display the sense of universal rhythm through the particular rhythm studied on the model.* These pages can, indeed, without any betrayal of their nature, be described as being a study and an analysis of the details of plastic rhythm.

Sié Ho himself passes in his second law to the consideration of the composition of rhythm. The law is (it is well to repeat) : *The law of bones by means of the brush.* This figurative language of the East demands some explanation. In these occult terms Sié Ho means to call attention to the necessity for the painter, once he has seized the real nature of the elements of the world, to penetrate to the secret folds and centres of things and beings where the Tao lies hidden. The expression, by means of the brush, of this secret governing of things becomes confounded with the demonstration of the internal construction. In this way the artist evokes the feeling of the tangible object. His task is to define the essential structure which gives to things their transitory individuality wherein the eternal principle is reflected. It is only after he has discovered the profound meaning of appearances ; after he has found that it lies in the junction between the rhythm of the spirit with the movement of life ; it is only after he has conquered the possibility of expression by holding and con-ceiving the essentials of internal structure, that he can hope to reproduce *form in its conformity with the beings of the earth.* Here we are in contact with an excessively ancient Chinese notion, that of Saintliness in man. The Saint in China is one who is possessed of perfect conformity with his own nature or—what comes to the same—with the universal principle and order which is in him. By this very conformity the Holy Man becomes the equal of Heaven and of Earth ; by a

similar conformity the painted semblance takes on more than the value of a simple representation ; it becomes a veritable creation realized in the principle, itself, of the Tao. This is evident when we remember that as each being or each object represented in the work of art is, according to our supposition, in complete conformity with its own inherent nature, the work of art becomes automatically the image of a perfect world wherein the essential principles balance one another in harmonious proportion. But the strict application of the spirit of the second and third laws of Sié Ho must inevitably lead the painter to the study of the essentials of the form ; hence to an astonishing synthesis of them, which indeed we find never to be lacking in the masterpieces of the Far East.

The fourth law now appears as an almost logical consequence of the preceding ones. *Distribute colour according to the similitude of objects.* The essence of structure being disclosed, perfect form being defined, it remains to clothe these essentials with the living and evanescent mantle of tint ; and this tint should be meted out in accord with the likeness of the beings and of the objects. Being in accord with them, colour also must evoke, by choice and measure, the fundamental elements of all. It may appear curious that it is now, and now only, that the Chinese aesthete begins to consider the ' *ensemble* ', the composition as we might insufficiently say, for I think here is contained more than we are usually inclined to include within the signification of the term. True, the text of the fifth law runs : *Arrange the lines and attribute to them their hierarchic places.* In other words the artist is enjoined to carry out in the arrangement of the lines, masses, and other pictorial elements through the space where he is at work, the same suggestion of immanent natural harmony which he has learnt to be omnipresent. Between the shape of the surface and the distribution of the pictorial elements the harmonious principle of the universe finds renewed

expression. When the Tao is thus realized throughout the entire work the artist has of a truth created ; and legends similar to that of Pygmalion are not lacking ; legends that tell of the dragon or genie coming to sudden life beneath the master's brush and quitting silk or paper to disappear in swirling clouds.[1] By thus creating forms which contain within them the essence itself of the universe the picture becomes a real propagation of forms (6th Law) ; the difference between the natural and the humanly created form disappears, for in each case the form becomes, as it were, no more than the external vesture of one and the same thing, the essential principle, the Tao. Thus there is complete welding, complete homogeneity between natural and artistic creation. There is no longer an aesthetic ; the aesthetic is the same thing as, is identical with, general philosophy, which itself is indistinguishable from the whole phenomenal universe, so interwoven together are the comprehending and perceptive values.

.

During the history of the world two completed artistic systems have been constructed, and two only. I speak of the Chinese, and of the Greek and its descendants.[2] Doubtless Egyptian Art was a great and enduring wonder ; doubtless Assyrian Art reached a high point of excellence before it passed away ; the various branches of the art of the Indian peninsula have a character of their own ; still none of these aesthetics has adequately covered the whole area of plastic manifestation. As a rule they have remained *stylisés* and decorative, none of them has developed a naturalist school and, as an almost inevitable concomitant of it, a school of landscape art. That a certain voluntary stylization of natural things may lead to a more or less decorative result,

[1] See Chapter XI for ' participation ' in art.
[2] I am not for the moment concerned with the vast and debatable subject of ' primitive ', ' prelogical ' art. See Chap. XI.

that this result may enable us to express more abstract aesthetic intentions than those within the reach of a purely natural school is without doubt true. It is not here that I can discuss this delicate and complex point. None the less, arts that aim too soon, too irremediably at *stylization* executed by means of traditional formulae, condemn themselves to final stagnation and to a narrow field of influence, however great may have been their achievement.

The Greek aesthetic was free, it admitted the study of nature, it has formed the base, it generated the immanent spirit of European art in its entirety. It penetrated towards the East, encountered the aplastic creed of Buddhism in search of a formal aesthetic, and seems, in the sculptures of Gandhara, to have influenced to some degree the development of Indian Art. But Asiatic thought differs from European, the generating axis of Hellas lay to the west and not to the east, and while the magnificent schools of Italy and France owe their being to Greek ideals, the early Grecian penetration of Asia waned and died away, leaving no appreciable trace.

The most cogent reason for this failure was that, once on the confines of Central Asia, Greece found herself in presence of a most redoubtable adversary ; a great and even then highly organized aesthetic barred her progress, an aesthetic more openly abstract than her own, hence more fitted to the metaphysical east where it had its birth. No more than the Greek does the Chinese aesthetic close the door to nature study, on the contrary, as we have seen above, it teaches profound delving in search of the hidden secrets that govern the natural world ; but, characteristically Asiatic, it leaves aside the mediate logos of Greece, whence has sprung the long theory of European science, and passes straightway to an intuitive metaphysic that would at the cost of one sole hypothesis eliminate the unravelling of the physical complex.

FIG. I. Gathering and splitting of papyrus reeds at Thebes. Tomb of Puyemrê

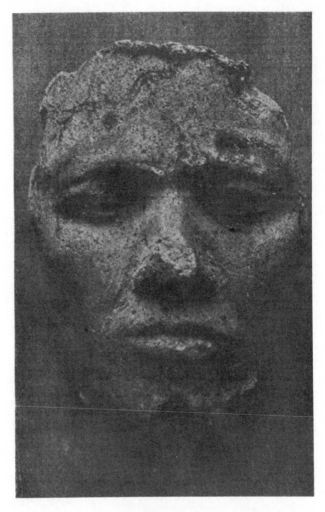

Fig. 2. EGYPTIAN HEAD IN PLASTER

ABOUT B. C. 1370

Found at El Amarna. Perhaps of Amenophis III.
Shows extraordinarily natural treatment leading to the
supposition that the use of the traditional formula was
quite voluntary

We cannot help but feel that the Chinese position is the more essentially artistic, if indeed such a phrase have a meaning.

Both Greece and China have represented the human figure, each in its own faultless way, though each is so different from the other. The representation of ourselves would seem to be a *sine qua non* of dominating art. The Celtic, the Germanic, races were unable to produce a figure art without the fecundating influence of Greece, though in our comparative ignorance of Greek origins it would be safer to say that the northern parts of Europe never produced adequate figure presentation till they inherited the Mediterranean and Greek tradition. Celt and Scandinavian were skilful in pattern-weaving, but in the art of representing objects they remained negligible. Indeed it would seem necessary to institute rather a sharp boundary between drawing as an art of representation, and the conception and execution of decorative design [1]; after all, it obviously requires less subtle observation to produce fairly well-balanced geometrical inventions than it does to follow, with a view to subsequent reproduction, the intricate rhythms and equilibria of living forms. Egypt and Assyria were too special in their arts to leave lineal descendants. Their arts, intimately attached to their religions, could hardly persist when the beliefs were dead. Tens of centuries had frozen Egyptian Art to a hieratic formula fitted to the valley of the Nile, and when it at last expired it passed utterly away, for no living truths remained to be handed on as a heritage to future generations, to future peoples. Here and there in the history of Egyptian Art come outbreaks of naturalistic tendency ; such had to be the case in order to conserve the wonderful verity of the wilful schematization, but such outbreaks would seem to have been almost intentionally suppressed, and in the thousands of years of its exercise this art scarcely deviated from its strict and

[1] See Chapter XI on Primitive Art.

decorative path. The annexed reproduction (Fig. 1) may almost be taken as an example of extreme Egyptian naturalism, at least in definite work ; though the plaster head (Fig. 2) is still more natural. It is, however, one of a few isolated fragments ; perhaps it was only destined to play the part of a preliminary study to a work in which the variety of nature was to be severely suppressed anew.

At this point it will perhaps be tedious to discuss in general terms the exact ideals of various arts that will be examined during the course of this work. Of the two main aesthetics the Chinese, a conscious aesthetic, has been roughly sketched above ; a few words must be said about the more familiar and less conscious Greek ideal, and about the growth of our own from it.

Seemingly Greek Art reached its apogee before its principles were discussed, and, were not the example of China before us, we might be tempted to think of such discussion as necessarily linked to sterile decadence. Greek Art, like the Greek religion, may be termed non-metaphysical. It is the offspring of a people intensely, instinctively alive to the outward balance and beauty of things, of which they readily found an agile transcript unhesitating in its reduction of mystery to the measure of man. Abstractions were rare till Platonic times ; the theogony, to the human scale, was readily presented in the human image, and formed almost the total sum of the artistic subjects. Such a clear-cut outlook was favourable to the development of a perfected plastic art fundamentally simplified in kind ; and, indeed, the rise of Greek Art was extremely rapid. On the over-intense simplicity of this stem was grafted the complexity first of Christian, then of scientific thought, with the result that to-day we have no definite aesthetic orientation. Irresistibly the Greek basis of our civilization claims belief in its ideals ; but to these ideals the complexity of modern thought was

unknown, for it there is no place in them. European Art may almost be termed, at least in its higher efforts, one long hesitation between Hellenism and Mysticism. But Europe is essentially inartistic, especially its northern races, who, as we have seen, when left to themselves, produced naught but meaningless design. When later they learnt to reproduce the aspect of things animate and inanimate, reproduction of outward semblance, or at most of emotion, became almost their single aim. It has been reserved for quite recent times to feel vaguely the need of other and deeper artistic intent, and to grope, in a blind and disorganized way, for some few of those foundations of art that were catalogued two thousand years ago in China. What will be the outcome of this new self-consciousness of European Art ? it is impossible to say. Will the Hellenic tradition amalgamate with an aesthetic which has a transcendental origin, amalgamate to complete homogeneity ? I fear that it will be many a day before such an end is fulfilled.

Now that this unquiet state is realized, now that an intense interest is taken by many in the ideals of the Far East, it becomes increasingly difficult to write such a book as this, much more difficult than it would have been fifty or more years ago. Then all was fairly plain sailing. A few embarrassments cropped up, it is true, concerning the exact estimation of the worth of ' primitive ' drawing, and a drawing by Michael-Angelo would have had to be co-ordinated with one by Brygos, the ideals of Ingres and of Delacroix would have had to be reconciled. But now all such aims and ideals must be brought into just relation with those which discard to a greater or less degree the outward aspect of things and propose to exhibit inner and transcendental significance.

Recapitulation

Artistic anatomies fail to give the student a just idea of the relative constructional importance of the facts dealt with ; the combination of two or more anatomic facts to make one aesthetic fact is hardly ever indicated. Figure-drawing is the best method of study even for those not devoting themselves finally to it. Ruskin's praise of nature study and condemnation of anatomy is incoherent. Ignorance is not an asset of art, nor is knowledge baneful. Just and ordered choice is at the base of artistic execution. Equilibrium should be established among all the parts of a work of art. A great work is integral in its nature. Finish is added fact. Knowledge is not a cause of decadence, though it may be a concomitant of the end of ascendance. We are obliged to help out by anatomical knowledge where the Greeks succeeded more intuitively ; art was then nearer daily life. Cézanne was an uncouth artist seer. Modern pseudo-science in art is a cause of inefficiency. The present moment is an important period of aesthetic change. The insidious influence of the ideals of the Far East on modern European Art is more and more marked. An explanation is given of the Chinese aesthetic doctrine of the Tao, or universal moulding essence, the universal harmony which it is the aim of Chinese Art to suggest through the external appearance of things. The Six Painting Laws of Sié Ho are quoted. The draughtsman should strive to display the sense of universal rhythm through the particular rhythm of the model. An explanation of the Six Laws is given. The meeting of the Greek and Chinese ideals. The want of figure art among the Celtic and Germanic races is remarked. Greek Art, like Greek religion, may be termed non-metaphysical art.

II

RELATIONS BETWEEN COMPOSITION AND DRAWING

LET us define our terms as far as possible. Composition is a poor and misleading word. It is, however, consecrated by long use, and to replace it would be confusing. The word composition gives the impression of building up, of assembling, and placing together of parts. Though this may be true of the later steps of picture-making, it should not be true of the principal structure of the arrangement. The main facts of a composition should present themselves simultaneously, together with their relation to the surface to be covered, as one single act of the painter's imagination. I have little or no hesitation in saying that the more complete the first idea is—the less it is necessary to modify it afterwards and the fewer the gaps that have to be filled up in it—the more valuable will be the final result. Though the taking of infinite pains be a part and parcel of great art, the pains should all be taken before and not during the execution. The great picture is painted easily, but as the result of unceasing study. A picture that demands repeated alteration and painful effort on the part of the artist will hardly ever be a success. Art should be a florescence of the spirit, a bright-tinted embellishment of life ; it should pass light-footed over great profundities, yet should bear before it in outstretched hands a fair symbol of their essence. The certainty with which the early Chinese monochrome brush-drawings were executed is no mean factor in the fascination that, more than ever to-day, they possess for us. That this certainty was the fruit of long and categoric thought their authors themselves have told us.

Indeed such mastery of varied brush technique allied to, one with, inward intention, as the work of say Mou-hsi (about 1250) or Liang K'ai (first half of thirteenth century) displays, can only result from long meditation aided by an already secular tradition. Would it not be well to quote here, in these early pages, a few of the notes that the son of Kwo Hsi (probably died about 1080) made of the sayings and painting methods of his father.

When Kwo Hsi intended to work, his first acts were to open the windows, dust his desk, wash his hands, clean his ink-slab. Meanwhile his spirit became calm, his thought tranquil and creative. Then, and only then, did he begin to work. I would draw particular attention to the importance here attached to the state of mind which is necessary to happy composition, to just and valuable inspiration. In England especially, painting is too often looked on as a craft that may be learnt, provided one has a certain gift that way. Tidiness of workmanship is too often the measure of excellence ; even the seeming carelessness of a water-colour sketch must be deftly executed. Whether this deftness be empty, or applied to the rendering of higher things, is a question seldom asked. All that is thought to be necessary is that the deftness, or the careful detailing, should be there, and should adequately transcribe the outward semblance of things. Now and again some count will be taken of the emotion of the artist ; but truly emotional work is rare in the British school.

I have said above that a picture of worth should almost execute itself without trouble to the painter. But I did not say that it should be carried through in one uninterrupted action. Kwo Hsi often left a painting aside for many days before working on it anew. Art is not a mechanical trade, it is a continued creation of the spirit. At one moment creation is easy, ideas are generated one knows not how, the work proceeds happily and without hitch, line and accent are

placed justly, values fall into their places. Then comes a sudden instant when the productive machinery halts and stops ; the wise worker lays down his brush or his pencil without striving to continue. Should he try to go on, the creative act will turn into a conscious effort of the intelligence. By applying his knowledge he can construct a result, he will decide that an accent should be placed there, that here a mass wants balancing according to the approved laws of aesthetics, but this result will be cold, wanting in that convincing semblance of life that stamps all valid work with its imprimatur. It is in this way that the commercial artist works, the illustrator who has learnt his business and possesses his gift of producing a workmanlike representation of objects, a gift which may be helped out by a second, a skilful fancy in designing or in inventing. To such men I would willingly deny the name of artist ; yet they make up almost the whole of the so-called artist community, especially in England. These men can produce work to order at almost any moment, unless they be incapacitated by some evident cause such as fatigue ; to them the state of mind to which Kwo Hsi returns unceasingly in his sayings is unknown, it is not needful for them to ' nourish in their souls gentleness, beauty, and magnanimity ' ; nor need they be ' capable of understanding and of reconstructing within themselves the soul-states and emotions of their fellow men '. When an artist has succeeded in understanding his fellows, he will hold that comprehension unconsciously at his brush-tip, Kwo Hsi assures us.

With a delight in imaged analogy natural to an Oriental, Kwo Hsi tells us that water is the blood of the mountains, grass and trees their hair, mists and clouds their divine colouring. He tells us also that a mountain is powerful, and that its form should be high and rugged with free movements like those of a man at ease. Again he tells us that water is a living thing, its form is profound and tranquil, or sweet and

unified, or vast as an ocean, or full with the fullness of flesh, or circled like wings ; or, darting forth, it is elegant ; or, rapid and violent, it is as an arrow. Sometimes it runs, rich, from a fountain afar off making cascades, weaving mists over the skies, casting itself upon the earth where those who fish are calm and at ease. Grass and trees look upon it with joy, and are even as sweet veiled women . . . veiled with mist. Again—as sunlight floods the valley—it is radiant, sparkling with delight. Such are the living aspects of water.

What lesson should we learn from the poetic vision of Kwo Hsi ? We should learn to banish the commonplace from art ; we should learn that art is essentially a symbolism, that its end is in nowise mere reproduction, that our every line of drawing, our every conception of arrangement should be filled with intent, with suggestive power. It is the province of the plastic arts to compress within the nature of a line, of an arrangement of shapes, of a harmony of tint, an entire outlook upon life and thought. If this outlook be not clear and decided on the part of the artist, it will not find expression in his work ; and skilful though this work may be, still it will remain valueless and void. Would you learn to draw ? learn first to think and feel intensely. Ah ! there is just the hitch, for the poet is born and not only made. Yet the birthright alone is not enough. As I said above, it must be cultivated with untiring care, much of technique must be painfully learnt, only a small proportion of it is intuitive, and even the greater part of that intuition itself is due to prolonged habit of already recognized technical means. In some arts, as for example the Egyptian, individual technical innovation was almost completely suppressed. Though the whole of the craft of plastic execution cannot be learnt, yet a very great part of it may be taken—and should be taken—from the experience of our predecessors. Of a truth originality is really confined to a slightly novel arrangement of already known facts and methods.

It is obvious why I have termed ' composition ' a poor and misleading word. It should evidently denote all the first steps taken in producing a work of art. It is impossible to disintegrate the component acts of composing. Even though we agree to set aside as a thing apart (and are we justified in so doing ?) all the processes of general culture of the artist's mind, still in the particular act of composing a particular drawing or picture, or rather, as I prefer to say, in the birth of the conception of the arrangement of the lines, areas, and so on that make it up, the intervention of the abstract meaning of the arrangement cannot be overlooked ; for were the arrangement carried out otherwise, the meaning of it would be different. I take the word ' composition ' to denote : The arrangement of the elements of plastic expression with a view to satisfying our sense of balance, and to expressing certain abstractions natural to the artist's mind. In the case of a picture or a drawing the edge or frame of the surface is of course taken into consideration as one of the elements. Sculpture and architecture are more or less free of this condition. I object to the suggestion of ' making up ' inherent in the term ; the main arrangement should be simultaneously conceived as a whole.

.

What then may Drawing be ? Can it be absolutely distinguished from Composition ? To the latter question I am inclined to reply that I think not. On the other hand one may be quite an excellent draughtsman and yet an inferior composer. I myself draw with greater ease and certainty than I compose ; others—and I believe the case to be more usual—compose better, and with more ease than they draw. Yet without a highly developed sense of rhythmic balance one can neither draw nor compose ; the logical rationalist would be inclined to say that the same sense which allows of rhythmic balance being attained among the different volumes of a

figure, from which balance comes truth of pose and movement, or in other words, the major part (if not indeed the whole) of excellent drawing, that this same sense should allow of similar balanced arrangement being attained over the surface that is to be pictorially decorated. However, this is not the case. The sub-classifications of the creative artist's mind are extremely complicated. This matter I have treated somewhat extensively in *Relation in Art*,[1] I will only briefly touch upon it here. In that book I have called attention to the fact that the poses imagined by great painters are always sculpturally satisfactory, that is, that if we make a clay model from the pose it will always be found to be balanced in composition when looked at from any point of view, and not only when looked at from the normal view-point determined for the picture. One might conclude from this that every painter of worth is a potential sculptor ; to a certain extent this may be true, but it is not so entirely. The complete expression of the sculptor's mind is shut within the limits of his single figure, or at most group of figures. Though a painter's conception of a pose may make satisfactory sculpture it does not completely express what he has to say ; part of his natural method of expression consists in establishing relations between pose and background, in developing certain arabesque relations which have their place in the less strenuous art of painting, but which would constitute feebleness in the male and architectural art of sculpture. Hence we at once see a differentiation between the two types of mind. I myself conceive more naturally a free, self-contained pose fitted to sculptural realization, than I do a pose imagined as an integrant part of an accompanying background and extended decorative unit. In short, I think we may safely say that the power of conceiving balance in three dimensions (and not only in a schematic way in two over the surface of the picture) is an

[1] Clarendon Press, 1925.

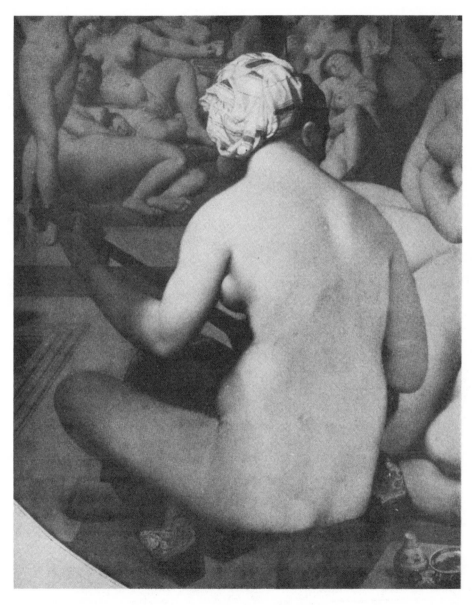

FIG. 3. Baigneuse. Detail of 'Le Bain Turc'. Ingres
Louvre

FIG. 4. Mountain after a summer shower. Kao Jan Hai or Mi Fu

British Museum

essential of perfected art ; but that, this basic fact apart, there is difference enough of type·between the imagination of the painter and that of the sculptor.

Many painters—such as, for example, Ingres whose ' Baigneuse ' might be translated without change into equally satisfying marble—make use of a style of drawing which attaches them closely to the confraternity of sculptors, but the greater number grade off towards a more or less total elimination of the precise formal element, and supply its lack by charm of colouring, or mystery of light and shade. The more emotional an artist is—in a disordered way—the less use will he have for the precision of formal expression. Where in this descending scale of formal precision shall we say that drawing ceases to be drawing ? It is obviously impossible to say ; though the difference between the precise shapes of Ingres and the fluidity of the ' Mountain after a Summer Shower ' (Fig. 4), attributed to Kao Jan Hai or Mi Fu, is more than patent. Yet the eastern landscape in no way gives us the impression of being the work of a poor draughtsman, as indeed it is not. Why should this be ? A sense of balance of mass and of rhythmic contour need not of necessity express itself with the uncompromising exactitude of a Grecian vase drawing, with the faultless precision of a Leonardo silver-point. Power and knowledge need not always be pressed into the front rank, they may be gracefully dissimulated, modestly veiled, hidden behind a seeming indifference to their worth, and we feel with ease what inspired Kwo Hsi to state that a mountain deprived of clouds and mist would be even as springtime bereft of her flowers. The danger lies in relying upon the lack of precision of an enveloped technique (see p. 252, *Relation in Art*), to hide ignorance of constructional fact and rhythm. An ill-armed critic may be led astray by this deceit, but fully instructed scrutiny detects the fraud. The road to masterly drawing is long and arduous even for the unusually gifted,

indeed only by them may its higher paths be trodden. But even moderate success demands much long and tedious work, much direct vanquishing of difficulties that the faint-hearted avoid by some plausible technical trick ; few, very few have the courage to pursue the struggle year after long year.

In the ' Mountain after a Summer Shower ' it is not easy to decide whence exactly comes our impression of the capable draughtsmanship of the painter. Contour there is none. Mass rhythms are suggested by exquisite gradings of tint. Drawing does not consist in the establishment of an outline ; nor does it consist in any form of technique. Drawing is a loose term to which we must accord at least two meanings. It consists first of all in a perfect comprehension of the structural nature of objects ; and secondly (and here only begins the aesthetic interest) in the power of expressing thought and emotion by means of a writing down of such structural nature. As to the method employed in such writing down, it comes far afterwards in rank of importance. How many people place it before all else ! In the ' Mountain after a Summer Shower ' a contourless method is chosen ; but this does not prevent the gradings of value-variation (p. 192) from conjuring up the exact modelling of the surfaces they seem to overlie. Once the artist holds within his mind the conformation of the object he would draw, what tool or what method of drawing he employs is matter of small importance. The difficulty is in conception, not in execution. Faulty execution is the result of faulty, of incomplete conception. It is no ' easier ' to veil objects behind mist than it is to draw them clearly and explicitly. The main secret of Turner's mystery was an unflagging study of shapes and a remarkable gift of innumerable imagining of them. This modelling of the shapes in our example is probably not the only reason why we feel that we are looking at the work of a master draughts-man ; the perfection of the compositional balance would also

seem to play its part in producing our impression ; but here we enter upon the delicate marches that lie betwixt the realms of drawing and composition where discussion is at fault. Art invariably defies ultimate analysis ; one of the reasons of its very being is to supplement the deficiencies of categoric thought.

The most vexed question in connexion with drawing is that of the degree to which accurate representation of the appearance of objects should be practised. To this question no reply can be made ; unless indeed the following discussion be considered to afford a solution in part of the difficulty. Neither open modification nor exact reproduction of appearance can be taken alone as a criterion of drawing excellence. One of the primal factors of personal artistic production is the satisfactory balance between the unchanged appearance of things and the particular modifications that the artist's temperament obliges him to superpose on what we may term the average man's perception. We have already sketched out the Taoist position with regard to this point ; there is no need to repeat. That such a view neither proscribes nor prescribes modification is evident ; hence we find in China highly detailed study of Nature encouraged to the same extent as the hyper-stenographic notings of some of the great monochrome draughtsmen. China early saw that the aim of art is not reproduction ; reproduction should be a by-product of more serious aims, visible shape should only be, so to say, the material support of the invisible. So the question of outward semblance is tacitly passed over. But this is a dangerous doctrine to the unwary ; before casting away the legitimate aspect of an object, before bringing some serious modification to its appearance, we must be sure that the change is worth making, that we are not making it in order to follow a fashion, or for the sake of appearing original at small cost. Such modifications, only too rife to-day, amount to

nothing more than technical trickery or servile imitation of others. As a rule valid modifications are made unconsciously by the artist, he cannot help them, they are a direct product of his active personality.

As I have said, neither the copying of Nature nor the converse can be chosen for praise or blame. The careful copying seen in a ' Pre-Raphaelite Millais ' is almost aesthetically valueless as drawing. The yet greater care of a Leonardo silver-point is, on the contrary, of great suggestive value. One of the probable reasons of this difference will be dealt with later on p. 221. Without going so far as the Ultima Thule of certain Cubistical tenets, we may throw into sharp contrast with the cold methodical reproduction of detail in an early Millais the ecstatic neglect of it in a drawing by Van Gogh. Van Gogh's ignorance as a draughtsman was remarkable, his all too short painting life did not allow of his making the necessary studies to become ordinarily proficient in drawing. Had he had the time to study, would the exaltation of his temperament have consented to such drudgery ? Probably not. Van Gogh belongs to the numerous class of draughtsmen who supplement want of knowledge and of capacity for what we may call workman-like execution, by impassioned emotion. To this class belong painters like El Greco, like Delacroix. The Impressionists and Cézanne may almost be assimilated to this group, though in reality the *naïvetés* of Cézanne can hardly be said to be based on violent emotion ; on the contrary they are mostly due to a slow and uncouth striving after architectural stability. The wilful simplifyings of that very fully equipped artist, William Blake, had a similar cause. Seeming *naïvetés* were to him a means of detaching spiritual visions from the real, as well as being a method of insisting on sculptural stability. But all these men had weighty reasons for adopting a very personal drawing-vision ; unfortunately of recent years it has become

the fashion to imitate the liberties that they took with form without first being assured of either the possession of William Blake's very complete information, or of Van Gogh's super-intense contact with vitality, the super-acute sensitiveness of a real madman. A deliberate imitation of the irregularities of such men falls at once to the grade of a cold and painful caricature. Before we try to reproduce one of the hurried notes that Rodin used to make from the moving model, it would be as well to assure ourselves that we could also repro-duce the modelling of the ' St. Jean ', and show as considerable an acquaintance with the facts of construction. There is suppression of fact on account of ignorance, and there is another kind of suppression that may come from intention, or from circumstance. The two types of suppression or modification may seem alike to the uninstructed ; in reality they are far apart. The liberties that great draughtsmen, at different epochs and for different ends, have taken with natural form will, of course, be noted throughout this book.

To say that exact copying of the model never has con-stituted—and never will—great drawing is no exaggeration. The precise reporting of facts, so necessary to worthy scientific research, must be eschewed in art. At the same time I would proclaim the need of study as exact on the part of the artist as on the part of the scientist. The differentiation between the two thinkers comes later ; even then is it as great as many would have us think ? The scientist classes the results of his observation, attaches word labels to his findings, and proceeds to induce from his accumulated facts certain general laws stated in verbal form. The artist also in his own way classifies the results of his observations, realizes—though not verbally—the compelling necessities of natural phenomenal appearance, and then by the light of his understanding of great universal laws, he modifies the complex aspect of nature, simplifies that aspect in certain ways, so that the modification itself becomes

the means of expressing a single universal view. Without this last step drawing, painting, or sculpture remains beyond the pale of art, and only amounts to a statement concerning the appearance of Nature, even though this statement be dressed out in the disguise of unusual technique. Michael-Angelo brings to his knowledge of the model modifications which insist upon the powerful and splendid fatalism of natural laws circling in planetary space—not that this is all his message. Botticelli will turn a similar knowledge to the chanting of more gracious themes by a line less robust, less tormented than that of the greater Florentine. Pheidias by wide and reposeful plane and Olympian rhythm of shape tells us of bright gleaming abstraction withdrawn from the various struggle of terrestial life ; an abstraction that, smiling a sun-lit smile, cuts clear, unhesitating, to the changeless perfection of its own desire.

Although it is impossible to lay down absolute rules concerning the kind and degree of the liberties that may be justifiably taken in representing natural form, still we can come to fairly accurate conclusions with regard to this matter by carrying out a systematic study of work which has proved more or less fully acceptable in the past. From such a basis in the past it would seem to be admissible to speculate concerning the future. This is the position I must be understood to take up when I make definite statements concerning the necessity of including such and such a fact in an artistic transcription. It is at least improbable that the future may hold in store for us a totally new aesthetic quite divorced from natural law ; though this natural law would seem to be taking to itself a new shape and aspect before our eyes.

It should be quite clearly understood, then, that exact copying of the model is an affair which bears little or no relation to the excellence of the work. But it must not be thought that in so saying I am advancing a doctrine by which the

lazy and inefficient may benefit. Quite otherwise ; it is much rarer to meet with the qualities that allow the leaving aside of imitation of the form, than it is to meet with those minor gifts that permit of more or less exact reproduction of superficial appearance. The path of literal inexactitude combined with aesthetic worth is the more arduous of the two, and is generally only followed with success after many years' apprenticeship. Neither ignorance nor carelessness ever yet produced valid art ; if we bring modifications to the proportions, or to the evident detail of the model, these modifications must be justified by an aesthetic reason. Such modifications are of two kinds : The personal modification brought to form and proportions more or less throughout the artist's work ; such is the tendency of Michael-Angelo to exaggerate muscular development, such is that of Clouet to insist on a clear and sharp *spirituelle* precision, that of Rembrandt to emphasize massive stability by means of strongly marked verticals. The second type of modification, which is not logically separable from the first—but which I will treat apart, because its precise nature is less often recognized—is a series of more subtle modifications which are closely allied to, and which result from, the exigencies of composition. Of the existence of this type of modification I have already spoken briefly on p. 31 ; it remains to examine it more closely. Now obviously the general nature of an artist's composition is a direct result of his personality, just as direct a result as the drawing modifications we named a moment ago. Also both forms of modification, having the same origin, will be intimately allied in kind ; consequently it is very artificial to separate them. I shall, however, do so for the sake of clearness.

Henri Matisse upheld the doctrine that it is better to modify proportions than to invalidate compositional balance. Undoubtedly ; but I cannot help thinking that it is better to conceive a composition which shall allow of correct repro-

duction of natural proportions, and which shall at the same time
conserve its balance. Yet, any one who will take the trouble
to experiment with the living model will find that Michael-
Angelo, on the Sistine vault, has taken strange liberties with
the possible proportions and arrangements of the human
figure. While controlling the British Academy in Rome I
profited by the occasion to carry out such a series of experi-
ments on models of the same types as those which figure in the
magnificent fresco, and was surprised to find how much at
variance with the possible many of the figures that appeared
strictly correct in drawing really were. This is evidently, I
think, the test of legitimacy in this direction : the modifica-
tion should add to the expressive quality of the whole ; and
its presence should only be apparent to searching technical
analysis. An obvious modification is a fault. While I was
occupied with the question I noted, amongst other deviations
from the strict proportional path, that one leg, the left, of
the Pugillatore in the Museo Nazionale (Rome) is about one
and a half inches shorter than the other. The composition
of the figure would be quite upset were the leg of its natural
proportional length. On the contrary, the backward out-
stretched leg of the Subiaco figure in the same museum is
about as much too long ; this modification aids greatly in
intensifying the movement of the statue. One leg in a J.-F.
Millet drawing of two peasants, a man and a woman, return-
ing from work in the evening, is much longer than the other.
The elongation greatly helps the forward sling of the tramp-
ing figure. But the casual observer would never notice these
intentional variations from mechanical truth, which are made
in the interest of a wider truth of suggestion ; they are so
cunningly fitted in with needs of movement and composition,
which are in turn modified in their relations with one another
and with the type of drawing. Having said so much I must
present the adverse side of the question. Intentional or

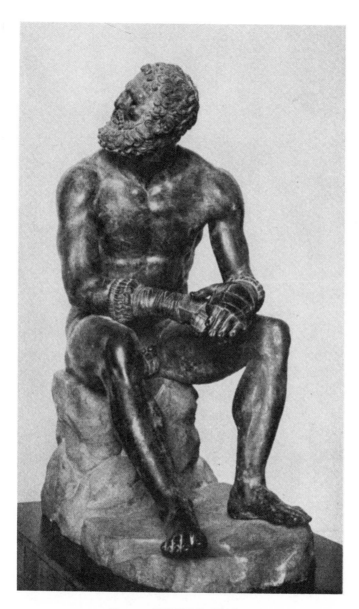

FIG. 5. PUGILLATORE

Museo Nazionale, Rome

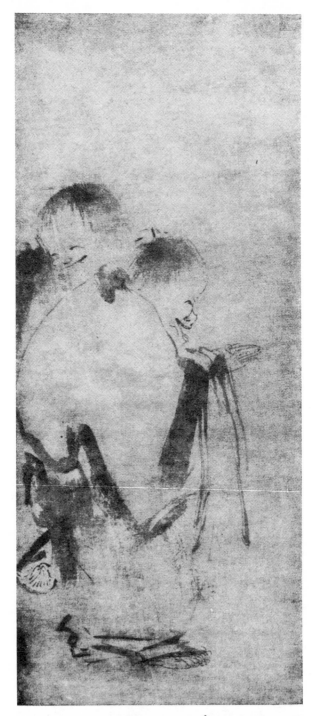

FIG. 6. HAN-SHAN AND SHIH-TÊ BY LIANG K'AI
1st half of XIIIth century. *Tokio*

unintentional grotesque must be accepted as an aesthetic element. Many forms of primitive art unquestionably owe a large part of their interest for us to their deformations. Of recent years modern art has deliberately dealt in deformation, and achieves thereby much that is unusual, much that arrests us, much that engenders a strange atmosphere. Shall we say that such an atmosphere is totally illegitimate, totally reprehensible ? I have slightly discussed the pros and cons of this question in the chapter on modern art in *Relation in Art* ; it is superfluous to repeat here, more especially as I have the intention to go fully into the matter in a later volume consecrated to modern technique alone. It is evident that such modifications are the affair of the artist ; they must be the result of his own convictions ; they can scarcely form the substance of didactic writing, though, once executed, they may form that of critical examination.

However, all drawing worthy of the name is a deviation from strict exactitude (if, indeed, exactitude were possible). It is rather difficult to treat in general terms of the variations and exaggerations that may be generally looked on as permissible. On the whole it will be better either to mention them each in its separate place, and at the same time to let an understanding of them grow out of the general thesis of the book.

Though we must not attach a singular importance to technique, it and aesthetic expression are inextricably interwoven, as indeed are all branches of our subject. To one form of composition a certain drawing technique is best adapted. One feels instinctively how great would be the incongruity of adapting a Greek vase technique to the *mise en page* of Liang K'ai's Han-shan and Shih-tê. In this drawing the occasional sharp black accents, the fine lines alternated with wide brush-marks of varying intensity all

play their parts in the compositional balance. Were such an arrangement condemned to count only on the delicate and constant line of a Greek vase it would prove eminently unsatisfactory. We are thus obliged to recognize the closeness of the conjunction between drawing and composition. The two dark accents just above the feet of the foremost figure are called for by the accents of the eyes and mouths. The intervening space of drapery is bare of small accent because the compositional balance does not need it. And similar reasoning may be applied to every kind of brush-mark and its placing in the drawing. Thus the way in which we indicate form is determined not only by facts connected with the form itself, but also by the position it takes up in the decorative whole of our work of art. Sufficient attention is not often drawn to this very important point. As a consequence of it, every study that we make should be made with a clearly conceived decorative intent. You have before you a sheet of paper. You are about to make a drawing on it from the living model. Let your first movement be to act as an artist, to attack an artistic problem. You have before you a rectangular shape, decorate it with the pose that the model is giving. If, as is often unfortunately the case in an art school, the pose be insipid, uninspiring, utilize only a part of it, make a study of the torso, of a leg, and place that study decoratively upon and into your paper. Any sheet of studies by Leonardo or by Michael-Angelo may be framed as a decorative whole. Not that I believe that they took into conscious consideration the problem of decorative arrangement of a mere study ; they were complete artists and worked as artists on every occasion.

The sheet of studies by Michael-Angelo, that I had originally chosen for the back and front studies of children and for the graphic inscription of constructional leg-forms, may serve as an example (it is the first page of drawings I

take up) illustrating the truth of this observation. Three of
the drawings are in pen and ink, one is in chalk, yet notice
the excellent balance of the arrangement. One might use it
for a demonstration in composition. A main diagonal line
starts in the groin of the isolated leg, runs up under the
buttocks of the chalk figure, to finish in the groin of the
front-view child. The cut head of the back-view infant, the
ankle of the foot, the top of the chalk head lie on another
and parallel line. The top of the shoulders of the chalk
figure is prolonged upwards by the pen trials which lead to
the written word, and downwards by the child's left shoulder.
The essence of the composition, and one, which when it is
pointed out, cannot but be seen, is the opposition of these
three or four hidden diagonals (there is another slightly
curved one from the bottom of the right chalk figure scapula,
its left elbow, and the complication of the pen and ink knee)
with the four obvious verticals of the three studies. The curve
just parenthetically described is finely balanced by one in an
opposed direction from the cut child's head through the toes
to the top of the chalk head. The thing is a symphony in left-
to-right upward diagonals and verticals. Michael-Angelo
himself would without doubt have been astonished had one
pointed these things out to him. They come unconsciously
into the work of an artist ; this is precisely my thesis. But
such unconsciousness may be cultivated just as the uncon-
scious certainty of hand is cultivated by much practice. The
lesson to learn is never to work as a dry-as-dust grammarian,
but always, even when studying, as a poet. Notice too the
exquisite fitness of the shape and placing of the writing in the
decorative whole. Hide it and note how the composition
loses in unity when deprived of its upward lilt.

 This is not the only lesson we may learn from this
masterly page. Let us specially consider the chalk figure,
probably drawn at an earlier date than the pen studies.

The decorative data of the page were then established once and for all. From a void rectangle capable of receiving an infinite number of decorative schemes it at once became a fixed and definite work of art, it became, at the bidding of Michael-Angelo, the symphony of diagonal and vertical that we have described ; the main decorative axis from the left ham-string region to below the right buttock is established ; round this line the whole *mise en page* swings decoratively. It is easier to point out than to describe the highly satisfactory arrangement of light and dark lines about this diagonal, itself accentuated. But it is not accentuated alone ; the vertical limiting the right buttock is also accentuated, for it gives the key-note of verticality needed to complete the harmony. And this key-note is discreetly repeated all up and down the perpendicular right side of the figure. Although the figure is passably contorted, the whole of one side lies on the same straight line. This is what the contortional followers and imitators of Michael-Angelo never realized. It is just there that an element of restraint and measure penetrates his work. Twisted as the torso is, the basic aesthetic idea is the opposition of two rectilinear directions. So basic is this intention that he automatically continues to carry it out when, later, he comes to add three detached pen drawings to the page. But to modify the ' diagonality ' of the line of the shoulders and the main compositional axis, note how cleverly the horizontal rectangular shaped pelvic mass stabilizes the whole ; just the right and left limiting lines that curvingly enclose it are emphasized, and from it the sweeping volume of the left thigh falls away. As ' diagonality ' is the theme, he slightly insists on the left calf, while the right leg is almost effaced, as is also the upper part of the torso. How much the drawing would lose, were the shoulders drawn in as heavily as the axial ham region and buttocks ! The diagonal would pass from a discrete theme to an exaggerated

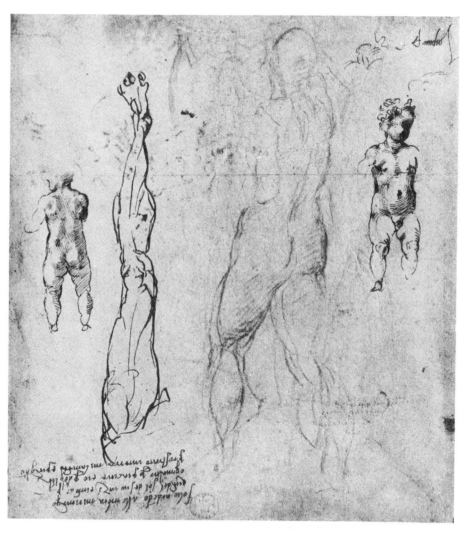

FIG. 7. DRAWINGS BY MICHAEL-ANGELO

Shows compositional arrangement of sheet. *British Museum*

obsession. If it be argued that in a finished work the shoulders would be as definitely executed as the rest, I would reply : Yes, but then an entirely new series of relations, of accents, of harmonies, of passages into a background would be elaborated ; the work of art would no longer be the same. In the drawing as it stands a delicate series of suggestions is slung about the median diagonal, and the thing is eminently satisfactory. Drawn in another way it might be equally satisfactory, but it would be another drawing ; the whole question is begged.

It is time to leave off talking of a median diagonal line, and to call it by its right name : a median diagonal *plane* ; Michael-Angelo has carefully marked this fact by emphasizing three diagonal lines of shading below the right gluteus maximus and below the mass of the biceps cruris. This plane harmonizes with the plane lying over the shoulder-

Fig. 8. Diagram of central figure of Fig. 7 showing constructional and compositional arrangement of masses and planes.

blades and the back of the upper arm. They are parallel in direction of extension and are very nearly at right angles to one another (I trust my meaning is clear, I purposely avoid a statement in strict mathematical language). We have here another example of the underlying simple relations of great work. It is already unnecessary to develop farther the intimacy of the kinship between drawing and composition ; the lightness or the darkness of the lines, the placing of the

accents in a drawing, belong as much to the compositional arrangement as they do to the exigencies of local form rendering. All the same it will be perhaps more convincing if I give a diagrammatic sketch showing the main facts made evident by the foregoing analysis. The diagram will, I trust, explain itself, will demonstrate sufficiently well the really geometric and mechanical basis of what at first glance appears to be only an emotionally contorted pose. I might point out, as an extra indication of the truth of our examination, how Michael-Angelo had first sketched in the profile of the right calf at A. On second thoughts he brought it back to D, now lying on BC, thereby gaining in simplicity of design and reticence more than he lost in intensity of movement.

.

It will be as well before leaving this question of compositional analysis in relation to drawing—one which I must reserve for more detailed treatment in a subsequent volume—to examine a drawing very different from the Michael-Angelo nude. Let us examine Wang Wei's (?) waterfall. Again I give a diagram of its essential facts. As we are now dealing with the Chinese aesthetic it is not surprising that we find that the principal subject of our picture is made up of curves, and not of straight lines or flat planes. The straight lines and flat planes are reserved for secondary functions, just as the walls of Chinese buildings are subsidiary to curved roof development. Here the theme is the magnificent curve of falling water A which, suddenly disappearing in a swirl of minor curves B, skilfully renders notions of continuity and of disrupture, of unity and of multiplicity, the ' unity in multiplicity and multiplicity in unity ' (وحدت در کثرت و کثرت در وحدت) of Persian sufi philosophy. Hence the great principal factor, the fall, is traced with powerful strokes imbued with the spirit of speed, but parallel and of consummate simplicity, of extraordinary oneness of arrangement. The confusion of small

Fig. 9. WATERFALL BY WANG WEI. 699–? A.D. Tang Period

curves at the foot of the cascade is lightly treated in order not to distract from the unity of the conception. It should be noticed that each wave is completely conceived in modelling and fully drawn out ; and also that the waves, especially the lower waves, of the turmoil constitute so many small arches which, so to say, arrest the downward shoot of the cataract, which give it a firm basis ; for we are not dealing with real movement, only with a stable plastic presentation of it. The

FIG. 10. Diagram of compositional elements of Fig. 9.

plastic laws of stability must not be violated in favour of exaggerated rendering of motion. Again remark how all the movement of this part of the picture is in a backward direction and opposed to that of the fall, which, thanks to this ingenious stopping does not tend to carry the eye out of the picture. Here again we see the very method of drawing intimately bound up not only with the abstract ideas that it is the intention of the artist to suggest, but also with the facts of the composition. One drawing method is used in one part of the composition, another in another part. On each side, and so to speak, framing the main motive, we find an arrangement of rock masses treated again in quite a different way.

They are limited by the planes C, D, E, F, G, whose arrangement is evident from the diagram. One might even liken them to so many buttresses consolidating the central mobility, which is also counteracted by the horizontal line HI, almost exactly continued by the top edge of D. This line HI and others, shorter in the rocks as at E, furnish the decorative straight element which cuts the curved system MN. The rock treatment is (see p. 106, *The Way to Sketch*) curiously analogous to the modern handling of Cézanne and his followers ; but here it forms only a part of the symphony ; the three handlings of (1) the cascade, (2) the turbulent waves at its foot, and lastly (3) the rocks, give the measure of the unusual inventive power of Wang Wei. To use three different techniques in the same picture is only too easy ; to render three distinct techniques harmonious among themselves to such an extent that they become parts of a single whole and essential to the aesthetic intention is a rarely accomplished feat. These subtle adjustments and a hundred others like them, this variation in unity carried out so discreetly, this perfect expression of abstract ideas by purely plastic means are some of the causes which make of this painting a seldom equalled masterpiece. Here again it is impossible to separate drawing from composition. One may perhaps go so far as to say that one never should be able to separate them.

.

A last example, this curious drawing by Luca Cambiaso. The thing is far from being a masterpiece, and for this reason I have comparatively little to say concerning it. I am reproducing it as an example of obvious drawing by means of plane and volume executed in the middle of the sixteenth century (Luca Cambiaso was born in 1527 at Moneglia near Genoa, and died at the Escurial in 1585). I shall reserve a complete discussion of the composition of this drawing for subsequent writing on the subject. For the

FIG. 11. Composition by Luca Cambiaso, 1527–1585

Shows use of geometrical construction

moment I will merely draw attention to the fact that we have here an example of an artist who deals with incompletely grasped ideas. He has made a valiant attempt to split the child figure in the foreground to rectangularly constituted volumes and planes, but the splitting is done by no sure hand. From this attempt, carried out more or less through the picture, a sense of solidity springs. But solidity is not all in all. Here indeed lies the principal lesson that we can learn from such a drawing, for failure may sometimes vie in instructive value with success. It is not sufficient to split form into simple masses in order to produce good work ; it still remains not only to organize these masses amongst themselves, but also to organize them in a way analogous to the convention adopted in the splitting. Now in this drawing one feels a want of unity between the attempted simplicity of the constructional simplification and the species of composition employed. The composition is of a type that I may perhaps be allowed to term florid, the front of the crowd that presses forward is broken up by a smallness of light-and-shadow-complexity due to arms, knees, and so on. Complexity may be taken as a departure point for an aesthetic, though I think I am right in saying that the results of such a convention are never so satisfactory as those of a simply posed aesthetic hypothesis. For the moment let us accept a complex convention as worthy. Why, then, has Cambiaso used a type of drawing fitted to simply conceived architectural conceptions ? That he is not quite sure of what he is doing may also be seen from the varying way in which the different figures are drawn ; the advancing principal figure just behind the child is almost a ' romantic ' piece of pen drawing in quite a ' flowing ' and calligraphic style which makes an uncomfortable contrast with the rigid geometry of the child. This is indeed a different sort of technical variation from that we have just seen ordered by the masterly brain of Wang Wei. There

we had homogeneous variation, here it is heterogeneous. A first-class artist would not have used this ' cubical ' method of drawing in conjunction with such an unstable composition. Or it would be even better to say that he would not have employed such a composition at all. Into the details of its confusion I cannot now go, I must content myself with calling attention first to the incongruity of the conceptions of the composition and of the drawing ; and secondly to the incongruity of the different parts of the drawing among themselves. We can conclude, what is after all obvious, that all the parts of an aesthetic conception must be harmoniously co-ordinated, and consequently that there must be a close relation between the type of drawing employed and the nature of the composition. A complete discussion of the relation between the different classes of drawing and the corresponding conceptions of composition would necessitate a long examination of the divers forms of composition and would find better place in a work on the latter subject.

Recapitulation

Composition is a bad term ; it implies a building up, an assembling. Composition should be as integral as the other parts of art. The more complete the composition is in the first conception of the artist, the better it is likely to be. Kwo Hsi's method of attuning himself to work before starting is described. We must not confuse tidiness with finish. Kwo Hsi tell us that we must nourish in our souls gentleness, beauty, and magnanimity ; and must be capable of understanding and of reconstructing within ourselves the soul-states of other men. Kwo Hsi assures us that this power and knowledge will show itself at the brush's tip. The commonplace must be banished from art. Art is essentially a symbolism. Before drawing one must learn to feel and think intensely. In different schools tradition and individuality are variously encouraged. In ancient Egypt tradition was almost all ; nowadays individuality is encouraged. Originality is in reality only a slightly novel arrangement of known facts and methods. Drawing cannot be distinguished absolutely from composition. Method of drawing is both decided by nature of composition, and varies over the different parts of the composition (see also p. 236). The poses of great painters are always sculpturally satisfactory. A painter should

conceive his pose contemporaneously with his background ; for the picture is but one thing. The sculptural precision of Ingres is compared with the fluidity of expression in the decorative value painting of a ' Mountain after a Summer Shower ', attributed to Mi Fu. Knowledge should exist, but may be, should be, suppressed and concealed. Faulty execution is the result of faulty or incomplete conception. One of the reasons for the existence of the plastic arts is to supplement the inefficiency of categoric thought. The exact degree to which imitation of Nature is to be carried is discussed. Modifications of normal natural appearance are generally (or should be) the unconscious result of the artist's producing personality. The emotional modifications that Van Gogh brought to form are mentioned. The modifications of Cézanne are often due to a striving after stability. It is useless to copy the modifications brought to form by Van Gogh, by Cézanne, by William Blake ; all modification that we bring must be the direct product of our own personality. Exact copying of the model cannot constitute great drawing. The scientist classifies the results of his observations and induces from them a natural law. The artist unconsciously classifies his observations and imagines a conditioning of form to suggest the result of his classification. Painting or drawing which does not suggest in this manner may belong to craft, but not to art. We cannot state exactly what modifications can be lawfully made in natural form. The original artist invents his novel modification. In that lies his originality. Matisse stated that it is better to modify proportions than to destroy compositional balance. Is it not better to fulfil both desiderata ? The left leg of the Pugillatore is one and a half inches shorter than the right for compositional reasons. The back-stretched leg of the ' Subiaco ' figure is as much too long. Primitive arts often owe interest to deformation. It is dangerous to attach too much importance to technique. Technique is allied to species of composition. Michael-Angelo composes even when dealing with a sheet of studies. Lines and values vary in intensity according to the needs of the composition. The Waterfall by Wang Wei is examined and found to fulfil similar conditions with regard to intensity of line and type of line in relation to compositional data. The plastic expression of abstract ideas is discussed. A curious drawing by Luca Cambiaso in which rigid geometrical volumes are used is examined to a slight degree. The suitability of such geometric rigidity in combination with that type of composition is questioned. Method of drawing must be in harmony with method of composition

III

TECHNICAL METHODS

IN these pages I shall recommend no brush, pencil, or charcoal technique, but I have exercised considerable care in choosing the reproductions in order that they should afford a wide range of examples of technical methods ; a thoughtful examination of them should be enough for the serious student. From time to time, in an unclassified way, I shall call attention to special technical excellences. On the other hand I shall at once speak of right and wrong methods of employing the tools.

.

Each tool is adapted to a particular use, just as each material employed by the artist is fitted to rendering certain services well and others badly. The pencil, the silver and gold point, the etching-needle, the graver exist, why strive to make a drawing in line with a piece of charcoal, unless indeed the drawing be of unusual size ? Charcoal is excellently fitted to the making of light and shade studies in correct value (p. 180). Let it be reserved to that end. Charcoal has, however, one quality which is useful in practice ; it may be easily dusted off. On account of this it is often convenient to use it before definite drawing is attempted, for a rough and tentative placing on canvas of some difficult problem in composition. Charcoal may be easily graded with the thumb or finger, and effaced with wash-leather, or with bread, or again with one of the modern forms of malleable india-rubber. I have a particular hatred of stump and chalk drawing, at least as a method for the use of students, for the following reasons. It is exceedingly tedious, and invites the

student to concentrate his attention on the single fragment of his drawing on which he happens at the moment to be working. Now there is no question that the most difficult problem with which the artist has to deal is the continual management of the relations over the *whole* of his picture. An accent on the right hand of a canvas is called for by, and takes its value from, say, a line on the left. During the execution of a work of art an artist must continually keep before his mind his total intention, which is made up of the relations of all the parts among themselves. He cannot exercise himself too soon in this difficult matter. There must always be a certain homogeneity about a work of art ; the right way to obtain it is the way just stated. How is homogeneity in the finished chalk drawing of a beginner obtained ? By tidiness, with which art has nothing whatever to do. By dint of unthinking, stupid application during a sufficient number of hours and days, a tidy stippled surface is obtained in which the gradations are so prettily executed that one is inclined to forget to ask if they have any relation to truth of modelling. Far from being an exercise in drawing such work is an exercise in automatic somnolence, and is as opposed to the keen, ever-alive observing of the true artist as it can be. No beginner should finish a drawing. Finish in art should result from : first a complete comprehension of main facts, then an understanding and knowledge of the secondary facts, and so on through comprehensions of less and less important facts down to the ultimate details. How can a beginner be possessed of this vast store of knowledge ? He cannot be. He can only achieve a pseudo-finish by putting tidiness in the place of knowledge ; and every time he does that he closes to himself, to one further degree, the door to future progress. Why study when we can do without real knowledge by adopting meretricious methods ?

The stump is a detestable instrument ; it is the only

instrument with which it is practically impossible to follow the form with feeling and intelligence. It is stupidly rubbed on the paper in any direction with next to no reference to movements of mass or of shadow effect. I know of no method of drawing that can more surely put a student on a wrong road. Italian chalk and its analogues belong to the category of point instruments. A word concerning their use.

Fig. 12. Ancient Egyptian method of holding brush.

The invention and use of the pen has militated gravely against the tradition of plastic formal representation. The slanting way in which it must be held is hostile to the true method of point drawing, or indeed of any kind of drawing. In *The Way to Sketch* [1] I have recommended its use combined with wash. Modern European draughtsmanship is largely based on the sloping method of holding the tool. The method has in a way become an inherent part of our techniques. I thus accept its use on account of the moulding action which it has had on all our plastic aesthetic ideal. A pen can only be used with perfect freedom in drawing a line from the upper left corner to the lower right corner of the paper. It is almost impossible to use it in the contrary direction. Other directions are more or less difficult to follow. A drawing instrument should be capable of equal freedom of use in any direction. The Egyptians, the Greeks, the Chinese, the Japanese, all the

Fig. 13. Greek vase painter's method of holding brush.

peoples who have shown themselves to be past masters of plastic rendering, have drawn with the brush, *and this brush has been held by all of them vertically to the surface on which the drawing is made.* Thus, and thus only, can unbiased freedom of movement be obtained in every direction. The accompanying figures show the different ways of holding the brush adopted by the different peoples just named. If we hold a pencil as we do a pen and then trace a circle with it we are not in reality using it as a pointed instrument, we are using the side of the point all the time, and moreover, according as the pencil is moving laterally to its length or more

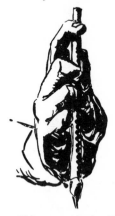

FIG. 14. Chinese method of holding brush.

or less endwise, it necessarily traces a line more or less wide. Now width of line should not depend on the hazard of an instrument, it should be a part of the compositional constitution of the work ; a line should here be thick, there be thin, according to the needs of the drawing. By holding a pencil slantwise to the surface of the paper we are deliberately depriving ourselves of a whole part of plastic expression. Unfortunately amongst modern Europeans, peoples not imbued with an unconscious love of form, the way of holding the habitual pen for writing has dictated the way of holding pencil and brush for drawing and painting. Shall I advise a draughtsman to adopt one of the unusual methods just described of holding his drawing instrument? He will evidently find great difficulty in acquiring so new a habit. One would be, perhaps, adding unnecessarily to the already large number of difficulties. It is a matter for personal judgement

and choice. A way of drawing with the pencil that I adopt myself most frequently is to cut a new pencil in half, and then hold it—of course vertically to the paper—between the thumb and assembled finger-tips, and completely within the hand ; its shortness allows it to be directed towards the middle of the palm. In this way the pencil is rigidly imprisoned, and the fingers rendered immobile among themselves; an important point, for no drawing should be done by finger-movement, all movement should come from the shoulder and elbow, even wrist-flexion should be suppressed. Do not fear that such a method of drawing will render fine detail work impossible, on the contrary you will find that in this way you have remarkable power over precise pencil-movement. I am inclined to recommend you to hold a brush in any way you like except as one holds a pen. You will find that useful variety in technique goes hand in hand with a changing method of holding the brush, always supposing that it be held as nearly perpendicular to the surface as possible. The amazing variety of handling displayed in the best Chinese and Japanese work comes from agile freedom in the method of employing the brush ; sometimes it is squashed point down on the paper, then partly picked up again and hurried off to trace a line of diminishing width which returns, perhaps, on itself, finishing in a suggestive swirl. In our countries one is taught to pay attention to the drawing, and not to the movement of the instrument which is producing it. It is hardly an exaggeration to say that one should be able to make a drawing without once glancing at the paper. A large part of my own drawings is always executed in this way, I look down from the model hardly more than is necessary to make sure that I am replacing the pencil on the paper at the right place. Rodin also drew in this way. He often completed an entire drawing without once taking his eyes from the model ; that is why some of his drawings appear so

grotesque, with arms or legs not always joined to the trunk. Though such a drawing may contain that kind of obvious fault, it also contains less evident but not less valuable positive qualities, obtained through the fact that the artist's attention has never been distracted from its concentration on the feeling and movement of the pose, on the rhythmic harmony of the mass arrangement. Such a drawing is always more living and suggestive than one more carefully made ; it is, so to speak, an unadulterated transcription of the artist's emotion unfettered by *soucis* of technique. It is an invaluable touchstone of suggestive freedom, a record of first enthusiastic impression : it is of inestimable worth to keep by one during the long subsequent hours of elaboration of statue or of picture from first studies ; hours during which keenness of attention, of creative power, inevitably flags and wanes, enfeebled by the worries of practical work and by sheer lasting of the application. I cannot too highly recommend at least occasional practice in making ' unseen ' drawings from the model. They have nothing whatever to do with drawing a pig with one's eyes shut. The aim is not to see what one can produce on paper under those conditions, the aim is to carry out a point-by-point, a mass-by-mass study of the pose in the most uninterrupted way possible ; and thus to get a sense of the rhythmic interconnexion of the various parts of the whole without losing the current of impression-reception, as one necessarily does when one takes one's eyes off the model. What one does on the paper matters not two pins. Yet at the same time one cannot do without the drawing, otherwise one would have no fixed and definite reason for studying each portion of the model in turn and in order, nor would one produce in one's mind an artistic reproduction of the rhythm (which one does, or should do, however badly and inadequately it may be written down on the paper). I cannot too strongly combat the ingrained idea that it is the picture or

the drawing that matters ; it does *not*. What matters is the constructive mental act of the artist, this it is that must be exercised and carefully trained. A properly trained mind gifted with the capacity of thinking into plastic terms will produce good work. To this training come many extraneous factors, extraneous, I mean, to the subject of plastic art. Some twenty-five years ago a friend of mine denied this truth. ' Of what use to a painter ', said he, ' is general instruction ? Look at Millais, he began working in an art school before he was out of his pinafores.' I still submit, to-day, that Millais's work lacks greatly in interest ; that his reputation diminishes steadily and surely ; that in course of time he will be almost forgotten. Kwo Hsi's humanity of brush-tip may be understood to originate from an unlimited extent of knowledge. The drawing of a cultured man will always differ from that of his uncultured brother, and, *ceteris paribus*, will be of greater value. Do we not all feel something slightly inadequate in the work of Turner, who also started early on his career of painter ? Does one not regret the want of a greater significance in the multitudinous creations of Rodin ? Pheidias frequented the highest intellectual society of his time. Why speak of Leonardo ? Le Poussin was a cultured man. A work of art is the expression of a man's mental position. The completeness of that mental position should be his first care.

In another way it is not the drawing that matters, what matters is the way in which the producing tool is employed. How often does one see industrious people leading a water-colour wash over the paper, and concentrating their entire attention on the wash, its doings, its tidiness. To them the brush is nothing, or at most a means of running a wash or making a brush-mark. To the true artist the very handling of the tool is a joy, the commanding of its movement is the fact itself of his artistic creation. Here lies the need of direct cutting in stone by the sculptor himself. Every movement

of the chisel is dictated directly by the inventing mind. This cannot happen when a workman ' pointer ' copies a plaster cast from a clay original. A painter should take pleasure in varied ' fencing ' with his brush, in its slow or rapid movements from side to side, or up and down, the inventions of greater or less pressure on it, of rapid twists of it, of a sudden leaning over of it, should be so many sources of new and unexpected pleasure to him. There should be a living excitement in the use of the brush, just as to the fencer there is in the agile and variable use of the rapier. In short, let invention be rather directed towards brush-movement than towards doing and combining things on paper. When painting, caress the imaginary surfaces and volumes with the brush, to the extent of forgetting the very existence of the paper's surface *behind* which you can create them.

.

The curse of artistic instruction is the academic system which obliges drawings to be done in a certain way, on paper of certain dimensions, perhaps already bearing the school stamp. To leave out some part of the model in order to realize some superior arrangement would of course not be allowed. Liang K'ai's cutting of both figures by the edge of the paper would certainly be forbidden (Fig. 6) ; his utilization of only the lower part of the paper would be considered as a method of escaping the necessity to make a drawing of the size that the all-important person, the examiner, had in mind. The very facts that made of Liang K'ai a great master would debar him even from competing in such an examination. ' But ', it will often be argued, ' such an examination is not intended for artists ; it is only meant for students.' Students of good behaviour as judged by the rules set up by a bureaucratic assembly, or perchance students of art ? All one's life one remains a student of that inexhaustible subject. When may one be said to cease to be a student ? Laws there may

be governing art, but rules there should be none. Every true artist is an innovator, though his innovation be confined to a new and personal exposition of ancient laws. From the very first an artist should strive to produce artistically valuable work ; a lifeless copy-book system of schooling is noxious in the extreme. From the first, imagination, that rarest of things, should be encouraged, and, delicate plant as it is, it should be carefully nurtured from the start. Study is fascinating, and itself spurs on to further effort. Drudgery is disheartening, useless. I, myself, at school at the age of twelve or thirteen fell into the hands of drawing masters (those beings who pretend to teach a subject they themselves have failed to understand, otherwise they would not be filling the posts they fill) ; in some three months they succeeded in so disgusting me with drawing that I threw it up, and took no further interest in the occupation of all my future life, till nigh on the age of twenty. Day after day they demanded from my inexperienced hand an accurate copy of a hideous design. Training of hand and eye ? Not one bit of it. On the contrary an organized numbing of all the keen perceptive vision that instantly descries the vital values of things. A mechanical exactitude of symmetry that it is Nature's glory to defy. A dead equality of line obtained at the cost of a thousand erasures. I would banish the use of india-rubber from the art school. Each time you erase a line, either in part or in entirety, and replace it by another you lose a chance of once more training your eye to correct and complete observation, your hand to the transcription of that observation. When you have rubbed a line out, you will inevitably replace it by another not so much observed in relation—proportional and otherwise—to the whole of the work, but as a differentiation from the previous error. Now it is in no way useful to learn what is the difference between your quite wrong line and your somewhat righter correction. Only one

thing is useful to the learner : the real relations between
facts upon the model ; or shall we say two things, that
already mentioned and the technical relations by which he
sets them down ? Both these things he will only learn by
unflagging study of interrelation of facts on the model. Take,
then, a large number of thin sheets of paper ; draw in your
figure rapidly, concentrating your attention to the utmost of
your power on the analysis and understanding of what you have
before you. This concentration, this highly acute observing
effort is the real discipline which every artist should undergo,
under pain of producing to the end only work of casual and
of incomplete interest. If there be a genuine differentiation
to be made between the student and the artist it can only lie
here : whereas the artist is obliged to attach a primary im-
portance to the work he is producing, the student should
almost solely consider the training of his mind and eye with
a view to future production. In other words, look upon all
your early drawings as things of naught. Spend no time in
tidying them up, set store not by what you have created but
by what you have learnt. Time enough to create when your
quota of knowledge is sufficient to the task. Presentable
drawings will only be made at the start by meretricious means.
Difficulties will have to be avoided, dissimulated behind tidy
shading or careful line ; that such trim shading should truly
model real variations in form, or variations which are the
outcome of an imperious artist's spirit, is impossible in early
days. The trick of hiding inefficiency will all too soon be
acquired. When the drawing on your first sheet is finished,
or even before, let us say as soon as you note a grievous error,
take another sheet and start your drawing again, profiting
now by all the observations you have made the first time, and
add new observations to them. Thus you will be continually
training your eye to correct observation. Every time you
measure you lose an occasion of learning to estimate relative

distances and volumes automatically. Have the courage to
produce many bad drawings in order that you may all the
more quickly produce good ones. Do not hesitate, do not
spend hours over one drawing ; work freely and gladly, not
cast down by repeated failure ; you will find your work
slowly improve, as the accuracy of your vision improves by
repeated exercise. It is the state of this accuracy that should
be your only care, not the appearance of the drawing, ex-
cept in so far as its first lines afford a measure of that accu-
racy that should become increasingly and rapidly attained.
Learning to draw is largely learning to intensify one's powers
of observation, learning to condense into the space of one
brief glance an understanding of a multiple series of corre-
lated facts. At first one is obliged, through lack of training,
either to be content never to make a presentable drawing, or
to take infinite pains over it. The drawing that I should now
make in a matter of some minutes, would have taken me
a week of half-days twenty-five or thirty years ago. The
drawing reproduced in Fig. 19 was executed in less than
ten minutes, the lines all being first lines with neither trials
nor erasures. If you have the courage to do so, I repeat,
eschew all attempt at perfection in the beginning.

To place a line correctly, once and for all, means the
simultaneous exercise of several kinds of observation. Let us
examine them. There is, of course, a preliminary and general
act apart from the others : the artist's appreciative viewing
of the pose, his estimation of its aesthetic possibilities, his
decision as to the treatment of it (whether, for example, by
pure line, or by a light and shade technique, and so on), as
to the placing of it on the sheet of paper. Intimately bound
up with this is the sensation that he acquires of the relative
arrangement of the masses (pp. 75 et seqq.), and at this point
we may say that he should become entirely possessed by this
plastic idea of the mass organization, he should be oblivious

of all else. Having identified himself thus with the great rhythm of the pose, he proceeds to transcribe it on his paper. Now comes in the necessity for simultaneous complex observation. Before or while executing each line he must make all the following decisions. Each line should engender a sensation of the mass, of the volume it limits ; hence the draughtsman must observe and hold in his mind the *total* form of the volume, and not only its profile shape on the side that he is engaged in drawing, as do the greater number of draughtsmen.

' First lines ', ' blocking in ', various ingenious disposings of points over the figure, plumbed verticals, imaginary horizontals, all sorts of fragmentary geometries are recommended as aids to the beginning figure-draughtsman. Refuse them all. There is only one true way for an artist to work : by appreciating and transcribing on his paper the volume and surface rhythm before him. If you ' geometricize ', if you ' dissect ', this rhythm, you assassinate it. You will never resuscitate it again in its pristine freshness. If you once reduce a perception in three dimensions of solid volume to a thought in line lying upon the picture plane, you will never adequately regain a sense of its solid mass.

The organic and geometric relations of mass will be dealt with specially in the next chapter, and subsequently throughout the book. On pp. 67, 83, and the following pages I speak of Mr. Hatton's *Figure Drawing*, but it will complete this chapter if I make a preliminary reference to that book in which certain ' methods ' of drawing are advocated. Mr. Hatton gives a choice between two ways of drawing the ' lines ' of an arm in order. But an arm has no ' lines '. An arm and hand are composed of three main volumes : the upper arm, the forearm, the hand. What must be understood at once, and either put down thus on the paper, or momentarily reserved for combination with further observa-

tion of more precise kind, is the spatial rhythm established
among these masses, the exact arrangement of the angles
that their approximate axes make one with another. In
the accompanying diagram and elsewhere, I am obliged to
' geometricize ' in order to make my meaning clear, but an
executing draughtsman should hold such facts in his mind
for the passing instant, and at once clothe them anew with the
supple vesture of living flesh. That, and that only, should his
pencil portray on the paper.[1] The language of all art is
rhythm, rhythmic relation of some type or another. To teach
a student to plumb and measure and to draw by rule of thumb
is to deprive him of the language itself of art, is to render him
inartistic. If he is incapable of realizing and using rhythmic
relations from the very first, let him turn out and learn some,
any, other trade. He is fundamentally unfitted to be an artist.
I reproduce diagrams (Figs. 15 and 16) similar to those of Mr.
Hatton ; the figures are his ; they indicate the order in which
the lines are to be drawn. I am wholly at a loss to imagine what
idea presided at these distributions. If there be important
points to fix in this arrangement they are those established
by the subcutaneous bones ; the head of the humerus at A,
the olecranon process of the ulna (and part of the humerus)
at B, the radius head and carpal bones at C. Why in Fig. 16
Mr. Hatton begins by placing 1, an outline of a finger far
away in empty space, I do not know, unless he be seeking
of malice prepense the best way of assuring that the finger
should have no rhythmic connexion with the supposed torso.
Why he then jumps back to the boundary of the arm-pit (one
of the most negligible points of the body) I understand, if
anything, still less. Why in each case, even by leaving out
the deltoid, he encourages the student to commit once more

[1] I am assuming for the moment, in addressing the European student, that he is
subservient to the natural Occidental ideal of reproductive art. Needless to say this
is the position occupied by Mr. Hatton, whose advice I am at present discussing.

the classic fault of looking on an arm as stuck ' on ' instead
of ' into '—far into—the torso, again I cannot think. The
real statement of the situation is that the scapular and deltoid
masses form a foreground, beyond which the more or less
cylindrical volume of the upper arm stretches back at (we
will suppose, though Mr. Hatton's drawings do not express
the fact) something like 45° ' into ' the paper. A, in Fig. 17,
is the ' sky-line ' of the deltoid, which, skirting the trapezius
comes forward on the scapula. The scapula should always be

FIGS. 15 and 16. Diagrams of order of FIG. 17. Diagram of arm masses
drawing first lines of Arm. After Hatton. and constructional points.

considered as forming part of the arm group, for it is ulti-
mately mobile with the other parts of the arm. A bony point
on the periphery of our figure is afforded by B. It is partly
formed by the opposite extremity of the humerus from that
already in evidence at A. We may thus feel at once a rhythmic
relation of a fixed nature between these two points. Between
B and C is established the complex relation due to the twist
of the radius on the humerus (to be explained later), yet
though its cause be somewhat complex, as a relation it is
nevertheless clear. These are all osteological facts which
determine, and peripheral facts which enclose, the flesh-
forms that complete the volumes ; they are facts which are
bound together by simple and direct rhythmic relations. It

is in such a way that the draughtsman should represent them to himself. If we are ' blocking in ' do not let us do so with flat unmeaning lines ; let our lines at once establish the main volumes, a precise limiting contour can easily be drawn afterwards through the curved indications of perspective cylindricity when once the illusion of solidity is firmly established. But better train yourself to combine all these analyses into one swift synthesis expressive of the organic harmony of volume with volume and of component bone with flesh.

.

For learning purposes a drawing from 18 to 20 inches high is to be recommended. A larger drawing is difficult to ' hold in the eye ', a smaller one does not allow of sufficiently faithful detail study, and does allow of contracting painful smallness of style and neglect of proper attack on difficulties which may be slurred over in a small-scale work. When the artist is already an efficient draughtsman, a 6-inch drawing is all that is necessary as a study from which subsequent work is to be done. The smaller size has the advantage of lying completely within the field of vision, at the ordinary drawing distance, and may thus be appreciated to a full extent without effort. When the draughtsman is really competent there will be no danger of his slurring over difficulties ; indeed it is on account of them, and on their account *only*, that he makes the study. All the ordinary parts of the work his past experience of the model would enable him to draw from *chic*. One studies from the model the unexpected refinements of shape which result from a movement of the thorax on the pelvis, and a thousand and one delicacies that it is impossible to invent. But before such delicacies can find a place in the drawing it is evident that the main facts on which they are superposed must be properly established. I have said that it is only on account of the impossibility to invent certain details of form that one uses the model. This

is not quite correct, for we also use the model, as did Rodin so largely, as a source from which to draw natural poses, that we should be at a loss to arrange for ourselves. Rodin's method—and an excellent one it is—was to allow the model to move freely about the room. When some pose that took the sculptor's fancy presented itself, he either called to the model not to move, or he made a rapid note from the momentary mobile impression that he had received. I cannot encourage this kind of work too much, even from the start. It is the best training one can have in rapid comprehension of essentials, in rapid estimation of aesthetic worth of pose and composition, in, briefly, the most fundamental and rarely attained qualities of the artist. You must not be discouraged by many hundred failures, but work steadily on, making a point each time of recognizing at least one reason why the last drawing proved a fiasco : You had omitted to notice just the angle that the shoulders made with the pelvis ; you had not seized on and fully felt the rhythmic forward balance of the head on the neck and shoulders ; the exact angle of recession of that foreshortened leg had not been estimated, and so on.

Always watch the model at the moment he or she takes up or relinquishes a pose or gets upon or down from the stage. It is just then, and during the rest, that you will generally notice the most unexpected and beautiful movements. Frequently in drawing classes I have hardly drawn during the pose (so often stupid and academically trite) and have reserved myself for rapid noting during the rest. At an art school in London where I went once or twice recently to keep my hand in, without exception the students (?) behaved in an exactly opposite manner. The moment the pose was finished they turned their backs on the model and began talking among themselves, innocently oblivious of the fact that they thereby declared themselves wholly unfitted for the career they had chosen, and showing that they had chosen it,

mainly because they had not chosen some other, such as account keeping or pharmaceutical chemistry. Study the model? Delight in rhythmic cadence of motion? Note for future use truth of movement? Not a bit of it! They were there to learn to make a drawing from ' the life ' which should satisfy the omniscient gods called the examiners of the Board of Education, who are, as every one knows, so many acclaimed geniuses, who know all that is to be known concerning ' drawing from the life ', and who consequently cannot commit errors in ordering instruction of future artists. By the by, I wonder what are the examiners' distinguished names. The high-water mark of stupidity was touched when an officious ass stepped forward in one class to shroud with a dressing-gown the descending movements of the female model at the end of the pose! We had been allowed to gaze fixedly at her naked self for three-quarters of an hour; but see her get down from the throne? Never! How improper! I ask you what form of emasculated art, to be absorbed together with afternoon tea in the drawing-room, can proceed from such an atmosphere. Could there be a better method of turning the student aside from the way of true progress? As I said above, the British drawing master made me lose seven years of valuable study; last year I found on returning to England after twenty-five years' absence the same negation of artistic sense and conditions. In England the model is hidden from sight while he or she dresses or undresses, so one misses all the interesting movements that result from the various acts. Remember the soldiers putting on their trousers in the famous battle cartoon of Michael-Angelo, if you wish to see what may be extracted from such movement. Now, I repeat, so important is the point, the system is all wrong. The student is taught to attach value to a tidily produced drawing, and not to the sum of real knowledge he acquires. How to make a drawing is taught, and not how to

cultivate a true gift of draughtsmanship by storing up un-
limited knowledge of the veritable facts of form.

.

 ' The veritable facts of form ' ; but not all facts concern-
ing form are of equal value. A very delicate discrimination
must be exercised in collecting and classifying them. An
example of a class of information which always seems to
promise utility and so rarely proves to be of any practical use
is the numerical study of proportions. Mr. Hatton says :
' The artist rarely or never uses the tabulated proportions
which always appear so useful and prove so inapplicable.'
Great artists, Leonardo da Vinci, Albrecht Dürer in chief,
worked tediously at establishing proportions, sagely decided
whether a figure should be eight or only seven and a half
heads high. To think that such work could be of use to art
was an error of the nascent science of the time. Exact
measurements of the body are useful to anthropologists, to
comparative ethnologists, but an artist can safely leave them
aside. Especially so can the draughtsman ; not only does the
flexibility of the body disturb their application at every
moment, but the introduction of foreshortening renders
them at once quite inapplicable. But there is a yet more
cogent reason for ignoring them. One of the factors of
aesthetic expression is the harmonious co-ordination of con-
stituent parts. Each artist creates his own type of co-ordina-
tion, it is special to himself, it is his own personal language.
Some artists, for example Henri Matisse, have of recent years
gone so far as to consider that the proportions of the body
should be modified to an unlimited degree according to the
needs of the decorative arrangement of the whole picture ;
that is, if the composition demand it for completion of
balance, an arm should be doubled in length. I cannot help
thinking that this again is only a half truth. If the excellence,
if the significance of the composition be taken to be successful,

undoubtedly we should not hesitate to falsify a detail in the interest of general balance. But one is at once tempted to ask the question whether the composition that necessitates a serious derogation from natural conditions may not be inferior in quality to one that attains to balance equally well while observing them.[1] On the other hand, the field of artistic expression is wide, and it cannot be denied that the distortions of a Matisse or a Van Gogh make statements different from those of the perfections of Le Poussin ; inferior it may please us to think, still statements that it is impossible to neglect. However, as the present tendency (at the moment of writing, and judging from the recent Salon d'Automne of 1924) is once more away from such deviations from natural conditions, it will be as well to assume that a student should strive to compose in harmony with the proportional indications of Nature. But in any case the artist should not rely on a mechanical system for determining such a fundamental factor of his expressive means as is proportion. The imagining of proportions is an indissoluble part of plastic imagination. The artist who announces himself incapable of imagining proportionally is no plastic artist. Yet again, it is quite certain that all forms of imagination benefit by practice of them ; as we grow older in their exercise, the processes of constructive imagination become more flexible, more fertile, more readily active. Every time you have recourse to a mechanical system of elaborating a proportional scheme you are missing a chance to improve your proportional imagination. There is only one way to know the proportions of the human figure, and that is to make thousands of drawings of it. The first of them will be ill-proportioned, the last better in harmony of volume. This phrase suggests another error that is essential to the usual system of linear proportions. Equilibrium is the result of mass proportions, and it is some form of equilibrium—

[1] See, however, the consideration of ' primitive ' art; p. 355 et seq.

more or less complex—which governs the relative proportions of the body. Now though a volume is a function of its length, it is measured not by one sole length, but by three conjointly, and for our present purposes we may take volume and mass as interchangeable terms. The artist, be he either sculptor or draughtsman, should deal with the rhythmic harmony of mass, or, in other words, not only with schematic arrangements of lengths on the surface, but with the underlying verity of massive equilibrium that can only be expressed by taking into consideration all three dimensions. The linear method of treating proportions is only another temptation to ' see flat '.

.

' When the artist begins to sketch in his figures he represents them by bold sketchy lines, which, though drawn rapidly, are sufficient for the purpose of summarizing the form and fixing the proportions.' So Mr. Hatton. That this is often, that this is generally so, I do not deny ; but whether it be necessary or advisable is another question. Perhaps in the case of beginners it would be as well, as I have said above, that they should only indicate, in balanced correlation, the main structural masses, of which the several forms will be dealt with hereafter. But it is not needful for the well-equipped artist to hesitate, ' to wince and relent and refrain '. An amorous, passionate joy inspires the first daring essay of the pencil, a joy whose keenness knows no return, a joy born of the first sharp contact of the artist's spirit with the ineffable beauty of natural form ; it is the first transcendent moment of realizing anew, and intensely, how beautiful indeed is the model's form. The tracing of the line in its splendid subconscious rendering of first emotion brooks no academic ruling, must be untrammelled in its new creative effort. True, later, when, say, a completed picture is the aim, this first rapturous graphic may be worked on, may be refined,

may be brought to the standard of some convention, of some measured melody ; it may gain thereby qualities of repose, qualities of stability, glyptic qualities that we must in no way disdain. But the quality of life that springs from the espousal of impression and imagination is hard of gaining by other means ; and the quality of life is essential to living art. True, again, that Hellas was the home of measure and restraint, but it was also true that she was vital in her wide view of all aspects of life. Hard pressing on the Olympian serenity of Athene came a dancing crowd of Maenads, came the joy of life, came the bright colouring almost Eastern, almost of that barbarity against which the new spirit warred, came the obscene band of satyrs, vile followers in the train of the great God, Dionysos. The sense of life was full in Greece. And so it is that her abstractions live.

Some sense of this dithyrambic conditioning of form prompted Mr. Hatton to write : ' The drawing must be made in as long lines as possible, there must be no patching together of little bits.' No, art is not patching together ; it is integral inspiration. But can we go to the extreme of laying down Mr. Hatton's simple law ? I fear not. Dot and accent, especially in some aesthetics, above all in those of the Far East, have primary importance. Once more, there is no way of drawing. But this I think we can say : if short elements be used, they must be used intentionally, and not through hesitation and weakness. Art is neither weak nor hesitating ; gracious, delicate, infinitely subtle she may be, but never weak. It was this weakness of tentative fragments that prompted Mr. Hatton to write his phrase, to write it forgetful of the full extent of its imperative significance. A serpentine litheness is often one of the aspects of the figure that we would realize ; obviously it may best be rendered by long and undulating means ; it is often the appanage of a young girl's form and pose, so we find a note by Rodin

of some female gesture set down with a paucity of uninter-
rupted line, but much of Sesshū's rudeness lies in the *staccato*
of his touch.

I would re-edit Mr. Hatton's words ; rather than tell the
student of what kind of line his drawing should be made,
I would counsel him concerning his way of looking at the
model ; I would say to him : See the model in the fewest
possible number of masses ; in the fewest number that is
consistent with a true rendering of the pose ; see the inter-
relations of those masses in the simplest possible way, and set
down your resulting impression just as it occurs to you to
state it. We are all unhappily influenced by a feeling of the
proper way to do things, the voice of the greater number
dominates us till we forget the value of the individual. No
one not possessed of a distinctive personality can figure in the
ranks of artists ; for artists are, *ipso facto*, originators and
instigators of fresh things. One of the most difficult problems
before the studying artist is to find, to complete, and to
translate into action his own outlook ; the temptation is great
to reflect that of others. Diffidence and want of daring pro-
duce many disasters. In some ways it is not a bad thing to
' play the sedulous ape ' with the end in view of collecting
various technical knowledge. But aping should be done only
to- this end, and for the time being ; also we should ape the
method and not the defects of another ape, with a view to
learning the best that may be found in him. Lastly, it is well
to ape many, lest we become definitely enslaved to a style
which is not of our own inventing. To all this it may be
replied that hieratic and traditional arts have largely sup-
pressed individuality, thereby sometimes attaining to im-
personal abstractions beyond the reach of an isolated worker
largely dependent on himself. So it may be ; but we do not
possess such a definite tradition ; we must put our hope in
individualism. Work always appears, at the moment of its

novelty, to differ more from its antecedents than it does even quite a short time after the newness has worn off. The pictures of revolutionary Manet seem strangely classical and matter of fact to us looking at them so few years later. They take up their place in the normal sequence of the ' French School '. If our originality be genuine, and not an eccentric pose, we need never fear being too original.

.

Some pages back I recommended making drawings not much over six inches in height when ulterior work from them is in view. This does not apply to head studies, which we often find it convenient to make life-size ; though here again such master-draughtsmen as Leonardo set us the example of only two- or four-inch studies of wonderfully perfected detail.

If we make a six-inch drawing with a view to executing a larger painting from it we generally enlarge it by squaring out. A convenient geometrical fact to remember is that the angle made by the diagonal of a rectangle with one of its sides is the same in all similarly proportioned rectangles. So if ABCD be the primitive sheet of paper we can easily, and without calculation, construct a similarly proportioned rectangle by drawing the diagonal AC and producing it to F, which point we determine by the intersection of the produced diagonal and a perpendicular either to AE or to AG, to whichever of the two it may be more easily fixed from the new data of the enlargement. The other proportional length results immediately. It now only remains to divide ABCD into a convenient number of rectangles and AGFE into the same number of similar rectangles. We can now make an enlargement without fear of error in the proportions. The rhythmic delicacy of an original drawing will of course be unattainable by this method of squaring out, but in repetition work the ' first fine careless rapture ' is often adequately replaced by

stabilizing elements, by adjustments to a general conditioning of composition which provide another kind of worth or charm in place of that inevitably lost. Here comes in the need of such swift casting on paper of first emotional notes of pose or movement ; our pristine mental state is fixed before us ; we can summon it up at will, if not in all its fresh-ness, at least as a colourable simulacrum not without a use. The rigid lifeless lines of an enlargement may be revivified anew by re-contact with the inaccurate palpi-tating scrawl.

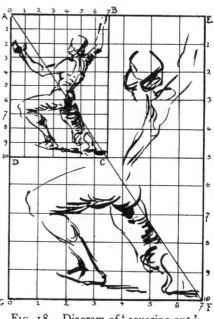

Fig. 18. Diagram of 'squaring out' a drawing.

The Italian Renaissance painters (and, of course, others) often used to execute a cartoon (for a fresco) the size of the final painting. The contours of the drawing were carefully pricked with a needle. Then the draw-ing was fixed to the wall and tapped all over with a pounce bag, filled with either light red or charcoal in powder, which left a faint dotted trace upon the wall, faint but sufficient to guide the out-lining brush that afterwards drew over it. For smaller work, nowadays, we can use carbon tracing paper. When I trace I am never too careful. A rough tracing over which one re-draws quite freely is preferable to precise tracing which is bound to yield a dead and mechanical result. A lilt of shape and line must be re-invented to replace that of the original drawing.

Further than this into the region of studio recipes I must not venture. The methods of transferring a drawing to lithographic stone, technical methods employed in etching and so forth, are adequately treated of in special volumes. I would carefully avoid speaking of fancy methods of drawing, such as the use of two or three coloured chalks. There is evidently no harm in using the rapid method of noting plane and volume lighting that is afforded to us by the use of black and white chalk on tinted paper, if we do not allow a pretty result to blind us to fundamental defects in the work. That is why I consider it useless to take up space in this volume with discussing fancy ways of drawing. Long before a novice draughtsman has attained skill enough, knowledge enough to use them with impunity, he will have had but too often the occasion of learning the little that there may be to know about them. After all, for European use few instruments can beat the ordinary lead pencil used as a line tracer, and charcoal as a means of studying value relations ; though these again are perhaps better studied in oil paint.

Recapitulation

Each tool is adapted to a particular use ; charcoal to light and shade studies ; pencil to line drawing. The total intention of a work must always be present to the artist's mind during execution. From this comes homogeneity of execution. No finish should be attempted by beginners. Finish comes from complete knowledge. Finish without complete knowledge is tidiness and trick. Point instruments should be held vertically to the paper. The sloping European method of holding pen or pencil is hostile to good drawing. The methods of brush-holding in Ancient Egypt, in Greece, in the Extreme Orient, are described. My own way of holding a short pencil is described. Occasional drawing from the model without looking at the paper is recommended, because it encourages following the rhythm of the form uninterruptedly. The drawing does not matter ; what one learns from studying the model while making the drawing matters. General instruction is of great use to an artist. There is a joy in properly handling the tool ; invention should lie rather in the movement of the tool than in the resulting drawing where it appears as a result of the movement. Academic prescriptions of methods of making drawings for

examination purposes are to be condemned. It is largely in the way in which he makes a drawing that the artistic capacity of a student becomes patent. Study should be encouraged, drudgery eliminated. Do not use india-rubber. Make a very large number of rapid drawings, never rubbing out mistakes, but commencing anew. Do not plumb nor measure. Train the eye to observe correctly without aid. The various kinds of observation, needful to placing a line correctly, are discussed. There is only one way to draw : *Completely realize the organization of the volumes before you. Then state this organization on your paper in the terms dictated by your special aesthetic.* Study the spatial rhythm of the distribution of masses. *Rhythmic relation of mass is the language itself of the plastic arts ; it is sometimes completed by the effect-factors of light and shade and colour.* ' First lines ' obviously induce into error ; they distract the draughtsman's attention from the difficult task of volume conception. The mind must remain fixed on volumes. Eighteen or twenty-inch drawings are recommended for learning and exercise. Smaller drawings as working studies ; they are more easily ' held in the eye '. Rodin's method of letting the model move about is mentioned. The necessity of rapidly grasping the main facts of construction, or the relative arrangement of the different masses in any given pose. Always watch the model, he may give a good movement at any moment. The slight use of tabulated proportions is mentioned, they should be replaced by the artist's own conception of the harmonious co-ordination of the various parts. Justification of variations from natural proportions. The joy of the first inspired tracing of the pencil, and subconscious transcription of emotion, should not be lost by employing a method of ' blocking in '. An inherent part of drawing is the pagination of the study. The academic system of ordering a drawing of so many inches high on a sheet of such and such a size is a paralysation of the sense that it is most important to train. No rubbing out should be allowed, because the student is not there to learn to correct ; he is there to learn not to make a mistake to begin with. New drawings should be repeatedly commenced on thin cheap paper. I use thirty or forty sheets at a time, attached by the top only to the board, and turn over and begin again instead of correcting. It is no use studying detail before you are master of putting down great facts. One should train oneself to observe simultaneously all the data needful for the putting down of a line at once, or, of course, for making the *tache*, or brushmark definitely, if line be not used. All mechanical and measuring methods should be eschewed ; they retard the training of the eye Measurements are anti-artistic ; the conception of rhythm is the base of art. We should at every moment cultivate its inception and execution. You should thus continually observe the model (and Nature also ceaselessly on every occasion) in order to catch any passing aesthetically useful rhythmic movement. Avoid tidiness in a drawing, pursue real finish which means perfectly co-ordinated great and less facts. Never replace want of knowledge by tidiness. ' Proportions ' are practically useless ; knowledge of them comes from a combination of practice with sense of equilibrium. Deliberate modification of correct proportions has

been frequently practised by the greatest artists The imagination of a new scheme of proportions is a part of artistic originality. The proportions of Michael-Angelo are not the same as those of Le Poussin. Linear proportions are to be left aside ; proportions of masses are those, if any, to be studied. But no tabulation has ever been made of them. Some aesthetics depend on long and simple rhythms, others on co-ordinated staccato touch. While preserving all respect for tradition, personality, true personality should be cultivated, especially as, unlike Egypt or China, we have no definite tradition. The method of enlarging proportionally by means of equal angles is described.

IV

MASS EQUILIBRIUM

TO over-insist on the importance of plastic equilibrium, which is another term for composition in the widest sense, and to over-insist on the importance of conceiving this equilibrium to be above all one of mass to mass would be difficult. Arabesque ornament takes, as a rule, the direction of purely flat decoration of a surface by means of balancings of differently curved lines and variously shaped areas. The Greek key gives us an example of an equilibrium established by means of straight lines. But I think that I shall arouse no polemic discussion if I say that, level for level, such types of drawing are inferior to those which aim at a representation more or less styled—for some abstract reason or other—of natural form. We meet far more frequently with fairly successful flat decoration than we do with even moderately successful renderings of mass and volume. Indeed these last are very rare indeed. We may even go so far as to say that harmonious mass co-ordination contains implicitly harmonious ordering of flat shapes. Though the rough-hewn masses of an unfinished figure by Michael-Angelo may be said, in one sense of the phrase, to be perfectly harmonious among themselves, we must stop and ask ourselves in what other terms we shall speak of the polished harmony of the 'Night', or of the 'Hermes' of Praxiteles. From the two latter instances we can isolate, by the simple means of cutting sections through the figures, an infinite number of flat rhythmic arrangements of shapes. In this way flat harmony may be said to be implicitly contained in mass harmony. The subject of decorative and more or less geometrical

design is again one too special to be fully treated in this volume. Its laws really fall within those enunciated or suggested here ; their application to that particular case must be reserved for future treatment. Inevitably I have already been led to speak many times of the subject-matter of this chapter ; indeed no part of our subject can or should be separated from the rest. Leaving aside further general statements, I will first examine in a particular case the nature of the process of reproducing mass organization, and will then continue to deal with various systems of mass equilibrium.

.

It will be as well to begin at once by giving the analysis of the method of thought which led to the production of the drawing reproduced in Fig. 19, rather than to continue to discuss it in general terms. Let the reader beware of thinking that some of the things that I am now going to say are self-evident and consequently negligible ; it is precisely the great facts, those which should be self-evident, that are ignored by all but the great draughtsmen. Few attain to the direct, almost infantine, simplicity of truly great artistic vision. For tens of thousands capable of reproducing detail only a chosen few will deal in the organization of larger harmonies. One interlude of self-excuse. It will be noticed that I have made use, for the illustration of this volume, of reproductions of drawings by great masters. Why this is not always done, I am at loss to say. Why does the author of a book on drawing invariably give us, as models to be followed, reproductions of his own work ? I am prepared to admit that for full explanation some diagrammatic work is necessary. I hoped to find still among the sheets of masterly work all that would be needful ; but I have had to relinquish this idea, and to reconcile myself to making diagrams explanatory of certain points. Why then am I on this occasion reproducing and analysing one of my own drawings ? The case is special.

Fig. 19. Nude study by the Author

I am not talking of the defects or qualities of the drawing, my theme is an examination of the mental acts that led to its production. I can but suppose the nature of these acts in the case of another, though I can suppose them with very tolerable certainty ; in my own I can affirm them, having many times and oft 'watched' myself at work.[1] Let us return to the drawing.

I first noticed the massive simplicity of the back in its doubly convex curve, and at the same time realized its three-dimensional existence from back to front. This is the great primal fact of the pose that must at all costs be rendered. One intoxicates oneself, so to say, with the sense of its stable placing, somewhat horizontally askew and directed towards the left. Arms, legs, a head, are adjuncts to a firmly established pelvis and torso, they are of secondary importance. Hardly had I realized the three-dimensional planning of the figure than I was engaged in recognizing that it had a back and sides, and that the limits between the two were arranged roughly as in the accompanying diagram. These facts also must be implicitly contained in the drawing ; indeed the position of the diagrammatic lines will easily be felt on examining the drawing. Now none of these diagrammatic lines really exists in the executed drawing ; even the line

Fig. 20. Diagram showing construction of Fig. 19.

[1] ' Dans tous ces exemples je me suis autant que possible cité moi-même, par cette seule raison qu'en fait de raisonnements et de procédés intellectuels je serai bien plus sûr de ce que j'avancerai en racontant ce qui m'est arrivé qu'en interprétant ce qui a pu se passer dans l'esprit des autres.' Claude Bernard, *Introduction à la Médecine expérimentale.*

approximately corresponding to AB, does not quite correspond to it. Some of the forms belonging to the right-hand side of the figure are designated by the line of the drawing ; so this line has for mission not only to designate the change of plane AB indicated in the diagram, but also a perspective view of some of the forms which belong to the right-hand side of the figure. This is not all ; the line CD of the diagram does not exist at all in the drawing, yet one feels the possibility of its existence. This feeling can only be the result of some quality contained in the lines corresponding to AB and to the line down the left-hand side of the trunk. What is that quality ? This I cannot state ; doubtless it consists in certain subtle, automatic insistences on facts connected with the observation of the volumes. It probably also is concerned with a reproduction of displacements of the normal profile which are due to binocular vision, or even to an actual slight displacement of the point of view. In any case binocular vision enables us to see a little farther round the figure on each side than the single vision of a photographic lens permits. All that I can state with certainty is that this quality appears in a line as the result of fully conceiving in one's mind the three-dimensional organization of the object one is engaged in drawing, and disappears from the line at the precise moment when, from fatigue or from inattention or from sheer inability, the draughtsman ceases to comprehend this organization perfectly. While my pencil is still moving over the paper I can state that the line it is producing has ceased to be plastically valid, to give the impression of actually modelling in relief the surface of the paper that lies within the boundary it is tracing. The line ceases to be plastically efficient at the exact moment when I cease to grasp fully all the adjacent facts of modelling.

The exigencies of discussion have enticed me forward into the subject ; it is now hardly necessary to give a verbal

description of the main facts of the pose, more especially as the diagram explains them quite sufficiently. All the same it will be as well to call attention to one or two points which will be more fully treated in their right places. The head, a volume apart, is rhythmically poised above the volume of the torso ; the draughtsman should become impregnated with the nature of this and of all other similar rhythmic balancings. The head too has front, back, and sides. In the present drawing I have hastily indicated the tone of the hair by a flat line shading ; this is a defect, the shading destroys the sense of volume of the head ; much better would it have been to have shaded as in the diagram. Drawing may be said in one of its divisions to consist in a continual establishing of a compromise between the flat and the round. You may regard an arm as two joined cylinders, or as a pair of rect-angular prisms bounded by planes. The truth is somewhere intermediate between the two. According to his own personal vision, an artist will place his rendering nearer to one or to the other extreme. In the diagram I have indicated one upper arm as cylindrical the other as prismatical. One of the many subconscious brain actions while drawing is to invent— without pause and continuously—a satisfactory balance between roundness and flatness.

.

We shall not have a clear idea of the organization of the masses until we have fully grasped their relative proportions ; this, then, must be done ; and at the same time we must adjust our mental mechanism to the reduction of the life-size impression to the scale of drawing that we have decided on. You should not try to estimate distances as abstractions apart, you should cultivate the simultaneous sensing of rhythmic relation and linear measurement. One would not go far wrong in setting up as an ideal the complete suppres-sion of linear measurement and in obliging oneself to

estimate the relative shapes of volumes amongst themselves. The eye should continually caress the whole *thickness* of the figure ; never let yourself be tempted to see form as a thin flattened profile line. The drawing we are considering, I suppose, must be called a line drawing ; but mark how it was conceived. Never at any moment did I feel that I was drawing a flat two-dimensioned line upon the plane surface of the paper. I made myself the ceaseless victim of my own illusion (a necessary condition of artistic production) ; the actual profile of the model is never at the same recessional distance from the draughtsman ; for example, consider the single line profile of thigh and left buttock ; the buttock is much nearer than the knee. I made myself believe that my pencil-point was in reality nearer to me while drawing the part of the line representing the buttock than while drawing the same line towards the knee. The more one can ' think ' the back-and-forth rhythm of the line between the two points as well as ' thinking ' the actual lateral rhythm immediately disclosed in the drawing, the better will be the result. In other words : let us suppose we have a plaster model of the figure ; let the artist look at it from the viewpoint of the drawing ; let a second person, instructed by the draughtsman, mark the point A on the plaster and then the point B ; mark them at the exact places which become the profile from the chosen point of view, that is, neither too much in front nor too much behind the ' edge ' of the figure. Carry out a similar operation at several points along the line AB. Join up these points. The resulting line will not only be sinuous as seen from the chosen viewpoint, but will also be sinuous from any other point of view, notably from one situated on a visual axis at right angles to that first chosen. It is this sinuous or spiral nature of the line that should in each case be fully conceived by the draughtsman although he is only able to deal with a two-dimensional

projection of it on the surface of the paper. But we are not now dealing with logical and exact mathematics. Were we so doing the line upon the paper would be a pure orthogonal projection of the other.[1] As it is we are free to introduce a hundred modifications which shall have the office to suggest the existence of modulations that we cannot directly and literally transcribe. An unconscious increase of pressure on the pencil as we feel the line to recede, a lightening as it should return towards us may be sufficient to give to it that hint of verity which counts for so much among the other subtle imponderables of art. To such variations of value (p. 199) may perhaps be added slight lateral exaggerations of curvature made in instinctive harmony with the sense of volume seen in perspective ; but the whole thing is very subtle. For what exact reason, on account of what quality of the line does the left deltoid profile of this figure appear irresistibly to be nearer than the point where the lower line of the arm disappears towards the arm-pit ? All that can be said with certainty is that while you are drawing you should carry out all the thought that would be necessary to model the figure in the round. If, because you are doing a line drawing, you pay attention to the edges of the figure only, your work is fore-doomed to unsuccess.

Indeed, the finest way to learn to draw is to model in clay. Not, as so many do, by repeatedly turning clay and model alike, and thus slowly building up a sufficiently accurate series of contiguous profiles, but by working with full-handed double caress, pushing and managing the clay directly to and from you according to the advance or recession of the form, and to the passage of planes round the figure from front to back and from back to front. Drawing is a convention, an illusion ; better is it first to deal directly with the reality of shape in clay, and then, when we are far

[1] Not quite, though, if we take into consideration the *conical* pencil of rays ' from ' the eye.

advanced in learning of its true form, then only to apply ourselves to rendering it on a plane surface with all the added difficulties of perspective, of values, and the like.

There is a rhythmic arrangement of volumes among themselves, there is also a rhythmic sequence of surface form. It was this rhythm that we saw treated by gradings of tint in the ' Mountain after a Summer Shower ' (p. 30). Here again there is a real complex rhythm of Nature upon which the artist bases his own simpler rhythmic convention ; one adapted to the expression of his personality. When this rhythm is observed along the profile of the figure it becomes that on which is based the rhythm of the line of a drawing. The slowness, the rapidity of this rhythm must be noted and intensely felt. Now it is soft and flaccid, a short space farther on it becomes tense and strained. All such changes in its nature must reappear in the line of the drawing.

Each time that we place pencil-point on paper anew all these several observations must be made, and the results co-ordinated and transposed into the particular convention of the drawing. Herein lies the great difficulty of placing a line at once and correctly. We have simultaneously to consider the plastic modelling work that it has to do, its proportional length, its general direction, its quality, its sinuous rhythm. We consider these things simultaneously because, of a truth, their separation is artificial, and only made with a view to aiding discussion. For example, it is obviously impossible to separate the general direction of a line from the plastic modelling work it is destined to carry out. I am inclined to suggest that the beginner, in order to simplify his task, should exercise himself in splitting up the figure into its main component masses as they appear in the several diagrams in this volume. He should accustom his eye to judge their relative volumes and their mutual angular relations rapidly. When he has once accustomed himself to an analysis of the form into

its fundamental architecture of construction, he may safely go on to the study of seductive rhythm without fear that his renderings of it may become flat and weak instead of becoming refined and gracious.

.

At this point it will be as well to call further attention to some of the evil counsels that are but too often given to prentice draughtsmen.

Perhaps the best book that I know of on figure-drawing is that by Mr. Hatton. It contains the outcome of much careful observation, it strikes, in an excellent way, the balance between geometrical construction and anatomical detail. Mr. Hatton fearlessly calls attention to the aesthetic unity of a mass which is anatomically composed of various factors ; all this is fully praiseworthy. I would only quarrel with him, as I have done in the previous chapter, when he recommends ' methods ' of executing a drawing. He is in the position of a man who has seen half the truth ; and if I speak of him here it is with no intention of disparagement, it is because he affords an extremely interesting case, by studying which we shall materially advance our knowledge. He shows us how all-important is the position we take up, whether consciously or subconsciously, with regard to the facts of Nature. I will at once acknowledge my indebtedness to Mr. Hatton ; throughout his volume from place to place appear many excellent diagrams of the arrangement of planes and volumes in and on different parts of the body. I have made liberal use of them in preparing the diagrams for this book. But here comes the noteworthy fact : *these diagrams are the only pieces of solid drawing to which he treats us !* How is it that Mr. Hatton is false to his own doctrine ? Simply because he has never realized the full consequences of a part of what he teaches. He almost excuses himself for telling us that ' the representation of solid forms in line is based upon the drawing

of the cube and the cylinder '. So it is ; but why introduce the words ' in line ' ? Mr. Hatton is still obsessed by the all-importance of technical methods. Before he teaches us to observe the nature of form, he is talking about drawing in thick lines or drawing in thin lines just as if that were of any consequence ! The cloven hoof shows in the very first pages ; for him the bases of art are not steadfastly laid on an under-standing of the immutable and universal, for him they become ways of putting lines or brush-marks on paper in order to get a plausible result. Drawings or pictures are not to be classed by varying value of aesthetic nature, but are to be catalogued into oil paintings or water-colours, into pen or charcoal drawings. The result of this is that when Mr. Hatton himself takes up a drawing-pen all the excellent information that he has imparted to us takes flight, and he becomes possessed with the idea that he must make a ' pen drawing ' and use for its confection some particular method of curved or straight pen-strokes. So without exception his outlines ' come forward ' in front of the inner reliefs of the figure they ought to suggest and model. ' If you draw by outline you must trust almost to luck for your modelling,' I notice on p. 16 of the 1917 edition ! Now I would undertake to carve a stone figure from the indications of modelling in the drawing reproduced in Fig. 19 ; and I would beg Mr. Hatton to believe that those indications are by no means the result of ' luck ', but are there on account of the strained attention that I paid to the real modelling of the woman's form while I was making the drawing. Mr. Hatton's own drawings do not possess this quality, not on account of no ' luck ', but because, having learnedly discussed the solidity of form and the arrangement of planes, he proceeds in practice to ' see ' the model flatly, and a drawing contains an implicit statement of the artist's way of looking at things. He will lay out schemes for measuring which necessitate the joining of points

that lie by no means on the same recessional plane, and he does not see that, in this way, he destroys the delicate perception of relative receding distance that it is so hard, and so necessary, to cultivate ; and yet on p. 27 he says with perfect truth : ' It is a fault, and a grave one, to allow oneself to regard a drawing of the figure as merely an assemblage of lines decoratively arranged, and to forget that a figure should never be drawn but to represent some one veritable person, which person will certainly be solid, and have air all around him.'

Any estimating of lengths should be done within the limits of the figure itself, by which I mean that no such measurement as that from the right elbow to the point B (figure on p. 77) should be for an instant thought of or countenanced, it would be equivalent to mentally bringing the point B and the elbow on the same recessional plane and thus would be destructive of the verity of recession so difficult to conserve. That is one of the reasons why I should never counsel the would-be figure draughtsman to begin by drawing from the antique. The motionless marble or plaster figure will tempt him to employ a system of copying flat shapes external to the body of the figure, such as, for example, the shape that might be enclosed between a bent arm, with hand posed on hip, and the adjacent profile of the torso. Though application of this method may lead to some passable but necessarily flat or ' modelled up ' result in the case of the immobile lifeless plaster or marble, it can never do so in the case of the living figure, for such a shape will be continually changing. This is why the nude is a better school than the antique for, say, the drawing of waves. In drawing we are representing solid realities, our attention should be fixed on the solid forms we are striving to represent, and not on the spaces that intervene between them. Moreover, the question of embracing binocular vision or of slight change of point of view, when applied to an intervening

space, will obviously react counter to the desired end. Undoubtedly Greek sculpture affords an unparalleled school in which to learn the inherent ideal and accompanying technique of European art. How much am I myself indebted to it for my own small knowledge ! Yet I doubt whether the beginner is, as a rule, capable of drawing benefit from its magnificent teaching. Greek Art itself was born under brilliant skies long centuries back, skies like the one beneath which I write these words, not far from one of her early colonies, Massilia. Greek sense of form was developed in free and sunbright presence of the nude, was developed in touch with crystal-clear undoubting modes of thought, to us no longer possible. Straight from thought and nature it drew its principles ; sad would it be to construe its lesson to one of servile copying ; even though the copying be done from the very Greeks themselves. But while we continue inevitably the Greek tradition, now openly, again in a manner scarcely perceptible, let us too return unceasingly to the source of all art, Nature ; and as thought and epoch vary let us take from her inexhaustible store-house just what for the instant, the passing instant, is needed for its aesthetic expression. Stand later, if you will, humiliated before the timeless marble Gods of Greece ; but in the beginning, even as in the end, serve in the temple of that still mightier Goddess, Nature.

.

Our perceptions of the world and its material components are strongly founded on a sense of that mysterious quantity, gravitation. That gravitation should have eluded all attempts at comprehension until the recent genial suggestions of Mr. Einstein, in no way vitiates the fact that it is above all the most easily perceived of natural phenomena ; though it might be argued that cohesion and light are its close runners-up ; but at least cohesion is probably only another manifesta-

tion of the same conditioning. Plastic art gathers the matter of its expression from the visible and tangible universe ; it may be readily admitted that plastic expression should not derogate in its suggestiveness from the universality of gravitational law. Let the draughtsman lie fully and without cessation under the spell of a feeling of gravitational strain. Never let him draw an arm without feeling profoundly that the mass of the arm is dragged downwards towards the earth ; that if the limb be outstretched the tendency to fall is counteracted by muscular strain. Let him feel instinctively the mechanics of the situation ; thus will he execute successfully those almost imperceptible exaggerations which are so often the concomitants of fine drawing. The tense line of the muscles in contraction will be drawn by him while he himself is in an almost breathless and painful state of mental tension, slackened with a feeling of relief as his pencil now sweeps round the curve of relaxed form that sags freely at gravity's behest.

Again, when he is fully conscious of the ten-stone weight that presses on the standing model's feet, he will instinctively trace the flattening of the soles, the diminution in curvature of the arch of the foot ; and moreover he will be induced to throw into proper perspective the floor on which the feet are resting. His drawing will deal in mechanical truths, and will thereby gain inestimably in value. Note in the Greek vase-drawing by Euphronios (Fig. 21) how flatly the soles of the feet are applied to the ground in order to support the incumbent weight adequately. Then again note how the instep of the foot about to quit the ground has resumed its more curved springing, though the toes still remain flattened against the earth. One feels, too, the flattening strain on the toes of the forward foot. Both figures are intensely stable in spite of the perfectly suggested movement, suggested but not imitated and exaggerated ; between these two aesthetic propositions lies a world of difference. The Greeks were past masters in

the sense of architectural stability, and architectural stability is little else than a just equipoise between thrust and resistance. But before developing this important division of our subject farther, I will return for a moment to a small but far from negligible detail of drawing execution. In any seated figure, for example, the fleshy mass of the buttocks flattens under the weight of the body, and to a certain extent squashes out. On examining my drawing of a seated woman (Fig. 19) it will be noticed that neither of the two lowest parts of the buttock profiles is strictly flat ; yet the figure appears firmly seated. In contour drawing a contour always plays more than one part, it suggests more than one fact. Here two facts are suggested by the one line : the flatness of the surface on which the model is sitting ; the convexity of the gluteal mass towards us. As the perspective view-point is above the surface on which the figure is sitting, the line of contact between buttock and surface is apparent to us as a curve seen in perspective. This is the curve I have drawn. And the point specially worthy of notice is that I drew it *en pleine connaissance de cause*, fully aware of all the explanations that precede and follow these particular words. None of Mr. Hatton's ' luck ' presided at the conception and tracing of that line ; it was a result of mechanical comprehension of certain facts concerning mass and flexibility of flesh, and its behaviour under pressure, of internal organization of bone support, of geometrical perspective construction (it should be remarked that the two buttock curves and the sole of the foreshortened foot lie impeccably on the same horizontal plane in perspective ; again there is no ' luck ' about this, believe me). The solidity of the figure springs from a hundred kindred observations and reflections ; in them neither chance nor luck has any part. Forgetfulness of application of perspective laws to the nude or other figure-drawing is a common omission. I have even heard one art school teacher say that it was

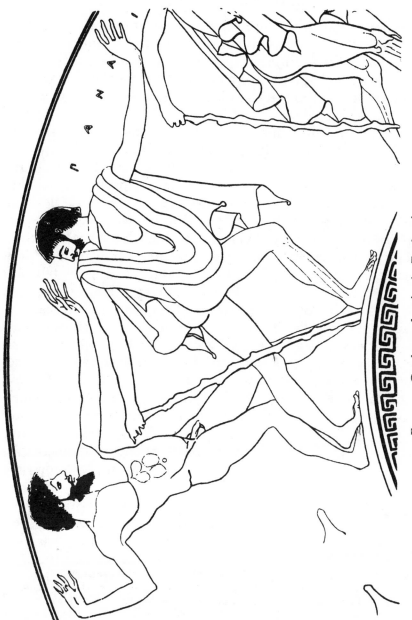

FIG. 21. Greek vase drawing by Euphronios.

necessary to 'arrange' the rapidly rising line of the feet when drawing a model standing upright on the ground too near the artist. Two different perspective visions in the same representational [1] picture of a natural ordering of things must lead to disaster, though the disaster may be of a refined type and not very evident. It is however on such subtleties that truth of impression finally depends ; detail and finish may readily be dispensed with if care be applied to such parts of the work as true and exact establishment of the unique perspective convention. If too steep a perspective prove disagreeable, the whole scheme must be altered and not one part of it alone ; otherwise the illusion will be destroyed. Surely this is evident. Yet it was not so to that teacher. Every line in such a sketch as that of 'Schaffhausen', by Turner, reproduced in Fig. 119, does not, I suppose, fall into exact perspective rank, fulfil all its perspective duties ; yet now I come to look at it with that idea in mind I am really at a loss to put my finger on any one that openly transgresses. We can safely say that transgression is here the result of necessarily rapid workmanship, and is in no way deliberate. Probably this transgression tends now in one direction, now in another and so neutralizes its own action. In any case such transgression becomes a part of the representation of aesthetic emotion, and as such is not only excusable but praiseworthy. It is meretricious when it is the result of incomprehension— in my school teacher—of carelessness, or of simple ignorance. Then again some arts, such as the palaeolithic and the Egyptian, are innocent of perspective ; but as the perspective convention does not exist at all they are homogeneous. The error of the teacher in question was to use a perspective

[1] It should be noticed that I have introduced the word 'representational'. I intend it to forestall objections that may put forward works of art into which enter multiple perspective schemes. See, for example, p. 126. I am here dealing with a European 'study' from life.

convention throughout ninety per cent. of his picture, and then suddenly use a second convention different—but similar in nature—for the other ten per cent. of the work. And he made this change not with a view to carrying out some peculiar kind of aesthetic suggestion, but merely to please the eye and not to violate certain rules of stability of which he vaguely felt the need, but which he would have been much put to it to enunciate clearly. Sometimes the Chinese openly neglect perspective construction in favour of certain other perspective balancings (see p. 126 et seqq.). But then the picture makes no pretence at being merely imitative art. Sometimes I have myself wilfully flattened a whole area of canvas, while next to it I have modelled a volume to the best of my ability. This has always been with a view to constituting a shock of form, just as one may use a shock of colour, or a musician may use a carefully studied dissonance of note in order to produce some special aesthetic result. All these efforts enter into the category of the varied techniques of the Wang Wei waterfall, varied yet delicately adjusted among themselves. Such intentional variations are justifiable when they are fully successful and attain the aesthetic end at which they aim. The art school teacher's aim was simply a colourable reproduction of Nature, the least worthy of all artistic ambitions ; his varying was a concession to the conventional vision of the crowd, he was afraid of being told that his figure looked as if it were standing on a slope, a remark within the power of the least adequate critic. Which remark leads us to another aspect of the question. The instructor, as might be expected, did not draw solidly. Within the limits of his figure solidity of mass and of volume were not properly expressed. Indulgent and amused by detail or by tricks of technique, the eye condoned the fault, even accepted the convention of flatness ; but on suddenly arriving at the evident rising lines of the floor it became puzzled ; the linear perspective, intended to give the

illusion of three-dimensional extent, was correlated with no volume-illusion in the figure. Three-dimensional illusion is a delicate matter to produce ; if only half the mechanism of the production is set going, the illusion will not be engendered. The sharp upward trend of the floor-lines remains inefficient, consequently troubling, hence it must be suppressed. So our inefficient artist suppressed it. Inefficient solidity in the work necessitated weak artifice to hide inadequacy. Now had the figure been solid, had the laws of perspective been consistently observed throughout the work, the illusion would have been perfect, the casual observer would never have noticed that the perspective lines of the floor sloped upwards, everything would simply have appeared natural to him. In my drawing of the sitting woman the foreshortened foot is considerably higher than the buttocks, yet one feels at once that the surface on which she is sitting is horizontal. Yet there are no calculable perspective lines on the paper, no ground line, no background of any kind. Still one instinctively feels that in placing and drawing the volume shapes throughout the figure the perspective convention has been tacitly observed, so the up-sloping imaginary line from the seat to the foot is not remarked as being extraordinary, for the simple reason that it is not ; its inclination is implied by the mutual relationship of all the other parts of the drawing, each to each and all to all.

Let us now turn to the consideration of a few of the different forms that aesthetic interrelationship of mass to mass has assumed at different periods and among different peoples.

.

Whatever sort of modification or styling of form be adopted by an artist or by a people, we notice that a stable posing of the objects represented has always constituted an important part of the conception. Objects themselves are

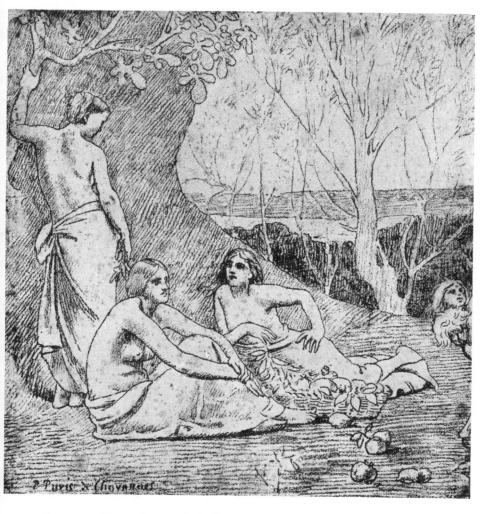

Fig. 22. Group from red chalk drawing 'Doux Pays'; by Puvis de
Chavannes

Shows linking up of poses

generally in a state of rest relatively to their surroundings ;
the eye is accustomed to seeing a state of balanced organiza-
tion of gravitational action and of passive thrust-resistance to
it. Even when flying human figures are represented with
success we are made to feel that only one assumption is
demanded ; that of a reduced specific density of the floating
bodies ; this admitted we feel that they behave as they would
do were they swimming in water. The work of inferior
draughtsmen is branded by a lack of gravitational sense, their
figures neither stand nor sit, and, most usual fault of all (or
should I say most obvious fault), their reclining figures rest
with no weight upon the ground. The drawing in the
accompanying reproduction from a part of ' Doux Pays ' by
Puvis de Chavannes may at first glance seem too *naïf* ; but
perhaps very few draughtsmen have better known how to
make an impeccable choice, brooking no omission, of the
essentials of mass representation to the exclusion of all that
is secondary and not indispensable. Ignorance or *naïveté* can
approach near to the outward appearance of such work, just
as they can to the hurried scrawls of Rodin, but they do not
deceive the capable critic who has himself practised the diffi-
cult art of precise choice. In the case of an artist such as
Puvis de Chavannes absence of complexity is due to perfect
choice. In the work of the inefficient, absence of complexity
is due to want of refinement in observation. Hence the almost
invisible effects of the action of gravitation on the mass
invariably escape them. Puvis knows and feels that such
subtleties are of primal importance, they above all create the
reality of his figures, which are—one sees it at once—masses
submitted to the action of gravity. Having made choice of
the subtleties which he intends to transcribe, he pitilessly
eliminates the detail that a vulgar eye would demand, knowing
so well, great decorator that he was, that the large wall spaces,
which his genius called on him to cover, would inevitably

lose in splendid extent were he to give way to the temptation
of displaying a world of that minor knowledge which, allied
to the principal facts, delights us in the work of Leonardo—
where it is imbued from commencement to end with aesthetic
intention—or which arrests us in the almost equally impec-
cable workmanship of Lorenzo di Credi from which the genial
spirit of Leonardo is lacking. Note specially in the light of
this context the figure of the reclining girl, hand on hip ; note
how truly she reclines. Yet Puvis has denied himself the
resource of the moderately competent ; the flattening of the
flesh and other forms against the ground. The lower profile
of the figure is hidden. He also thereby deprives himself of
a great aid in rendering the solidity of the form. How is the
solidity of the masses rendered ? Simply on account of his
puissant conception of their volume. There is a most exact
placing of the fingers of the hand resting on the hip. Though
there be no modelling at all of that hip one feels that the
finger-tips take up exactly the position that they should take
up upon it. The modelling existed in the mind of Puvis ; in
order to keep his rendering simple he restrained himself, and
did not put the modelling down on paper. Reticence and
not incapacity presides at the production of such a drawing.
And such a type of drawing is, it may be, the most difficult
to produce. No detail, no technical trickery, is allowed to
amuse the eye, to which full scope is thus given to detect the
faintest fault. The whole figure is a piece of sculpture,
massive and complete in organization. It is almost shadeless,
save on the arm and neck, and where it passes behind the
leaves and fruit. It is almost an outline drawing, yet here
again one can carve a figure in stone from its data. The
forward-leaning mass of the chest is completely—but how
simply—stated in all its directions ; the receding mass of the
pelvis runs back just at the correct angle ; the thigh comes
forward in a most clearly established way ; and lastly the

leg runs back in fairly rapid foreshortening. All this is done by the nearly unique aid of the one upper profile line ! Again, I repeat, so important is the point, complete comprehending of mass organization, and not ' luck ' is responsible for this plastic success.

On this group may also be studied with profit the interwoven relations of linear compositional arabesque and mass equilibrium. It is not necessary to call special attention to the extremely architectural stability of the front and of the standing figure ; their stability is obvious. But a cube lying on a horizontal surface is an extreme example of stability ; unmodified it can only serve as poor matter for artistic expression. Mere stability in formal work is not enough, it must be cunningly modulated by flexile arabesque. Sometimes this arabesque is reduced to a minimum, as (shall we say ?) in the stately progression of the panathenaic damsels in the Parthenon frieze, where stability and spaced placing play the greater part of the expressive rôles. Sometimes, as in much Chinese work, it becomes nearly sole actor and the necessary stable sense is generated from its very rhythmic organization. The mystically beautiful Kwan-yin of Mou-hsi painted about 1250 and now at Kioto, may be said to attain to the highest possibilities of rhythmic arabesque stability. Arabic work itself, whence the term is derived, naturally offers an example of the quality. To return to the group by Puvis de Chavannes, where the upright figure rises as a tower above the firmly established mass composed of the two other figures, the great simple sweep of line starting on the left profile of the standing figure's torso, carried on by one of the few folds of the drapery, continued by the under profile of the right arm of the seated figure, terminates at the hipposed hand of the reclining girl, and at the same time is hinted at again by the parallel upper drapery fold. The base line of the foremost figure is in exquisite harmony with the

left lower folds of the standing figure's drapery, and is con-
tinued by the cushion on which the reclining girl's feet are
placed. The right arm of the standing figure is prolonged
in gracious sweep by the seated figure's shin and instep. The
group is a symphony in straight (or nearly straight) lines,
crossed and commingled with clear and single curves. These
lines and curves serve to bind together the statically placed
masses, by weaving over their rigid mechanism a fair and
rhythmic suavity.

.

With the reserves necessary to all statement concerning the
plastic arts, the art of which the Kwan-yin (Fig. 23) is a masterly
example may be said to content itself with suggesting the
straight line that is openly drawn in European Art, and to
depend on just equilibrium among curved surfaces for its
aesthetic balance. We instinctively feel the action of gravity
on masses to take place vertically downward in a right line.
Chinese Art often counts on this instinctive sense to supply
the right line lacking in sheer fact to the drawing. Special
call is thus made on mass equilibrium for the completion of
the design. In the picture of the Kwan-yin, some slight
rectilinear verticality is expressed in the surrounding rocks,
while nothing but the stability of the figure expresses verti-
cality, horizontality, or any other kind of straightness within
the limits of the figure itself. Yet how intensely we feel these
qualities suggested by the double method of perfect conception
of the mass balance and exact equipoise of curve against suggest-
ing curve. The balance of the curving rhythm is faultless.

Gravity is counteracted by the cohesion of matter, and
by such forces as the muscular. Let us never forget this fact
while we are drawing ; let us decide in each case the relative
part played by each force in the conditioning of each portion
of the subject we are drawing. A mountain may be said to
owe its mass organization almost entirely to gravity. When

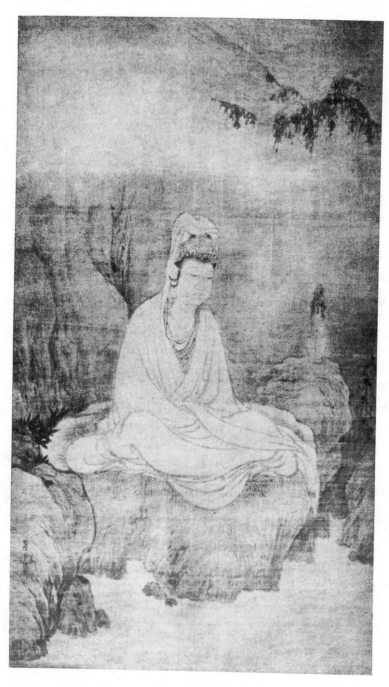

FIG. 23. Kwan-yin by Mou-hsi

XIth century. *Kyoto*

FIG 24. Jonah of Sistine Chapel

Michael-Angelo

we are drawing it we must bear this fact continually in mind, and almost feel our pencil dragged downward on the paper by the dominating force. A plant or tree is the outcome of a compromise between growing tendency, the resisting co-hesion of its component matter, and the ever-present drag of gravity. The first two enjoy a passing victory over gravita-tion, hence the essential quality of the unstable arrangement of a tree is a certain springing and fountain-like quality of form. This time, while we remember to engender with our line the weight and solidity of a tree trunk, we must simul-taneously render in the same line the converse upward vital straining. Our pencil-point is poised within the opposition of two adverse terms. The mobile nude contains all the terms of the variation. Gravity acts upon it. It is the product of organic growth. It is a remarkable example of mechanical system. It is an engine productive of motor-force. All these facts must be rendered in a drawing. The organic growth finds its manifestation in subtle undulations of surface, and in the automatic adjustment of the shape and volume of form to the proper support of other dependent masses. The whole bony skeleton is little else than an excellently arranged system of complex levers in which the moments of the applied forces are perfectly calculated for the best result. The measure of the motor-force is in each case evident ; it is a direct function of the muscular volume. Thus the human body, of which the subtleties are not hidden by fur, is a wonderful epitome of the mechanical universe. At the same time it is the outward and visible casket which contains our personalities, ourselves, it is after all *par excellence* the subject-matter of plastic art which interests us most. Perhaps to it may be traced the mysterious hidden ways of the ultimate aesthetic. From it may be studied plastic equilibria in their most subtle and exquisite degrees.

.

One phase of plastic equilibrium may be studied with special ease on the nude model. In natural movements of the body a balance is automatically and immediately instituted by the model. An arm is stretched out to the right ; immediately the torso leans away to the left. The great movement of the small arm bears the same proportion to the small movement of the larger torso as the great mass of the torso bears to the lesser mass of the arm. The adjustment is perfect and unhesitating, it is a natural phenomenon belonging to the category of phenomena on which our automatic observation causes us to base our aesthetic sense. For perfect tuition in the recondite and unwritable laws of plastic balance no school can equal that of the nude. If I had my way every architect would pass a long and serious stage in the life class.

Though the architectural balance of Michael-Angelo may be adversely criticized, the perfection of balance in his figure work will be, I think, universally admitted. I choose to speak of it now because he of all men has employed the most violent and exaggerated formulae of equilibrium. It is precisely for this reason that his architecture and decoration are less satisfactory ; or it would be more exact to say that great architecture and superlative decoration are not the offspring of a mind which seeks natural expression of so complex a kind. But the violence and complexity of his movements render them particularly fit for purposes of demonstration ; it is evidently difficult to examine the almost imperceptible subtleties of balance in which some arts deal, though between them and the art of the great Florentine there exists only a difference of degree. Different aesthetics are only so many different choosings of equilibria, necessarily of the same kind, from the inexhaustible variety of Nature. The mentality of the people, of the artist, of the period, governs the choice.

The Jonah of the Sistine Chapel may be chosen as an example of violent opposition of mass direction ; the leg and

thigh volumes are respectively parallel to and perpendicular to the plane of the picture. The torso is twisted respectively to them in a way that the reproduction saves the need of describing. To this back-thrown twist comes the counter-action of the head turned in the opposite direction, to a limiting degree. These strained oppositions of Michael-Angelo are repeated to a less extent in Greek Art, and conse-quently throughout European composition ; Michael-Angelo has pressed forward to the positive extremity of the formula ; but the formula is one which particularly suits the European cast of mind. Egypt dealt in exact balance in her great work. But till now exact balance has not proved felicitous among the peoples of Europe. Recent Germanic sculpture has attempted it on several colossal occasions with a result that appears self-conscious and reveals its intentional origin. Even the straight-ness of the architecturalized figures of the porch of Chartres Cathedral (or of any other Gothic structure for that matter) are laterally varied as much as is consistent with retaining their columnar destiny. Whether it be possible later to evolve a formula of exact lateral equivalence which shall satisfac-torily express some future European mind-cast I cannot foresee ; but I doubt the probability of it.

.

On re-reading what I have just written the fear comes to me that I may be understood to strive to reduce aesthetic balance to a simple replica of mechanical balance. This is far from my real notion. I by no means intend to enunciate something of this kind : If the mass of a head be turned through a certain angular deviation from the normal position, the sum of the two products of the mass of the head by its deviation and the mass of the torso by its deviation should be equal to zero in the case of plastic equilibrium. Such a state-ment would be a veritable reduction of art to science. Of course, though such a proposition may contain a small quota

of truth, it must be modified and complicated by a very large number of reservations. As crudely stated just now, it may be said to contain the germ of our sense of equilibrium ; but only the germ of it. The first criticism one would apply to it would be that it is quite false to isolate the single relation between head and torso. That one relation, were it complete in itself, would determine the final term of the work of art. We must take into consideration the masses and placings of the arms and legs. The resultant relation between *all* the masses is the only one that can disclose a complete equilibrium ; no fragment of a work of art can or should be complete in itself. Nor will it be any good supposing that, Rodin-like, the artist may have limited his work to a head and torso alone. We cannot draw or model a torso without indicating, without suggesting the pose of the arms and legs ; and in a work of art a suggested is often even more important than a realized factor. For example, in figure-work direction of regard, although a purely imaginary line, is a potent determinant of compositional balance ; it may almost be likened to a real rod projecting across the composition, thereby binding separate parts of the arrangement together, or acting even as a lever-like counterpoise to mass. So in determining a torso-equilibrium we must in no wise leave out from our count the influence of suggested limbs. Then, again, a small dark accent can, and generally will, be more important than quite a large field of half-tone ; though here again I should like to imagine in this matter a kind of constant determined by the product between the measure of the intensity of the value and the area over which it is spread. If none of these ideas be strictly correct, I do not think that any harm can come from bearing them in mind. I do so myself and have not yet been told that my work suffers in a way attributable to them. We are already far from the simple statement made a few lines above, yet the list of evident modifications to be

brought to it (not to speak of many other subtle and elusive ones) is not yet exhausted ; and it should be remembered that each new variant that we bring into the calculation increases with amazing rapidity the variety of the result. One last and very important modification I must mention : The employment of intentional unbalance as an aesthetic factor of expression. Just as a musician will use an intentional discord to provoke a certain mind-state in his audience, so a plastic artist may wilfully derogate from the unwritten laws of plastic harmony. Derogations from strict perspective like those to be found in the work of Cézanne and other recent artists are sometimes due to intentional discord, sometimes to the exigencies of arabesque balance. An examination of this delicate, and in many ways rather novel question will find a better place in an examination of the techniques of modern art.

Recapitulation

It would be difficult to over-insist on the importance of equilibrium, and it is that between mass and mass which is important. ' Flat ' harmony may be said to be implicitly contained in ' mass ' harmony. It is very rare to meet with artists who seize on the rhythm or harmony of great masses. Analysis of a drawing is made, giving the method of thought which presided over the invention of the profile lines actually executed. Never let yourself be tempted to look on an object thinly and flatly. Always think of it in thickness in recession. A profile of a nude or of a tree-trunk is really a sinuous line that recedes and approaches from and towards us. The best way to learn to draw is to model in clay, obliging oneself to model to and from one, and not by profile. The mind thus gets used to thinking in mass shapes. In drawing a pencil-profile we should imagine that we are actually cutting the solid mass out of, say, a block of clay, and that our pencil-point actually plunges into the surface of the paper while following the recession of a line. Too much attention is always attached to the process employed—pencil, pen, brush, &c.—and never enough to the understanding of the form which is displayed. There is no ' luck ' in the suggestion of solidity by means of a line. Solidity comes ' from the pencil-point ' when the conception of solidity is in the artist's mind. There should be no drawing from the antique for beginners ; it is apt to lead them to piece by

piece drawing, and to various other defects, owing to its immobility. Beginners do not yet know enough to benefit by its real and invaluable teaching. Continually ' feel ' in your work the action of gravity, feel that your pencil is being drawn downwards. Many lessons of architectural stability are to be learnt even from the second-rate art of the Greek vases. A number of facts are represented in a single line. The suggestion of the perspective surface on which a figure is seated is made by subtle modifications of the flattened buttock line. Modification of perspective is frequently carried out by draughtsmen who fail to give directly the impression of solidity in order to prevent easily observed perspective facts from clashing with badly observed but more subtle facts. The stable posing of mass has always formed a part of successful works of art at all times. The suggested line of gravitational attraction on the centre of gravity may be looked on as a compositional factor . . . as may be the equally imaginary line of eye-glance. The reticence of Puvis de Chavannes is studied, and his neglect of tricks as means of obtaining certain results. To stability must be added the factor of arabesque. A figure by Mou-hsi is examined. A stability is obtained by curve-equilibrium instead of the rectilinear equilibrium of Europe. Gravity is counteracted by the cohesion of matter (which would seem to be only another manifestation of the same phenomenon). Living natural form is the result of the struggle between growth and gravitation. The human body is a machine ; its surface not being hidden by fur, it affords us the best model for study of refinements of change. Michael-Angelo has employed the most violent forms of distorted equilibrium. Aesthetic balance is not an exact reproduction of mechanical balance. Many factors, both real and suggested, both suggestive of realities and suggestive of abstractions enter into aesthetic balance. Intentional discords can be introduced into mechanical equilibrium.

V

PERSPECTIVE

THE whole of drawing is an artificiality. It is nothing else but a symbolism based on a veritable abstraction of which the following are some of the most obvious assumptions. The first assumption is that it may be possible to represent three-dimensional objects in an intelligible way on a two-dimensional surface such as that of a piece of paper. Then sometimes we make another assumption, namely, that solid bodies may be represented by a more or less tenuous line drawn in a certain fashion, and generally marking the outside limit of the mass. Sometimes we do not use this method at all ; we replace it by darkening, by some means or other, parts of our surface in the belief that these variations of light tone and dark tone will suggest to the observer the play of light and shade over the real object. Sometimes, again, we make use of both these last-named conventional suppositions in the same drawing, and count on the goodwill of the observer to accept in one place the convention of use of line, and in another, but hardly removed, to admit our use of tone as means of provoking illusion. One of the most recondite points in aesthetics is the curious fact that the most primitive peoples and children at once accept and employ that amazing hypothesis : that a line drawing can represent a volume. We never find such people attempting light and shade modelling, though it is evidently largely by means of light and shade that we perceive, on the retina, the shapes of things. The most primitive people see shadow. Even an animal will walk towards

observed shade when he is too hot. Yet the artistic use of
shadow is a very late development, and the use of strong
light and shade with cast shadows belongs to late Europe only
(China and Japan may be said to have dispensed with cast
shadows).[1] Many arts have lived, attained their apogee, and
died without ever employing light and shade, as distinct from
tone modelling. Greek Art occurs to us, of course, as the
most familiar example. It is also curious that such peoples
should have hit on the use of tone modelling, which is no
other than a perception and use of light and shade, without
carrying experiments and investigations farther afield in the
direction of fuller chiaroscuro schemes. Tone modelling is of
great antiquity on the face of the earth, as the monochrome
reproduction of a two-colour drawing of a wild boar galloping
shows us ; for it is a palaeolithic drawing from the cave of
Altamira in the north of Spain. I need hardly say that,
beyond stating that it was drawn several thousand years before
Christ, our actual knowledge does not allow us to fix its date.
The suggestion of the volumes is above criticism ; aestheti-
cally the drawing is completely satisfying, I shall return later
to the examination of certain parts of it.[2] While admiring its
successes, we must remember that though its author was
ignorant even of the use of metals or of baked pottery, he
must none the less be looked on as a worker coming late in
the history of a people, coming perhaps near to its end, near to
the end of what we must perforce call a civilization. Palaeo-
lithic civilization was destined to die out—it seems—without
attaining to a high degree of complexity, just as that of

[1] See p. 200.

[2] For many years I have had the intention of visiting Altamira, but have not yet
done so. I have not examined the original drawings. Owing to circumstances they
cannot be photographed in an intelligible way. Doubtless M. l'Abbé Breuil's copies
are . . . ' improved '. However, my conclusions are not based on examination of these
reproductions alone, but are the general outcome of acquaintance with other original
palaeolithic engraving and sculpture.

Fig. 25. Boar from the Cave of Altamira (North Spain)
Palaeolithic epoch. From a copy by l'Abbé H. Breuil

Tahiti, for example, disappeared while still in a primitive state.

To the conventional assumptions already named we will for the time being add but one more ; but that is perhaps the most astonishing of all. It is tranquilly assumed, and rightly as it appears—for no one raises objection—that by mere geometrical constructions on the surface of the paper we may give the impression of recession, of the placing of one object behind another. Of this assumption it would seem that our palaeolithic artist had no conception whatever, in spite of his excellent perception of the solidity of mass. The side of the boar is most markedly nearer to us than the lower part of its stomach ; its right foreleg may well be accepted as being farther off than the left foreleg, because they are both short and still near the mass of the body. But when we fix our attention on the hind legs we at once notice that the leg that should recede into the picture comes uncomfortably forward to the plane of the really nearer leg. While there is palpable connexion of solid form between two points our artist manages his relief admirably, but he would seem to lose his head, if I may so express myself, when he has mentally to cross an intervening space and place one complete object behind another.

The concept of perspective is, it would seem, a very late introduction into art, the deliberate calculation and construction of it dating from the latter part of the Italian renaissance. Amongst others, Paolo Uccello [1] worked much at the subject, so much that he almost entirely abandoned painting in its favour. The simple writing of his name tempts me to a digression concerning the work of this remarkably interesting artist whose work is very insufficiently appreciated. For the moment I will resist. The earlier aesthetics adopted in place of perspective as we know it, a superposition in different

[1] See Vasari.

vertical registers ; such was the habit in ancient Egypt and Assyria ; though in Egypt we may trace here and there a faint beginning of perspective in landscape.

.

For a complete study of perspective I must refer the reader to some such work as Mr. Storey's (Clarendon Press) ; at the same time I feel that to leave the subject wholly untouched in this volume would be to allow too great a lacuna to exist in it. I shall limit myself to roughly indicating the main facts and to giving a few practical methods sometimes exact, sometimes only sufficient approximations ; I shall also do what is seldom done in treatises on the subject, speak about its limitations and about the justifiable departures from its laws.

We may even begin by noting one of its limitations, indeed, what is really an unjustified hypothesis. The theory of perspective, as generally expounded, assumes that we look at natural objects from one eye only. The theory takes no count of binocular vision. In reality we deal with two per-spective systems not quite superposed, and automatically draw our conclusions concerning the placing and shape of an object from a mental co-ordination of the two impressions. This act is as unconscious as that of turning the right way up images received upside down on the retina. I think that there is, as I have already pointed out, a close relationship between the power of a drawing to generate the illusion of solidity, and the unconscious act of the artist in exaggerating in his transcript of them certain impressions gained by seeing a little farther round an object than a mathematical monocular vision, such as that of the photographic camera, would allow him to see. In my own case I know how much the recent loss of the sight of one eye has impaired my facility in drawing and has obliged me to make a more or less conscious call on almost imperceptible applications of acquired knowledge to

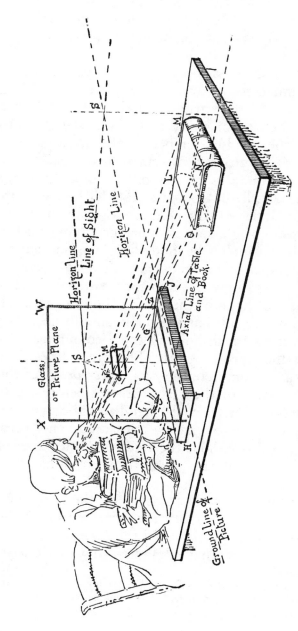

FIG. 26. Diagram of experimental perspective apparatus.

extend and to complete my no longer perfectly efficient vision, now deprived of its binocular quality.

.

A frequent fault of writers on perspective is to present the matter in an unnecessarily arid and abstract way. A beginner will certainly get a better grip of the subject by following the experimental method of study at the start. Let him either look through the window, or better still, set a pane of glass upright WXYZ (Fig. 26) in a saw-cut YZ made in a board GHIJ, and place the apparatus on a table at some little distance from its edge. At the edge of the table let him pile up three or four books and rest his chin on them, while he looks through the pane of glass at another book lying on the table a foot or eighteen inches beyond the glass, one edge of the book being parallel to the glass, and the book being placed centrally.[1] Fig. 27 shows in LMNO approximately what he will see as perspective shape of the book. The lines LM, MN, NO, OL, representing the sides of the book, should be now traced on the glass with a brush holding some colour just too thick to run down the upright glass. The other lines should be drawn in, so as to complete the *perspective image* of the book on the *picture plane* of the glass. Either before tracing the image of the book, or now, the height of the eye above the table should have been exactly measured, and great care should be taken throughout the tracing not to move the eye from its place. These operations being terminated the eye may be moved.

From the table upwards measure on the glass the height of the eye, and at that height draw with the brush the horizontal line HH'. This line is called the *horizon line* of the picture of the book that we have drawn. Now continue the lines

[1] In all these instructions I am carefully avoiding the use of exact geometric phraseology. The reader not used to mathematical texts would be confused rather than aided by such precision.

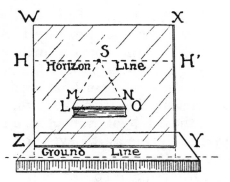

FIG. 27.

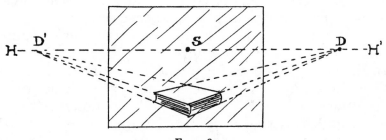

FIG. 28.

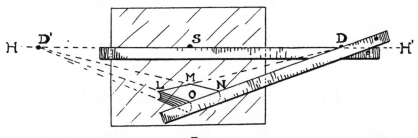

FIG. 29.

LM and ON upwards on the glass. If the work has been done carefully enough, these two lines prolonged will meet in the point s which will fall on the horizon line. This point s is termed the *point of sight*, and is exactly ' opposite ' the eye. The line HH' is called the horizon line because, if there be a sea horizon depicted in the drawing, it will lie exactly on this line, which is at the height of the eye, or, if it be preferred, on the same horizontal plane as the eye. That is why when we go up in a balloon or an aeroplane the horizon always appears to be on our level, and consequently the earth seems to be hollowed out below our feet. This also is the fact expressed in Tennyson's ' hollows *crowned* by the summer sea ' ; as an artist he treats of the appearance and not of the reality of the scene ; for, of course, really the sea lay below the level of the edges of the hollows, hence could not ' crown ' them, as it appears to do to an observer standing upright in a shallow depression of the dunes.

In the symmetrical arrangement just studied, the point s —called the point of sight because a perpendicular from it to the surface of the glass runs through the observer's eye— unites in itself this property, and also the one of being the point to which the lines of the book sides converge. If, however, the book be not placed squarely and centrally in the system, the result is not quite the same. Let us now lay our book still flat on the table, but with its edges making angles of 45° with the picture plane (that is, let us turn it through half a right-angle). Repeat the tracing on the glass ; draw the horizon line as before, but this time measure, and note as well, the distance of the eye from the glass or picture plane. Fig. 28 will represent our new result. When now we try to prolong the lines representing the four sides of the book, we find that, unless our eye has been placed remarkably close to the glass, our prolongations at once run off the glass without meeting. But if we lay a lath (Fig. 29) along the horizon

line and another straight-edge along on and lm, we discover
that all three prolonged lines, hh′, lm, and on, meet now in
a same point d on the prolongation of hh′. This point d is
known as the *distance point* ; because, as may be observed by
measurement, it lies at exactly the same distance from the
point of sight s, as does the point s from the eye. In other
words, the length sd is the distance at which the observer
is supposed to be placed when he looks at the picture. The
choice of this length plays a very important part in picture-
making ; we will return to this later. It should then be
remembered that the distance point lies on the horizon line,
and is the point at which intersect all lines which lie in reality
at 45° to the plane of the picture. If the lines ol and nm
be prolonged in a similar way they will be found to intersect
at d′ at the same distance the other side of s.

The points s, d, and d′ are three particular instances of
what are called *vanishing points,* so termed because really
parallel lines seem to disappear in some such point when they
are drawn in perspective. s, d, and d′ are special instances
because they are respectively the vanishing points of hori-
zontal lines perpendicular and ' half perpendicular ' to the
picture plane. Parallel lines making other real angles with
the picture plane will have vanishing points of their own,
which may be found by means of various complicated
geometrical constructions, for information concerning which
I must refer the reader to special treatises.

There is, however, no real need of these complex methods
for setting out a perspective scheme. Indeed we are already
in possession of all the facts necessary for solving in a very
simple way any perspective problem that may present itself
to an artist.

But before proceeding farther I add another term to
our perspective vocabulary. Returning to Fig. 26, the line
yz is termed the *ground line* ; or, to be more exact, it would

be so termed did the thickness of the board not intervene betwixt it and the table, on which the book lies, and from which the height of the eye is measured ; the line under-lying yz, and on the surface of the table, is the ground line.

Suppose that we now want to put into perspective a flat object, rectangular or not, lying at an undetermined angle with the picture plane. Let us begin by making a ground-plan of our future picture. Here I may parenthetically remark that it is never waste of time to make a ground-plan of work, even though we do not mean to make a perspective construc-tion. A really first-class composition will always make a good decorative arrangement when drawn as a ground-plan. The preparation of a ground-plan will aid enormously in giving the artist a thoroughly clear idea of the spatial interrelations of the various objects that make up his composition. Let us then make this ground-plan of our work (Fig. 31) and indicate on it the flat shape LMNO lying at the requisite angle with YZ the ground line (hence with the picture plane). Having drawn out our ground-plan let us now take steps to put the matter into perspective. The first thing to do is to cut up our ground-plan into a convenient number of squares. The next step is to decide on the position of the point of sight on the surface of the picture, that now and henceforward replaces our pane of glass. This point of sight s (Fig. 30) need not be in the centre of the canvas, indeed it should not be. If it be so placed, there will always result from such placing an uncomfortable sense of mechanical symmetry which cannot fail to be harmful to the general impression given by the work. Such decisions may without danger be left to the artist to make ; he makes them subconsciously ; if he do not make them satisfactorily he is simply no artist. It is thus superfluous to lay down rules as to the degree of asymmetry allowable in such cases. Indeed to do so would be tacitly to assume that we foresee all possible future artistic develop-

ments. A degree of asymmetry incompatible with other aesthetic factors that we have heretofore known may be compatible with aesthetic modifications as yet unforeseen. Is it

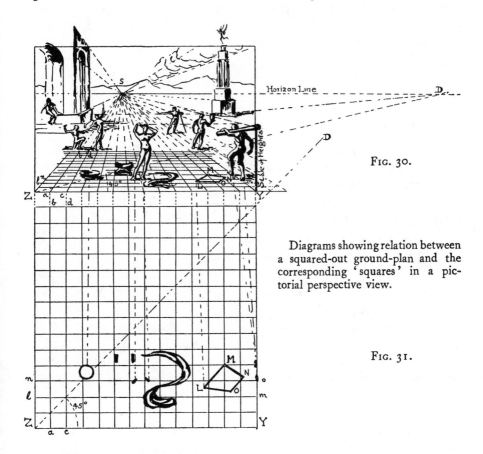

FIG. 30.

Diagrams showing relation between a squared-out ground-plan and the corresponding 'squares' in a pictorial perspective view.

FIG. 31.

necessary to add that this reserve applies to all critical aesthetic writing? However absolutely one may seem to state a proposition in the interest of clear demonstration, one always withholds in the background the understanding that it may be partly invalidated by future aesthetic invention.

The ground line YZ (Fig. 30) of the picture must now be divided into as many equal parts as is the ground line YZ (Fig. 31) of the plan. Each of the new points (Fig. 30) is now joined to the point of sight s. The resulting lines will be the perspective views of the lines ab, cd, &c., of Fig. 31. They are analogous in all respects to the lines representing the sides of the book in Figs. 26 and 27. Let us now consider the diagonals of the squares traced on the ground-plan, Fig. 31. I have not drawn them, for it is only necessary to call attention to the fact that they are at angles of 45° with the ground line YZ. Being at ' half right-angles ' with the ground line they become in all respects analogous to the sides of our book in its second position (Fig. 28) ; so the point of their perspective intersection is the distance point. This point, as we have seen, is on the horizon line, which is a horizontal drawn through the point of sight. We must now decide on the distance between the point of sight s and the distance point D. This distance is, it will be remembered, the same as the distance from the eye to the canvas. If this distance be chosen too short we shall be dealing with a perspective too ' rapid ', which will give rise to an uncomfortable sensation on the part of the spectator. Fig. 32 shows an example of the inconvenience of such a choice. The same diagram serves to illustrate another weakness of ' geometrical ' perspective. Unless we choose our various distances with great care, the impression given by a picture is false. In this case the three lines of cloud vanish to one of the distance points, D. It follows that these lines of cloud must be at angles of 45° with the picture plane in the real landscape. In the diagram not one of the three gives us that impression, indeed, the right-hand one seems to be at right-angles with the picture plane, and so to recede straight away from us, instead of lying diagonally across our field of vision. So we see that ' geometrical' perspective is no truer than other systems, it

is only acceptable, even to us, within certain narrow limits of application. Though the choice of the distance from which the artist regards his subject, and consequently the distance between the point from which the picture should be looked at and the canvas (which two lengths are the same when reduced to the same scale), must be left to the artist as forming important parts of his personal aesthetic and compositional intentions, still we may say that in ordinary cases it is not possible visually to take in an object unless we are at from two and a half to three times the length of its greatest dimension from it. That is to say, in order to draw a standing human figure, with the intention of giving a natural air to our work, we should place ourselves at some five or six yards distance from it. Having by exercise of judgement fixed the point D (Fig. 30) we draw the line ZD. If we now draw lines parallel to YZ through all the points of intersection between ZD and our perspective tracings of ab, bc, &c., these lines will become the perspective views of the lines lm, no, &c. (Fig. 31), and so we shall have a perspective view of our ground-plan squares. We are now in possession of all that is really necessary to lay out a sufficiently accurate perspective view of a still-life group, of an interior, or of a landscape. The smaller we make the ground-plan squares the greater precision we shall be able to bring to our result, as will soon be seen. Let us suppose that we wish to represent in perspective the object figuring on the ground-plan (Fig. 30) as L, M, N, O. Of these four points M alone falls on the intersection of two lines. As it does so, its transportation to M in Fig. 30 is perfectly simple, we note that it is four squares inward from ZY, and two squares from the side Y towards the side Z. But L, N, and o do not fall exactly either on an intersection or even on a line. It is here that we must introduce the chance of a little imprecision in order to avoid really unnecessary geometrical complication. Unless our squares in perspective (Fig. 30) are much too big, we can

estimate the place of L, for example, in its square with quite sufficient accuracy by noting that on the plan (Fig. 31) L is half, or a third, or a quarter of the way across its square, and by placing it similarly in the corresponding perspective square in Fig. 30. The distance of L into the picture, and into its square, is estimated in the same way (though this time the chance of error will be theoretically a little greater, it still may be neglected for our purposes). A little reflection will show us that, in Fig. 30, bd is the perspective length of ac at the distance ab or cd (Fig. 31) into the picture from the ground line. Consequently, if we wish to erect a perpendicular at that distance into the picture, a perpendicular which shall be equal in height to the length ac, we shall only have to draw an upright equal in length to bd. Or, if we prefer it, we can construct a scale of heights by marking out equal distances up the side of the picture from Y (Fig. 30) and joining each division in turn to the point s. The human figures in the diagram explain with sufficient clearness the way to use such a scale.

Perhaps it will be needful to add one or two further hints concerning the use of our perspective squares. We may have, for example, an arch to put into perspective. We draw an elevation of it to scale (Fig. 33). On this elevation we measure the heights of a few points such as h, i, and k ; the more of them we employ, the more accurate will be the resulting perspective curve. Then by the method just indicated we transfer all these points to their right places in our perspective view after having, of course, drawn the ground-plan of the arch on the squares of Fig. 31.[1]

.

[1] A useful thing to have by one is *R.'s Method of Perspective*, published by Batsford, High Holborn. It consists of a collection of loose plates of squares in perspective, which may be used as a guide under semi-transparent paper.

Leonardo da Vinci tells us that painting is founded on perspective,[1] which is nothing else than the art of properly figuring the office of the eye, that is to say, the semblance of objects as they reach the eye. Elsewhere he calls perspective the bridle and rudder of painting.[2] To-day we should express ourselves in a plainer way, and should reserve to the term perspective a more precise meaning. In the late fifteenth century both perspective and light and shade were comparative novelties, and without them, according to Leonardo's

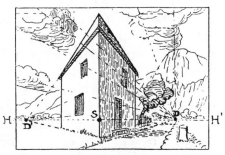

FIG. 32. Diagram showing too rapid
perspective.

FIG. 33. Diagram
of arch for perspective.

gospel, there could be no health in art. We cast aside less hastily than he the arts which employed neither. Whatever may be the value of Leonardo's voluminous notes on art, the fact remains that he was a great genius as an executant. We can seldom do better than turn to him for examples of execution, even though his reasoning concerning his own work was confused and, more often than not, incomprehensible. That it was so was the fault of the age not then ripe for precise scientific examination and analysis.

[1] La prima parte della pittura è che li corpi cõ quella figurati si dimostrino rilevati, e che li cãpi d'esse circũdatori, colle lor distantie, si dimostrino ẽtrare dentro alla pariete, dove tal pittura è generata mediante le 3 prospective, cioè diminuition delle figure de' corpi diminuitiõ delle magnitudini loro e diminuitiõ de' loro colori . . .

[2] La prospettiva è di tale natura ch'ella fa parere il piano rilievo e il rilievo piano.

The accompanying reproduction is one of a well-known pen-drawing by Leonardo. In it the point of sight is at the head of the central rearing horse ; to this point converge all the lines which in reality are perpendicular to the picture plane. Lay a ruler over the principal lines and verify this fact. All the rest of the drawing seems, however, to have been drawn in freely. Some of the edges of the steps vanish to the point of sight, others do not. This is of course a derogation from the laws of perspective, but I very much doubt whether the drawing loses in quality on account of it. On the contrary, I am inclined to think that a certain agreeable flexibility, which would otherwise be missing, results in the general effect. The various arches would also seem to be intuitively drawn ; and indeed here is my chief reason for reproducing the study. In text-books which treat of perspective we are told to enclose a circular or other curved form within a suitable rectangular or polygonal figure, and to put that figure into perspective where it will become a quadrilateral, or a polygon, of more or less irregular shape. We are then told either to trace directly a freehand curve within this new figure, or, if considered needful, to establish other perspective points on the curve by means of renewed constructions. Now all this is very tedious, and, I am inclined to think, as a rule quite superfluous for an artist. That the main lines of fair-sized work should be laid down in perspective, as Leonardo has done, I quite admit, but if a draughtsman, when once he has his main perspective scheme fixed before him, cannot draw into that already existing illusion of solidity the appearance that any given curved form should take up in it, he had better leave off trying to draw. No amount of perspective geometrical construction will ever enable him to plot into perspective the various and subtle curves of the human body ; yet he must be able to put them as unerringly into foreshortening as he would the arches of a bridge. I am quite

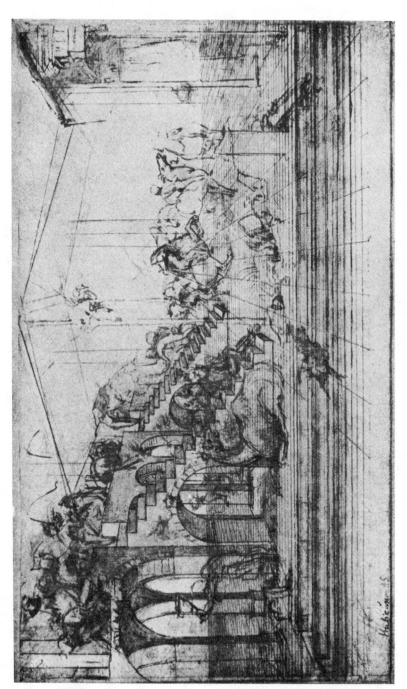

Fig. 34. A perspective drawing by Leonardo da Vinci

aware that such subtleties are not attempted by almost the totality of so-called figure draughtsmen, but that is precisely one of the chief reasons why their work is without value. A draughtsman, as I have said before, must so habituate his mind to recessional thinking that he no longer tries to make a curve in perspective look right on the surface of the paper, but that he actually lays, with his pencil, the real curve into its place, or—shall we say ?—follows the appearance of the real curve—it may be, lying horizontally into the paper—with his pencil-point. On one occasion I was looking at a diagram made with a view to explaining the absolute geometry of perspective. The author of the book, a professor of the Paris Polytechnique, had employed the recognized liberty of drawing a three-dimensional diagram without submitting to the laws of perspective, although his treatise was on that very subject. Indeed he put himself, all through the book, to great pains to render the subject as abstract and as difficult of practical application as he very well could. The diagram represented the ground plane and, upright upon it, the plane of the picture. At first glance I realized the spatial convention and said to another person (not an artist) ; ' Why has he made the far side of the picture plane longer than the near side ? ' My companion first failed to understand me, then affirmed at once that both sides were equal according to the usual convention of the geometers. Even then I could not see the equality, so much was I under the empire of the three-dimensional spatial illusion I had carefully cultivated for so many years, an illusion that my companion had never troubled about. I was obliged to measure the lines in order to convince myself that they were of the same length. If you are in this way a complete victim of your own spatial illusion you will have little or no need of geometrical construction for establishing perspective ; except in special cases of work too large to be taken in at a glance from a convenient

working distance. Even then a small drawing squared out will probably give, not a sufficiently good result, but *the* result needed ; namely, one that is not too rigidly correct in theory, and consequently not at variance with the character of the other aesthetic factors of figure-drawing, of envelopment, of colour, and so on, which are not susceptible of accurate calculation. Physicists will tell us that it is useless to exaggerate accuracy in one group of measurements when another group in the same experiment does not allow of more than approximate correctness. I think it fairly evident, in the annexed drawing, that Leonardo made call only on his power of conceiving shapes in recession when he drew the arcades ; indeed, when one is practised in this type of thought, it is no more difficult to draw a circle in perspective than it is to draw one ' full on '. He did not even trouble to draw the joints of the stones radially ; yet one can hardly say that the artistic value of the sketch suffers by this omission.

.

It is a common belief among beginners and ordinary draughtsmen that foreshortening of the figure is more difficult than drawing a figure ' full on ' in a simple pose. The very contrary is true. In foreshortening, provided the recession be rendered, even great errors, even considerable inexactitudes pass unperceived ; the variety of possible foreshortening makes it impossible for us to have exact knowledge of the appearance of, say, an arm, in the circumstances in which it may have pleased the artist to show it to us, hence we are not fitted out with the information needed to bring him to book with an adverse criticism. Why foreshortening is said to be difficult is because almost without exception people conceive the form flatly, and then try to make it look ' right ' *on* the surface of the paper. The method of copying the appearance of the model flatly is employed, they carefully notice that such an ' intersection ' is just over such another, or just so

much to the right or the left of it. Alas, the model is not immobile ! Even if the draughtsman's observations be impeccably made (and how often are they ?) their value is entirely destroyed by the fact that they have not been made simultaneously. The slightest error in such linear observation of volume in recession brings with it the equivalent of a very large error in suggested perspective volume. As the artist's mind has not been entirely preoccupied with the conception of this volume, or, I should say, generally not occupied with its conception at all, when his flat linear accuracy fails him, nothing remains to fall back upon. If, on the other hand, we look at the model's arm as an arm with whose form we are generally acquainted, and then proceed to throw this form back in recession into the depths of the paper, only, so to say, taking hints from the actual appearance of the model's arm from our position ; then, victims of our own illusion, we push a real arm back into the paper, and any mistake which would mean an alteration in volume, or in volume direction, is instinctively avoided, it 'feels' wrong. No drawing is accurate, we may certainly say that no drawing should be accurate, also it is quite obvious that no drawing can be accurate, for the complexity of Nature will always surpass our powers of imitation. A great draughtsman chooses, eliminates, exaggerates, simplifies, according to the dictates of his genius. The usual 'linear' measurement method of drawing counts on accuracy for its success ; it should count on comprehension. When we comprehend the shapes that we are putting into perspective, and the special conditioning of the perspective into which we are putting them, we have no more need of accuracy in dimensions. This is why Michael-Angelo can take such marked liberties with the proportions of his models, and yet remain the greatest master of foreshortening. Many of his formulae, such as unnaturally small hands following on hypertrophied deltoids,

rendered impossible the observation of the relative placing of intersections studied on a flat view of the model. When our minds are fixed on an organization of volumes, the contours of which only appeal to us as an afterthought, we shall inevitably represent the volume character of these volumes even though they be seen in rapid perspective. Also, even though we wilfully diminish or augment a volume—as Michael-Angelo did—we shall only modify the volume of the volume, we shall not in the slightest way compromise the fact of its being a possible volume—an inconvenience which at once arises when we try to draw flatly. The smallest error in the co-ordination of the various intersections at once destroys the possibility of illusion, we feel immediately that something is wrong, that things do not ' join up ' in a possible way. One should draw volumes as though they were of rather indefinite diameter but enveloped quite determined axes or cores. The annexed figure (Fig. 35) may show more clearly what I mean. It may be taken as representing the most fundamental aspect of the deltoid mass D, the upper arm U, and the forearm F. I have schematically represented the three masses as three truncated cones, I might have even simplified further and drawn three cylinders. Now what is important for the draughtsman to seize on first is the relative spatial placing of the three axes ab, cd, ef, of these three volumes. He must note whether cd is an exact prolongation of ac (it will not be) ; whether cd is parallel to ab (it will not be), if not, what is the exact quantity of its deviation from that direction, and so on. In a word, Fig. 36 may represent the first state of his thought. Inseparably from these estimations, aiding in their making, a very inherent part of them, comes the aesthetic appreciation of rhythmic arrangement ; but of this I do not wish to speak for the moment. Once we have established the direction (in perspective) of our axes it remains to clothe them with volumes. The exact width of

the volume now becomes of quite secondary importance, and we see at once how Michael-Angelo could take such liberties with this quantity. What indeed does it now matter whether the outside of our forearm cone be placed at *gh* and *ik*, or at *lm* and *no* ? In one case the elbow intersection falls at *x*, in the other at *x'* ; our 'flat' draughtsman who depends on

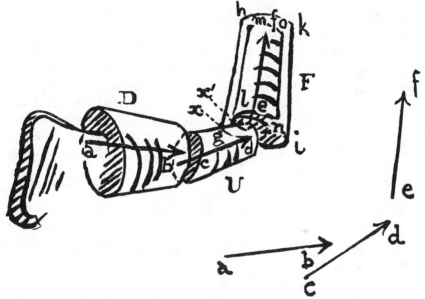

Fɪɢ. 35. Diagram of arm volumes. Fɪɢ. 36. Diagram of arm directions.

the position of his intersection in order to make his drawing look right would be quite at sea. What I have just stated is true and applicable throughout the whole of the domain of drawing, whether it be question of an arm, of a torso, of the branch of a tree, of the swift curve and fall of a wave about the imaginary axis that it hurries to envelop, of the piled wonder of a massy cloud in June.

At this point, while discoursing on the reduction of

natural form to its simplest geometrical statement, and the casting of such a statement into perspective, it will be as well, for the further convincing of the reader, to give at least one analysis of a drawing ; although by so doing we are venturing rather prematurely into the territory of construction. Let us consider for a moment the left arm of the accompanying drawing by Michael-Angelo. It is hardly necessary to explain in words the diagram (Fig. 38) which I have made of the way in which he first realized his masses ; when once pointed out the thing is evident. I say in which he ' first ' realized his masses. In reality this splitting up into chronological order is somewhat artificial, it really only corresponds to an order of importance, not necessarily to an order in time. Indeed, there is and should be a coherent simultaneity, which defies ordered analysis, in the inspiration of the dictates of genius to the executing hand. On account of clarity of presentation *only* we are obliged to split and to throw into chronological order.

The second study, with the upper arm in more rapid foreshortening, is also instructive. Here we see marked quite distinctly the way in which Michael-Angelo thought of one mass as being behind another ; we see the mass of the upper arm u (Fig. 39) behind and beyond the mass of the deltoid, D, just as in looking along a valley we see round, over, beyond one mountain shoulder to another. Then fainter and still farther off, this time hardly indicated, comes the forearm ' in the distance ' and seen behind the profile of the upper arm. The dominating fact in the drawing is the profile of the shoulder (trapezius and deltoid), *beyond* this fact all the others fall into place more or less in the background. We should also notice the second study of the hand. In the main drawing he had insisted a little too much on the primary geometrical construction of the figure. That is why I chose this particular drawing to illustrate my point. Now construc-

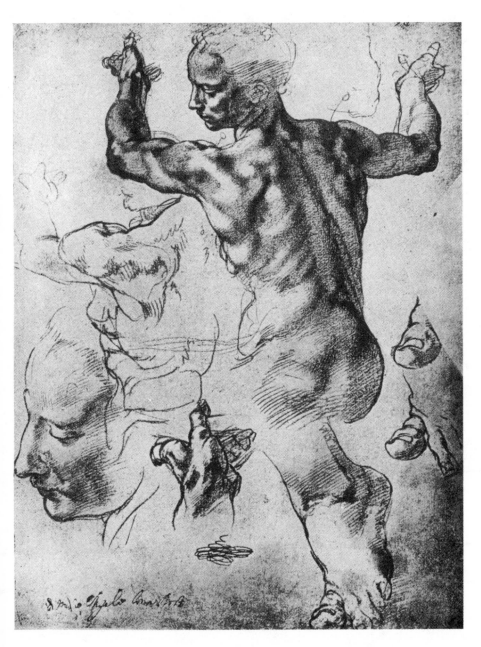

FIG. 37 Sheet of studies by Michael-Angelo

tion in completed work should exist but be hidden. Michael-Angelo, when he had made his first main drawing, found that the transition from the forearm to the hand by the wrist was too geometrical and violent, so he made a new auxiliary

FIG. 38. Diagram of arm construction. FIG. 39. Diagram of arm construction.

study of the supple rhythmic junction between these two parts of the body.

The artists of the Far East have often been accused of ignoring perspective. There is here a misunderstanding, the word perspective is used with a lack of precision. In the adjoining group (Ku K'ai Chih (?) fourth century A.D.) the artist can scarcely be accused of being ignorant of perspective. There are, it is true, no straight lines already existing in the picture which enable us to establish a perspective system rigidly, yet one feels intensely the surface of the receding ground on which the figures are kneeling. It would be quite easy, with a little experimenting, to establish on it our

squares in perspective in such a way as to make them lie properly under the kneeling figures in the foreground. The distant group of three figures belongs however to a slightly different perspective scheme ; the superposed register system referred to on p. 105 is employed to a moderate extent. The break between the two systems occurs in the empty interval between the two foreground groups and the distant group. The foreground groups are homogeneous in perspective quality. This may be the work of a man who ignored the modern geometrical constructions connected with perspective, but it cannot be that of a man who, first, did not see solidly, and secondly, did not compose recessionally into his paper. Not only was he aware of the perspective appearance of objects but he also used this perspective appearance, just as we more modern artists would, as a primary element in his composition. His composition is triangular ; it is triangular on account of the rise towards the distant secondary group. This rise, as already pointed out, is neither entirely due to ' geometrical ' perspective nor to simple decorative superposition. Ku K'ai Chih has skilfully combined the two data. Because he does so he is neither too realistic nor too improbable. Such a knowledge of perspective is really all one requires ; further demands are only made by those who confuse mechanical reproduction with art. This mistake the Chinese have never made, hence they have never seen the use of laying down rigid rules concerning the perspective trend of lines. As we have already seen, the visible universe, the terms of plastic art, are (or were) to the Chinese artist no more than the means of bodying forth abstractions. If the rhythm of pattern in a composition require it, that is, if one of the most important aesthetic factors require it, a Chinese artist does not hesitate to change the direction of a receding perspective line ; rhythm is more essentially important, on account of its aesthetic suggestive value, than is exactitude of

Fig. 40. Family group. Ku K'ai Chih (?)

IVth century A.D. *British Museum*

FIG. 41. The battle of Ashur-bani-pal against the Elamites
Assyrian bas-relief
Showing superposed registers in lieu of perspective
British Museum

appearance. Again, the Japanese artist who drew the wrestlers in Fig. 108 has felt, with unerring accuracy, the floor surface beneath their feet, although he has not represented it.

Imported by missionaries, themselves artists of very secondary talent, the perspective rules in use among the later studios of the Italian Renaissance reached China during the seventeenth century. But though we find traces of the subject in Chinese writings, the introduction of European monocular perspective remained without result on the art of China. Idealistic East and reproductive scientific West were not yet to influence one another. Of recent years there has taken place a superficial and unfortunate Western influence on some Chinese and Japanese painters; I say 'unfortunate', because it has hardly assumed other aspects than that of simple copying of Western methods. The Oriental has ever proved to be, at will, a skilled imitator. This, of course, only results in forgery and not in art. At the same time the Japanese rooms in the Salon d'Automne of 1924 showed quite a marked tendency on the part of several Japanese— Fujita is perhaps the best known of the group—to produce an art which owes many factors to Europe, while it remains all the same strictly Oriental. But I must not deviate from my present task into the fields of general art criticism. On the other hand we have learnt much, very much, from the Far Eastern aesthetic outlook.

In Europe perspective was at quite a late period established on a geometrical basis, and started from the supposition that the object (and subsequently the picture) was looked at with one eye. Hence the perspective that we have rapidly sketched in during the first part of this chapter. As in reality neither object nor picture is regarded by a perfectly stationary single eye, nor are our impressions of the world in general collected in that way ; artists instinctively bring to this rigid result certain modifications the existence of which I have already touched

upon. Chinese perspective proceeded from quite another standpoint. It did not pass through the scientific and hypothetical period, it is on the contrary a direct descendant of primitive bas-relief perspective in superposed registers, the method employed in Assyria and to a slightly less degree in Egypt. 'The Battle of Ashur-bani-pal against the Elamites' (Nineveh Gallery, British Museum) is an example of the primitive solution of the problem of representing several recessional planes on a flat surface. It would seem that the very refined artistic sense of the Egyptians led them to feel that such a solution of the difficulty was not wholly satisfactory ; they more frequently adopted lateral shifting of objects on more distant recessional planes ; the shifting took place in the direction in which the figures faced. The painting, in the British Museum, of 'Inspection and Counting of Cattle' shows this way of dealing with suggestion of perspective. Chinese perspective then springs from the superposed register system ; this is why Chinese pictures, and those of the Japanese as well, tend either to develop in narrow height (the *kakemono* of Japan), or in interminable width of panorama (the *makimono*). The exact reason of this development is that no special attention is paid to the height of the point of sight, and consequently of the horizon. Instead of convergence of parallels to a vanishing point their parallelism is maintained, whence the panoramic *makimono* in which the point of sight becomes a horizontal line, or the horizon itself if it be represented. If, however, the artist wish to accumulate plane behind plane he finds himself tempted to mount higher and higher as he passes from plane, recessionally, to further plane, whence the *kakemono* shape. Another result of this parallelism comes from the fact that it can only be developed through a certain amount of recessional distance at one time, without leading to results too discordant with the appearance of Nature. Hence now and then a break is

instituted in the system. This break is generally carried out with the aid of mist intervening between us and the lower part of a mountain. Sometimes, as in the *kakemono* by Shūbun (fifteenth-century Japan) the high narrow shape allows of what one might term a side scene, or wing introduction, of each separate recessional plane, from the side of the picture. A moment's examination will show the parallelism of the lines of sight in this subject. Were we to have such an approximation to a bird's-eye view of the stretch of water in Nature we should only see the tops of the foreground trees, instead of which we easily see under them in the drawing. A new point or line of sight is then established for the dark brush-strokes half-way up the picture ; then a third, and even a fourth, for the distant mountains, the far shore of the water being seen with its trees and houses under just the same perspective angle as is the foreground ; in reality the foreground would be viewed nearly vertically downwards, and the distance, as nearly, in a horizontal direction. It is evident that these three or four different perspectives cannot be satisfactorily joined by a continuous series of uninterrupted forms, hence the necessity of inventing a plausible interruption. In this case the indeterminate water surface effects the transition. Far from being an aesthetic defect this dislocation of continuity plays a very important rôle in the plastic language of the Far East. I mentioned the point in *Relation in Art*, but did not there develop its cause as I now do in this more detailed study of practical technique. From this discontinuity of perspective system, from this dubious variation of the view-point arises a dream-like sense of unreality. Indeed it is not otherwise that we perceive, or suppose that we perceive, in dreams. In a dream, imagined perception is freed from its subservience to optic laws. Our imagined perception when we dream is curiously void of perspective. The persons or objects that we

think we see are solid, possess their three dimensions; but their
co-ordination one with another is generally of the vaguest,
hiatuses quite analogous to those in a Chinese painting are
frequent. As soon, or almost as soon, as Europe seriously
turned her attention to the production of a painting art which
should differ from the purely decorative ambition of Byzan-
tine things, she developed perspective as we know it, a logical
concatenation of observed physical facts, based, it is true, on
an inexact, or only approximately exact, hypothesis, that of
monocular vision. Positive practical Europe from the first
aimed at the rendering of appearances as they are ; art was
from the first to be imitative ; now and then it dragged a
little abstraction, a little philosophy, a little idealism along
with it, but it always remained divorced from the great
problems of the universe ; they were made over to science
in the main, and to little encouraged philosophy. Not so art
in China ; there representation of objects has always been
subsidiary to suggestion of abstract idea ; no Chinese paint-
ing is void of obvious and recognized symbolism ; thus the
tiger is the symbol of the Terrestial Principle, the bamboo
that of Wisdom, the pine-tree evokes a vision of Will-power
and Life, the flowering plum-tree combines the vigour of Life
with the grace of Knowledge, or rather again of the principle
of Wisdom itself, so it becomes the image of Virgin Purity.
Then how can a people who attach in the first place so great
an importance to such conceptions as that of the Tao, who
in the second have submitted to Buddhistic creeds which
teach the passing of all forms, the illusion that the universe is,
how can that people place the interest of its art in the repro-
duction of transitory shapes ? Shapes are to the Chinese
artist as words are to the poet, without them he cannot express
himself, but it is not the words that matter, it is the idea
behind them that he expresses by their aid. All the better
then, if by some dream quality he can deprive his shapes of

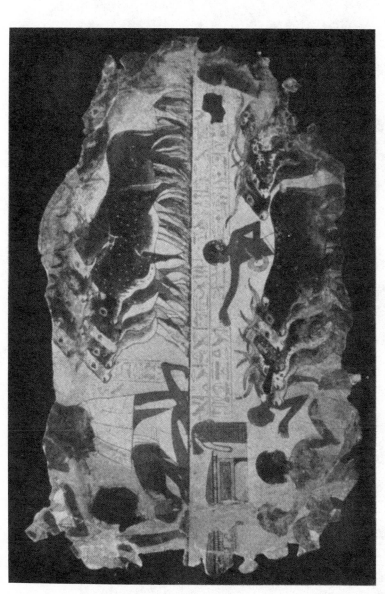

Fig. 42. Inspection and counting of cattle. Egyptian wall-painting

Showing perspective representation by advancement of each receding figure in the direction of its movement

British Museum

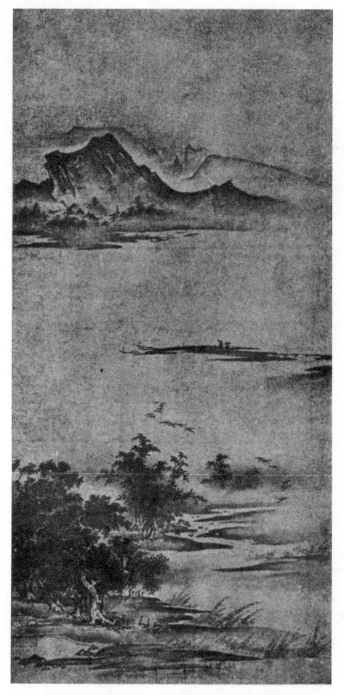

FIG. 43. LANDSCAPE. AUTUMN EVENING
XVth century A.D. By Shūbun. *Japan*

their obtrusive reality, of their connexion with the positive world of practice and of tangible, material fact, the while that they retain just so much of appearance as not to lose their symbolic value. Based on European perspective, Chinese Art could not so well have attained its end. More than that, Chinese perspective is the necessary outcome of the Chinese mode of thought, it is homogeneous with the rest of their forms of aesthetic and philosophy.

To what extent it may be allowable to European Art to copy, to borrow, such a form of perspective, which would seem to be as much at variance with our modes of thought as it is compatible with those of China, is a very moot point. I will not take upon myself to pronounce. A deliberate technical borrowing not completely welded to other national methods, and not in harmony with the national background of thought, spells insincerity.

.

It is not in my present province to trace a history of the development of perspective among different peoples and in different epochs. Mughal and Persian perspective may be passed by, they belong to the Eastern group of which the conventions have been so perfectly worked out by the Chinese. The very vexed question of a Central Asian origin of the Eastern aesthetic is fascinating but must be left aside ; the conclusions are yet doubtful, the mass of matter to be handled in such a discussion is enormous. Enough has already been said to show that the method of attacking the perspective problem is perhaps one of the most distinctive features of an ethnic aesthetic ; that because we are educated to admit only monocular optic perspective, we have no right to condemn others which may bring with them aesthetic qualities impossible to obtain by means of our scientific and reproductory method. Europe has from the first leant towards our modern solution of the question. The mosaic of

St. Demetrius at Salonika (it dates from the sixth century) is cast in a perspective which, while established only on a basis of sentiment often in error, still prepares the way for the mathematical studies of the Florentine Renaissance, and itself is but a repetition of Pompeian classical perspective. The whole of solid representation on a flat surface is a convention, the part of this representation which we call perspective is also a convention. The European system, in order to escape unconvincing dryness, has to be modified by the judgement and invention of the artist ; the Chinese system has likewise on occasion to abandon subservience to its formulae. We are once more reminded that Art and perfectly co-ordinated Scientific Theory are not identical.

Of recent years these modifications brought to European perspective have vastly increased. An extended discussion of this matter belongs more properly to the domain of the technique of modern art. I will only mention the change here in a few words. I believe Cézanne was the first to call attention to the fact that we never really see at all as perspective would make us believe that we do. We are so steeped in convention that we always bring to the examination of a picture our convictions concerning what a picture ought to be. This is especially the case in England, where ready-made opinions, those of the neighbour, are perhaps more rife than in many other countries. That we do not see perspectivewise has no influence on our judgement. We have been brought up to think that a picture should be executed according to the accepted rules of perspective. That it should be is an accepted fact, as firmly established and as unquestioned as the Houses of Parliament and afternoon tea. In reality a moment's experiment will convince us that perspective is a most remarkable artificiality. Fix your vision on any given small object before you, and take great care not to move your eye or eyes. In the first place you will notice that

you can hardly see clearly anything else but this small object ; that everything round it fades off into ever-growing imprecision. If we are really desirous of painting the appearance of things, why is this effect not always reproduced in all pictures ? In our perspective we assume a motionless monocular view-point, and then deliberately paint, all over the surface of the canvas, detail just as ' finished up ' as though the eye (and consequently the point of sight) were exactly opposite each point of the canvas in turn. We are hopelessly in contradiction with ourselves. Then notice that not only are objects to the right and left of the object we are looking at fixedly (which becomes thus the point of sight) seen indistinctly, but that low horizontal lines, such as that of the near edge of the table on which it may be placed, have a distinct tendency to curve upwards ; indeed all lines whether vertical, horizontal, or inclined, seem to tend to arrange themselves in a circular way round the limits of the visual field. Why is this effect not reproduced when we assume an unvarying monocular point of sight ? (It is not very easy to *perceive* things without looking *at* them. People who have not trained themselves to command the automatic reflex act of directing the visual axis according to the dictates of the attention will find considerable difficulty in carrying out this experiment. Also it should be remarked that the longer one fixes one's vision on the point of sight the more curved do the perimetric lines seem to become.) The elaboration of one sole point of interest is often done in sketching, the rest of the sketch being left *flou* and imprecise. I think I am right in saying that the artist often instinctively makes the elaborated point lie on the visual axis of his perspective scheme. In this way, as in others, sketches may be said to be more ' true ' than finished work. Here again we frequently meet with artists, especially water-colour painters, who adopt a method of work based on a combination of undecided

flowing colour smartly brought up here and there by sudden accent. This has always seemed to me to be a most reprehensible form of technique, which I believe found origin in a fractional, misunderstood, copying of Turner. It is now rapidly becoming a thing of the past. It was strictly a specialty of the English school. Whistler has experimented in the definition of a flower,[1] or of some other object in a portrait canvas, in lieu of defining the face left mysterious and deliberately vague. This seems to me to be quite a justifiable aesthetic convention which brings with it a certain mysterious sense of half-perceived presence and consequent detachment from the too coarse reality of things ; it is a step towards abstract expression in plastic language. On the other hand the *flou*, the envelopment of Carrière is a method of seeing, a way of painting ; the interest and chief definition is generally in the portrayed eyes ; the more precise French spirit does not allow of detachment of interest from the principal subject.

Modern painters often render theoretical perspective quite subservient to other exigencies of their art ; compositional needs, and even wilful strangeness of presentation, take precedence ; also, without doubt, though I have not yet heard the doctrine promulgated, an ill-understood seeking after the quality of detachment from natural representation, with accompanying gain of abstract intention on the lines that I have just put forward, prompts them to this break with European tradition.

As a matter of fact the impressions that we receive from the visible world are very far from transcriptions of the real shapes. Portions of shapes are always missing or distorted, and many of the apparent pieces of careless drawing on the part of Cézanne correspond to genuine variations of received impression. A circle in perspective never really appears to

[1] Not necessarily situated at the point of sight.

us as a geometrical ellipse free from variations.[1] The Futurists made an attempt at employing several European perspective systems in the same canvas ; but their method was incomplete, a heterogeneous patchwork was more often than not the result. But I must reserve to a special study the examination of these questions.

.

Before closing this chapter I will call attention to the fact that, in Fig. 32, I have employed at least two perspective schemes ; yet I submit that the result does not shock ; and in spite of the rapid slope of the roof lines, too rapid it may be thought for purely naturalistic and representational painting, the whole presents a not too disagreeable decorative aspect. According to the perspective data of the foreground, the distant mountain, which would seem to be at a distance of about two and a half miles, subtends an angle of 45° which, given the foreground scale, would make its height about fifteen thousand feet above the foreground. Now it does not appear to have this height. The eye unconsciously makes an allowance for a second perspective convention. Also, with a distance point so near the point of sight, the sides of the composition would be invisible. The eye makes another concession. And doubtless there are more. The arbitrariness of European ' geometrical ' perspective is thus evident in several ways from this example. I have said above that in drawing the figure it is essential to restrict oneself to a unique perspective scheme. This is so in the representation of a single object by means of European imitative technique ; otherwise inconvenient shape dislocations will occur. But

[1] A circle in normal geometrical perspective always becomes an ellipse, save in two cases : If a line be drawn through the spectator's feet and parallel to the ground line of the picture plane : (a) the circle in question is tangential to this line ; the perspective of the circle is then a parabolic arc ; (b) the circle passes behind the spectator ; the perspective is then a hyperbolic arc.

even this doctrine may be discussed in the light of post-Cézanne aesthetics.

.

A very frequent error is to forget that cast shadows obey perspective laws just like any other shapes. Only shadows

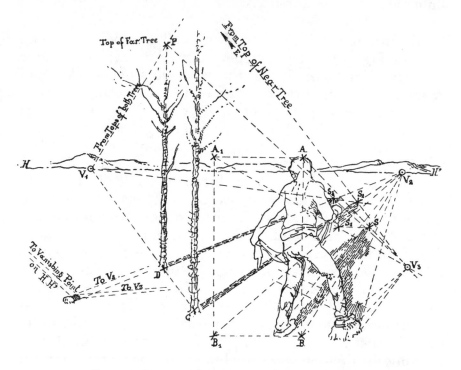

Fig. 44. Diagram of shadow-perspective construction.

exactly parallel to the picture plane remain parallel in the drawing. If they are not parallel to the picture plane, they must vanish to a suitable vanishing point as in Fig. 44. Sun shadows are parallel because the great distance from the source of light renders the rays practically parallel, hence the shadows are parallel in reality and may be treated as converg-

ing to a vanishing point in a perspective scheme. I include
a diagrammatic sketch (Fig. 45) taken from one of my own
pictures which was painted from Nature. The sun is almost
directly behind the spectator, so the shadows recede almost
directly from him. Notice how the cast shadow of the tree
branch becomes very much smaller where it falls on the stone

FIG. 45. Shadow perspective. From study from Nature
showing reduced apparent size of branch shadows on ground
and distant stonework.

troughs in the middle distance. It is not smaller in reality on
them ; it is exactly the same width as the central upper part
of the branch which casts it ; it simply appears narrower, on
account of its being further off into the picture, just as
everything else does. Were there another tree on the left-
hand side of the picture (there would thus be a tree on each
side of the visual axis) the two cast shadows would converge
to about the point of sight. I say ' *about* the point of sight

because I am not quite sure whether the sun is exactly behind the spectator placed in the necessary perspective position.

Most of the treatises on perspective which have passed through my hands deal with the shadow problem by starting from a known position of the sun, and then by means of descriptive three-dimensional geometry—which though not very abstruse is still quite difficult to follow—enter into elaborate recipes for shadow designing. Besides the unnecessary arduousness of this route, it is only conveniently applicable to quite a few cases. Although Turner and Claude specialized in including the sun in the picture, it is no exaggeration to say that this type of canvas is the exception. A perspective system which obliges us to use, as a principal factor, a point situated outside the picture is practically cumbersome, and to be avoided if possible. Not only is there this objection to the usual methods recommended by professors of perspective, but there is also the very cogent one that an artist does not worry about what is outside his subject. If the sun is not in his picture he really does not mind where it is, its effects *only* interest him. A cast shadow will often be a main factor in the composition ; and, as such, its shape will be fixed in the earliest stages of work. If, for example, he wishes to enlarge a rapid sketch to picture state in the studio, it may quite well happen that he may wish to establish more definitely the shapes of shadows which were indicated in a way too summary in the sketch. These shapes must be in accordance with that of the first main shadow. So the problem presents itself to him in this way : Given a shadow shape construct other shadow shapes in accordance with it. This is the problem of which I have given a particular solution in Fig. 44. Even in painting landscape from Nature it is as well to possess certain general ideas on this point, for the shapes and directions of sun shadows change continuously, and it is materially impossible to note their simultaneous

appearances, at least in fairly finished work. I strongly recommend exercises in problems such as the present ; the result of such work is an automatic understanding of the question, the good effects of which will be felt in the work, just as once acquired but subsequently lost anatomical knowledge never disappears entirely—far from it !—although the draughtsman would be sore put to it to anatomize at all completely any given portion of the body. It may never be necessary to carry out such a geometrical construction as the present in practice, yet the exercise in similar problems gives a certainty in shadow handling attainable by no other means. Even though your credo be not the one of reproducing Nature, still I do not hesitate to recommend such practice. One of the most difficult artistic problems is to imagine the shapes of shadows. In Nature they are always unexpectedly strange, unimaginably decorative. The abstract and geometrically formal artist has everything to learn from reality in this respect, and though, for reasons already advanced, geometrical perspective and reality of appearance are not exactly coincident, still they are sufficiently allied to render them equally fitted for the service of decorative suggestion.

In drawing Fig. 44 I supposed the length and direction of the shadow of the man to be either observed or postulated. I then reasoned as follows : Let AB be the height of the figure, and BS the *perspective* length and direction of its shadow. By joining A to S we obtain the direction of the sun's rays, the point S being the shadow of the point A. Any line joining any two such points will, in *reality*, be parallel to any other such ' sun-ray ' line. Hence, in *perspective*, all such lines meet in a point (which we will call v_3) ; unless, the sun being situated exactly in the plane of the picture—or in ordinary language, exactly on one side—the sun-ray lines happen to be exactly parallel to the picture plane ; in which

case they remain parallel in perspective. In order to render the other shadows in the picture compatible with the shadow of the figure we must find the point v_3. At present we only know that it is on AS produced. Let v_1 be the Vanishing Point, on the Horizon Line HH′, of the line joining the central points, C and D, of the bases of the trees. v_2, at the intersection of BS produced and HH′, will be the Vanishing Point of all shadows in the picture. Now let us transfer the height AB to A_1B_1 (by means of parallel lines, parallel also to the picture plane). Call s_1 the shadow point of A_1. We must now determine the position of s_1. To do so we join B_1 to v_2 ; s_1 must lie on this line which would be the perspective direction of the shadow of A_1B_1, did it exist. As the *real* length of BS is equal to the *real* length of B_1s_1, BB_1 is *really* parallel to ss_1. They are both parallel to the picture plane, so they remain parallel in perspective ; thus we can determine the position of s_1 by drawing ss_1 parallel to BB_1. The intersection between B_1v_2, and ss_1, gives us s_1. If we now join A_1 to s_1, we shall obtain a line giving the direction of the sun's rays, and so *really* parallel to AS. These two lines being produced will meet in a perspective Vanishing Point, v_3. Let us call E the top of the nearer tree, and F the top of the farther tree. Cv_2 and Dv_2 are the perspective directions of the tree shadows, which are parallel *in reality*. The shadow point, s_2, of E will be at the intersection of the sun-ray line from E to v_3, and of the shadow direction Cv_2. In a like manner the shadow point of F will be at s_3, the intersection of Dv_2 and Fv_3. In this diagram, in order easily to verify the exactitude of the construction, I have supposed the two trees to be of equal height, so that their shadows shall be of equal length *in reality*. Hence the line joining s_2 and s_3 will be, *in reality*, parallel to CD. So, *in perspective*, these two lines should meet in v_1, the Vanishing Point of CD, which they do ; s_2, s_3, and v_1 lying on the same straight line. This fact

shows that the construction is correct. The shadows of the two stones are traced in a similar way evident from inspection of the diagram.

Further than this I cannot go here into the geometrical treatment of cast shadows in perspective. I must refer the reader to special treatises, such as that by Mr. Storey, if he wishes to deal fully with the subject.

In *The Way to Sketch*, and also in the present volume, I speak of the great importance of correct drawing of shadow shapes when giving a light and shade representation of a natural scene ; it is more important to study shadow shapes accurately than the shapes of the masses which cast them. This statement is only in seeming contradiction with the doctrine of the primordial importance of mass conception. Having conceived the mass as it really is, we conceive it thrown into perspective ; to conceive the shape of the shadow we must not only conceive the shape of the object which casts it, but also take into consideration the direction of the luminous rays, and then conceive the whole thrown into perspective. That we suppress the actual contours of the mass in places as in Fig. 69 has no effect at all on the method, any more than the suppression of indications of modelling within the area contained by contours is a proof of non-observance of relief shape. To execute a drawing such as Fig. 69, only *really well*, requires, one might almost say, a more complete understanding of the shapes than if we allow ourselves an explanatory contour ; if our shadows are not quite well drawn and placed with reference to our conceived solid form they will not suggest its existence, and will only produce a meaningless muddle. Again, it is not the way—line, or shading, pen, pencil, or brush technique—in which a drawing is executed that counts, but the way in which the drawing is 'thought'. As in landscape-drawing more often than not the shadow falls on a non-plane surface, in order to draw the

shadow correctly great attention must be paid to the exact shape and modelling of the surface. This is what is so rarely done. Whether we use as a conventional method of expressing the result of our study of these volumes, of these surfaces, a line-contour technique or a light and shade technique makes no whit of difference to the necessity of first studying the masses mentally.

Recapitulation

All drawing is an artificiality. It is a symbolism. It is based on a series of assumptions. Light and shade is a late development in art. One would think that primitive peoples do not see shade effect. Yet tone modelling is of greatest antiquity. Altamira bears witness to this. Accepted European perspective is really as unjustifiable as others, only we are used to expecting its particular assumptions in a picture. It is theoretically a monocular system. We appreciate solidity by binocular vision. Frequently a large number of view-points are really included in a picture without the spectator realizing it. Perspective phenomena may be satisfactorily studied by tracing the appearance of objects, as seen through a pane of glass, on the glass itself. A convenient system of laying out the ground plane of a picture in perspective squares is given, a system which enables perspective constructions to be simply made for painting purposes. Leonardo executed a large part of the reproduced perspective drawing free-hand ; there is no need to construct very elaborately. The human body is not exempt from following the laws of perspective. Each form of the body must be thrown into perspective in a drawing. But perspective in art must not be too rigidly correct on theory. Contrary to ordinary belief, foreshortening of the figure is easier than straightforward elevation drawing of it. No one can criticize adversely errors in foreshortening, unless they be very evident. But the trained eye is very capable of criticizing an erroneous ' elevation '. Volumes must be foreshortened by intensely feeling their form and imagining that one is really pushing the form back into the paper. No drawing can or should be accurate. A drawing is the expression of a mental attitude by means of plastic shapes. A direct imitational representation of Nature would express no mental attitude beyond that of a desire to imitate. Great draughtsmen bring modifications to natural form. These modifications constitute their language. Michael-Angelo took liberties with proportions, and yet is a great master of foreshortening. He cannot have observed his foreshortening on the model, he must have ' conceived ' his shapes back into the paper as indicated above. The ' axis ' of a volume is ' conceived ' into recession, and then clothed with the surrounding shape. An analysis of a Michael-Angelo drawing is given in support of this

theory. The artists of the Far East have been accused of ignoring perspective. Perspective is an essential part of the composition of a group of Ku K'ai Chih, fourth century A. D. The hypothesis of monocular vision which is at the base of European calculated perspective is false. The perspective used by an artist in Europe is a compromise. That used in China is neither more nor less of a compromise ; it is only a different one. Chinese perspective is a descendant of superposed bas-relief perspective convention. Superposed perspective contented the Assyrians, but to a less degree the more artistic Egyptians. Chinese *kakemono* perspective has often three or more points of view, the resulting perspective schemes are co-ordinated by deft interposition of water or mist. The ideal of abstract suggestion dominates in Chinese Art, representation is avoided, hence scientific perspective has not been encouraged. All shapes are transitory, teaches Zen Buddhism, why then attach importance to the impermanent ? Shapes to the artist are as necessary as words to the poet ; without them expression is not possible. But the words are not the poetry, the shapes are not art. Of recent times less importance has been attached to perspective. It is easy to realize to what an extent perspective is a convention. Fix an object with the eye, only a small field of vision remains clear. Yet we finish up a canvas often right to the frame. To see such finish it is necessary to use a very large number of view-points. We do not see Nature so finished at one glance, but we are brought up to think that a picture should be so produced ; a perfectly gratuitous convention, as gratuitous as the Chinese conventions. Whistler experimented on fixing some point of minor interest and vaguely perceiving the rest of the picture. At least two perspectives are employed in one of the figures of this book. This complexity is not evident until pointed out. It is often forgotten that shadows obey perspective laws. Cast shadows, not lying parallel to the picture plane, vanish like all other parallels to a vanishing point. A receding shadow becomes narrower as it recedes. It is most important to draw shadow shapes correctly when employing them. This is in no contradiction with the doctrine of mass-shape conception. The shape of the mass must be conceived before its shadow is understood and thrown into perspective. Whether we suggest the existence of the mass by an outline or by an outlineless shadow the underlying need of mass conception is the same. The way of suggesting it is a subsequent convention that we adopt.

VI

THE MAIN MASSES OF THE HUMAN BODY

BEFORE dealing with the different parts of the body it will be as well to consider it as a whole. In reality it is a mobile motor, sometimes the motor force is applied in the direction of locomotion, sometimes it serves to do other forms of work. In the latter case the major part of the machine is often more or less braced into a rigid support, from which the force may be adequately applied to the extraneous work. No machine that we know comes anywhere near the animal body in efficiency ; no known machine will execute anything like so much work per unit of fuel (food in this case) consumed. However, it is not this side of the matter that interests us for the moment. We take the force supply for granted, and beyond looking on each muscle as a motor of which the power can be estimated as being directly proportional either to its mass or to its volume, which quantities, if density be constant, are measures one of the other.

To drawing there is a whole aesthetic side ; the artist has a practically infinite choice of modifications which, if it please him, he may bring to the exact scientific statement of the body as it is, or as we perceive it. Yet I think that we may safely state that, though the range of permissible modifications be very great, a certain fundamental sense which we have of balance must always be respected. I also believe that this sense of balance is mostly drawn from our experience of the multiple forms of mechanical balance that rule the physical universe. This I have already stated, as well as stating that the living body is a remarkably good

subject on which to study such balance because the visible forms modify themselves according to the mechanical rôle they are called upon to play, and also because perfect and delicate examples of static equilibrium between the various masses are continually afforded in unending variety. Evidently I can only touch with the lightest hand the modifications that an artist may choose to bring to the natural form in his plastic use of it. Some variations would seem to be quite inadmissible; though, especially since the rise of contemporary aesthetics, even such a reserved statement is dangerous. If, in the following pages, I lay down the law a little too absolutely, may this fundamental reservation be remembered. The statements that I am about to make specially concern what one might term the raw material of aesthetic work ; in other words, I am going to describe the nature of the human body in so far as it interests artistic work, and I

Fig. 46. Diagram of 'cubical' construction of the body.

am going to point out facts concerning it which must be rendered *if you wish to produce a plausible reproduction of it* according to the European formulae which have held good and have been practised till recently.

The accompanying figure gives the most simple expression of the arrangement of the volumes of the human body. Do not hastily put it aside as too grotesque to merit consideration. It is made up of precisely those facts which we only find adequately rendered in rare drawings by great masters. When you arrive at clothing this coarse and clumsy foundation with the fair raiment of subtle observation, of exquisite

rhythm *without losing one iota of its primal massive simplicity* wherein volumes have their being and obey the combined laws of mechanical balance and of optical perspective, you will have no more to learn about drawing. To draw such a diagram is easy. It is not much more difficult (though many would have us believe that it is) to make a drawing which shall express, more or less well, rhythm and flow of outline. The trouble suddenly begins when we try at one and the same time : (*a*) to conceive in simple volumes ; (*b*) to modify them in a thousand almost imperceptible ways without losing the first sense of their simplicity ; (*c*) so to co-ordinate these modifications that they shall produce a wished-for rhythm ; (*d*) so to arrange matters that this rhythm is completely analogous to the rhythmic arrangement of the great masses ; (*e*) finally, to throw all these complex curves, resulting from these realizations, into faultless perspective and so create the illusion of the solid figure in its three dimensions. To cast up in the air and catch again a single ball is not difficult ; things are otherwise when that single ball becomes many. The first ball that draughtsmen invariably drop is the one that stands for the few crude facts represented in my diagram. The draughtsman who perfectly respects the *perspective relation* between a point A, situated on the front of the torso, and a point B, situated on the side of the torso ; who places them in such a way that they accord with the chosen height of horizon line, with the measure of the distance of the point of view, with the position of the point of sight, and consequently with the whole scheme of special vanishing points, enters, almost *ipso facto*, into the company of masterly workmen. He enters not because of the difficulty of executing a comparatively simple geometric task, but because people, carried away by the beauty of rhythmic form or colour, of facial expression, of the thousand charms of natural form, forget to base the transcript of those charms on a solid founda-

tion. Ungoverned emotional ecstasy is not genius, genius is
the power first to conceive great co-ordinations intuitively,
and at the same time to feel intensely ; then to reconstruct
calmly, taking heed of all the essential components of the
subject. Few succeed in combining these almost antithetic
qualities ; strong emotion must be allied to calm reflection
and restraint ; not only that, the intuition must be of a wide
and splendid kind.

 But the body is not an immobile piling up of masses.
These masses are jointed together, and are mobile one with
regard to another. Let us now study the mechanism of this
mobility. The main office of the legs is to support the body ;
consequently the thigh-, knee-, and ankle-joints sacrifice some
universality of movement to the acquisition of strength. On
the contrary, in the human species, which walks erect, and
has learnt to execute different forms of manual labour, the
joints of the shoulder, elbow, wrist, and hand sacrifice sheer
strength to suppleness and variety of movement. A relative
examination of the osteology of these parts will make this quite
evident. The head poised upon the neck, performs, among
other offices that of directing observatory. It is mobile to the
extent we know. Many works on artistic anatomy devote
much space to describing, both by words and by diagram,
the limits of movement and flexibility of the different parts
of the body. This seems to me to be quite unnecessary. The
student can, and must, carry out on his own body, or on that
of another, a long and careful series of experiments in this
direction. If he is ever to draw the figure he must fully
understand its possibilities of movement. No amount of
explanation will replace the knowledge, which in this case
is so easy to obtain, and which is born of experiment. Why
say that the hand may be flexed on the forearm till one
nearly makes an angle of 90° with the other ? Try the experi-
ment yourself while you are reading these lines. From the

experiment you will bear away a visual memory of shape in which neither ' 90° ' nor ' nearly ' figures ; you will bear away the kind of idea, one of shape, with which an artist's mind must be furnished. Stand with your feet together, and, without moving them, turn your body to the right or to the left, carefully noting the limit of possible movement. Repeat the experiment with every imaginable movement of every part of the body. Evidently the degree of movement varies with the individual, hence many experiments on different persons are really necessary. You can never be too learned in such facts connected with the body ; the figure artist (and indeed any artist) should live in a constant state of observation. Store your mind with such information ; to the acquisition of it there is no royal road. To be an artist of any value entails enormous work. To this question I shall not return.

The method, then, of jointing the different parts of the body varies. The knee- and ankle-joint may be for the moment considered as simple hinges with back-and-forth movement. The joints of the arm we will suppose for the time being to be simpler than they are, and we will draw up a diagram of the simplest rough presentation of the human machine (Fig. 47). As with the mass diagram, we must once more remember that, however refined be our drawing, it must always implicitly contain the mechanical facts expressed in this diagram ; these and many more, but these must never be left out. The foot is a lever with its fulcrum at the ankle, for the heel projects behind the ankle. To the back of the heel is attached a tendon, which, by way of muscles, joins the heel to the back of the knee. When these muscles contract, shorten, the heel is dragged up and the front part of the foot is lowered and extended on the leg. This is what happens when we stand on tip-toe. If the skeleton be deprived of muscles, or if the muscles be relaxed

by death or by insensibility, the whole construction collapses. The various hinges are kept from folding up by the tension of muscles arranged before and behind them ; a joint is stiffened by the opposed action of the flexor group (which bends the joint, when free to act) and the extensor group (which straightens out the joint, when the extensors are not opposed by the flexors). Examination of the diagram will render further description super-fluous.

Bones and muscles be-tween them make up the various masses of the body. These masses are disposed in a harmonious and rhyth-mic fashion. It is this rhythm that we must first look for in drawing. Some parts of this rhythm are of practically constant nature ; for example, except for the slight swelling or diminu-tion of muscles in tension or

FIG. 47. Diagram showing the main mechanical construction of the body. The muscles (with tendonous attachments) are lettered M.

in repose, the rhythms of each segment of limb remain fairly constant. It is to be remarked that the muscular masses are never arranged straight along a limb, they are always set some-what diagonally to its length ; and when one mass has run to the right, the subsequent mass brings the movement of the form back to the left. The annexed drawing of a leg by Michael-Angelo (Fig. 48), if compared with the diagram (Fig. 50), shows this fact very clearly. The pen study by Leonardo (Fig. 55) and the other drawing by him of a head

(Fig. 56) show the diagonal arrangement exceedingly well without the aid of a diagram. The main directions of the masses in the arm of the torso study by Michael-Angelo (Fig. 49) are shown exaggerated in the diagram (Fig. 51). Further arm analyses are suggested by the diagrammatic rendering of the study of head, shoulders, and two arms from another of Michael-Angelo's drawings (Figs. 53 and 57). Examinations of the component volumes of an arm are given on p. 125 (Figs. 37, 38, and 39), and also in Figs. 52 and 54, again from originals by Michael-Angelo. On pp. 229 *et seqq.* the drawing of an arm by Degas is discussed (Figs. 74, 75, and 76).

.

Perhaps it would have been more logical to commence this study of mass arrangement by an examination of the pelvis. I was led not to proceed in that way by my desire first to show the main rough mass organization ; then immediately afterwards to show the mechanical aspect of the question in an equally rough way before specializing at all on particular shapes. Now, without further loss of time, I will deal with the pelvis. The pelvis is, from our point of view, the key to the situation, it is a rigid bony arrangement which gives us seven points always fixed relatively to one another, three behind, four in front. Before you begin to draw, get a perfectly clear idea of the exact position and inclination, in all directions, that the pelvis takes up in space. If the reader will refer to the two anatomical plates from Vesalius (Figs. 93 and 94, p. 294) he will be able to gather a good notion from them of its shape and use. The accompanying diagram will make its utility to the draughtsman still more clear. The draughtsman should always decide in his mind on the exact lie of these points among themselves, both of those of which he may be able to see the position approximately, and of those which he must imagine on the other side of the figure. The

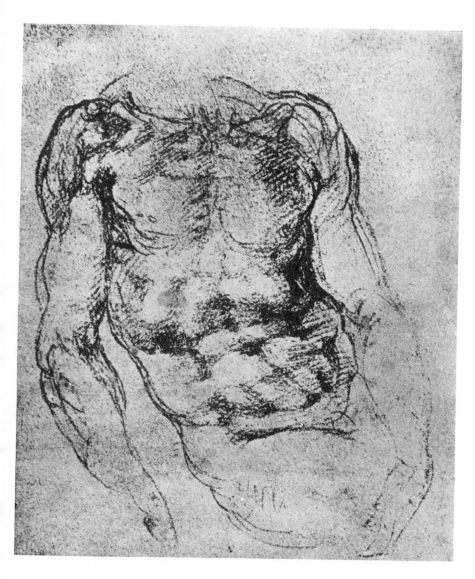

FIG. 49. TORSO BY MICHAEL-ANGELO

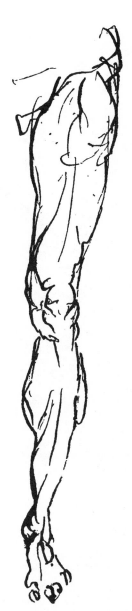

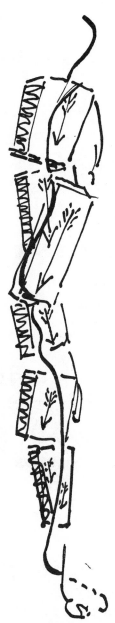

FIG. 48. Pen study of leg,
by Michael-Angelo.

FIG. 50. Constructional diagram
of Fig. 48.

back view anatomical figure is standing on its left leg ; the pelvis, which supports the weight of the torso, is in turn only

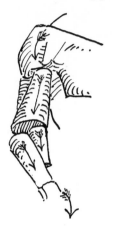

FIG. 51. Diagram of masses of arm in Fig. 49.

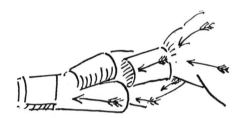

FIG. 52. Diagram of masses of Fig. 54.

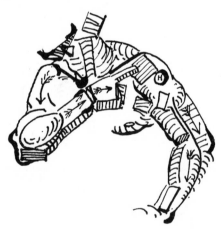

FIG. 53. Diagram of certain constructional facts noticed in Fig. 57. H marks the head of the humerus.

held up on the left, consequently it falls away to the right. Exactly how much it falls away is given by the tilt of the

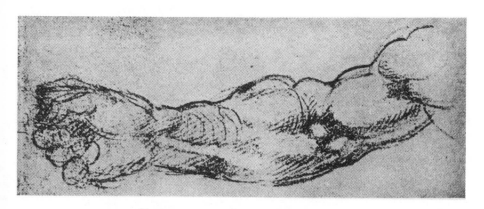

Fig. 54. Arm study by Michael-Angelo

Fig. 55. Anatomy of neck by Leonardo da Vinci

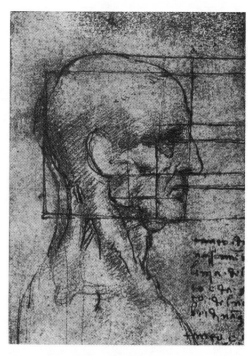

Fig. 56. Head and neck study by Leonardo da Vinci

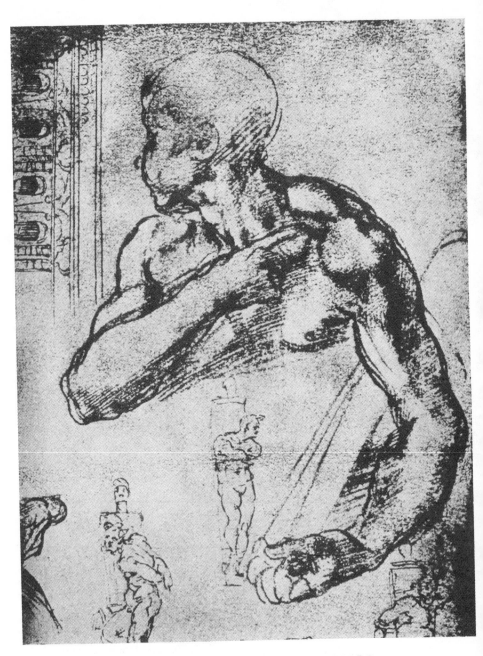

Fig. 57. STUDY BY MICHAEL-ANGELO

triangle 1, 2, 3 (Figs. 58, 59, 60, 61) ; all three points are subcutaneous, and so visible. When modelling it is as well to begin by establishing this triangle firmly and definitely,

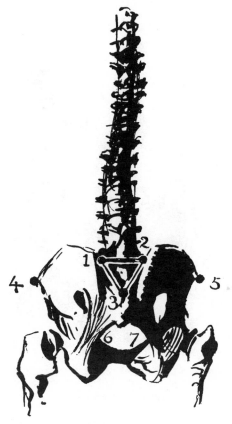

FIG. 58. Back view of female pelvis showing constructional sacral triangle on which is based spinal column.

both as to its sideways and as to its back and forward tilt. In the front view the quadrilateral 4, 5, 6, 7 (Figs. 58 and 59), is equally rigid and, of course, also gives the exact tilt of the pelvic mass. All seven points must be mentally co-ordinated

among themselves. Although these points correspond to excrescences on the skeleton they show themselves as depressions on the surface of the body, for from them start, in all directions, swelling muscular masses.

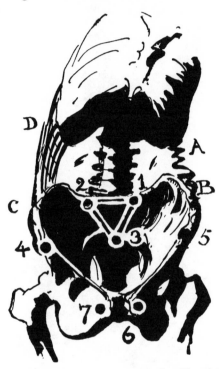

FIG. 59. Diagram of pelvic construction (female), front view, and connexion with thorax.

From the triangle 1, 2, 3 of the sacrum springs the almost immediately flexible spinal column, which supports the thoracic cage, or ribs. The thorax is fairly constant in shape ; a good idea of it may be gathered from the Vesalius engravings (Figs. 93 and 94). The important fact to notice here is that, apart from the already flexible backbone, of which the composing vertebrae are also capable of rotatory movement one

on another, there is no bony connexion between the pelvis and the chest ; consequently Fig. 59 gives an exaggerated caricature of what happens when, the pelvis fixed, we lean the upper part of the body over on it forwards or sideways (backward leaning can only be done to a very limited degree,

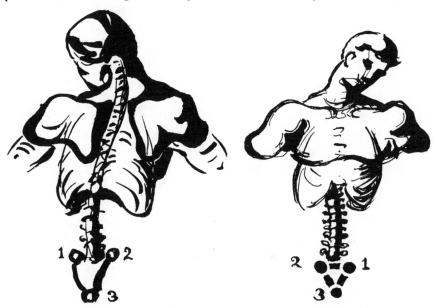

FIG. 60. Diagram showing the shoulder mass which fits down over the thorax and makes a whole with the pectorals on the upper chest, back view.

FIG. 61. Diagram of the shoulder mass fitting over thorax, front view. Also see p. 292.

its main result is a stretching of the stomach forms). The fleshy mass AB tends to form concertina-like folds, while CD stretches out between the two bony systems. The ribs are not quite immobile, so above A they may close up a little and above D separate, but this change is quite small—though not by any means negligible—for the ribs are set close together normally and there is not much room for further squeezing, especially as the intercostal spaces are already filled up with tissue.

Fig. 49 shows these facts very clearly. The squashing is evident in the dark area on the right of the drawing, the stretching on the opposite side. The relative arrangement of the front pelvic points (Fig. 59) is well marked in this study, which makes an unusually precise statement of the relative directions of the pelvic and thoracic masses. The thorax is nearly vertical, while the whole pelvis is tipped at an angle of about 45°. This drawing is a remarkable example of constructional knowledge. I learnt much from it myself many years ago. The student should continually refer to it, and seek on it the existence of the constructional facts of which I make mention in these pages. It is most instructive to note at the same time both the constructional fact and the exact way in which it is used by a great draughtsman, to note the exact relative importance which he attaches to it.

The thoracic cage may be looked on as a truncated cone set with the apex uppermost, that is to say, rather the reverse of what appears to be its shape, for the shoulders are wider than the waist. This is another example of what one might term the law of contradiction of which I have already spoken. As the thorax dwindles in mounting it inserts itself into the mass of the shoulders which cover and envelop it like a cape. The nature of the back and front aspects of the shoulder masses may be seen in diagrams 60 and 61. I may at once call attention to the need of not looking on the limbs as extraneous additions to the body. Just as the thoracic cage is inserted into the mass of the shoulders, so are the thigh masses inserted into the pelvis, and the arms into the upper part of the trunk. It will be noticed that I have drawn the deltoid masses (Figs. 60 and 61) as forming a part of the whole upper mass of the shoulders because we were considering this mass. Had we been considering the arm I should have drawn not only the deltoid mass as belonging to it but also the shoulder-

FIG. 62. NUDE STUDY BY REMBRANDT

British Museum

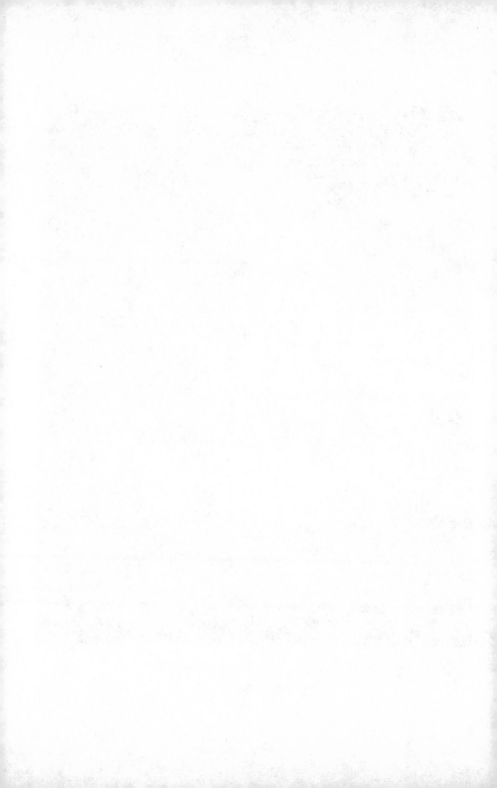

blade, with its muscular attributes, and the clavicle or collar-bone. The whole body is coherent ; consequently our descriptive separation is false. I have already spoken of the common error of beginners in overlooking the ' carrying on ' of the forms over different sections of the body. Bad draughts-men draw a forearm *to* the elbow, or an upper arm *to* the shoulder, and leave it at that ; they overlook the rhythmic insertion of one group of forms into the other. Among other interesting facts, the drawing of a woman's back by Rembrandt (Fig. 62) shows this quality of the insertions of forms one into the other very well indeed ; we may almost say that it is the thesis of the drawing, that it is for the moment the gospel text of his aesthetic sermon. Nearest to us comes the pelvic and buttock mass, of which the truncated cone-like form often seen in women is well shown. Upwards one follows it to coherence with the thorax, whose existence is just indicated in a masterly way by the two little strokes just under the right arm-pit, and the subsequent insertion of the combined mass into the ' cape ' of the shoulders. Penetrated with this idea, Rem-brandt has drawn the shoulder and arm lines in an enclosing parenthetical way, almost eliminating from their eloquence all other fact than that of insertion of 'mass into mass. Save for the one slight accent marking the limit of the posterior superior iliac spine (No. 2 on my diagrams, Figs. 59 et seqq.), the sacral triangle and the backbone line are unmarked. They are unmarked but not unobserved. The one little accent and the V at the top of the buttocks enable us to understand with certainty (as Rembrandt himself understood it) the inclination, slightly forward, of the triangle ; from it we instinctively feel the graceful curve of the backbone up the back, although the curve itself is only suggested. It is the rhythmic sweep of this curve through space that determines the growth of the neck out of the shoulders, and, in turn, the poise of the head on the neck. The varying rhythm of

backbone movement has been perfectly and intensely felt by
Rembrandt. Being perfectly and intensely felt, there is no
need to transcribe the sensation in any but the most summary
way. The gluteal V, the single iliac accent, the one curved
line of the neck are enough to suggest all the rest. When any
aesthetic rhythm is complete and valid, definite, delicate
placing of but one or two of its components is all that is
needed to suggest the fullness of its being. Indeed we
experience much aesthetic satisfaction from comparing parsi-
mony of means with completeness of result. I know of few
instances of such pregnant use of line as this ; even certain
Far Eastern masterpieces, more fascinating in various sensi-
tive use of instrument—for the line of Rembrandt is somewhat
wanting in variety—generally express less full summation of
conjoint solid form. It is interesting to compare this drawing
with that by Michael-Angelo reproduced in Fig. 92. The
Florentine had a similar end in view, but his mind, developed
on more glyptic lines, insists on a more complete implication
of composite mass. Rembrandt, the pure painter, was able
to deal with his figure as an unbroken area of light which
collaborates with other background lights to engender his
aesthetic whole. Michael-Angelo has conceived his figure
apart, it is complete in itself, it can stand alone as a piece of
sculpture in the round. Though it was not absolutely needful
so to do, this mind position led him to enrich the movement
with diversity of volume invention destined to give, from any
point of view, a profile fully decorative in its own unaided
arabesque. The art of Rembrandt dispenses with the com-
posite invention of pose. Naturalist painter, he sought the
material.for his pictures uniquely among the gestures of daily
life. His imagination almost restricted itself to strong creation
of unusual light and shade. Michael-Angelo as a painter
worked inversely ; like Le Poussin he first conceived his
arrangement of volumes which stood complete without the

aid of light and shade ; to them he added a normal lighting which produced in turn a magnificent chiaroscuro scheme. No doubt because Michael-Angelo conceived his pose complete in isolation people look upon his sculpture as greater than his painting. Yet I feel that his frescoes satisfy more fully than his marbles. Not because his brush enriched a splendid shape with wealth of tint, with mystery of shade and light, but because his invention is too unquiet to attain to the serene composure of the greatest glyptic art. The drawing that we are now considering would be undoubtedly fine as a statuette, less fine as a life-size marble ; I cannot help but think that its finest working out would be as a decorative painting. Far more sculptural in architectural sense of up-built formal mass are the figures of Donatello.

Very much may be learnt from the comparison of these two drawings ; but before dealing with that of Michael-Angelo let us complete our examination of the Rembrandt. One might call the drawing an organized series of parenthetical enclosures of volumes ; the parentheses enclosing the pelvic mass sweep inwards and partly terminate the buttock volume, or, more exactly, follow the line of fatty accumulation below and outside the real buttock volume. The next parenthetical inclusion of the thighs denotes with marvellously delicate suggestion the forward movement of the masses as they come out from within the pelvic volume. The last parenthesis, that of the legs, hints most refinedly at the mass return towards the spectator. The right-hand line, sure and straight, falls from the hip, for the greater part of the weight of the body is upheld by that leg, consequently muscles and tendons are taut, and the angle of the right iliac crest is sharply marked at the summit of the haunch. The interrupted left profile is less certain and more flaccid in treatment as the muscles are relaxed. The shading between the thighs is also not very determinate because it is especially the outer

group of muscles that is strained in the right thigh ; the right thigh also hides the inner profile of the left. Lower down, where the calf comes back towards the spectator, the outline is definitely established, it being necessary to circumscribe what now becomes a foreground volume. A few pages back I called attention to the need of expressing the back, front, and sides of a figure. Rembrandt here fulfils this desideratum with great skill. It is quite clear just where the side of the face turns into the back of the neck, at the little line shaped like a 3. The change from the back to the side of the right arm is ably and unhesitatingly indicated by the swift crook-shaped line down it. The short vertical on the left arm performs a similar office. The passage from buttock to haunch is clearly marked on the right by the two parallel curved lines that enclose the side plane of the figure at this point. The shading determines the inner side of the left thigh ; the outer side of the right one lies between the double lines. The thick line that shapes the left calf plays a shadow contrast part, useful in insisting on the prominence of the mass. The left side of that leg is very cunningly suggested by the exact prolongation, beyond the interruption, of the thigh profile by the line of the tendo Achillis at the heel. This shows how unnecessary it is, as I stated a short time back, to carry a rhythm out fully ; it is only needful to catch it up from place to place. The spectator's imagination fills in the rest. One cannot repeat too often that this rediscovering of rhythm of direction ' farther on ' is the very soul of drawing, whether figure or other. But I have said enough to convince the reader that the origin of the pen-strokes in this drawing was, first and foremost, to enclose volumes, secondly, to transcribe certain rhythmic relations between them. We have spoken of most of the lines of the figure, and we have seen exactly the reasons that presided at the conception of each. All-masterly chiaroscurist that Rembrandt was, we have seen that it was *not*

distribution of light and shade he seized on first (with the slight exception of the shading between the thighs—which is in reality only the marking out of a plane—and the almost negligible accent under the calf, one may say that there is no shadow indicated at all), but that his first step was to prepare the solid volumes *over* which to make his light and shade play *subsequently*. This is always done by great men. With them lighting is always subsequent to shape. In *The Way to Sketch* I have already pointed out how the first preoccupation of that greatest worshipper of light and mystery, Turner, was carefully to consider the shapes which were to be lit by the light and concealed in the mystery. Light, shade, mysterious envelopment are but garments of the solid form. To return to our Rembrandt drawing, I doubt if it would be possible to suggest more facts of solid modelling with so few lines. Follow the centre of the figure downwards, feeling the undulations of form to and from you. Note how exactly the neck-plane recedes upwards into the picture and is seen over and behind the horizontal line of the shoulders. A less understanding draughtsman would not have drawn this line at all. In that particular lighting nothing in the aspect of the model suggested it. The reason of its being lies in no factor of effect, yet Rembrandt, master of effect, drew it ; he drew it because it was necessary to limit the top of the trunk volume, and because it was necessary to mark the limit of the mass *over* and *beyond* which a new series of volumes, the head and neck, found their placing. There is an expression which should be deleted from writing on art, it is 'drawing by light and shade ' ; there is, or should be, no such thing. Unfortunately such a way of looking at things is employed, but its use inevitably debars a draughtsman from the lustrous company of the elect. There is drawing, drawing of many kinds, that is : many ways of choosing and modifying formal facts ; then on this drawing light and shade is or is not superposed, according

to the aesthetic aim. I do not mean to say that both form
and effect may not be, should not be rendered by one and
the same stroke of brush or pencil, I simply mean that the
conception of the form must take precedence over the con-
ception of the lighting, just, indeed, as form takes precedence
over lighting in the natural scheme. Shape remains, or does
so within the limits we are considering ; effect is transient.

Continuing our examination of the back, we note how the
quite unindicated curve of the backbone makes itself felt,
suggested how ? Mainly by the relation established between
the upper sweep of the left arm profile and the precise placing
of the right-hand waist curve. Isolate the two lines on a
separate piece of paper and you will see how much of the
suggestion lies in them. Then comes the slight recession of
the sacral triangle, so frugally marked by the solitary accent.
The advancing and receding spinal curve finishes in the
prominence of the gluteal mass, where we come, for the first
time, on direct indication of the backbone's existence. Now
this excellently felt but unexecuted rhythm is no result of
chance or of accident. Rembrandt felt it intensely while
drawing ; everything that he did was built round it, depended
on it, hence suggested it. The back view of the body and
not the front is the important one to the draughtsman. Truth
of construction and pose depends on understanding of what
is happening to the backbone. In the front of the body there
is no continuous bony following up. Lateral rotation of the
body does not take place about an imaginary central axis,
but about the backbone which practically lies directly under
the skin of the back ; thus the diagram of relative movement
between chest and pelvis may be drawn as in Fig. 63.
Obviously there is little or nothing that we may firmly grasp
in the displacement of the forms of the stomach which are
at once dragged and pushed in complex ways out of their
normal shapes. On the other hand, we may get a clear and

fairly simple idea of what is happening to the spinal column, just how much lateral deviation it is undergoing, just how much rotation, just how much back-and-forward flexion. It is from such a clearly conceived starting-point that we must build up the arrangement of the other parts of the trunk. If we are drawing a back view and can see the backbone line, so much the better ; if not, we must imagine it, hold it ever in our mind's eye, and adapt all other rhythms to its primal

FIG. 63. Diagram of rotation of torso round spinal column.

one. Thus, and thus only, shall we obtain unity of rhythm and intention. I cannot insist enough on this point, hardly ever sufficiently realized. Draughtsmen too often draw from and by the front of the figure alone.

To break off suddenly in the middle of a work on drawing, in the middle of a chapter mainly consecrated up to now to the detailed examination of a pen drawing by Rembrandt of a female nude, thus to break off and enter into an examination of architecture, more especially ogival, may, at first sight, seem to be the height of inconsequence and incoherence. None the less I am doing it after mature reflection, and with a clearly defined thesis in view ; I am doing it here because I can conceive of no better moment for developing a thesis which, far from being a side issue of the present gospel, is

an inherent part of it. If we seem to branch off from the main line of development, it is only for the moment ; for my thesis is the real identity between the higher forms of draughtsmanship and the architectural sense.

I have several times put forward what may seem to many to be naught but an amusing paradox, to be a passing opinion, of the possible verity of which I should find it difficult to give a demonstration. I have said that not only is nude-drawing the best school for all kinds of drawing and design, but I have specially stated that, if I had my way, I would oblige all architects to study the nude profoundly for many years. In *Relation in Art* I have condemned in too summary a way English architecture to a secondary standing ; had it not been that I was writing in English for an English public I should no more have mentioned English architecture (considering the space that I could devote to the subject) than I should have mentioned Norwegian, or Russian. I should not even have spoken of it as little as I have of Byzantine or of Indian in its different forms. The present book is again written in English for English readers. This time I will put forward more clearly the weakness both of English figure-drawing (or, if it be preferred, of English drawing as a whole) and of English architectural design. The defect is one and the same. By presenting it from two different points of view I shall but make its nature more clear. This, then, is why I pass without transition from a discussion of the nude to an examination of ogival architecture ; and in so doing break down, at least for myself, the artificial divisions that are pedantically erected here and there in what is in reality a coherent subject : Art. The essence of great drawing is rhythmic structural *ensemble*, the essence of great architecture is rhythmic structural *ensemble*. In England the sense of coherent structural ' oneness ' or ' unity ' is singularly wanting ; it is replaced by a sense of tidiness and order. How poorly the

two English terms just employed replace the French! Shall we make a hideous word nearer to the mark : 'togetherness'? Vocabularies in all languages are weak in terminology that does not express a need of the people. This lack of a term really proves my thesis.

.

In my phrase 'structural *ensemble*' the mechanical exigencies of architecture are also tacitly implied. Again I repeat that the nude offers an excellent schooling in types of mechanical equilibrium which are at the same time aesthetically valid. I am inclined to think that, far from waning in excellence as an architectural school, the nude is likely to become even more fitted to future application in this way. In the old forms of architecture tensional strains were rare, were confined to certain tie-beams. Compression and flexion reigned nearly supreme. Now all is changed with the introduction of steel girders and reinforced concrete. Every attempt is generally made to convert all stresses into tensions. The human body is largely a tensional system.

.

The law may be unhesitatingly laid down that artistic worth is always to be measured in terms of cohesion, of apt fitting together of parts. The site of Salisbury Cathedral was a virgin site, so Mr. Francis Bond tells us in his *English Cathedrals*.[1] He goes on to say that ' from this fact resulted a cathedral different from any other that we possess. In other cathedrals we study the medieval architect designing under difficulties ; what we see in such a composite cathedral as Hereford or Chichester or Rochester is not one design, but a dozen designs trying to blend into one design ; sometimes, as at Canterbury and Rochester, rather ineffectually, sometimes, as at Hereford, with remarkable success. At Salisbury it is not so ; the design is one design, all sprang

[1] George Newnes, London.

from a single brain, except the west front and possibly the upper part of tower and spire. We have no such homogeneous design in our medieval cathedrals. The French were less conservative, perhaps less penurious ; their Gothic architects were iconoclasts ; no French architect could have allowed such frightful solecisms to remain as disfigure our cathedrals to the purist's eye, and endear them to the artist '.

This is why I have chosen to reproduce a view of Salisbury Cathedral vaunted as an example of homogeneous work. Homogeneous work would seem to mean to Mr. Bond work of the same style, belonging to the same period. Again the underlying idea of tidiness and general conformity to evident rule reveals itself, to the damage of that higher and more difficult type of conformity to plastic law which enabled French architects to marry successfully styles separated by centuries. I have no hesitation in writing what I have just written, for Mr. Bond finishes his paragraph by the enlightening phrase : ' and endear them to the artist '. Again the tacit assumption appears that art is necessarily a disordered and irrational affair, for it should be noticed that the artist is cited in strong opposition to the ' purist '. Now all this is quite beside the point in the case of the higher forms of architecture. What is essential to great work is first of all just such a homogeneous growing together of all the component volumes as we have seen reproduced by Rembrandt with fine mastery in the nude-drawing recently examined. The details may or may not be of the same style, a Renaissance chapel can without harm be welded to an ogival cathedral provided that balance of mass, intention of eloquent mass arrangement, and coherent mass organization be observed. It is neither defect nor quality in the Parthenon that all its parts belong to the same style (do they ? for the metope sculpture is a very different type of work from that of the panathenaic frieze) ; it should be no defect in the

Fig. 64. SALISBURY CATHEDRAL

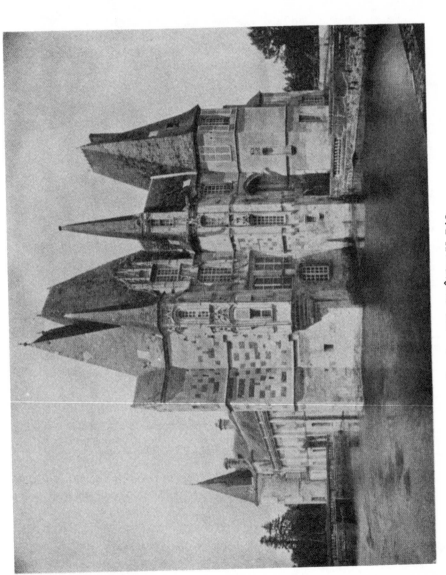

Fɪɢ. 65. LE CHÂTEAU D'O

XVIth century *Argentan*

façade of Lincoln Cathedral that an ogival architect has con-
tinued a Norman façade ; but it becomes a defect, because
the ogival architect has worked badly. To me it is incon-
ceivable that a man should for one moment think of first
using the meaningless horizontal repetition of arcades in the
top row, and further be so devoid of invention as to use
them again below, and then simply leave off stupidly when
he comes to the existing Norman front. Such work shows
the most amazing lack of all sense of architectural *ensemble* !
There is no kind of reason why Gothic work should not be
intimately married to Norman (or Romanesque) ; the thing
has been done in France time after time successfully ; I need
seek no farther than the Church of Les Baux a hundred
or so yards from me at this moment. There all styles
from earliest Romanesque to advanced Renaissance are har-
moniously intermingled. That they are harmoniously inter-
mingled is due to the fact that the fundamental laws of plastic
composition are observed, that one part is intimatèly welded
to another just as the thorax masses of the nude are intimately
associated with the masses of the pelvis, though the shapes
of each part are by no means identical or even similar in
design. It is just in this opportunity of studying the occult
way in which the shape of a finger is allied to that of, say,
a breast that the nude offers to us an incomparable field for
the study of refined interrelation of form. It is within the
reach of any one to obtain in any line of artistic work a
pseudo-homogeneity by using the same shape of window all
over a building, by using the same invariable rhythm and
rhyme scheme throughout a piece of poetry, shall we say in
the manner of ' Marmion ' ? To intermarry dissimilar quanti-
ties by means of intentional artistic co-ordination is a much
more difficult matter. This is the reason why illustrators
learn a particular technique in order to hide their want
of power of true plastic co-ordination behind a spurious

co-ordination which is nothing more than a form of tidiness and submission to obvious rules (as opposed to fundamental laws). Such a subterfuge is often dignified (if dignified it be !) by the name of ' mannerism '. There it is that the delicate point of criticism is met with : To distinguish between personal expression and adopted mannerism. I think we may safely say that all the British pen illustrators, and most, if not all, of the British water-colour painters may afford examples of this meretricious method of substituting pseudo-correlation of parts by means of an adopted technical sameness, in place of true plastic relation of parts which springs from already co-ordinate plastic conception, a valid result of what I have termed in *Relation in Art* : Plastic Thought.

Let us return to the consideration of the accompanying reproduction of Salisbury Cathedral. The innocent method of obtaining *conformity and not homogeneity* is at once evident everywhere. One or two window shapes are used and are repeated everlastingly. England, or at least the English ' purist ', is satisfied, the rules are followed. Perhaps the English artist may be less so, he may find the thing lacking in untidy picturesqueness ; but I fear that had he his untidy picturesqueness he would be quite content and would bother us no further for such useless abstractions as homogeneous co-ordination of parts. As for general co-ordinate effect in the present elevation of Salisbury Cathedral one may say that it does not exist. It is with difficulty that one realizes that there is a congruous ground-plan to the building, which appears more like a church-spire dominating a casual group of houses than anything else. Let us for the moment compare it with a piece of architecture in aim and nature quite different : Le Château d'O. Surely the almost supple—yet nervous—way in which the masses fit into one another will at once be evident. One feels that from any point of view the profile of such a building will be fascinating and full of inten-

tion. It is not because the architect has traced a ground-plan which is, I have little doubt, satisfactorily symmetrical, that he has achieved a homogeneous work. Given even, at Salisbury, that his ground-plan was good he has not known how to build upon it. No doubt the ground-plan of a building would be the most essential part of construction, *were we justified in separating an aesthetic inspiration into component parts,* which we are not. An architect is usually obliged to consider his ground-plan first, or, shall we say? he is obliged to consider the shape of the ground at his disposal before allowing free flight to his imagination. But this first consideration over—and it only amounts to coming into contact with the needs of the case—his plastic invention should proceed by conception of volume scheme, he should not build up perpendicular ideas on an already existing flat ground-plan. The architect of Salisbury seems to have completely forgotten to take into account such points as, what effect the sky-profiles of the tops of the various masses it has pleased him to place on his ground-plan would produce. As usual he has arrived at tidiness, in lieu of co-ordination, by distributing everywhere the same gable-end fitted with a pair of pinnacles. Need I draw attention to the extraordinarily varied co-ordination of a clear formal kind which is shown in the upper masses—or elsewhere, for the matter of that—of the Château d'O ? No one can accuse the Château d'O of meaningless repetition. There is repetition of pilaster and window shape on the just visible façade, but such repetition is reserved to a minor portion of the building and plays a similar part to that of neutral greys in a colour scheme ; it stabilizes and holds in restraint what might otherwise run the risk of becoming a debauch of variety. When I look at Salisbury I am at once struck by the poverty of its invention. By which I do not mean a lack of complicated detail, which may often be the refuge of a mind incapable of inventing splendid and simple proportions, one

that seeks refuge in the confusing effect of multiplicity in order to hide its inadequacy. We at once get the impression of a number of small and similar buttresses all turned out to order, each with its quintuple striation about half-way up, each crowned with its regulation rooflet. There is no climbing up of general effect in Salisbury. The almost universal defect of English cathedrals, that of a weak junction between a centrally placed tower and the roofs converging from it, is most evident here, with the result that the centre of the building appears to be lower than its periphery, while from this seemingly lower point a tower suddenly starts up for no apparent reason, and makes between itself and the surrounding roof ridges an angle which is in reality a right-angle, but which is always condemned to appear to be less on account of its perspective position. All re-entering angles in the limiting planes of a mass are weak, unless very carefully employed as, for example, in the roof profile of the Château d'O. The reason of their validity in the latter case is that they are a necessary concomitant of a very satisfactory arrangement of conical roofs. What strikes us here is not the re-entering angles but the conical masses themselves and their method of juxtaposition ; whereas in Salisbury we instinctively feel that the idea of the vertical plane of the tower which simply leaves the horizontal roof is not an invention at all, is not a work of art, any one could conceive it ; it is plastically silent as a relation in form.

The saving resource of the British Gothic architect is pinnacles. And unfortunately he means you to see them. There are generally more pinnacles on a French Gothic church, only they are less evident, they fit into the general scheme, they climb up and hug the main structure itself ; as there is a general idea of composition they fall in with it ; they simply add diversity to a general intention which they in no way upset. Any French church may be compared

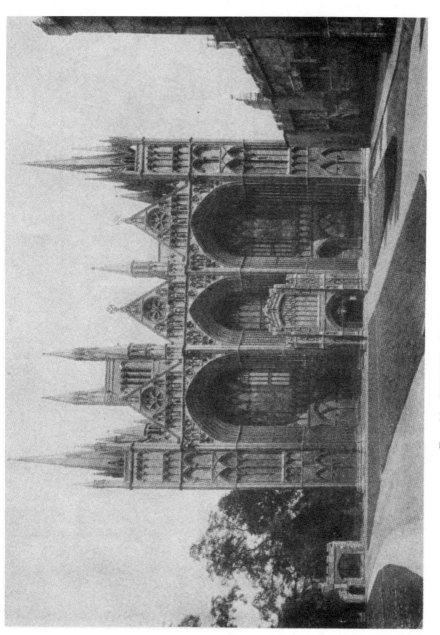

Fig. 66. PETERBOROUGH CATHEDRAL

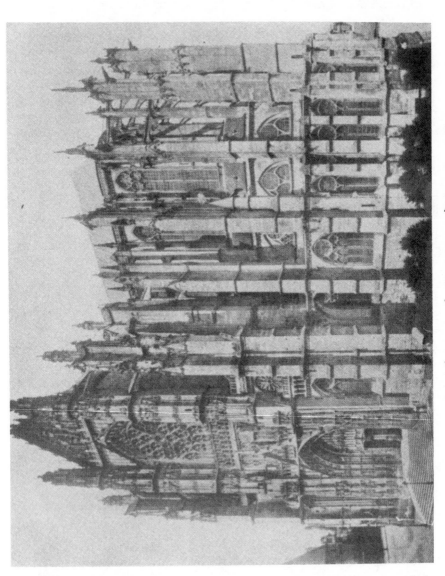

Fig. 67. LA CATHÉDRALE (ÉGLISE ST. PIÈRRE) BEAUVAIS

with any English one in this respect. Let us take Peter-
borough and Beauvais, though any other pair would do
equally well. The proportions of the facade of Peterborough
are particularly unlucky ; the enormous arches seem placed
there to hold up the thinnest of string-courses, although the
architect has been careful to provide each arch with a super-
incumbent triangle exactly like its brethren. In truth the
central triangle had to be smaller than the lateral ones, but
the designer, terribly upset at this want of tidiness, has quite
ingeniously made it to appear to be of the same size as its
lateral neighbours by flanking it with the usual resource of
completely detached pinnacles. Unfortunately ingenuity is
not the same as art. Look how unsatisfactory the placing of
the three gables over the three arches seems to be when we
compare it with the happy way in which a similar triangular
shape is *emmanché*, is ' ensleeved ' over the porch of Beauvais.
What a lack of plastic invention is shown at Peterborough in
the placing of the arcade which forms the base of the tri-
angular gables, and with what charming invention—with
none of the tiresome repetition of Peterborough—is the same
element of Gothic architecture interwoven with the pointed
arch and the triangle at Beauvais. Then at Beauvais how the
forms rise up and up, cut here and there by horizontals which
give, without any undue insistence, the note of horizontality
and its accompanying effect of stability. The string-courses
wind in and out over the surface, so that although reason sub-
consciously tells us that a level is one and the same, yet owing
to variety of perspective view it never appears in the uncom-
promising cold severity of aggressive and meagre horizontality
as at Peterborough and Lincoln, or in the insistent horizon-
talities of Wells which persist, obvious, in spite of the more
broken surface of the façade. These thin conceptions give an
air of chilly and poor rigidity in place of the living stability of
genuine Ogival. It is curious to what extent the inevitable

English pinnacle remains detached and aggressive against the sky. It never grows naturally from flying buttress or from up-piled columnar mass as in the French churches. Those round the flanking towers of Peterborough west front are prolongations, it is true, of the columnar forms at the angles, but so unhappy is the idea, that the pinnacles actually appear thicker than the cylindrical forms which they prolong. This compositional error is magnified ten times in the case of the two central pinnacles. The eye runs up the thin central columnar line between the great arches and is suddenly surprised to meet with a massive pinnacle balanced atop of its exiguity. Compare the graceful succession of forms up the columnar masses which soar heavenwards from either side of the Beauvais porch. They are neither thin nor heavy, they are wrought over with ingenious tracery which helps to bind them to the main mass, not by a weak repetition of the same form, as in the continuation of the same arcade across the towers just above the great arches of Peterborough, but by a delightful criss-cross of compositional elements. Thus the trefoiled shapes of the gallery just below the rose-window are not repeated on the lateral tower-like forms ; but slightly lower, in order to avoid a fatiguing symmetry, the supple curves are replaced by points ; the difference of level and the difference of form are so slight that unity of design is maintained while disagreeable uniformity is eschewed. What a derogation from coherent design is made in the intersecting ogives half-way up the Peterborough flanking towers ; a system which demands a sequence as cause for its being is represented as an amputated single element. Thinness without elegance, rigidity without balance of proportion is the impression I take away from the Peterborough façade, an impression rendered acutely painful by the regiment of spikes presented, at tidily-arranged intervals, to the sky. What a distance from the jagged metallic sensation of this

profile to the supple *agencement* of Beauvais, where the masses are so cunningly distributed as to banish all sense of repetition from a thing which is, nevertheless, in no way accidental nor unordered in plan. I am quite aware of the literature, concerning daring greatness of arch and immensity of doorway, which has been written about Peterborough. As a rule ideas well-fitted to expression in one Art are ill-fitted to expression in another. Artists seldom realize this. Rodin was continually attempting to render literary ideas in sculpture, whence many failures. Literature plays too great a part in English plastic art. The language of architecture is proportional balance of mass. The finest architecture is divorced from the incompleteness of the literary idea. Architecture is a finite art which can only suggest infinity by the perfect co-ordination of its finite and tangible parts. In this it is unlike literature which can establish a suggestive train of thought, and then cease its technical development leaving the reader's imagination to proceed. The thinness of the tops of the Peterborough arches may afford occasion for literary encomium, it is none the less a plastic crime.

Before writing these last pages I developed their matter, *viva voce*, to an Englishman, but with the photographs in front of us. I asked him if he thought that the points I was anxious to make would be evident to the British reader when they were once indicated to him. My friend's reply for the moment amazed me. ' Yes,' he said, ' of course they will be evident. But your reader will say that all the same he prefers the English cathedral.' On reflection I saw not only the probability of this, but its reason. The art of any people is made by that people to express a national form of mentality. It includes in its formulae the expression of the desires of that people ; it does not include ideals foreign to the race. That such ideals should be lacking does not matter one iota either to the executant or to his public. Neither feels any want of

such ideals ; so their absence is passed over unremarked. Coherent design is the weakest point of British art, which falls back on technical execution. A moment's comparison between London and Paris is all that is wanted to demonstrate this. Think but for an instant of the splendid sequence of the Tuileries and the Champs Elysées up to that great gateway of the Arc de Triomphe ; think of the terraced gardens falling away from the Trocadéro to the Seine and their continuation onward past the Eiffel Tower. Think again of the Esplanade whose perspective, at one end closed by the Invalides, runs out at the other between the Grand and Petit Palais des Beaux-Arts to join the greater artery of the Champs Elysées. Then again there is the vista extending from the Luxembourg to the Observatory ; but it is needless to prolong the list, in rivalry with which London can but show us Kingsway and the unbalanced avenue leading from Trafalgar Square to Buckingham Palace ; on one side of it are buildings, on the other is the park ; as planning, it is a makeshift.

This book is not entitled The Art and Craft of English Drawing, for it proposes to treat of drawing and its various ideals wherever they may be found ; I am thus obliged to point out the relative successes and failures of different artistic systems to the best of my ability. But it may be asked on what shall be based the estimation of the relative worth of aesthetic factors ? Simply on a co-ordinated examination of all the aesthetics ; from it one can finally extract a kind of table of aesthetic factors presented in a more or less valid order of worth, much in the same way as the exchange value of the moneys of the different countries is established, and the pound sterling or the dollar is declared to be above or under par, although at that particular moment it may be that no currency is actually at par. The whole matter is merely relative. There must also be taken into account the conviction of a

critic who has taken the trouble to penetrate as far as possible into the aesthetic ideals of various peoples and who has brought to each a determinedly unbiased interest. But the price one pays for taking up such a detached position is that one remains necessarily isolated. Art is world-wide it is true, but each manifestation of it is to a great degree separate and individual, and is made for a particular public, to satisfy its particular needs. The case of Gothic architecture is, however, special. Whether it be carried out in France or in England it deals with approximately the same formulae. While it becomes a very difficult problem to estimate the relative aesthetic worth of Chinese and Greek Art on account of the wide separation between both the ideals and the technical methods employed, while it may even be idle to propose such a problem at all, I cannot help feeling that two conceptions of the same art, that of constructing Gothic churches, may justifiably be compared. It is regrettable if the English architects have not known how to produce the better result. Can it be other than right to consider the English Art inferior to the French, seeing that the estimation of the superiority of French buildings is based on their successful homogeneity, a factor common to arts so widely different as the Chinese and the Greek, a factor whose worth we learn to appreciate in our studies of that source of all plastic art, Nature herself.

But it is perhaps time to leave this study of a special subject, to leave it on this note of subtle co-ordination and inter-grouping of parts which constitutes the basis of all true art, this homogeneity of detail with the whole that we can so excellently study on the nude, the more proper subject of this volume.

This excursion into the regions of mass organization in its architectural aspect has for a moment led us into what, considering the main line of our present argument, must be

looked on as a by-way, though in reality we have been dealing with the least-mixed expression of the most important and fundamental fact of all plastic art, and so of our subject. Still one must, under menace of becoming unwieldy, split into the usually accepted divisions what should be treated as uniform in kind, or as simple varieties of result depending on one single system of laws and facts. So we must leave architecture to special treatment in special volumes and do no more here than indicate the point or points of contact which exist between it and our present study.

Before touching upon building-construction, we had discussed the remarkable statement of the methods of mass insertion into mass that a Rembrandt drawing set before us. It is always dangerous to present to the reader only one example executed in one particular technical way ; he may be convinced of the exactitude of the analysis in that particular case, but does not feel inclined to take on faith the comparative work done by the author, who thus fails to convince him of the general application of his thesis.

Recapitulation

The human body is a machine ; as such it is subject to the ordinary mechanical laws. It is the most efficient machine that we know. The force furnished by a muscle may be taken as proportional to its volume. Though the artist may take liberties with natural form, it is thought to be advisable that at least a memory of mechanical possibility should be preserved ; for it seems probable that our sense of aesthetic balance is really drawn from our experience of mechanical balance. The variations of the pose of a nude offer the best opportunity for studying the relation between aesthetic and mechanical balance. The underlying distribution of mass must be conserved, although we clothe it with, and conceal it behind, surface and other rhythmic arrangement. The various volumes of the body must be thrown into perspective in a realistic drawing. Genius is the power first to conceive great co-ordinations intuitively, and at the same time to feel intensely ; then to reconstruct calmly, employing every essential component of the subject. The student must learn to feel in a subconscious way the limits of flexure of each part of the body. The system of the levers that constitute the limbs must be understood. The main facts of the

mass arrangements must be fully grasped. The importance of the pelvis as a constructional starting-point ; the rigidity of the sacral triangle, and the iliac crests ; the flexure of the upper torso on the pelvis ; the flexibility of the thorax ; its introduction into the shoulder mass ; the insertion of limbs *into* the trunk ; all these facts are noted in a very summary Rembrandt drawing ; which should be compared with a Michael-Angelo. Michael-Angelo and Rembrandt employ chiaroscuro differently. The continuation of a same rhythm ' farther on ' in the drawing. All chiaroscurist that Rembrandt was, his first care was to prepare the solid basis over which his light and shade was to play. Turner did the same. There should be no such thing as ' drawing by light and shade '. Part-rotation of the chest with regard to the pelvis. The line that the backbone takes in space is all-important, and should always be considered. Nude-drawing is an excellent school of architecture. Rhythmic structural *ensemble* is needed in architecture. The lack of keen conception of *ensemble* in England. The body is largely a tensional system. The tendency of modern reinforced concrete is towards tensional systems. The conception of Salisbury Cathedral lacks in *ensemble*. True plastic *ensemble* is replaced by uniformity of detail. Bad conception of Lincoln façade. Romanesque, Gothic, and Renaissance may be combined satisfactorily. Subterfuge of hiding want of plastic co-ordination behind tidy technique. Interfitting of the masses of the Château d'O. Architecture must be conceived as a rhythmic organization of masses. Weakness of junction between central tower and radiating roofs in many English cathedrals. Bad composition of Peterborough façade. A comparison is effected between the non-co-ordinate conception of the parts of Peterborough and the co-ordinate conception of those of Beauvais. The abuse of completely detached pinnacles in English churches is reproved. The want of sense of *ensemble* is illustrated by the non-existence of satisfactory vistas in London ; there are many vistas in Paris. Though a quantitative estimation of the relative worth of Greek and Chinese Art may be unjustifiable, a comparison between two conceptions of Gothic Art may be made.

VII

VALUES

WHEN writing on drawing it is difficult to decide which of the several subjects, into which the plastic arts are arbitrarily split, can with safety be left out. Colour, it may be, we can omit ; yet certain enthusiasts—not perhaps wholly bereft of reason—have gone so far as to speak of the colour-suggestiveness of monochrome, and I am even inclined to think that in many cases one would be tempted in drawing from Nature to use at times a different quality of line (not to speak of value in tone-monochrome work) to surround an area were it tinted in one colour or in another of equal value. This, however, is a subtle affair, and were I to make any absolute statements I should be fearful of laying myself open to justifiable and hostile criticism. I will, then, only hint at such technical possibility in passing. If a study of colour can be omitted safely from this volume one of values must be made, for without a correct under-standing of values no satisfactory shaded drawing can be executed.

But I am already employing the word 'Values', before I have defined its meaning. The other day I was both sur-prised and pleased to find that the artistic meaning of the word figures in the *Oxford English Dictionary*. I copy : ' (Paint) Relation of one part of a picture to others in respect of light & shade (out of v., too light or dark).' This is an excellent definition so far as it goes but perhaps not quite complete enough for our special needs. As I have pointed out in *The Way to Sketch* (p. 55), there is a quality of lightness

or darkness attached to each tint which makes its lightness or darkness independent to a small extent of the light and shade effect of the picture. Hence, restricted to a definition in a few words like that of the dictionary, I should have written: 'Relation of one part of a picture to others, in respect of lightness or darkness of tint.' Then we receive an impression of values from Nature, indeed it is our chief method of understanding the meaning of the retinal impressions ; so why speak of ' one part of a picture ' ? I have just looked out of the window and mentally compared the value of the pale grey sunlit rocks of Costa Pera with the lighter parts of the flocculent clouds that break in, drifted by the mistral, on the fair unsullied faintness of this turquoise sky in spring. The clouds, as they slowly pass behind the mountain profile, are identical in value and in tint, in their lighter parts, with the rocks in their sun-lit areas. Thirty years ago, more youthful, more ingenuous, I went one day with an equally youthful friend to South Kensington Art School and there interviewed the head master—if such be his just title. My friend had brought with him one or two oil sketches with a view to requesting admission to the school. The master criticized them . . . of course adversely, they merited such criticism. But at one moment he said : ' Nothing on the earth is ever lighter than the sky.' That single phrase settled the question for me. Never should I become a student of South Kensington, of a place where such palpably erroneous dogma, palpably erroneous even to my then ignorance, was propounded. I went to Paris and to Italy.

It is true that at this moment the rocks of Costa Pera are no lighter than the clouds, the lightest part of the sky ; but were there a white patch lying on the mountain-side it would certainly be lighter than any part of the sky or clouds ; and how often the whiteness of a house in summer sunlight, or

the blanched rose of early almond-blossom strikes clear against an azure depth of heaven. Once again, dangerous is the absolute dictum when we speak of art.

.

In *Relation in Art* I have defined the meaning of the word ' Values ' as follows : *The study of the relations of the various quantities of light, with which the artist deals, is called the study of values.* We see objects by means of light, either emitted by them or reflected from them. Curiously enough light and shade, as we usually understand the term, came as a comparatively recent introduction into the art of representing objects by drawing or painting their shapes on a surface. Yet it is far more often that we owe our visual impressions—or rather the comprehension of them—to the system of light and shade that plays over the solid reality of things, than we do to some boundary or colour-field differentiation. It is true that a dark-coloured object seen against a light ground will be first seen on that account, but as such it will be ' understood ' by us as a dark patch, as a *tache* upon the lighter ground, and it is only by observing its light and shade system that we can come to any adequate conclusion as to its solid shape. Indeed the colour-impression may be quite deceptive in this matter ; we all remember the *camouflage* of the war when this principle was turned to use for deceiving the enemy and concealing the real shapes of objects, even of annihilating visual impression of them. Nowadays the artist who aims at the reproduction of natural effect in a direct way, either in painting or in drawing, is obliged to devote a considerable part of his studies to that of values. The modern eye has learnt to perceive by values of shade and light, the mind to realize, either consciously or unconsciously, that it does so. It is very regrettable that we cannot make the experiment of presenting a modern shaded drawing to an ancient Greek. I should not be at all surprised if he did not realize the intentions of the

artist, and only saw in the matter a whimsical arrangement of graded tones. Many years ago, when in company of other students I was drawing for a short time in the British Museum, a policeman on duty came up to the drawing of one of us, looked at it for some time, and then asked its author why he had made the figure black when the original was white. The student thought this rather a good joke against the comprehending power of the policeman, and came over to where I was working and told it to me as such. Now of course the policeman's criticism was an excellent and damning one for the drawing. The policeman was no longer in what may have been the position of the ancient Greek. The policeman had seen modern pictures all his life, and was used to recognizing automatically the nature of objects when they were represented by the methods of modern drawing or of photography. Had the value scheme of the student's drawing (a shaded one in black chalk, naturally) been correct the policeman *would not even have realized that the drawing was shaded*, he would unconsciously have realized that it was 'like' the object it represented ; the dark side of the drawing would have correctly rendered his unanalysed impression of the shadow side of the marble.

The drawing had been made according to the then regulations about the test drawings for admittance to the Royal Academy Schools, regulations that were carefully calculated to do the student as much harm as they reasonably could. A shaded drawing on a white ground was demanded, and it was generally understood that the drawing should be executed with a stump, and tickled up with a fine Wolff or Conté pencil-point during some six months of completely wasted labour. Comparison of the accepted with the refused drawings showed that tidiness of work was the criterion, and not even approximate accuracy of placing of parts—without going into any higher plastic criticism. It would be difficult

to imagine any more deleterious invention of a country that persists in placing tidiness not only just after godliness, but a very long way before art. I say that a shaded drawing on a white ground was demanded. To execute such a drawing so that it should be an artistic success makes a call on a most elaborate system of value transpositions, an affair far too difficult for a beginner to tackle. An artist who is dependent for successful presentation upon finish may be at once written down as worthless. Were I examining for entrance to a school I should allow the shortest time possible for making a drawing or rather a sketch. The important fact to learn about the candidate is his artistic capability of judging the relative importance of the different facts of the complex impression he receives from Nature. I should give him no chance of humbugging me with microscopic and patient mechanical copying of detail ; ten, fifteen years later, when he has mastered, in order, the great decreasing scale of importance of observed facts, when he knows how to subordinate those of little importance to those of great, let him finish his work to the extent to which, without violating any of the basal facts of drawing or of values, the figure from ' Le Bain Turc', of Ingres, reproduced in Fig. 3, is finished. But at first let him learn to represent that *baigneuse* in the very fewest possible number of brush-strokes, not on a system copied at second-hand from some artist who has manufactured some technique such as, say, that of Mr. Nicholson, who, in the times of my youth, when one side of a figure was laid in tidily in black, put in the other with some lighter tint, usually brown, if I remember rightly ; but on the system of looking at the model and comprehending its primal constructional and effect data, and then noting them as his own artistic sense dictates in a free and feeling way. I cannot repeat too often to an English audience that in matters artistic the way of understanding always takes precedence

over the way of executing.[1] Technique is excellent, but better no technique than no understanding, no emotion. It is the inversion of this proposition that has kept England, from the period of Turner and Constable onwards, out of the pages of the history of artistic development during the nineteenth century and the first quarter of the present one. Taking its *élan* from the Nature study of those two great English artists, naturalistic art proceeded by the Barbizon School to the Impressionists, and then after having drunk to the full of naturalism, the aesthetic swung back towards greater abstraction, the ideals of Eastern Art began to exert their scarcely understood influence, and combined with the example of Cézanne to produce the art of the first period of the twentieth century. In all this development England is only a follower and imitator, she has established a 'water-colour school', based on carefully studied technique, and a 'Pre-Raphaelite School' which has expired without issue. The names of her artists are unknown beyond her limits, and do not count as do those of Millet, Corot, Manet, Monet, Cézanne, Van Gogh, Matisse, and the later names too near us, as chapter headings in the scroll of art's history.

.

Many years ago I realized that understanding of construction and appreciation of breadth of effect took complete precedence over technical methods. At that time I adopted what may be called a scribbling method of drawing from the model, or indeed of drawing anything. I determined that tidiness of execution, or trick of execution, should have no

[1] A similar idea was expressed by Faraday when the institution of scientific degrees was being discussed in 1859. He wrote, 'No numerical value can be attached to the questions, because everything depends on *how they are answered.*' Then, referring to the teaching at Woolwich, he says, 'My instructions always have been to look to the note-books for the result.' He evidently attached far more importance to understanding and to method of attack, than to mere memory or other mechanical qualities. He was himself notoriously deficient in memory.

Fig. 68. Rough pen drawing from the model by the Author

part in whatever quality my work might have, that having observed a fact I should note it in the most hasty, unworkman-like way possible and, so to say, force it to have an aesthetic worth on account of the sincerity and rationality of the observation and in spite of most evil execution. I reproduce, for whatever interest such method may possess, and to illustrate these words by example, one of the ' drawings ' of that period (Fig. 68). However, such a drawing is not by any means the limit of negligent execution following on careful observation, my intention not having been at the time to exemplify that theme. So in Fig. 69 I give a reproduction of a scribble I have just made in the most careless manner that I can, in order to convince the reader how unim-portant is skilful technical pro-cedure, and how all-important is intelligent and emotional ob-servation in the production of an aesthetic effect. I think neither of two facts will be denied ;

Fig. 69. Indication of main value areas by scribbling.

first, that the thing is not completely devoid of all aesthetic quality ; secondly, that such pencil handling, or rather non-handling, is at the beck and call of absolutely any one, it is mere careless scribbling. What is not at the beck and call of any one is the choice of the essential compositional and effect facts in order of importance, and a certain sense of the rhythmic relation of parts among themselves. The handling

of the tool should only be considered after we have reached a sufficient degree of observational power. In painting or other artistic work I have always found this rule excellent to follow : Try to make your picture look satisfactory from the start ; keep it continuously in such a state that, if obliged to do so, you might leave it for ever at any moment an unfinished but aesthetically satisfying thing. During the earlier periods of the work try to attain this end merely by means of large notings of shapes, values, and tints, without having recourse to detail work at all, such as putting in branches of trees, a lamp-post in a street (unless, naturally, its main mass happen to be an important factor in the subject's composition scheme), or any other enticingly easy bit of work, which by amusing the eye will interfere with its critical function in determining the rectitude of the relations between the great facts of the subject.

Now the careful reader will remark that these two counsels are to a slight extent irreconcilable. We can well paint a sketch of a subject in quite a few dozen brush-strokes, even in a single dozen, and, at the same time, in order that it shall remain satisfying after those few dozen strokes, some of them must be devoted to indicating, say, a few branches. I can only reply once more that art is neither a matter of rule nor of pure and simple knowledge, though both play a more considerable part in it than many people are inclined to admit. Note the above rules, and violate them, whenever your aesthetic sense prompts you to do so ; violate them, but do not forget them. And this last saying applies to all the good rules that have ever been propounded. Violate them because your aesthetic sense prompts you to violate them ; but do not violate them out of impatience to make your sketch look nice as soon as possible. It may look nice as soon as possible, but you may be sure that it is doing so at the cost of future and genuine excellence.

The above rule must not necessarily be read to mean that a picture should be carried through all over at once, that every part of its surface should be kept exactly to the same degree, at any given moment, of finish or unfinish. This is not a bad way to work, but it is not necessarily the only way to paint or draw. In the unfinished ' Madonna and Child ' by Titian in the Uffizi at Florence the infant Christ is completely finished, while the Madonna remains only indicated in the squarest of broad brush-marks that roughly strike out the great planes of form, and, consequently, of effect. But as the interest centres on the Child, the unfinished state of the Madonna gives us not the slightest aesthetic shock ; for the time being she serves aesthetically as a broadly-treated background to the per-fectly-finished subject—the Child. If any part of a drawing is to be finished, or even more advanced than the other parts, that part must be chosen in such a position on the paper that it can become, for the moment, the main centre of interest of the composition. In the eternally unfinished Titian, the Child is the centre of interest of the picture. It may be that, had Titian continued, the expression of the Madonna's face would ultimately have claimed prior importance ; in which case a subtle series of shiftings of importance from one place to another would have taken place throughout the elements of the composition. But here I am dealing rather with composi-tion than with drawing ; the study of the former must be left aside for the present.

.

The neglect of two branches of artistic study, branches which in imitative painting become more or less confounded together, is to a very large degree responsible for the in-adequacy of English painting art. These two branches are the conception of solidity about which I speak so often, and the study of values. The ideal of English Art has to a very large extent become an ideal of illustration. Both to the hand-

engraver and to the photographic process-block maker a refined study of values spells extra time, trouble, and expense. The nearer the approach to diagrammatic representation, the cheaper will be the reproduction and the clearer the result in rapid printing. Hence the greater number of ' artists ' aim at some artificial scheme of values which shall prove acceptable, usually by its tidiness of presentation, and the public eye in England, already too inclined to worship tidiness, is readily educated to demand such meretricious finish everywhere. The matter becomes a practical one, and ceases to be purely aesthetic ; all unconsciously the average Anglo-Saxon feels himself on safer ground. True, great masters simplify a scheme of values, but they do it in certain subtle ways, and I find in practice that I am always obliged to employ the more expensive process-block when in this, or another book, I wish to reproduce their work ; that of a modern pen draughtsman would be reproducible by a line-block. The pen drawing not done with a view to reproduction is almost always either accompanied by slight wash, or possesses certain refinements of value variation in the lines themselves which unfit it for the brutal line-block method.[1]

In Chapter II, and indeed from place to place throughout the book, I have insisted on the necessity of working as a creative artist motived by strongly-felt emotion. I wish to call attention to the inferior quality of the diagrams which I myself have made for these pages. In making them I was under the influence of no emotion ; I was intent on demonstrating some didactic point, in short, for the moment I was not an artist. These diagrams in themselves afford an excellent illustration of the thesis. I was harassed by the desire to do tidy work suitable for reproduction in an English book. With a view to saving expense I have tried to use ' line-blocks ' as

[1] Fig. 69 is a line-block from a pencil scribble. The reproduction is flat and quite different in aspect from the original.

often as possible. But, continually preoccupied by considerations connected with ease of photographic reproduction, I found myself at once bereft of what artistic talent I may possess. I was not transcribing emotions, I was trying to produce technically tidy work which should fit in with accepted notions as to what a book-page in the year 1926 should look like. All the quality of my work disappeared under the constraint of a system that circumstances imposed on me. When, instinctively, I desired to transcribe whatever aesthetic idea I might have by, say, a subtle variation in the value of a line, I was obliged to stop short and remind myself that the reproduction of such a variation would necessitate the use of a ' process-block '. I hesitated, was lost ; the work became necessarily feeble ; what I was employing was no longer an aesthetic impulsion but an application of acquired knowledge, of acquired knowledge of the kind that I have always, on principle, avoided since even the first few months of my artistic studies, and that consequently I possess badly. This acquired knowledge is what constitutes the stock-in-trade of the illustrator, and generally his entire stock-in-trade ; it is what he learns in the ' Art ' school ; it is what enables him to obtain a first prize at the end of so many months' frequenting of the school ; it is what makes his drawing acceptable to such and such a magazine or illustrated paper. If I have advice to give to the aspirant to such lucrative honours, it is : Do not read this book. Anything that you take from it cannot fail to do harm to the exercise of your trade, you will run the risk of doing for reproduction drawings as bad as mine, which are bad from every point of view, for they neither possess aesthetic qualities, nor are they ' well done ', tidy, or suitable for photographic reproduction and juxtaposition with well-presented, but sadly unaesthetic print.

Without exception each of the drawings by ' old masters ' reproduced here, has needed the more expensive method of

reproduction, for each drawing—even each pen drawing—is filled with subtle variations of line and tint value, the despair of the commercial block-maker and printer. Re-draw an exact facsimile of any one of these drawings with the uncompromising equality of tint given by ' waterproof Chinese ink ' on immaculate Bristol board ; you will be surprised how unrecognizable it has become. Art is an infinite congeries of *nuances*, of hardly perceptible refinements. Suppress them, and you suppress the art and replace it by a trade. *Nuance* and refinement are the bugbear of commercial enterprise, of production in series.

But, it may be argued, an artist should adapt his work, his methods of work to the circumstances, should to some degree submit to their dictates. Certainly he should ; I say, or hint, as much in the chapter on technique ; I have written on that subject in *Relation in Art* ; but in neither place have I advised the suppression of refinement of expression. Though by a simple use of pure black on pure white (I take this as an example only of the kind of restriction which commercial reproduction imposes on the artist) it may be possible to produce artistic work of a certain real worth, I persist in thinking that the highest expression is forever barred to any such method as is devoid of delicacies of expression, or to which the only delicacies possible are those of modulation of contour. Again, it will be objected that I have praised the clean-cut line of Greek vases ; yes, but do not forget that I have also spoken of them as being of an inferior order of aesthetic production of the period. Who indeed would propose to raise the finest Grecian vase to a level with the Parthenon frieze ? No, restriction of means of expression may lead to the highest results, but no further commercial restrictions must be placed upon the artist concerning his way of employing his limited medium. The great monochrome wash-drawings of China are epitomes of simple

expression. At the same time they are epitomes of infinite and subtle variation ; they are extremely difficult to reproduce with any degree of fidelity. In short, one may almost lay down the law : Simplify your means as far as possible ; and, having done so, set about combining infinite subtleties in your use of them. But by this method you will render your work very difficult of reproduction.

The hurried scribbles which I made while writing the text are of infinitely more artistic worth than the diagrams now reproduced, and over which I took as much trouble as a child learning to write, with the same disastrous result. This must not be taken to be a praise of the unfinished, of the hurried sketch. I have worked at intervals for several years on the same canvas, which I have painted and re-painted. When making the rapid scribbles for these diagrams I was free, untrammelled by fear of the block-maker. Free-dom is essential to an artist. An illustrator is the slave of the block-maker. What he is taught in the art school is the rules and regulations of his servitude. Every true artist is a master unto himself. These remarks do not apply to the three repro-ductions of my drawings, Figs. 19, 68, and 100, which were drawn (at widely different dates) from the model, without the shadow of an afterthought of reproduction.

Art is a jealous mistress. How many youthful artists have I known who set out gaily to earn their livings by doing some kind of commercial work with the fullest intention of doing ' serious work ' in their spare time ! But very soon the ' serious work ' which may have shown some promise at the start failed to progress, stopped short, then rapidly became indistinguishable from the clever trickery, in exchange for which commerce handed over the necessary bank-note. It is even impossible to teach according to the accepted school programme and to retain one's artistic personality. Little by little, even if he begin well, the teacher becomes infected by

the codified methods of getting round difficulties which constitute the very base and essential of producing the prize drawing in so many months. Much of the superiority of the Paris *académie* over the British *School* of Art lies in the individual liberty of the former, its freedom from continued personal instruction and overseeing. A genuine artist works out most of his own salvation on unforeseen lines.

I repeat that the completion of the valid work of art is the exact fitting together of a large number of separate individual inventions to one harmonious whole. The finish of the illustrator's drawing is in the consistent use of one kind of trick from beginning to end of the work. It is a form of tidiness.

.

I have said that solid representation and values really unite to form one problem. That is why the Impressionists made the partly true assertion that drawing is values. The beautifully delicate modelling of the back of the *baigneuse* in ' Le Bain Turc ' is due to a mutual adjustment between the values of every part of the surface. By means of this adjustment of values the surface is drawn, and is not tidied up and rounded off. It is so rarely realized that there is, or should be, just as much drawing in the modelling of a figure as there is in its contours; the modulations of value over the surface form must be as carefully studied in the middle of the figure as they are at its borders. I have often condemned drawings which do not fulfil this desideratum, and have been misunderstood for so doing by people who themselves do not realize that all great men have always worked in that way. A person who has not observed this fact naturally accuses me of capricious or of prejudiced judgement. When we do not know of the possible existence of a quality, we do not notice its absence. An exact study of value relation must result in exact modelling, though exact modelling may be rendered

by means of a perfectly factitious value scheme, as, for example, in the Leonardo study of a back (Fig. 72) where a studied equality of shading does not prevent glyptic information from being passed on to us. All early fresco painting may afford another example of often correct—or rather complete—plastic statement combined with, or rendered by, a conventional value system.

.

Except under very particular conditions exact transcription of natural values to the canvas is impossible. Black in shadow in Nature will always appear darker than black in light on the canvas. Sunlit white, or an intense source of light, will always be lighter than white pigment in half light. The best we can do is to deal in a proportional series of lights and darks, a series which covers a less wide range of difference. Colour contrast may aid a little beyond the limits to which pure value study restricts us ; but discussion of these possibilities hardly belongs to our present province. I have touched upon the matter in *Relation in Art*, p. 250, and in *The Way to Sketch*, pp. 48 et seqq.

Nor are we obliged, even when strictly working in monochrome, to confine ourselves to an absolute proportional reproduction of the value relations as they appear in Nature. A value takes on itself a different quantitative importance according to whether it is placed in one part of the picture or in another. We shall see (p. 235), when we examine the Degas drawing, that the thick contours can take on different ' values ' according to their decorative positions in the picture ; and that this difference in lightness or darkness is not always attributable to causes connected with the light effect. The same is true of patches, or *taches*, of light or dark tint distributed over the picture surface. A detailed study of this quality of decorative arrangement belongs to a discussion on composition and is too extended to be treated here.

A few pages back I condemned the practice of asking students to make a fully shaded drawing on a white ground. The most important part of training is to teach a grasp of *ensemble* of the relation of every part of Nature to all her other parts. One of the best ways to do this is continually to call attention to relations between the figure and the background. To ask the student to execute the value relations over the figure without studying the contiguous relations on the background, of which the values are often in many places absolutely indistinguishable from those of the figure, is to encourage him to see in a fragmentary way. Worse still ; none of the values at the edge of the figure can be properly observed and transported to the paper, because, contrasted with perhaps an adjacent dark note of the background, they appear to be lighter than they would appear to be were the background really white like the paper. A value at the edge of the drawing will appear too dark, when in reality, were the movement of light and shade over the background faithfully represented, it would be too light. Then it is obvious that such a series of changes carried out in the outlying values of the figure will forcibly necessitate changes in those next within them, and so on right across the drawing. In other words, a most complex series of changes and transpositions must take place. When we possess knowledge there is no harm in employing it in any way it may please us to imagine ; but while we are as yet ignorant it is better to restrict ourselves to the acquirement of knowledge. In the present instance, the student, not being a master of value observation, inevitably falls back on the system of ' making his drawing look right ' and look ' tidy '. Tidiness covers a vast multitude of artistic sins. An exponent of it hardly looks at the model at all while making his drawing, his only preoccupation being to produce a very perfectly stippled surface on his paper. His drawing is the only thing which interests him,

when it should be the only thing which does *not* interest him ;
for he should pay undivided attention to the study of the
model, his drawing hardly serving as more than a method
of fixing his attention in turn on every part of that model.
It may also serve as a practical demonstration of what he does
not yet know, and consequently has to study further. But
it should not serve as a thing to be corrected and tidied up, as
it certainly will if he make a finished up ' tone ' drawing on
white paper such as the Academy used to prescribe. When
we are quite sure that we know how to observe values correctly
we may play that kind of trick with them, but no sooner.

To watch those unhappy aspirants to academic honours
commence a drawing was a lesson in what to avoid. A char-
coal outline was established with how many pains ! with
how much industrious use of plumb-line and measuring on
a brush-handle held at arm's length from one opened eye !
Then stumping-chalk was laboriously scrubbed on the paper
with a stump for several days, and then more laboriously
taken off again with bread and india-rubber. All this while
no sign of any understanding of construction, of massing of
light and shade, in short, of any artistic element, appeared.
Why should it appear ? They were students there in order
to do a stippled drawing according to recipe. When they
knew how to do a stippled drawing they were to be entitled
to I know not what diploma, and were doubtless *ipso facto*
artist-draughtsmen. A deplorable system, not quite irre-
sponsible for the fact that the names of English artists are
unknown beyond the limits of England. Even the Beaux-
Arts of Paris did not descend quite so low ; admission was
earned at that period by a fairly rapid drawing from the nude,
done at the school ; a system which at least eliminated the
months of stippling. Yet since Ingres, hardly one of its Prix
de Rome has been remembered. Besnard is, I believe, the
only name which comes easily to mind, and he cannot claim

a place as an innovator. Also, I believe he had but little to do with the school, and only returned there in order to present himself at the final examination. But I cannot vouch for what I only heard casually many years ago. I trust I may be forgiven for insisting so often and so long on this point, to me so important, that of eliminating the 'finished' drawing from the work of students as yet incapable of any but meretricious finish.

.

Should the first lesson in value observation be given from Nature? Should it be given from some master's management of values? I hesitate. Perhaps a long series of experiments alone can decide which is the better method of instruction in actual practice. In these pages I am almost obliged to adopt the second method, not being able to give a demonstration before the model or in presence of a natural landscape. The first thing to notice is that—within certain limits—the more restrained the variety of values employed, the more aesthetically satisfying (*ceteris paribus*) is the work. Three values only enter into the value scheme of the Rembrandt reproduced in Fig. 62: Light (figure, edge of model-stand, palm, drapery, and light on the piece of furniture (?) to the left); Half-tone (top left corner, and behind the figure at the height of the knees); Dark (all the rest of the picture, and the pen lines). Also notice that these three values cover three continuous areas in the arabesque of the composition; they are not scattered about, here and there, in small isolated patches. Between the thighs of the nude Rembrandt has avoided using a brush-tint, in order to keep the impression of one simple area of light, even when a half-tint was really needed. The result of this is great 'breadth' of effect, never an unsatisfactory element in art work. In this drawing Rembrandt is true to his usual formula of centralizing the light on the principal area of interest, which he then, here, renders still more interesting by the pattern of the graphic pen lines.

The same is not true of the Mi Fu (Fig. 4). Now the lighter values represent formless mist or sky, or scarcely important water. The eye soars to the dark accents of the mountain-top, those of the foreground are only needed to balance them. On covering the foreground with the hand one is even led to ask oneself if it really adds much to the picture's success . . . but such criticism is almost heresy, only to be condoned by its drawing our attention to the eternal importance of leaving out the unessential. The farther one progresses in art the more one becomes a fervent devotee of the cult of compressed statement whence rose above all the ancient and amazing school of Chinese monochrome painting, from which even colour was banished as being an unnecessary term, and one due to a lower type of aesthetic emotion. The infinitely subtle play among themselves of the smallest number of irreproachable brush-strokes, varying in value, in width, in hasty rhythmic movement or in perfect repose, the hinted mastery of fully extended means, from which with rare reticence just the few units essential to the theme were chosen, such was the aim of artists who have striven far more than all others to fix on silk or on paper a symbol of the intangible human perception of the universe, of its seeming laws. From such abstract and quintessentialized painting every superfluous element of technical rendering was carefully banished. It is only needful to study for a short time such an artist as Mou-hsi to realize his astonishing mastery of varied technique, and his choice from the storehouse of knowledge that he possessed of the exactly-fitting method, of the method exactly fitting the spirit of the subject. Could any handling, any choice of material, be more delicate than those of the Kwan-yin (Fig. 23)? The artist wished to represent the Bodhisatva Avalokiteśvara, the Buddhistic personification of infinite pity. It is from about this period that the symbolic representation of abstract pity changed from

the male form that we find so strangely dignified in the
Nyoirin Kwannon, carved in wood, in the Temple at Nara,
to the feminine and—must we say ?—faintly decadent figure
of Mou-hsi, feminine, but hardly yet of fully determined sex.
As one studies, too, one tends to turn away from the Praxi-
telean suavity of faultless expression back to the ruder
strength of former things. There is a strange charm in those
early steps of art which are concomitant with simpler forms of
thought, current when the mind was less weary with the
weight of great experience. Art was then clearer and more
direct in its ways and meanings ; and can we deny the eternal
witchery of clearness and simplicity ? The grace of line of
that archaic Greek figure, almost cylindrical in shape, which
stands in the small Greek sculpture-room of the Louvre still
enslaves me, when later Pheidias has satiated me with per-
fection.

At another moment Mou-hsi will draw a starling, perched
on a pine-trunk, with the same decision as that of Su Kuo
(Fig. 123) but showing greater artistry ; for the bamboo-
leaves of the Su Kuo confuse the eye, and strive for pre-
cedence with the bird, whereas Mou-hsi sagely places the
dark accent alone, or almost so, in the *kakemono*. A single
hieroglyph of vine-stem accompanies it, a stem twined about,
and half hidden by, the almost toneless trunk.

Or more striking still in contrast with his Kwan-yin is
Mou-hsi's Saint Vanavâsi, in which he has given us his vision
of Zen meditation. The saint sits with closed eyes, a serpent
his only companion, amid precipitous rocks and swirling
mist. The symbolism opens out to us a few of its complex
intentions when we remember that the doctrine of the Zen
looked upon Mankind and Nature as two groups of charac-
teristic forms between which exists the most perfect sympathy
Need one speak of the fitness of such dogma to a plastic
artist's wants? But Nature is not pitiful, or but rarely, so

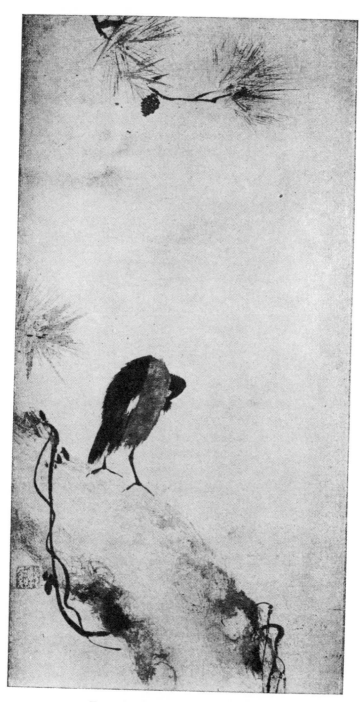

FIG. 70. Starling by Mou-hsi

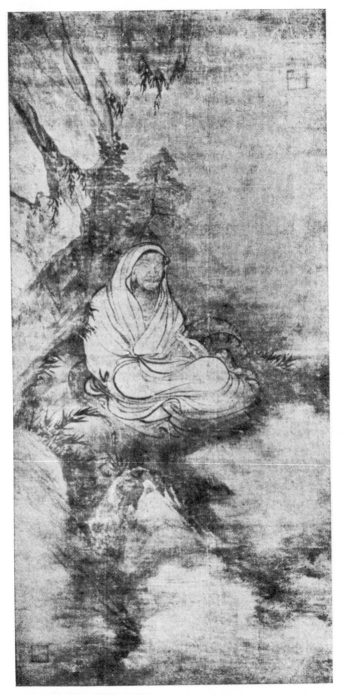

FIG. 71. 'Arhat' with serpent. The Saint Vanavâsi
By Mou-hsi. About 1250

the infinite suavity of touch in the Kwan-yin, the faint subtlety of its value organization here become strenuous and *âpre*, thereby instituting a valuable aesthetic contrast between them and the untroubled composure of the *arhat* nearing Nirvana. It is scarcely to be believed that the brush was handled by the same man, so far is the sturdy, almost brutal brush-work of the *arhat's* beard and moustache from the Kwan-yin's precision and delicacy.

Wild geese, again, will be drawn with surprising mastery ; one in full flight, with down-stretched neck, will be treated in a soft feathery management of half-tone, save for the clear black accents of one wing-tip and the webbing of the feet. A single outline marks the lower limit of the body, another traces the beak. Here comes the explanation of this examination of Chinese work in a chapter consecrated to a study of the use of values in drawing. Other schools have employed line combined with values as a vehicle of thought. Some, like the Greek vase-painters, have used line and tinted decorative field. Some have used values alone, as Velasquez used them. Some, like Rembrandt, or like Claude, have united pen line and value-play ; but no school save the Chinese, and the derivative school of Japan, has inseparably welded both together in a perfected and final drawing technique. We shall see in the drawing by Degas (Fig. 74) how often a European line may take on a value importance, especially— one may almost say, only—in rapid and non-final work ; but no one will gainsay that such double use is made in an elementary way when it is compared with the mastery of the East. In the wonderful brush-work of the East, line and value *tache* become indistinguishable ; one melts into the other ; the line spreads to a value area, and changes in intensity as it proceeds, thereby executing suggestion of modelling, of aesthetic and decorative rhythm. The pen line of Claude or Rembrandt seems a poor thing, and almost,

by comparison, void of significance, when confronted with its brush rival from the farther East.

.

True, however, to their creed of considering all imitation of Nature as an inferior form of art, neither Chinese nor Japanese have exploited the exact proportional transcription of values with a view to dealing with imitation of effect as the European schools have done. These two Oriental schools have always placed decorative and suggestive arrangement of value *tache* before the imitation of natural arrangement, which became almost the unique aim of the Impressionists. Since the period of the Impressionists and during the last twenty-five and more years a movement partly, if not entirely, due to closer acquaintance with Eastern Asiatic ideals, has taken place, away from the natural and towards the decorative use of values. In this transition period each artist must use his own discretion as to the extent to which he follows either school. Further discussion of this matter belongs to the provinces of modern art technique and of composition.

.

Comparison of values is not by any means an easy thing, especially as we are not dealing in art with any absolute measure of the quantity of light given out by, or reflected from, an object, but with the impression of that quantity which we get from it. Somehow the eye seems to have a tendency to institute immediate comparisons, and to modify the value of each term according to the difference between the two. Thus, supposing a background to be uniform in value—of not too dark a degree—this uniformity will appear to us to be darker behind the light side of a figure laterally lit and posed before it ; and will appear on the contrary to be lighter when seen in immediate contrast with the shadow side of the figure. Naturally this effect should be rendered

in executing a full value study. The necessary untruth of value studies executed on a white paper ground belongs to the same group of phenomena. If the comparison of contiguous values be not as easy as it might be, that between widely separated value areas is still more difficult. Yet to produce a satisfactory value study there must be value accordance over the whole of the picture. Value study is one of the weakest branches of British painting, yet one would have thought that the imitative standard so willingly set up in English art criticism, in combination with a decided tendency towards scientific research, would have led to much importance being attached to this subject. Nevertheless, ill-observed value relations furnish one of the first reproaches that we may address to the average picture exhibition in England. There is little doubt that this state of affairs arises from the hesitation which underlies all English artistic effort, the hesitation between the homage due to the two gods of Observation and of Craftsmanship. The French are more consequent and clearly delimited in their beliefs, hence Impressionism was a French thing; for the Impressionists, observation of effect was everything, execution of the canvas nothing. The reward was that fearless execution, as owing to the tenets theirs necessarily was, is never bad. That, of course, is why my scribble reproduced in Fig. 69 is not wholly bad, even as technique; the very fact that I was careless of any method became in itself a method, and who shall say if it be not, after all, the best? The farther one penetrates into the mass of exercise and knowledge from which executive power is built up, the more easy, the more untrammelled by technical care becomes one's production. In the end one often attains to a liberty of expression not wholly unlike the untroubled and unhesitating statement of childhood. It is true that the Chinese attached an even far greater importance to technical method, to brush handling, to traditional types of execution,

than ever the English have done. But the view-point there is
entirely different. In England good workmanship is sought
and praised for itself, praised for certain tidy and satisfactory
qualities it possesses, and there the matter ends. In China
things are quite otherwise, workmanship is looked on only
as a means of shadowing forth the abstract, the intangible ;
as such a means it is excellent when well done, but excellent
as a means only, not as an end. The Chinese position is
homogeneous and coherent, and may be summed up as
follows : The aim of art is the rendering of the intangible
permeating spirit of Nature. Part of the method of this
rendering is to be found in the artist's technical statement, in
his way of painting, in his way of producing relations among
the units he manipulates. His WAY of manipulating units
may be analogous to the WAY (' way ' is one of the meanings
of Tao, see p. 12) of Nature's manipulation of her units,
to her way of producing relations. The artist takes, though
not by any means casually, the units he employs from already
existing Nature and *manipulates them anew, for his aim is not
to produce an imitation of the impression that we receive from
the organization of Nature, but to suggest to us the laws which
preside over that organization ; the existence of which laws is
suggested to us by the manifestation of that organization. These
laws he, in turn, suggests to us by the organization of his picture.*
The view-point is totally different from that of England.

.

Perhaps it is useless to seek to explain the ideals of one
race to another. Do I waste my time ? Yet how can I write
on drawing without taking into consideration the ideals of
schools so weighty in the balance as those of Greece and China.
Drawing is precisely the weakest art of England, if we except
sculpture and architecture, which are after all one with the
essentials of drawing. I must then write of drawing as it is,
as it has been practised in other countries, so I am obliged to

develop their various aesthetic ambitions; unless I do, how can I talk otherwise than unjustly, ignorantly, of their drawing?

.

Of Chinese aesthetic ambition I have already spoken enough, though there may still be words to say concerning the actual executed result of the ideal. So abstract an ideal leads necessarily to concentrated expression, to which the conformation of the Chinese language lends itself as particularly well as does the monochrome brush. We hardly remember often enough that a language is a gigantic work of art at which generations of a race work ceaselessly, and which is none the less valuable as a measure and mirror of the national mind because it is an unconscious rendering of character. There is always strict coherence between the language of a country and its other arts. Poetry is most closely bound to the nature of the tongue in which it is composed. It will be no small help to an Englishman newly engaged in the study of Chinese or Japanese painting to pay a passing attention to the poetic forms of those two nations.

English poetry is suggestive in an imprecise way, in a way that makes no particular call on activity of intelligence, indeed it evades analysis, for that very reason it is said to be artistic. This is precisely one of the causes which has always presided at the continued modification of the English language. Any one who is unconvinced would do well to try to translate such a line as that from Lear—I choose at hazard—

O undistinguished space of woman's will!

into the precise language of France. From a vague and general appreciation of the line's undeniable poetic quality, we find ourselves obliged to ask what precisely is its meaning, before we can transfer that meaning into expression in other words. We find ourselves—or at least I find myself—quite incapable of attributing a precise and final meaning or meanings

to the phrase, to the extent of not even being quite sure
if Shakespeare means us to see in ' undistinguished ' a thing
with ill-defined boundaries, or one lacking in distinguished
qualities ! And did he know, himself ? A third meaning
would be that we are unable to make out the extent of it.
The French language, constructed by the French people for
their own use and to please their own tastes, does not admit
of this confusion of idea and casual suggestiveness. Although
we may say in French, with the same difference of meaning
as in English, both : *Nous pouvons distinguer cet espace de
l'autre* ; and : *C'est un homme distingué* ; it is anathema to
the last degree in France to attempt confusedly to suggest the
possible coexistence of the two meanings, or to employ a
figure so irritatingly vague in import.

> Mignonne, allons voir si la rose
> Qui ce matin avait déclose
> Sa robe de pourpre au soleil
> A point perdu cette vesprée
> Les plis de sa robe pourprée,
> Et son teint au vôtre pareil.

Surely the clear beauty of such verses cannot be denied ;
light, colour, imagery are there, but no indecision of meaning.
It satisfies the demands of clearly stated French Art, it is
devoid of confusion of meaning.

So much for two European poetic ideals, both of which
employ complete grammatical statement, in the one case of
an unclear idea, without limits to its possible extent of mean-
ing ; in the other of precise statement of precise idea. In the
Far East quite another system is employed, again intimately
allied to the nature of the languages constructed for their
own use by the Asiatic peoples.

> North Wind It Cold
> Rain Snow It Abundant-snow
> Kind And-again Good Me
> Conducts Hand Identical Walk

It Empty It Doubt
Past Quickly Only And-a-lot-more.[1]

is the absolutely literal transcription of the whole of a poem in
Chinese, Book III. 16. of the first part of the Cheu King.
The uninitiated European remains amazed, and perhaps a
little sceptical when told that this is read to mean :

> The North Wind blows coldly,
> Rain and Snow fall abundantly,
> Let the Kind One who loves Me
> Take my Hand within his that we may Walk together
> How can he Tarry so long
> Already He should have come in haste.

The reader will be still more surprised when told that the
Chinese literary authorities are agreed in seeing in this poem
an allusion to the dangers which menace a State.

We are evidently now immersed in an aesthetic widely
different from those to which we are more or less accustomed.

Let me give an account of an old Japanese poem discon-
certing in concision as all Japanese poems are. The trans-
lucent paper panel of a window is swept clean of dust in the
morning. Who is the actor ? the speaker ? We are left to
suppose that it is the girl charged with the work of the
house. One single final exclamation : ' Pine-tree shadow ! '
and the poem ends. But to the reader initiated into the
symbolism of China and Japan these parsimonious words
recall the teaching of Lao-tzü ; the beautiful form of the
pine shadow stands for the underlying harmony of creation,
renders, like a picture, the Tao. But—so still the poem's
symbolism tells us—this harmony of creation can only be

[1]

既	其	攜	惠	雨	北
亟	虛	手	而	雪	風
只	其	同	好	其	其
且	邪	行	我	雱	涼

perceived by a mind swept clean of the dust of prejudice, a mind such as the Zen doctrine of Buddhism linking man to Nature would desire.

What here again is the aesthetic conditioning ? First the most concise juxtaposing of elements, each beautiful in itself, juxtaposed in a beautiful way, that is : subject to perfected and complex laws of rhythm both verbal and ideal, deprived of any superfluous linking, even syntactical. Then behind this a background of harmonious philosophical doctrine, to which reference is continually, though tacitly, made, by means of almost recognized and accepted symbolism. We are in presence of an art ever striving to combine the two antitheses : immensely extended significance and the utmost reserve of expression ; yet at the same time doubt in the actual materials of the expression must be avoided ; and so one feels instinctively the clarity of the artist's conception. Undoubtedly we Europeans are at a great disadvantage. Fundamentally inartistic, when we have developed philosophic systems, we have developed them with little or no reference to art. We have no complete fusion between our art and our other modes of thought. Our recognized plastic symbolism is of the poorest and crudest. Cupid with wings, certain recognized ways of treating religious subjects, a list, in short, that I may leave to the reader to amuse himself by constructing if he will. Even then, Cupid = Love, and the matter is ended ; we have no means of referring plastically to a whole system of organized thought as have the Chinese. Also when we sit down to paint a picture we must have it as like Nature, as suggestive of Nature as possible. It never occurs to us to place a symbol on the paper, as the words ' Pine-tree shadow ' are placed at the end of the Japanese poem, placed and left to do their work unassisted, unhelped by linking up with surrounding facts, with the rest of the picture. All this point of view, to us new, to these Asiatics

most ancient, must be taken in before we can hope to enter into an understanding of the exquisite completeness and refinement of some of those monochrome masterpieces from which even colour is banished lest its superfluity be harmful to the perfect quintessentializing of the theme.

Only a short time ago I was accused—by an English painter staying here in Les Baux—in the terms of the trite reproach made by artists to literary critics of painting ; I was told that I saw more in a drawing than the artist ever meant to put into his work. I am fearful, in spite of the early pages of this book, lest the lines I have just written may be accepted, or rather rejected, with a similar shrug of the shoulders. But that is just where the difference comes in between the Asiatic and the European Arts. In China philosophy and art are one. I am only repeating here the formulated creed of the Chinese painters themselves, a creed—as I have already said—formulated and written down these fifteen hundred years. If British Art possessed a similar creed in place of the pipe-smoking, billiard-playing desire not to talk ' shop ' that is so rampant in English painting circles, English Art might count a little more in the universal ' Art Exchange '. I feel not the slightest inclination to ' see more than the artist meant to put into it in the average English picture that it has been my lot to gaze upon ; there never is more in any artist's work than he meant to put ; there is generally much less. When that ' more ' is not there, I fail to see it.

' Shop ! ' the evil is out, betrayed by the very word employed. How many English artists can plead ' Not guilty', to the charge of having considered saleability while constituting their technique ? On the other hand, can we accuse Monet in his younger days of having made that calculation ? Art and commerce are irreconcilable enemies, except in so far as successful general commercial conditions are perhaps necessary

for the encouragement of art. But the artist must not be
at first hand commercial ; or if, like Turner, he do not for-
get his financial interests, he must, again like Turner, only
consider them when, for the moment, his art is over and put
aside. The irony of the situation comes out when we remem-
ber that the saleable value of those who made it their chief
occupation inevitably falls, while the value of a Monet has
increased by something over a hundredfold. I should be
very happy to consider an offer for a portrait of my father by
Edwin Long, R.A. (without the frame !) of as many pence
as pounds were charged by the artist about thirty-five years
ago, a time when Monets were not yet very expensive,
though he has been painting since the 'sixties. The cele-
brated ' Salon des Refusés ' was held in 1863.

I recently passed fifteen months in England. I came
away with the impression that amongst the people who
know least about art in England may be counted the artists.
As a rule they are astonishingly ignorant of what has been
happening elsewhere, and of its importance. One painter
who prides himself on his modernity went to France while
I was in England. He came back having met by chance
Paul Signac, now a very old man. I was asked if I had ever
heard of him ! On the Impressionist movement followed—
rather as a corollary of it—the *pointilliste* school. Seurat
showed ' La Grande Jatte '. Round him were grouped Paul
Signac, Edmund Cross, and Luce. Paul Signac was for many
years the president of Les Indépendants ; not to know his
work and name means that one ignores completely the title
of a whole and important chapter in the history of modern
art, of the earliest break from pure Impressionist doctrine
towards a more decorative rendering of Nature. I do not at
this moment know the names of the president of either the
Royal Water-Colour Society or, even, of the Royal Academy.
The reason for my not knowing these gentlemen's names is

my knowledge that the history of the development of modern art is quite complete without them. My ignorance of their names is shared by the whole of the world outside England. I do not know that Paul Signac was president of Les Indé-pendants because he was president, but because he is Paul Signac, the *pointilliste* whose name one cannot afford to ignore.

But beside this oppressive shopkeeping (on a small scale) insularity, and beatified isolation amid tobacco-smoke clouds that surround a bewhiskyed heaven situate somewhere in Chelsea, I found, rather—shall I admit ?—to my surprise, an intellectual and moderately moneyed class which did not wholly isolate itself from passing aesthetic events. Such people had heard of Cézanne, and could recognize his work. Wonder of wonders, the Salon d'Automne, Les Indépen-dants, had been more than once visited by them. They had read modern works on modern aesthetics. They interested themselves keenly in that abstract side of the matter so regally spurned in general by the members of the various Royal societies of painters. To them one might talk ' shop ' and be listened to even with interest ; and they even went so far, and continue to go so far as to buy pictures from unknown me, pictures with which as a rule the British painter refused to compromise. Still more curious, and that is why I have mentioned the sales, such people always walked off with what was undoubtedly the best remaining picture of the lot, the one in which above all I had paid no attention to the presump-tive taste of a possible purchaser, and which I had only executed according to my moment's whim. It was of no use to lower the prices of the more sage (?) and ' classic ' produc-tions. I have thus come to the conclusion that the veritable enemies of art progress in London are the artists themselves and the dealers, that there is a considerable quantity of interest in, and understanding of, art in England, or shall we say, with more exactitude, a quantity of capacity to take interest in and

to comprehend art ? Such understanding would seem to be killed by instruction in schools and the general aesthetic apathy of the executing painters. Yet why, from this understanding class should there not spring some aesthetically worthy executants ? Abstract considerations, aestheticophilosophic tenets, do not militate against practical production, as so many who will not trouble to possess them would try to make us believe. I myself have produced considerably, I have recently put up, largely with my own hands, seven War Memorials all of considerable size (one of them contains more than forty cubic yards of stone) ; they comprise a large quantity of sculpture, all of it direct cutting in the stone from drawings, all of it entirely my own work. Surely I can claim to be a ' practical ' artist too, and not a mere verbose theorist, who sees more in a picture than the artist ever meant to put. The recent accusation was caused by my analysis of the Degas drawing which figures in these pages.[1] My reply to it was, that being possessed of that constructional knowledge myself, I noticed its existence, although sometimes it might be carefully dissimulated, in the work of a brother craftsman. Alas, in how many other drawings should I have been unable to notice it ! My objector little dreamt, while decked with noble scorn for my analysis, that he was proclaiming his own want of knowledge. I encouraged him to take up a pencil and to suggest a figure ; as I had expected, he failed; the few lines he drew were redolent of ignorance.

I make no excuse for the intercalation of this long discourse on the state of art in England. It might possibly have found better place in the chapter on technique, or in the introduction. But those chapters were already written and sent to press when the idea occurred to me to write upon the matter. Atmosphere is almost everything in art, without

[1] Before going to press the same accusation of ' mere words ' has again been tendered by a Royal Academician.

congenial atmosphere study is difficult. Evil example, evil and wrong teaching are very potent. To attack those factors which are hostile to good art production is almost as important in such a work as this as it is to direct aright. How shall the student, as yet unequipped with adequate judgement, distinguish between true and false gods ? Is it not necessary sometimes to depict the latter ?

.

Drawing and painting should not be void of craftsmanship ; but, as my title suggests, art must always take precedence over craft, and art is essentially an abstraction, the plastic arts consist in the rendering of the abstract by the concrete. This fact is not always recognized in England, or, indeed, elsewhere. Beginners are always apt to imitate ; there is no harm in this, one is always obliged to learn from predecessors. But unfortunately the beginner often displays a tendency to worship some local god, some obscure and transitory luminary, and even then to imitate only his mannerisms. If you imitate, only imitate the best. In London there is a most remarkable collection of magnificent masterpieces waiting to teach, would the possessors of them but be willing to learn. Instead of copying the technique of Mr. Cholmondely Montgomery of the Newest British Art Club, however excellent it may appear to your as yet inefficient judgement, go to the British Museum and study the wonderful collection of Claude drawings. You will come away rather surprised to find how ' modern ' they are, how much, very probably, in this year of grace, 1926, ' Mr. Montgomery's ' water-colour paintings resemble them, with the only exception that the Claudes extinguish their modern rivals. To what degree would the ' Dance of Pollaiuolo ' (p. 246, *Relation in Art*) appear out of place—except by excess of knowledge—in a collection of modern drawings ? If you have anything new yourself to say it will never be the

study of great and accepted masters that will prevent you from saying it ; for you will learn from them the basic essentials of art, and not the tricks for hiding ignorance that are so often the only furniture of contemporary and ephemeral lesser lights. Both Cézanne and Van Gogh were fervent admirers of established painting ; during his short painting career Van Gogh found time to make several copies—or rather transpositions—of Jean-François Millet ; so one need have no fear of lacking in modernity or in originality by paying attention to the great successes of the past.

I have been asked why, in *The Way to Sketch*, I have not spoken of copying. I did not speak of it because I do not recommend it. As much as I recommend study, intensive study of masterly work, by so much do I not advise copying, although Leonardo does. I do not for several reasons : first, because the great difficulty always is to teach the student to realize his third dimension, certainly a less effort to a Renascence Italian ; on this point I have discoursed already—though never enough. It is evident that if the student copies from a flat drawing he is accustoming himself to see flatly ; this should be avoided on every occasion. Secondly, copying is a tedious process which holds out every inducement to sleepy, mechanical, unthinking work, like the stippling up of an Academy drawing. Now no line should ever be drawn, no brush-mark made, unless the artist be in a state of constructive mental tension. Thirdly, when one copies, the way of doing the thing, of transcribing from Nature, is already pointed out by the master. Very often the most difficult points to tackle are elucidated by his genius in such a natural and easy way that the copyist passes over them without ever realizing that the difficulty existed in presence of the model. A method that I often adopted for study was to go to the Louvre, and to look at a Rembrandt or a Velasquez ; then to come back to the studio and paint from the model an imitation

Velasquez, an imitation Rembrandt. I was soon at a loss how to proceed, having encountered some such difficulty. A renewed visit to the Louvre, when I was furnished with an intelligent question to put to the canvas, led to a far better understanding of the situation than would have resulted from many days of probably mechanical transference of one Rembrandt brushmark after another from his canvas to mine. In the fourth place we can again in this matter consult the great men. All great men have studied their predecessors. We are in possession of many copies made by one master from another ; a copy of Mantegna's ' Calumny of Apelles ', made by Rembrandt, becomes a Rembrandt ; the ' Reichenbach ' by J. R. Cozens becomes a Turner when ' re-edited ' by him. The great men do not copy, they make notes from others' work, as Turner did continually from Claude, but they always conserve their own personality, the copy is never a mechanical reproduction. The ' Van Gogh Millets ' are not in the slightest degree attempts at copying ; though Van Gogh has taken the main lines of pose and composition from Millet, he has edited them in an entirely new way by employing his turbulent technique of dazzling sunlight, rendered by means of radiant and circumferential brush-marks, which constitute an aesthetic ideal about as far as possible from the tranquil and almost sculptural spirit of Millet.

One of the best methods of increasing one's knowledge concerning the pictorial use of values is to visit, sketch-book in hand, a gallery of paintings such as the National Gallery. Choose therein some of the most celebrated pictures and note the arrangement of value fields in them without paying any attention to the subject of the picture. Look on a light patch as a light patch without troubling as to whether it be constituted by a nude or by light reflected from a sheet of water. Scribble down on paper the result of such analysis without

considering exactitude at all. At the same time force your-
self to reduce the number of scribbled tones employed to
four at the most ; you will often be able to use even less.
This exercise is an excellent way to learn both to classify
values simply, and to learn from your study how genius leads
to the employment of simple compositional arrangement of
values. There is no need, in order to appreciate its merit, to
know what a picture represents ; its main aesthetic merit lies
in its fundamental statement of volume, arabesque, and value
arrangement. When we suppress the intelligible shapes of
the picture and reduce them to the aspect of careless scrib-
blings, the eye ceases to be distracted from an appreciation
of the underlying essentials, the formula of the composition
becomes evident when divested of the superficial embroidery of
significance in terms of ordinary thought. We see similarity
of aesthetic intention (between perhaps a seascape and a nude
posed in an interior) that would have escaped us when under
the domination of the obvious difference between the subjects.

In *The Way to Sketch* I have reminded the reader of
Corot's way of noting, in hurried sketches, the values with
numbers running from 1 to 4. This, too, is an excellent
practice, not only on account of the subsequent utility of such
sketches when made, but also for the practice which it entails
in reducing the complex series of values, with which Nature
presents us, to a simple and aesthetically manageable scheme.
As an aid during our first studies, a black mirror, or a piece
of green glass, may be of some service in suggesting simpli-
fications which might not otherwise occur to us. But I
strongly advise the student to learn to do without such
artificial aids, as I advise him to draw without measuring or
use of plumb-line. He may either half-close his eyes, which
will help him to classify values by apparently reducing the
intensity of the illumination, or, better, he may close one
eye, and throw the other quite out of focus, so that, by means

of this violent artificial short-sightedness, he sees the subject only as a blurred and meaningless set of varied tints. In the same way as our picture-gallery scribblings, void of comprehensible form, which thus no longer confuses, by distracting, the judgement, this myopic vision of Nature enables us to estimate with rapid certainty the simple relations existing between the different tints and values of the subject. Over other methods it has the advantage of not reducing colour in brilliancy, which I consider as being a very valuable point, partisan as I am in my own work of vivid tinting.

.

No quantity of explanation can replace personal study. The various ways of observing, estimating, and using values I have already indicated. It is hardly useful to multiply examples. This the student can do for himself, on the one hand by continually observing Nature from this point of view, on the other by observing how great masters have managed their values. Remember that an artist is always an artist. Art is not a thing to be put aside with a painting blouse, to be left behind us, after ' office hours ', in the studio. Years ago a friend complained to me of the eternal slavery of art ; in art there is no ' closing time ' ; never does an artist know when a new idea is coming to him ; the fête he is participating in as a relaxation may be precisely the point of departure of a new picture ; he may be, *séance tenante*, obliged to concentrate all his observing powers on noting effect for future use. The artist belongs to the category of original thought inventors. No one can command the nascence of idea. 'Elles nous viennent, les idées, en troupes légères, ceintes du mystère de leur naissance. Elles restent les ineffables maîtresses d'un moment. Elles passent, comme passe la rose qui jonche le sol de ses pétales.'

No need is there always to note down values. Here as elsewhere training of eye and observation power are the

essentials. Wherever you are, at whatever moment, observe, mentally simplify the values before you, choose a compositional arrangement of them, act, in short, as if you were really going to paint a picture. Decide just how much lighter or darker that tone is than the other ; decide which slightly different tones you will group together in order to simplify the values to three or four. A little of this reasoned mental work is worth far more than the making of many thoughtless paintings. While talking to any one, at the same time observe the constructional facts of his hand lying on the table, mentally note any pictorial quality that may occur in his pose. Better is it to make thoughtful observations than to have an eternal sketch-book in hand. Better still, though, it is to make the thoughtful observations and, having made them, to note them down, perhaps as a sketch, now and again, as did Turner, in the guise of mere verbal memoranda of things which have struck you. Figure-drawing needs more continual exercise even than landscape. It is perhaps not enough only to observe the figure ; but little good will accrue from observation unaccompanied by execution, many thousands of drawings must actually be made from it. One can only hope to possess a fair knowledge of nude-draughtsmanship after some fifteen years of work, earlier success will always be bought at the price of avoiding difficulties instead of valorously conquering them. Even then nude-drawing is of such a highly difficult nature that to produce one's best work means daily exercise. A twenty-four hours' interval is enough to blunt the keen edge of constructive observation. The first drawings that I make on sitting down to work each day during a period of regular sketch-class work, are never so good as those drawn after some little time. Then fatigue intervenes inevitably and the later drawings again show want of perfect concentration. What we learn in drawing-study is immediate, accurate, concentrated observa-

tion and creative noting of its results. As I said on p. 58, I now make in a few minutes a fuller study than twenty years ago I should have made in a week of academic mornings. In other words, I concentrate more observation into those few minutes than I used to spread over days ; but the price is paid in the shape of rapid fatigue, and forced relaxation of perfect attention. I am convinced that most of the inadequate draughtsmanship with which we are overwhelmed is the simple outcome of want of taking sufficient pains with the subject. Voluminous production is not a proof of serious work. The trouble of thinking well and completely is the first trouble that people refuse to take. In the case of England —though naturally the English are not the only offenders, far from it—I cannot but agree with Mr. Douglas, when he says, in *The South Wind*, 'The Englishman has principles but no convictions—cast-iron principles which save him the trouble of thinking anything out for himself.' Art without principles is chaos ; but this does not liberate us from the trouble of examining the credentials of a principle before adopting it, and thus separating the illustrator's trick from the basic necessity of great art. Such work every sincere artist must do for himself ; the difficulties which arise are of a nature that we cannot fix in words. But remember that the choice of great principles depends not only on intuition but on much study and thoughtful comparison. Mr. Douglas would no doubt tell us that it is more important to say this to an English audience than to any other ; and I believe Lord Tennyson was known to have remarked : 'Poeta nascitur ET fit.'

Recapitulation

Value may be said to be the relation of one part of a picture to others in respect of lightness or darkness of tint. Though we may also speak of the natural relative values of, say, a landscape without it being necessary to translate

those values into a pictorial scheme. I have also defined the study of values as : The study of the relations of the various quantities of light with which the artist deals. We see objects by means of the light either emitted by them or reflected from them. Light and shade is but a comparatively recent artistic invention. It is useless to ask a beginner to execute a finished drawing. One may obtain a much better knowledge of his capacities from a rapid sketch. Way of understanding must always take precedence over way of executing in matters artistic. It is better to ' scribble ' from the model, when one is as yet unfurnished with sufficient knowledge, than to attempt to do a ' tidy ' drawing based on insufficient knowledge. As knowledge increases the drawing will become more accurate. Do not fall back on careful execution of easy detail to hide your fundamental ignorance. It is a good rule (but not an inviolable rule) to keep a picture continually in such a state that it may be left off at any moment and yet will be aesthetically satisfactory. Solid representation and values often unite to form but one aesthetic problem. The palette of the painter is more restricted in extent of value scheme than is Nature. He is obliged to adopt what is approximately a proportional transcript of the natural series, though considerable divergence may be allowed from this theorem. The evil practice of compelling students to make what are supposed to be full value studies on a white paper background is to be condemned, satisfactory work on such lines demands complicated transposition. The student obtains a meretricious result by learning a trick for doing it. The value scheme of great masters is always very simple. The whole picture usually falls into three or four marked groups of values. Three values only enter into the Rembrandt drawing reproduced Rembrandt centres on light. This is not always so, Mi Fu (Fig. 4) centres on dark accents. The charm of reticence of expression is exemplified in the Chinese school of monochrome painting. The variability of Mou-hsi's technique is commented on, and the doctrine of the Zen mentioned. Attention is drawn to the perfect welding in this school of both line and value technique. The union of the two methods is much more complete there than in European pen and brush drawings. Chinese and Japanese consider all forms of imitation as inferior art. The causes of error in value estimation are reviewed, and methods of avoiding error are discussed. Value relation is one of the weakest parts of British painting. The Impressionists attached importance to observation ; the method of painting was indifferent to them. To be careless of method is in itself a method. To the Chinese the aim of art is to render the intangible permeating spirit of Nature, and not her transient appearances ; though these transient appearances may be used as means of rendering the permanent essence. This position is totally different from that of the Anglo-Saxon. A language is a gigantic work of art at which a whole people works, and it is the best expression of the ideals of that people. English, French, Chinese, and Japanese poetry are compared. The aesthetic conditioning of Far Eastern art is discussed. It consists first in a concise juxtaposition of elements, each beautiful in itself. Behind this is a background of harmonious philosophical

doctrine to which reference is made by recognized symbolism. Immense general significance is aimed at by means of strictly parsimonious expression. In Europe there is little or no relation between art and philosophical systems. The commercial ideal is, specially in England, hopelessly prejudicial to art. The artists and dealers are in England greater enemies of art than is a certain section of the intelligent public. As the title suggests, art must always take precedence over craft. The modernity of Claude and Pollaiuolo. Copying is not recommended ; imitation of a master's technique while working from Nature ourselves is a better method of understanding his way of work. Van Gogh has often ' re-edited ' Jean-François Millet, changing entirely the intention of the original. Rembrandt has done the same for Mantegna. The pictorial use of values may be studied in a collection of pictures by making rough scribbles of the value areas from the pictures, reducing the values employed to four at most. Composition is studied at the same time Corot noted the values in hurried sketches, using figures from 1 to 4. Values should be incessantly studied, not only when one is painting or drawing. One result of study is the power of concentrating into rapid compound observation the several acts of observation that we were obliged to execute one after the other at the beginning of our studies.

VIII

ANATOMY AND FORM

ON p. 150 I said that the pelvis, from our point of view, was the key to the situation, for it is a rigid bony arrangement which gives us seven bony points always fixed relatively to one another. Nevertheless it is usual to begin a drawing of a standing figure at the head. There is little doubt that this way of work is induced by the natural tendency of the artist's hand to descend, both as a result of the immediate action of gravity upon it, and as a result of the constructional nature of the arm and hand which is already in part determined, in the design of the human body, by this same force of gravity. Thus the hand both descends naturally and comes towards us over the sloping surface of the drawing-board. Nor must the influence of gravity which controls our method of drawing be forgotten in its effect on the moulding of the model's forms that we are copying. I myself by no means always begin at the head ; on the contrary, I hardly ever do. My first care is to establish a more main fact of pose than that furnished by the head. The head is in itself a relatively unimportant mass which springs from, which is balanced upon the more important masses of the body. When the pose presents a considerable degree of foreshortening, I think it will always be advisable to deal with the nearest masses first, and to throw the receding ones back into regular recession behind the completely established foreground volumes, whatever these volumes may be, whether they be head or feet or any other part of the body. I have just spoken of ' a considerable degree of foreshortening ' ; may I again

remind the reader of the fact almost always forgotten? that drawing may be said with something very near accuracy never to be free from foreshortening. What plane of any extent is ever parallel to the plane of the picture? What part of the body is sufficiently flat to be even approximately in that condition? It is the non-realization of this that furnishes us with so many flat drawings, with so many anatomical diagrams, which fail to suggest the real shape of bone or muscle. Let us suppose that we are looking at the bony pelvis from the front ; obviously the iliac crests are in almost complete foreshortening. More than this, if we are looking at the living model the sides of the stomach are more or less foreshortened as they recede from the central line round the abdominal convexity. *It is necessary to throw these receding forms into perspective.* The average draughtsman forgets this ; he establishes the sides of the figure in outline and then models up by shading the intervening volumes rather as an afterthought. It is very rare to find an artist whose work shows that he has thrown all the minor shapes of the body into just perspective foreshortening. The accompanying pair of drawings by Leonardo may help to show what I mean. I think it is quite evident from them that, to Leonardo, each muscular mass represented had first of all a separate solid existence, and was drawn as having such an existence in the round, the pen ' shading ' being a technical method of representing the convexity of the shapes—the sides of them foreshortened into the paper—and not the rendering of a light and shade effect. I need hardly point out that we have here information concerning Leonardo's way of conceiving his material ; when it came to executing a picture, this dislocated method of realizing each separate mass as a thing apart became veiled beneath a suave play of shadow and of light wherein rigidity of fact and of reality fused so often to the strange and mystic rendering of a spirit smitten with

unsatisfied desire, with passionate love of beauty of shape, of
grace of gesture or of pose. ' Sometimes ', says Walter Pater,
' this curiosity came in conflict with the desire of beauty ; it
tended to make him go too far below that outside of things
in which art really begins and ends.' But here we have the
essayist speaking, the man who only created in a minor
degree ; and against his opinion—perhaps not at all intended
for such a practical application as that to which I am here
suggesting that it should be put—we are at least justified in
placing the fact of Leonardo's own drawings, Leonardo's
own instinctive art, his own insatiable curiosity, which it
would be idle to distinguish from the other forces that made
of his creative genius an enduring wonder, a full and exquisite
thing. Are we justified in saying with Pater that any of
Leonardo's curiosity, even that part of it which led him to
delve beneath the exterior of form, could be eliminated
without harm ensuing to the whole result ? It is difficult to
exaggerate the importance of the very being of such work ;
its existence is more important than anything Leonardo
himself can tell us. An artist is worthy by his production,
not by his expressed opinion ; for in the latter he may often
be wrong, he may even believe that he works otherwise than
he does in reality. An artist may intuitively know many
things which find their expression in his art, and yet declare,
in words and in all sincerity, that he is ignorant of them.
An artist is not necessarily a categoric thinker in terms of
verbally expressible thought ; it may be quite allowed to
him to commit grievous errors in that direction. On the
opposite page Pater quotes an example which may illustrate
such faulty statement on the part of Leonardo himself.
Speaking of the relative nobility of painting and of sculpture
Leonardo says : ' Quanto più un' arte porta seco fatica di
corpo tanto più è vile ! ' (By so much as an art brings with it
more bodily fatigue, by just so much more is it vile !) Yet

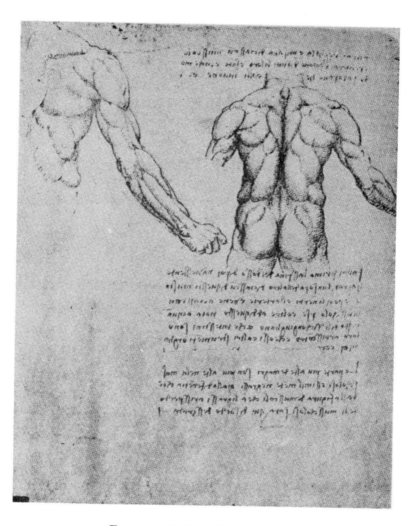

F<small>IG</small>. 72. Studies of back and arm

By Leonardo da Vinci

who shall deny the lordly domination that great sculpture exercises over the spirit, a domination yet more distinguished, yet more regal, than ever more sensuous painting has displayed ?

Pater's mention of ' that debate on the question whether sculpture or painting is the nobler art ' prompted me to take down from the shelves Leonardo's *Treatise on Painting* and to turn up the pages in which he discusses it. That curious destiny which so often conducts us to the discovery, just at the wished-for moment, of an apposite phrase would seem to have led me to the act, for I read at once :

> . . . anchora lo sculptore nel condurre a fine le sue opere ha da fare per ciascuna figura tonda molti dintorni, acciochè di tal figura ne resulta gratia per tutti li aspetti, e questi tali dintorni non son fatti se non della convenientia dell' alto e basso, il quale non lo può porre con verità, se non si tira in parte, che la veda in profilo, cioè che li termini delle concavità e rilievi sien veduti avere confini con l' aria, che li tocca, ma in vero questo non aggiunge fatica all' artifice, considerando ch' egli, siccome il pittore, ha vera notitia di tutti li termini delle cose vedute per qualunque verso, la qual notitia al pittore, siccome allo scultore, sempre è in potentia.
>
> [Again in conducting his work to its end the sculptor has to make many contours for each figure in the round, on account of the fact that the grace of such a figure from every side results from them, and the contours in question are nowise to be made if not from the inter-agreement of relief and hollow, which last he cannot place with truth if he does not place himself in such a way that he may see the concavities and reliefs limited by the (surrounding) air which is in contact with them. But this indeed brings no additional trouble to the workman, considering that he, like the painter, has true knowledge of all the limits (contours) of things as seen from whatever side, which knowledge is always within the power of the painter as it is within the power of the sculptor (the painter, as the sculptor, is always capable of possessing that knowledge).]

Now divested of the clumsiness of translation, divested of Leonardo's peculiar style of presentation, this becomes simply the doctrine of understanding of the conjunction of completely understood separate volumes, becomes the doctrine that I am advancing. And note a curious thing ; Leonardo

does not say, as we should expect, that the painter is obliged to understand shapes fully, and consequently as they would appear from all directions, just as the sculptor is, but he seems to take it for granted that the painter must be acquainted in such a perfect way with the form he employs and tells us that the sculptor must be furnished with the same science ! It is true that in the repetition he rather reverses the order of the statement, nevertheless we are quite justified in noting that Leonardo will not admit for an instant that the painter should be possessed of a knowledge of the form less complete, in the three-dimensional sense, than should be the sculptor. Surely this is a lesson to the draughtsmen who do not trouble to strain their conceptions into the third dimension, and who are often content to ' draw by *tache* ', by areas of shade, or to state with—I think—Monet : *Le dessin, c'est les valeurs.*

Leonardo goes on to say, speaking of the sculptor :

Ma lo scultore, avendo da cavare dove vol fare l' intervalli de' muscoli, e da lasciare, dove vol fare li relievi di essi muscoli, non li può generare con debita figura oltre lo aver fatto la lunghezza e larghezza loro, s' egli non si move in traverso piegandosi o alzandosi in modo che esso vegga la vera altezza de' muscoli e la vera bassezza delli loro intervalli, e questi son giudicati dello scultore in tal sito, e per questa via di intorni si ricorreggono, altrimenti mai porrà bene li termini o vero figure delle sue scolture.

[But the sculptor, having to take away material where he wishes to establish the intervals between the muscles, and to leave material where he wishes to establish the reliefs of these muscles, he cannot generate (make or construct) them—beyond having simply put down their length and breadth—if he does not shift, himself, from side to side, either stooping, or raising his point of view (as may be needful), in order that he may see the true height of the muscles (of the muscular relief) and the true depth of the intervals between them, and these are estimated by the sculptor in such and such a point, and by this method of contours they are corrected, otherwise he will never be able to place properly the limits (contours) or figure (general appearance of each part) of his pieces of sculpture.]

Here we read in words the fact so clearly expressed in Fig. 72, that the artist must have a complete idea in every

direction of each relief on the surface of the body, and—
which is of course the same thing—must quite understand
the shape, depth, and general nature of the hollows between
these reliefs. In *Relation in Art* I spoke of an observation
that I made many years ago on the digitations of the
serratus magnus of one of the Michael-Angelo figures of
the Medici monuments. I might have made it elsewhere,
I might have made it on the living model, but I could not
have made it on a figure by Rodin, for he never realized its
profound truth, a truth which he often violated when in
mistaken search for strength and violence of effect. I must
be forgiven for repeating here what I have already written ;
it is a point too important to be omitted from this book.
Look again at the drawing of a back by Leonardo (Fig. 72)
you will notice that all the muscular reliefs seem to be so
many reliefs stuck on an underlying torso surface, they seem
to be put on an already existing body which is, so to speak,
clothed with them, and which appears from place to place
at the lowest points of the intervals between the muscular
forms, intervals about which Leonardo makes so much con-
fused talk. In front of the Michael-Angelo statue, between
twenty and thirty years ago, I suddenly realized that,
consciously or unconsciously, he had considered the depth of
each hollow between the reliefs in relation to the next hollow
beyond the convexity. The hollow was neither too shallow
nor too deep to correspond rhythmically with the next. If
you will reflect a moment you will see that this is a *sine qua
non* without which the exact drawing of each muscular con-
vexity on the statue, or in the Leonardo study we are con-
sidering, would be impossible. Too great a depth—or,
inversely, not enough depth—would at once destroy the
rhythmic development of the outline which Leonardo has so
clearly drawn round each muscular prominence. In other
words, not only must we have a conception of the real surface

of the figure we are drawing, but we must also have an image before us of a kind of imaginary series of underlying surfaces on which are placed the convexities with which we are actually dealing. And these underlying surfaces must belong, each one, to a general rhythm of their own ; so that if we made a horizontal section through the middle of the Leonardo drawing we should find something like Fig. 73 in which the black lines represent the section of the real existing surface and the dotted lines the section of the imaginary underlying surface on which the convexities (hatched) are supposed to be placed, and which passes through the lowest points of the system of hollows between them. Obviously this imaginary surface is an aesthetic convention, and does not always correspond with anatomical facts ; or, at best, if systematic research did show up anything like a real existence of such a deep surface, it would be found to be composed of heterogeneous anatomical elements, now part of a bone, then portions of two or three muscles, and so on. As a matter of fact I think such a surface would be found to cut through the middle of the main muscular masses, and consequently to have no real anatomical significance, which, after all, need not surprise us. The definite geometrical conditioning of the dotted lines would seem to be the main factor in establishing an ' architectural ' quality in sculpture. Non-existence of such subjacent planes in Rodin's work militates against its sculptural and architectural value in spite of his capacity for simplification so well exemplified in Fig. 101. What we deal with is not a representation of an anatomical dissection but that of the complete living figure, complete with sub-cutaneous fat and covering skin. It is evident that our way of rendering this complete thing must be a kind of compromise based upon all the various facts. One artist will be tempted, like Michael-Angelo, to accentuate the internal anatomical elements, another—shall we say Puvis de Chavannes

or Degas ?—will often reduce such science to a minimum and bring out, it may be, some statuesque and marble-like quality of unity of surface in which all superfluous detail is absorbed and vanishes. The annexed Degas drawing (Fig. 74, the original is in the British Museum) may afford an example of such rigorous simplification ; nothing in it controverts anatomical fact, as might do some Byzantine mosaic or fragment of negroid sculpture ; yet no undue display of knowledge is thrust upon the spectator, complete information is modestly dissimulated behind seemingly naïve execution. Let us consider this drawing for a moment in detail. At first glance the outline may seem to be inexpert and even clumsy, but the more we fix our attention upon it the more we find that it is in reality excessively sensitive. All the bony prominences and chief con-

FIG. 73. Diagrammatic section of the body showing subjacent planes and surfaces.

structional points are most delicately indicated in a way which does not interrupt in the slightest the flow of contour or of surface. Note the determined flat accent under the right elbow giving us to understand that humerus and ulna meet and terminate there. Just above it, with what extreme delicacy the little plane in light due to the junction between humerus capitellum and radius head is indicated with its scarcely perceptible underlying shadow. The accompanying diagram (Fig. 75) shows the bony structure of this part of the drawing, while Fig. 76 gives a caricatural explanation of the facts noted with such extreme subtlety by Degas under guise of seeming sketchy carelessness. I wish to call very particular attention to this, because it is so easy to take up

a piece of charcoal and to imitate the external appearance of such a drawing, especially to imitate its seeming carelessness of detail, its apparent lack of precision ; we see that kind of work produced by dozens any afternoon in the sketching class of the Académie de la Grande Chaumière in Paris. The only trouble is that precisely these delicacies of observation and noting are invariably omitted. Follow the arm up to the wrist, the ulnar end is marked, while the diagonal direction of the mass of the extensors of the thumb is suggested by the upward bend of the upper line of the shadow tracing. People often forget that in the human species the thumb lies normally in a plane at right angles to that of the fingers. It also does so in the movement of the hand in the present drawing ; remark with what excessive refinement the thick charcoal line, that appears so coarse, really establishes the thumb plane seen in acute foreshortening. Place your own hand in the same position and examine it from the base of the thumb to the first joint of the forefinger. You will first notice the swelling of the head of the metacarpal bone of the thumb, soon followed by the prominence caused by its other end. You will find both these facts noted by Degas, as well as, by a very fine line, the upper limit of the plane of the side of the hand, while two little slanting slightly-curved lines give us the depression between the two extremities of the thumb metacarpal. The thumb disappears in rapid foreshortening, which fact Degas has indicated by a double line, the two parts of which touch, however. It should be noticed that in spite of the clumsy thickness of the general line, Degas does not sacrifice to it even so very small a fact as this almost invisible receding thumb plane, not because it is a very evident fact on regarding the model, but because it is needful to account for the bodily existence of the thumb. One-half of this double line also plays the part of limiting the fleshy mass of the abductor indicis, and one of the interossei dorsales. Degas

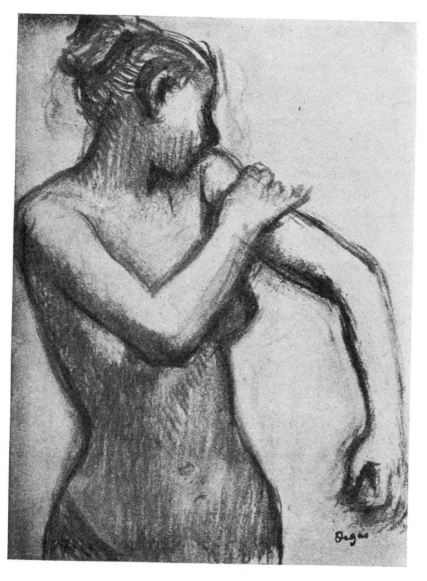

FIG. 74. Study of girl's torso by Degas

British Museum

has curved his outline round this mass and then momentarily straightened it out at the place where the first phalanx of the

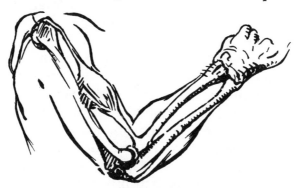

Fig. 75. Position of the bones in the right arm of the study by Degas.

Fig. 76. Diagram of planes and volumes in the right arm of the study by Degas.[1]

finger becomes subcutaneous, or at least is only covered by tendinous tissue. After this point we meet with no more muscular forms, skin and tendon are the only vesture of the

[1] The inward rotation (pronation) of the forearm is carelessly represented as greater than in Fig. 74.

bone, but when the finger is bent the skin itself forms a swelling intermediate between the joints. This also the sensitive line of Degas has noted, as it has again the three planes of the ' sky-line ' of the knuckle. It would be fastidious to describe the fineness of observation to this detailed extent over the whole of this drawing, but I cannot too strongly recommend the student to go over it patiently, millimetre by millimetre, seeking as he goes, the real reason of every, however slight, modification of line or of shadow form. He will not only gain from such work a very large amount of constructional and anatomical knowledge, but he will arrive at a clear understanding of what differentiates the seemingly careless draughtsmanship of a great draughtsman from the really careless drawing of one of his superficial imitators. At the same time I will continue to make a larger analysis of this very interesting drawing ; but before so doing I must ask leave to say that I chose the drawing at the British Museum and had it photographed without the faintest idea of making this detailed examination of it ; and indeed, even now, I am writing straight ahead, going on from one thing to the other as the photograph lying on the table before me suggests each new sentence, and as, in my present examination of it, I learn more and more about its subtleties. I had primarily selected the drawing as a specimen of moderately recent French drawing about which I should certainly find occasion to make a few remarks. At the first glance, and without any attentive study, I had decided that it was a good drawing, that it would suit my purpose ; at that moment I devoted no more attention to it. Why I say all this is to point out that any really fine drawing would have served just as well as the present one for a similar analysis. On seeing the drawing I automatically and at once decided that it was good ; what we are now doing is finding out *why it is good* ; I also know that any drawing which

satisfies me at first glance will inevitably allow me to analyse it in a like manner ; the same facts will always be represented though the ways of representing them will differ. These facts are the real subject-matter of this book.

The Leonardo drawing (Fig. 72) of course partakes more of the nature of a diagram than of a drawing, and although it contains many masterly qualities, although I should be very glad to be able to do it myself, still it may be used from one point of view as a *repoussoir*, as an inferior element of comparison which may serve to throw into relief certain qualities of measure and reticence which to a large degree Leonardo himself knew how to obtain when he wished, but which are already contained in the Degas drawing. Aesthetically this sense of reticence and measure finds an echo in the curious suggestion of polished marble form which insinuates itself among the nervous and hasty tracings of the charcoal. The seemingly less precise shapes of the Degas suggest to me, a sculptor, more of sculptural feeling than do those, more rigidly defined, of Leonardo, which sin against the tranquillity of stone surface, against its impassive lasting, much as do the equally tormented modellings of *bosse* and *creux*, of relief and hollow, that the unquiet spirit of Michael-Angelo imperiously forced him to create.

To return to the Degas drawing, and to enumerate rapidly its main points : We began at the right elbow and proceeded towards the hand ; let us now reverse the direction and work towards the shoulder. The first thing I notice is that, in the bend of the elbow itself the decided contour of the mass determined by the supinator longus and the longer and shorter radial extensors of the fingers, together with the common extensor of the fingers, comes slightly forward with an almost imperceptible inward tendency which moulds the rounded mass of muscle—and, in this case of the female form, the covering fat. Capable draughts-

men always pay great attention to the direction that the
very last fragment of such a contour takes ; the line, it
is true, leaves off, but the thought of the artist continued to
follow the form round into the mass, as did his hand move-
ment at and after the moment when the pencil left the paper ;
so the mind of the subsequent spectator of the drawing is
engaged to follow the same impulse and to feel the real
convexity of the muscular—or other—mass that is thus
thrown into relief by the very fact of the artist having
observed its relief. Remark in any of the drawings repro-
duced in this book this slight inward tendency of the ends of
such lines. Here this line comes in front of the commence-
ment of the line which runs up towards the shoulder because
the extensor mass is in front—in the present position—of the
lower part of the biceps mass that continues shoulderwards.
The line which bounds the lower part of this mass is faintly
drawn in order that, as a lighter value, it should recede
behind the extensor profile. But here we have another
example of refinement : the upper profile of the forearm,
dark and heavy where it leaves the hand (partly because it
there takes its place in the system of markings that con-
stitute the plexus of main pictorial interest, which centres
in the right hand), dark in its upper part, becomes as light
as the commencement of the biceps profile just at the bend,
because the intersection of the two lines is enough to give
recession to the hinder line, so equality of value is used to
give the feeling of joining up of the two parts of the arm,
which might otherwise become too distinct one from the
other, and thus militate against the unity of the body. This
danger once avoided, we come to a strong line which limits
the shape of the deltoid at the shoulder and at the same time
gently leads the form down into the biceps. This leading
down is not shown in the Leonardo drawing where the
profile lines of the deltoid all re-enter towards the humerus

with uncompromising anatomical rectitude.[1] In this drawing
Leonardo counts on the exact relative placing of his masses
to engender the feeling of rhythmic unity in the body. A
happy accident intervenes on Degas's biceps profile, a ' first
line ' persists both here and on the supinator contour. Both
aid in giving a feeling of solidity to the volume of the arm ;
and it is to be noticed that the darker of the two biceps
profiles, the one that persists, and in the end counts, is not
that in direct continuation with the deltoid profile but that
which lies a little beyond it. This has the effect of sug-
gesting to us the flattened front of the biceps. Do not
think that I believe for a moment that Degas was clearly
conscious of the meanings of all these details during the
feverish moments of production. These double lines were
evidently in the first case the result of erroneous placing of
the arm, but once in existence they have been left as they
are, for Degas, the artist, instinctively felt that they fulfilled
a useful and an aesthetic rôle. Much of a work of art is
unconsciously produced, is at best the result of a blindly-
working subconscious direction, due to the very personality
itself of the artist ; a personality which owes part of its
nature to study and experience. Knowledge is first acquired
by study, and then, so to say, enters into the composition of the
directing nature of the personality. When one is possessed of
knowledge and experience, it becomes impossible, even if
desired, to reproduce the weak work of previous ignorance.

The under line of the upper-arm is strong, clean, and
statuesque in curve. It is not only strong on account of its
being on the shadow side of the limb, but also in order that
it may definitely enclose between it and the deltoid line the
intervening mass, in what I may term a ' diagonal fashion ', so
' helping ' the shapes forward towards the forearm, and thus
somewhat counteracting the slight backward deltoid tendency

[1] Marshall's *Anatomy*, p. 345. The deltoid form is well shown.

(see Fig. 36 *a b*). The nearly subcutaneous humerus is discreetly marked by the faint darkening in the middle of the shadow up from the elbow along the first third of the upper-arm towards the shoulder; and the three darks in the middle of the shadow at the elbow itself establish without possible doubt the shape and position of the lower end of the humerus (see Fig. 75). Its upper end is of course in this position confounded with the acromion process. They are the cause of the oval light-patch on the shoulder of the Degas drawing, or at least of its upper part. Below this oval, the plane composed of part of the deltoid, the long head of the triceps, and the teres major,[1] falls vertically away. As it is seen in perspective Degas has indicated it by nearly vertical hatchings suggested to him by the instinctive desire to show this vertical drop. The lines being transverse to the perspective direction induce the feeling of foreshortening. Set at a very slight angle to them are the hatchings over the great serratus muscle which give us this new indication of volume. The volume is rounded into relief both by its farthest profile and by the almost invisible curved line of shadow running down it. Natural form is neither round, nor flat by planes; it is always a delicate compromise between the two. Here in his rapid but searching analysis of its nature, Degas has given these two characteristics of the form separated out, displayed apart on the laboratory table.

How much of the aesthetic pleasure we derive from looking at a sketch is due to the almost intellectual exercise that it demands from us to complete and to re-combine that which the searching view of the artist has put asunder? Truly a sketch may almost be likened to a skeleton of the completed work; and we, the onlookers, are called upon to clothe with flesh and skin this schematized presentation of Nature. Yet my figure is hardly just, for a skeleton is a

[1] Also, of course, the teres minor, and the supra- and infra-spinati.

dead thing, and one may almost say that an indispensable quality of a sketch is a vivid presentation of life and momentary vivacity of movement or of effect. But from another and more abstract view-point this cross-hatching of plane and rounded serratus form in the Degas drawing calls for appreciation from me. It is a deliberate plastic setting forth of the eternal laws of action and of reaction, of Zoroastrian balance betwixt the wish of Ahouramazda and that of Angrômaïnyous, that conflict which has ever ruled the human and the natural, which so many primitive peoples have seen typified in the diurnal vanquishing of night by day, inevitably followed by renewed supremacy of night. Music sometimes states the law in the back-and-forth movement of a Beethoven phrase. The plastic arts state in their turn the antique theme, antique yet ever new, irrefutable,[1] enduring beyond the most steadfast lasting of things, the theme of opposition, of contrast. Sometimes they state it in terms of tints wisely opposed ; sometimes, as in the Persian myth, in terms of darkness defeated by light ; sometimes, as here, by a contrast of qualities, by a contrast instituted between the straight and curved elements of a surface, which contrast is indeed the chief foundation of decorative arrangement. And who shall decide where drawing ends and decoration begins ? a drawing is decorative, and in its production decorative principles are employed. I have already said : Never make a study without first considering its decorative placing on the page.

The outline of the torso is thick and dark ; the shading of the area of the paper included within the boundary lines is comparatively light. By the faith of all unreasoned recipes for picture-making the profiles should ' come in front ' of the interior modelling. Yet here they do not ; the drawing is wonderfully solid. To be convinced of this it is perhaps

[1] Unless before us lie some new moulding of human perception to a relative position ; unless this perception of opposition be but a figment of human thought.

necessary to hold the page at arm's length at least, so that the visual angle subtended. by the width of the figure is not too great, and so that, consequently, the eye takes in the whole of the drawing at once, deals with the whole of the relations, without concentrating its attention on one particular part. For in spite of its sculptural quality this drawing is a painter's, it might be termed a painter's vision of sculptural form ; hence, unlike the Leonardo drawing, every part of this drawing is subordinated to the rest, even the treatment of the main point of interest—the right-hand—undergoes a kind of reciprocal modification with reference to the other parts of the drawing. From the point of view of simple setting down of the shape of the model the outer line of the left pendent forearm might be as dark as many other lines of the drawing. The line of the nose is one of the darkest in the picture, yet the nose should receive the light in much the same way as the forearm. It is the decorative place, in a quite subordinate position, of the forearm outer profile that dictates its lighter tint. The accent of the nose and the straight line below it that limits the torso, serve as a kind of axis of composition. The dark line at the back of the waist and the pale line in question of the forearm are about equidistant from the axis in mean measure. To have made the arm outline as heavy as the back waist-line would have produced an unhappy equality of area on either side of the median line. Degas has insisted on the decorative shape enclosed between the arm and the body. Copy the drawing, making the outer forearm line dark, and note how the whole design is destroyed. This is an excellent instance of compositional modification of drawing technique already spoken of on pp. 24 et seqq., 38 and 41. The varying intensity of the lines is not due to effect-rendering, otherwise how should we explain the sudden darkness of the line we are discussing in the part of it above the elbow ? The line intensities are governed both by the

needs of effect-rendering and by the necessities of decorative arabesque.

While looking at this arm we may notice the straight line at the inner bend of the elbow. It designates the muscular mass that there comes in front of the rest of the arm, and is composed by the long supinator in chief, combined with the extensors. Here again a main constructional fact is composed of several anatomical ones ; and we must carefully study the way in which the various anatomical facts group themselves together in order to make one single constructional fact. It is generally almost impossible to gather this knowledge from the usual anatomical plate ; that is why I have preferred to reproduce semi-anatomized drawings by Leonardo or by Michael-Angelo, in which the artist has instinctively grouped the anatomical factors according to his habit.

Let us look at the torso ; at the waist the front plane of the body is most clearly separated from the side. Then the upward-turned plane about the navel shows clearly as a light patch. A darker plane intervenes, and then the forward tilted flatness above the iliac crest, generated by the internal and external oblique and the transversalis. We have here a very simple statement of the principal constructional facts of that part of the body. At the height of the navel, between it and the hanging hand a dark accent and a break in the profile place the iliac crest on that side ; it is nearly half-way up to the breast. The intersection in the profile takes the form round to the back over the lateral shapes of the obliques, and shows the conical insertion (as did the Rembrandt drawing Fig. 62) of the chest-forms into those of the pelvis. In the Leonardo drawing too the mounting forms of the pelvic mass seem to embrace and clasp the conically descending shapes from the upper part of the trunk. These great facts must never be overlooked in drawing.

.

My intention is to treat separately of the construction of the different parts of the body, so for the moment I will consider this demonstration of possible relations existing between drawn form and anatomy as sufficient without pursuing the subject over the whole body. Let us now consider a few more of the abstract sides of plastic representation.

The most important division of our present subject is constituted by the difference that the reflecting critic feels himself bound to establish between two main groups of plastic representation. For want of better terms we will call the two schools the Formal and the Informal or Emotional. Each of these methods of plastic statement naturally represents a mind type. The first has often been represented by France, to the second belong the artistic manifestations of such peoples as the English or the Dutch. As I have pointed out in *Relation in Art*, such aesthetic distinctions must not be looked on as absolutely determinate ; on the contrary one type fades by indiscernible gradations into the other ; some plastic ideals find place as much in one group as in the other. Yet it is of importance to distinguish between the two aims, which, in their limiting cases, are so different.

In *The Times* of the 6th of March 1924, I read : ' The Critic (Charles Maurras) whose doctrinaire pedantry could lead him to write that Hugo *manquait d'à peu près toutes les qualités maîtresses de l'esprit, du génie et du goût français...* (lacked nearly all the chief qualities of French spirit, genius, and taste . . .) '. Now M. Maurras may be guilty of many crimes, this is not the place to discuss that question, but of one he is not guilty, that of ignoring what are the best French national traditions. A very considerable acquaintance with classical and French literature, combined with French, though meridional, birth (Les Martigues, Provence) would almost render such ignorance impossible. The trouble arises from the fact that *The Times* critic to whom was consigned the

criticism of French literature at that date was wholly unfitted for his task ; he read French literature with a quite unmodified English understanding ; he asked himself whether Victor Hugo satisfied his English wishes, found that Hugo did, and henceforward would brook no vile French statement that the art of Hugo was not a French Art true to the traditions of France. For you should remark that M. Maurras's criticism does not forget the word *français* ; on the other hand, truly British, *The Times* critic (what a pity his judgement was pronounced anonymously !) tacitly—but none the less evidently—assumes that his British touchstone of artistic worth is the one and only genuine test ; does he not call a Frenchman a ' doctrinaire pedant ' for daring to speak of the ideals of his own country, ideals that are his own ? How dare he have ideals which are not British ? That the romantic, unmeasured form of Hugo's poetry, the richness of its output should please the English critic should in no way astonish us ; its romantic picturesqueness and force appeal directly to the Anglo-Saxon who looks upon formalism and restraint in art as simply coldness and stiffness, or as ' doctrinaire pedantry '. Consequently no critical estimate of value, by such a critic of French literature, can be other than almost the exact inversion of a true estimate. I open Lanson : ' Victor Hugo,' says he, ' évidemment, a manqué de mesure, comme il a manqué d'esprit : visant toujours au grand, il a pris l'énorme pour le sublime, et il a été extravagant avec sérénité.' [It is evident that Victor Hugo lacked in measure— or rather, reticence—as he lacked in *esprit* (I refrain from translating into ' wit ', for the two terms are not synonymous ; one expresses a French, the other an English idea. We are again in contact with another aspect of the same problem) ; he took the huge for the sublime, he was extravagant with serenity.] Then M. Lanson goes on to explain the qualities of Hugo's poetry ; with them we are not for the moment

concerned. But Hugo's culpability is clear to the eyes of French tradition the moment that he lacks in *mesure* and in *esprit*.

Less prejudiced than England, France during the nine-teenth century produced a splendid output of romantic art. The amazing *verve* of Delacroix flamed across colossal canvases. The slightly vulgar genius of Balzac gave us the stupendous tissue of the Comédie Humaine, powerful, common, sometimes stooping to impossible sentimentality. Rodin accentuates the emotion of Rude, and, wanting in Rude's compositional sense, leads sculpture, by sublime fragments, to a blind alley. Glyptic Art has been obliged to begin anew. But after yielding to the seductions of unbridled emotionalism for the greater part of a century, France has decided to pick up once more the thread of her own tradi-tions, traditions which, however, had not by any means ceased to be active, as my too absolute phrase might suggest. I should be more hopeful of explaining the essentially vague ideal of English Art to a Frenchman—who nevertheless cannot away with the indeterminate phrases of Shakespeare—than I am now of rendering comprehensible to English readers the clear and logical reserve of France, a reserve that prefers sacrifice of effect to sacrifice of precision, that prefers Art to Nature, an Art which sets up formal and rhythmic expression in the place of imitation and ill-defined, if wide, suggestive-ness. We are trespassing here on grounds more philosophi-cally abstract than those to which I had designed to restrict this volume, especially as I have written rather fully, if ineffectively, on this subject in *Relation in Art*. Already I have exploited the reader's patience in developing, perhaps to too great an extent, the Chinese philosophical view ; but, without so doing, how could I make at all clear the angle from which the Far East attacks the problem of drawing ? Again, now, it is very difficult to see how one can present

under its true aspect such a drawing as that drawn by Euphronios and reproduced on p. 89, without at least sketching in the mind-cast which dictated its making, and the differences which exist between such a mind-cast and that of England. But perhaps it will be better to leave these pages a little incomplete in this respect and to refer the reader, whom the subject may interest, to the fuller treatment of it in *Relation in Art* ; while I content myself here by asking him to meditate on these words from *The Works and Days* of Hesiod : They know not, unhappy ones, by how much the half is preferable to the whole, and what riches lie in the mallow and the asphodel.

.

Leonardo is continually lost in admiration of chiaroscuro, the new discovery of his age ; like all new discoveries, salvation lay in its use. Four centuries of use have habituated us to its marvels ; we are, consequently, better placed than he to estimate its real qualities and defects. Light and shade brings with it intimacy, concentrates the attention on the individual, on the particular ; it is thus well fitted to an analytic, to an emotional, a subjective art, to an art which deals in sentiment it is fully adapted ; so Dickens makes great use of its literary analogy of violent contrast. To the clear harmony of sunlit thought it is less fitted. On Mediterranean shores, in other lands of the sun, it seems always to dwell as an alien. The direct acceptance of life natural to the peoples born in such regions finds a gayer, lighter transcription in the evident lines of the Euphronios (Fig. 21) sooner than in the tawny and shaded inconclusiveness of the Rembrandt (Fig. 62). Compare the quality of the lines of the two drawings. The Rembrandt line is hardy but not delicate ; it is there not so much as an element of expression as it is as a means of marking out volumes, its reason for existence is more practical than aesthetic. It may seduce us by its decision, but scarcely by

its rhythm. What strikes us at once in the drawing is the graded contrast of light and dark, the transparent shadowed air behind the figure, the dimly-discerned artist sitting at work, the discretion of northern light that falls softly from the window. There is seclusion, invitation to meditate, especially on the psychology of the individual, expressed throughout the page. With the Euphronios all is otherwise. Here is no mystery. The shapes of things are clearly stated just as they are evident in the searching light of the south where misty and mysterious off-shadings of form are rare and negligible. The black hair and beards of the men combine with the dark lines of the decoration to form a decorative design in the first instance, a design helped out by the thin arabesque of the figure outlines. But this is meagre matter for a work of art. Had Euphronios stopped here and employed the slightly eloquent line of Rembrandt in drawing the figures, how little we should be inclined to admire. Such is not the case ; the line, that with Rembrandt is but a secondary practical necessity for the indication of volumes, in the Euphronios becomes in itself almost the total work of art. Not only does it suggest the enclosed volumes discreetly, though quite efficiently, but it is instinct with a conscious rhythm, rhythm which constitutes the major part of the aesthetic message of Euphronios and of his greater national contemporaries whose work, at least in painting, is so unfortunately lost to us. I have but little doubt that the sense of solidity was much more keenly developed in the ancient Greek who lived before modern painting, before modern scientific understanding of the mechanism of sight, had encouraged in us a vision *par tache*, by stretch or area of colour or of shade or light. Hence, in spite of his moderate knowledge of perspective, you will never find a Greek vase painter of even indifferent grade omitting to note the placing of the main masses of the form. For example, notice

the rather naïve drawing of the back of Euphronios's back-ward-glancing man, a back half-obscured by the decorative lines of the mantle ; the plane of the buttocks is clearly felt ; then the upward-running profile of the back, instead of continuing from the far buttock profile as a latter-day student (and probably, certainly, more capable draughtsmen still than he) would carry it on, starts from the base of the sacral triangle, thereby very adroitly, if not very accurately, suggesting the insertion of the upper conical volume (of which I have already spoken so often) into the pelvic mass, suggesting at the same time the difference and the relation between the two masses. The Greek mind was used to think-ing in real and tangible masses ; not in intangible changing effect. Thinking ' all round ' his mass, all round and through it, being used to consider the co-ordinating of volumes among themselves, he was an incomparable architect, as the modern architect, racially used to the observance of effect, is not, cannot be. I myself experience the great struggle, in which one is so rarely successful, against heredity and environment, when I try to conceive in a purely plastic way for the invention of architecture or of sculpture. The task before us is far more difficult than that which confronted the ancient Greek. The problem is perhaps insoluble. Some time ago I made a sketch in colour, in light and shade, of certain pine-trunks, with a bright break of sunlight lying on a distant plain. The possibility of such a thing was unknown to the Greek. He dealt, artistically, in an arabesque of form aided by conventional fields of colour. He did not study the pos-sible losing of the pine-trunk among surrounding and equal values, or on account of natural equality of tint. To him a pine-trunk was a solid, cylindrical fact, whose existence must not—could not be disguised. What pre-eminent mentality for dealing with the inexorable facts of architecture ! Yet I am asked one day to see and appreciate these possibilities

of uncertain ill-defined form, another to combine aesthetically positive and existing shapes to produce architecture or sculpture. Even an architect who does not paint is brought up among the modern type of simulacrum; though he may not be adept in producing it, he cannot be otherwise than adept in construing the results of modern painting and photography. The pure unhesitating foundation of formal appreciation from which the Greek started is to us to-day unrealizable.

The Euphronios drawing suggests the volumes discretely. Another of the advantages of naturalistic painting being unknown to Greece was a certainty of decorative taste and invention. I am more and more convinced that a decorative painting which seemingly hollows out the wall surface (or whatever the surface may be) that we are decorating is an aesthetic error. That an easel picture may possess profundity may be, should be, accepted; the picture itself is the only object in question. But that the architectural fact of the existence of the wall of a building should apparently be destroyed by a perspective hollowing out of its surface, I am less and less inclined to admit. There is thus generated heterogeneity of intention; the work cannot fully satisfy. In all great and satisfying epochs of decoration this law has been observed. Since the introduction of 'illusion' painting, decoration has degenerated. The most satisfactory of decorators since the generalization of imitative painting is Puvis de Chavannes, who by a certain skilful flattening of elements of his picture recalls continually to us the surface of the wall. It is quite true that many modern decorators draw flat enough in all conscience, but, alas! that is only to exchange one defect for another. The instructed eye of the aesthetic critic is offended by the total absence of solid plastic sense. Euphronios hits the happy mean. The surface of his vase is not destroyed; the possible existence of the solid form is conserved.

The unhesitating line that engenders this formal possibility is in itself a rhythmic and eloquent joy, playing lightly over the surface of the vase, weaving upon it glad and visible harmonies recalling such visions as those evoked by the reverie of Mallarmé :

> Mes bouquins refermés sur le nom de Paphos,
> Il m'amuse d'élire avec le seul génie
> Une ruine, par mille écumes bénie,
> Sous l'hyacinthe, au loin, de ses jours triomphaux.[1]

.

One would fain define that most indefinable idea, formal expression, as being a very particular and restrained use of the expressive medium itself, of the very way in which the thing is done, to give to the result an enhanced expressive value. It may be looked on as a sort of clear and coherent harmony of parts which work together for the establishing of a philosophy of direct and simple nature unafflicted by doubt, fraught with certitude.

Thus it would necessarily be estranged from the composite dealing with an amalgam of fact and effect, of the appreciation of solid form withal here modified, there rendered totally invisible by casual play of light and shade, of chance emotional clothing of colour. The very movement of the brush or point is of importance to the formal artist, it must be clear and restrained in rhythm, it must not be unbridled like that of the splendid sweeps of brush-work that wove into being the great Rubens of the Uffizi. It must not be careless of the brush-mark's isolated appearance as it was when prompted by Impressionism, where minor rhythm was sacrificed to total effect. Above all, it must be measured and restrained. The traditional classic joy in this restraint and

[1] My books closed down upon the name of Paphos, by sole genius it pleases me to choose a ruin blessed with innumerable foam beneath the far-off hyacinth of its triumphal days.

measure, in quality of generalization, has never faded from France, where it constitutes the very foundation of ' les qualités maîtresses de l'esprit, du génie et du goût français ' of which *The Times* critic knows so little. ' How much the half is better than the whole ! ' But the effort of artistic appreciation that esteems omission and parsimony of harmonized expression above the fully executed is one of the last we make. A formal art is far from imitative, it is a symbol of an abstraction, almost the schematic presentation of an idea ; yet it is never a cold schematization, an inanimate result. What more full of life than our Euphronios drawing ? full of life yet curiously balanced and ordered ; not like the violent, disordered renderings of movement by highly emotional artists of more recent times, romantic and unrestrained. Movement, as I have said, is easy to obtain, its representation belongs to the regions of purely imitative art. It may be assured by simple tricks of unbalanced pose that only those ignorant of the higher significance of art are proud of knowing and employing. Movement is the antithesis of balance, and balance is the basis of the greater efforts of art. The prancing horses of the Parthenon frieze are, one and all, exquisitely balanced, Mu-hsi's Kwan-yin is perfect in repose ; even our two Euphronios figures, for all the gay movement they suggest, are models of stability. These and many more appreciations of a like kind underlie the determining of a formal art, of such an art as Hazlitt fails to be in sympathy with when he writes : ' The same remarks apply in a greater degree to the " Tartuffe ". . . . The improbability of the character of Orgon is wonderful. This play is in one point of view invaluable, as a lasting monument of the credulity of the French to all verbal professions of wisdom or virtue ; and its existence can only be accounted for from that astonishing and tyrannical predominance which words exercise over things in the mind of every Frenchman. The *École des Femmes*, from

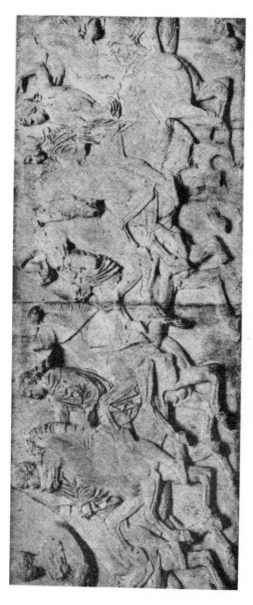

Fig. 77. HORSEMEN FROM THE PARTHENON FRIEZE

The great number of vertical imaginary lines should be noticed, e. g. the central vertical; to the left of the slab joint, passing through the horse's ear and the three hoofs. Also the vertical:—last face but one from left, horse's nose, horse's chest, hoof on ground. Many more are traceable. The horizontality of the accents under hands and one horse's nose adds to the stability, as do the almost horizontal accents under the horses' legs and bellies.

British Museum

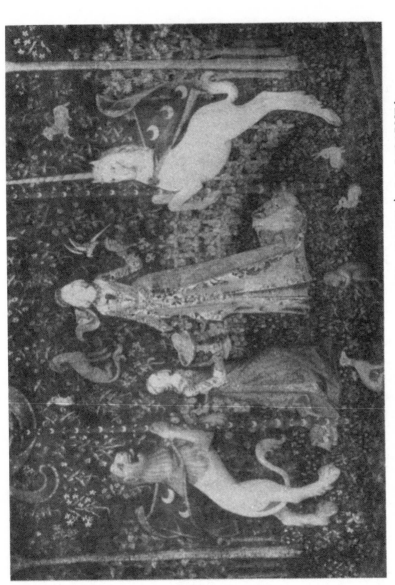

FIG. 78. DETAIL OF A PANEL OF 'LA DAME À LA LICORNE'

Musée de Cluny

which Wycherley has borrowed his " Country Wife ", with
the true spirit of original genius, is, in my judgement, the
masterpiece of Molière. The set speeches in the original
play, it is true, would not be borne on the English stage,
nor indeed on the French, but that they are carried off by
the verse.' Alas, poor Molière ! . . . or is it ? Alas, poor
Hazlitt ! For him the character of Orgon must be probable.
Hazlitt recognizes no other art than imitation. Unhappy
author of 'La Dame à la Licorne', unhappy Euphronios
—for his group is scarcely probable, scarcely should we
take it for a photograph from life ! Hazlitt falls back on,
to him, the only possible explanation : the set speeches of
l'École des Femmes are in verse.

We will listen again a moment to Lanson, a Frenchman
writing about a Frenchman. ' But let us speak of his charac-
ters,' says M. Lanson in his penetrating criticism of Molière
which I would fain transcribe in its totality. ' In the expres-
sion that Molière gives of them there is simplification and
magnification (this is what becomes improbability to Hazlitt)
as much with a view to showing up their comic side as in
order to bring forth truth. Boileau, Fénelon, La Bruyère,
who have accused him of forcing Nature, were never aware of
the large conceptions of Molière ; their realism attached all
importance to the minute details of superficial appearances
(Hazlitt is not in glorious isolation). But the realities that
Molière wished to show, were not particularities of costume,
of gesture, or of act, the little march of daily life ; he wished
to show the soul's underlying strata, its motives, the very
springs and essences of human life ; and he took from the
outside aspect only that which corresponded with these
interior and basal strata. The exactitude of which he was
proud had no relation to the outsides of life, but with the
inner secret motives of the soul.' So M. Lanson, so not
Hazlitt. And M. Lanson is right, otherwise how has the

reputation of Molière lasted till to-day as a living thing among a people recognized to be perhaps the most intelligent of Europe ? How have the characters of Molière become a part of the French vocabulary itself ? Why is Tartuffe (despised of Hazlitt, as a character) a French word of regular use and application ? How often do we say that a man is a Hamlet, a Falstaff ? Sometimes, but how rarely, once in a lifetime we may say that so-and-so is a Melancholy Jacques. Why ? because the art of Shakespeare is not of a generalizing nature, it is particular, multitudinous, confused almost as the aspect of Nature itself. It affords us hundreds of quotations which we make on separate occasions. We quote: 'To be or not to be !' when we happen to discuss that point of philosophy. We ask: 'What's Hecuba to him, or he to Hecuba . . . ?' when we wish to speak decoratively of that *single fact*, indifference. We say: 'O Romeo, Romeo ! wherefore art thou Romeo ?' when we are not quite sure of what we mean and want to eschew the difficulty of precise thinking and statement. Hamlet, Lady Macbeth, Polonius, are portraits ; Tartuffe, Orgon, Scapin, are quintessentialized types. The words of Hamlet are quoted ; Tartuffe himself as a coherent, clearly established type of humanity is carefully preserved, no one thinks of quoting his isolated sayings. He may almost be likened to an allegorical statue. And there we have the main difference between a formal and a particular artistic ideal ; the first quintessentializes—was not the second book of the *Faicts et Prouesses Espoventables* of Pantagruel, *Roy des Dipsodes*, composed by Feu M. Alcofribas *abstracteur de quinte essence* ?—the other belongs more completely to the class of imitative art. Hazlitt looks for portraiture when type is provided. Yet this statement may easily lead to mis-understanding. Generalization to type does not necessarily imply formal expression of that generalization. There is still the essential way of presenting this generalization. An

English critic of *Relation in Art* tells me that there is form in English manners, though it is not so openly displayed as in France. He mistakes the whole meaning of the French word. It is to the absence of *la forme* from English social CONVENTIONS that the raillery of such an author as Abel Hermant is addressed. Conventions, against which it is forbidden to sin, probably exist to a greater degree in England than in France. Neither convention nor its evidence marks the existence of the formal sense ; *that* lies in the special methods of their conception, their framing and their presentation. The arts of a people are fundamentally homogeneous, the draughtsmanship of France is one of type and form. To be presented anew with the unsolved problem of Nature is repugnant to the French spirit. The Frenchman feels with the Chinese that the real province of art is elsewhere.

But, it may be objected, the creed of the French Impressionists was a return to Nature. Yes, in phrase, and in part. Any quintessentializing must be done, to start with, on Nature herself. Before the Impressionist movement (if we make exception of the Barbizon effort—the overlapping and parallelisms of history render any absolute statement slightly false) the mass of French painting had become stiffly academic and unnatural. Hence the war cry of the Impressionists. But when we come to look at a picture by Monet, by Sisley, by Manet, we are bound to admit that it is far, very far from photographic transcription. It has a convention all its own, a convention of choice, of elimination of the superfluous, of wilfully nervous touch-and-go technique, a gaiety of rendering, a brightness of tint, bright yet sober, a simple unity of aim all of which attach this movement of Nature-painting (?) irremediably to the French *school*. A clarity of vision, perhaps in this case latent in the actual drawing, comes out in the delicate harmonies of tint, in straightforward candour

of brush-work. In spite of its *devise*, Impressionism was slightly artificial, perhaps as artificial in an opposed direction as the art it warred against, though artificial in a good and not in a meaningless way ; it was French ; it, too, was partly quintessentialized. Hazlitt might have found Impressionism, too, unnatural. Perhaps the truest, that is, the most natural, thing about it, more natural than even its colour, was its transcription of open-air values in place of the artificial bituminous shades of the studio-light convention it so splendidly replaced by flooding the gloom with plenitude of day.

.

By means of words one cannot hope to attain to precise transmission of ' plastic ' thoughts. The plastic arts exist because they are the natural and only way to transmit that species of thought from one human being to another. They necessarily deal in thought factors which are inexpressible in words. Consequently any explanation that one may attempt to give in words of the aims and qualities of drawing can be at best but an approximation, it can only serve as a hint or suggestion to the listener. If the listener take up a hostile position he will find it all too easy to make objections at every step. After all, situated as I am, I have only to salute an opposed dialectician, and return to my real business : that of making art, not of talking about it. All I am trying to do is to hand on to those who care to accept them, some of the results of long and careful study aided by a little personal gift of execution. Those who do not wish to benefit by these results, or who prefer to consider them worthless, are at perfect liberty to do so. I am open to learn from any one who shows me that I am wrong or that I am insufficiently informed, and that, on the particular point, his information is more complete, his comprehension more profound, than mine. That is a way by which knowledge is increased and perfected. But any one who contents himself simply with

contradicting statements, and who does not satisfactorily demonstrate adequate reasons for so doing, leaves me uninterested. I have generally found that opposition does one of two things : in general it opposes not what I have said, but what careless reading attributes to me. To that kind of opposition one replies by quoting the previous text. In the second case, not realizing that further knowledge might modify its opinion, hostility takes up a position that I have examined, perhaps occupied many years ago, and brings to the charge facts which in reality figure among those which I employ, but which I relegate to places of minor importance relatively to others which the objector does not take into account at all. As one has always much to learn, there remains a small residuum of valid objections from which one can really benefit. I say this because I feel how very easy it is for any one not receptive of the formal manner to misread, or to read as being without sense, what I have just written. He will say that I have not made my point clear ; my only reply is that to him it cannot be made clear, just as music cannot be appreciated by a tone-deaf person, or can only be appreciated in an erroneous and fragmentary way, say for its metrical effect. There is the form-blind eye—or should we rather say brain ? the point is subtle—as there is the tone-deaf ear. And by form-blind I do *not* mean shape-blind ; I mean an eye unreceptive of the rhythmic and expressive music of form ; not one simply capable of seeing whether a drawing is sufficiently exact, or even of directing its allied hand in the making of a correct drawing. In this question of the French plastic, or generally aesthetic ideal, I can only point out its existence, and give a few specimens of its manifestation ; then leave the rest of my argument to those susceptible of appreciating it. Let us, before quitting the subject, examine a few more examples.

· · · · · · · · ·

'La Dame à la Licorne' (Fig. 78), 'Le Bain Turc' (Fig. 3), the sheet of studies (Fig. 81) by Ingres, the study of a Torso (Fig. 74) by Degas, the portrait of Mlle Marcelle Lender (Fig. 80) by Toulouse-Lautrec, are all examples of French drawing. At first glance they may appear to be widely different, but closer examination will reveal certain common characteristics. One of the reasons why I chose the Degas drawing was that it showed, in spite of its imprecise technique, that *souci* of clean-cut form which is so essentially French. There is no difficulty in recognizing this quality both in the 'Bain Turc' and in the 'Dame à la Licorne', but perhaps we shall be obliged to compare the Degas with a drawing by a greater man, a sculptor withal, with a drawing by Michael-Angelo (Fig. 79) before we see fully the parentage of the Degas. The clear and simple suggestion of marble-like surface is in marked contrast with the robust and rough-cast texture of the Italian conception. Undoubtedly the Frenchman's outlook is more limited, the graceful fencing of his fancy is at a disadvantage when compared with the work of one of the very greatest of the elect; still the simple straightness of line conserves for us more of the purity of Grecian symbol than does the tormented power of the earlier Italian. How well in the Euphronios (Fig. 21) we can follow the ideal of the straight line! How slight would be the change in the drawing were every line of a truth strictly straight! The pellucid charm of simple statement hovers around the works of France; and though less general than the magnificent masterpieces of Greece, we cannot but admit their aesthetic worth, their charm. The Toulouse-Lautrec I have reproduced as evincing a slightly lower order of this charm, as affording a link between more powerful drawing and that in which the French excel, the light and *spirituel* work of lower grade. The original is again in the British Museum where it may be consulted easily by London dwellers. It is a lithograph

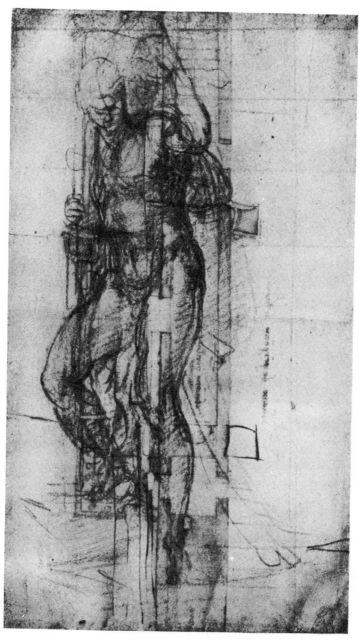

FIG. 79. DRAWING BY MICHAEL-ANGELO

Oxford University

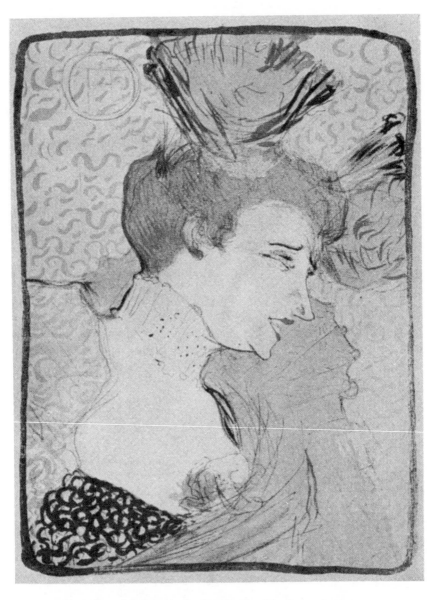

FIG. 80. Mademoiselle Lender by Toulouse-Lautrec
British Museum

and an example of what is by no means an easy method to manage ; it is a drawing in colour, by which I do not mean a coloured drawing, but a drawing in which lines of different colours are employed. I have made a considerable number of experiments myself in coloured contouring of mass with results that I find very difficult to reduce to any even approximately simple formula. In any case their discussion would rather belong to a treatise on the use of colour than to the present volume. In this matter the Toulouse-Lautrec, with which I was not acquainted till the end of last year, may be consulted with advantage. But I more especially chose it here with the intention of remarking on the mixture of sketchiness and precision adopted by the artist ; the sketchiness plays the part of a softening and enveloping addition to the rigour of the sharper lines. See, round the eye, how the lightly-sketched first tracings hint at a solidity of modelling. They are put forward in such an airy way that they interfere not at all with the graphic clarity of the three or four brush-marks which do just the absolutely needful work in determining the eyelids. Then an inferior craftsman would have insisted on the dark of the nostril. Not so Toulouse-Lautrec who abandons the instruction of Nature in favour of the necessities of decoration. The moment he uses the convention of sharp profile to nose or chin, convention may be accepted anywhere that it may be deemed needful to do so. The only deity to whom one must henceforward bow the knee, is that of plastic balance. The additional accent of the nostril was not wanted between those of the eye and mouth. We look at the face ; it is very simply treated as an almost unbroken expanse of white, which one feels to be cleverly modelled into relief by the quality of its contours. The relief makes it take precedence over the detail of the background drawn on a flat surface. The whole thing is a skilful bit of judicious pattern-making composed from the different values of face, hair,

background, dress, and so on. It would have been very easy to
convert such a design into a mere confusion over which the
eye would wander with divided interest. Note especially the
arrangement of the dark accents on the page ; their organiza-
tion corresponds to decorative and not to natural dictates.
The spirit that inspires the whole is intensely French in
sharp-cut *chic*.

In the sheet of studies by Ingres it is interesting to see the
first steps towards the immaculate marble perfection of the
back of the *baigneuse*. The line of the stooping man has
many qualities of clearness and decision, yet one cannot help
but feel that this final decision has been attained by degrees
of incertitude. The far leg is uncertain in its volumes, it is
even quite flat in the thigh. We are not wholly sure of the
exact recession of any given point, as we are in the Michael-
Angelo (Fig. 79), though it is far less careful and finished
than the Ingres. I feel that Ingres has drawn ' by profile '
first, and has then ' modelled up ' the profile map that he
had made. He certainly ' modelled up ' with great success
in his finished work ; yet one wonders just how much of the
unavoidable feeling of slight dissatisfaction that one feels
before an Ingres may not be attributable to just this primal
missing of the plastic bases of his subject.

At the beginning of this book I have thought fit to place
the portrait of one great recent draughtsman by another, the
portrait of Puvis de Chavannes by Eugène Carrière ; the
more so that the original lithograph in question offers many
interesting points for discussion.

It is, I think, fairly evident that if we seek an artistic
forefather of Carrière we must fix upon Rembrandt. A slight
comparison between the work of the two men may be en-
lightening. Carrière is an artist whose exact aesthetic worth
it is not at all easy to estimate. Even if it were not possible

to see from his paintings and lithographs the very complete knowledge he possessed of the human form, I myself could vouch for his possession of it, as I worked for some time under his instruction. To this knowledge he added a very personal vision, allied to a sentiment of unusual intensity. I have for long wondered why one hesitates to accord to him a place among the very greatest of the earth. The only reason that I can finally adduce is that his technique is a little too obvious, a little too much of the nature of a mannerism ; in short, that the technique strikes us before we receive an un-analysed impression of the work as a coherent whole. And coherence is always the mark of greatness. Technique should be subservient to the aesthetic message. Carrière, like Rodin, was very myopic. Much of his seeming exaggeration of *flou*, of indistinctness, was natural to his defective vision, and was not *voulu*, was not an ' artistic ' pose. I have mentioned Rodin. I am inclined to think that, during the first decade of the twentieth century, Rodin, Carrière, and Degas divided between them the honours of profound knowledge of anatomi-cal construction allied to a sense of its proper aesthetic employment. They belonged all three to an elder school which still held tenaciously to the belief in a high degree of the imitative element in art. Of the three, Degas perhaps stretched forth the most friendly hand towards the more decorative arts of to-day. I speak figuratively, for before his death Carrière was of sufficient breadth of mind to accept and to encourage newer aims. It was my luck to be present on the occasion on which Carrière first came in contact with the work of Henri Matisse. The story is both instructive and amusing. May I be allowed to recount it ?

The method employed by Carrière in correcting his class was the only reasonable method. Each drawing was taken as the text of a sermon addressed to the entire class ; a defect in the drawing was publicly expatiated on ; the drawing

itself was generally forgotten as the discourse proceeded. And
why should it not have been ? The lecture was not about what
the drawing contained, but about the facts that the student
had *not* observed. When once the drawing had suggested to
Carrière what it was needful to say, its part was played, it
disappeared from the scene. Never have I seen Carrière
' correct ' a student's drawing in the approved fashion, mak-
ing an arm a little longer, redrawing that side line of the trunk
a little nearer to what may be its right place. An under-
standing vision of the model was the incessant refrain of his
discourses. Once indeed—I have reported the fact elsewhere
—he redrew an arm that I had insufficiently ' understood '.
I was drawing in charcoal. He looked at the model and first
drew in the bones as they appeared to his instructed mental
vision, in spite of the clothing flesh. Over these bones
he placed the muscles ; then, laying down the charcoal, he
passed his thumb over the anatomical design, saying as he
did so : ' And then the light follows all the higher parts of
the modelling in this way.' The muscle and bone detail was
effaced and there only remained that interlacing arabesque
of shadow and of supple serpentine light which we associate
with his name. It was a lesson in true simplification, in the
simplification which is full of, and so suggestive of, underlying
knowledge. This occurred in 1900. At about the same time
Henri Matisse decided to come and work at Carrière's studio.
Matisse's easel was the last of the line counting from the door.
The canvas was so turned that Carrière was able to see from
a distance the amazing disproportions, the violent contrasts
of violet and green that Matisse (probably borrowing hints
from Van Gogh and still further extending the thesis away
from natural appearance) was then recklessly thrusting on his
canvas. Carrière himself hardly strayed from the perfect
reticence of brown or grey monochrome. As was his habit
Carrière had quitted the last easel but one, had left behind

Fig. 81. STUDY BY INGRES

him the student's inadequate simulacrum which provided the master with so few facts with which to instruct us, he was showing us on the nude model that here such and such a bone made its presence felt, that there certain tension of the skin must be remarked, that elsewhere a shaded form wound backwards till it became indistinguishable from an equal valued note of the background. The last few general terms of advice were given as he moved away towards the door. ' Pardon me, Monsieur Carrière,' interposed Matisse, ' but you have not corrected my study ! ' ' Haven't I ? I *beg* your pardon. Where is it ? ' pronounced a most obviously unhappy Carrière, for he was the most amiable of men. His question as to the whereabouts of the canvas was quite un-needed ; he had been for some time past casting uneasy glances in its direction. He placed himself before the aston-ishing medley of immense feet, and generally distorted representation of the pose in strong, and, at that time,[1] sombre strife of purple and carmine flesh-tones set off by viridian greens. ' Eh bien ! mon ami, n'est-ce pas ? '—Carrière was a nervous speaker and made great abuse of the palliative phrase n'est-ce pas—' each of us has his own way of seeing Nature, n'est-ce pas ? Your way of seeing Nature is not precisely the same as mine. Under the circumstances I really don't see how any remarks that I might have to make could be of any particular service to you, n'est-ce pas ? ' and with that he moved once more towards the door, took down his hat and went out.

At about the same period the ' Salon d'Automne ' was founded with the main idea of forming a Salon, other than ' Les Indépendants ', in which the apostles of the newer art could show. I myself was present at the meeting by which it was instituted. Now so broad-minded was Carrière that in a very few years, some two or three, I think, at most,

[1] Matisse greatly lightened and clarified his colour in after years.

perhaps even less, I forget at this distance of time, he became an ardent supporter of the new salon and its ways. Of course he did not change, at the end of his life—he died but a few years later—his own way of painting ; but he offered the unusual example of an artist so open-minded as even to encourage the worship of other gods than his own, and to realize that while art may be eternal the forms she assumes are many, varied, and forever new. He was true to his own statement to us that I have already quoted : 'I do not wish you to paint as I do ; my office is to point out certain facts upon the model which my experience teaches me must be found in any work of art. *How* you render these facts is your affair as an artist. But I must find them rendered in some way or another in your work.' . . . I make no excuse for repeating these valuable words. One can hardly repeat them often enough ; they are at the basis of plastic art ; they represent better than any others the very reason of the writing on which I am now engaged. But let us pass to an examination of an example of Carrière's own lithographic drawing.

.

I have chosen to reproduce a lithograph instead of either a drawing on paper or a painting, because better than either of the others a lithograph throws the particular technique of Carrière into evidence, throws into evidence both its strength and its weakness ; and so it serves for our instruction. Lithography as ordinarily practised may without hesitation be classed as drawing. One can imagine certain purists objecting to a Carrière lithograph being classed as drawing because it was executed almost entirely with a brush ; and in fact it is really nothing else but a monochrome painting. At any rate my view of drawing is not one which is limited by a classification based on the instruments employed. The first reproach I would make is that the wonderfully understood forms are slightly dissociated one from another ; not in their co-

ordination but in their lack of actual joining up of intermediate modelling. This defect is absent from his fully executed painting, as may be seen by a visit to the Luxembourg Museum. A more important adverse criticism I have already made : that the technical method is a little too obvious. Then in the case of the Puvis de Chavannes portrait I would reprove certain repeated equalities of light and a want of Rembrandtesque profundity of luminous shade in the rather opaque black of the background. Having said my hostile say, I will proceed to the eulogies. Notice the remarkable relief, almost at times over-exaggerated, of each particular shape. I cannot help regretting that Carrière did not imitate his friend Rodin and leave us a heritage of modelling in clay. Not, perhaps, that such work would have added much to the catalogue of the world's sculpture ; on the contrary, Carrière, being a born chiaroscurist was to my mind anti-sculptural. But modelling and sculpture are not the same. A Maillol or a Joseph Bernard is more of a sculptor than was Rodin, without having his power of vital expression. Perhaps one of the more important things to notice in the lithograph is precisely this want of sculptural sense in spite of the remarkable feeling of relief that impregnates the drawing. In Carrière's painting this lack is slightly less obvious, it of course springs in part from the almost negligible rupture of continuity between the surface reliefs, that I have already pointed out, but, in the main, it has a more deep-seated origin. Its cause lies in reality in Carrière's conception of the surface rhythm. His conception is of a rhythm composed of double curves of a serpentine nature ; such a conception is, I believe necessarily, of a romantic and non-sculptural, non-glyptic type. Take the high light of the nose : it starts, during the first eighth of an inch (I have before me at this moment the life-size original) of its progress nearly vertical ; it then, during three-quarters of an inch, deviates towards the

spectator's left ; the ensuing inch, which denotes the bridge of the nose, is again perpendicular ; and finally half an inch inclines again to the left over the tip of the nose. At least four directions are taken by one and the same brush-stroke, and moreover each of these segments is quite markedly curved. Doubtless this technique permits of much insistence on the suppleness of flesh ; it is a method of underlining the way in which the different details of the body interlace and hold together. At the same time it is too naturalistic to find a fitting application in that more abstract art, sculpture. It is a direct, rather than a suggested, transcription of the coherence of life ; and as such it is adapted to rendering a direct statement of emotion ; it is one with the intense emotion that arrests us before a canvas by Carrière. The artist's plastic emotion is awakened by an undulating sweep of form and he transfers that emotion unmodified to his picture, his brush is directly influenced by the impression he receives from Nature. It may be objected that I might have written the same thing about Manet, and yet the technique of Manet differs considerably from that of Carrière. The winding brush-marks of Carrière are absent from a Manet. Manet's brush-work is more direct, amounts to a placing on the canvas of an observed portion of colour well co-ordinated with its neighbour. Into this co-ordination naturally enters a certain necessary amount of rhythmic coherence of form with form ; without which painting cannot exist. But this formal coherence, in which Carrière specializes, and which he exaggerates into an almost morbid rhythm, is not the business of Manet. They both take directly from Nature ; but Manet is most occupied in gaining from her an emotion based on her coherent rhythm of colour, his drawing is but an accessory to the fact . . . by which I do not for a moment mean to say that he drew badly, I only mean that it is not as a draughtsman that he found his greatest expression. Carrière

eliminated almost entirely from his work the colour so dear to Manet, and insisted on, exaggerated, a particular side of natural rhythm of shape. For that reason it behoves us to discuss his work here, for he, so to say, puts under the microscope one particular quality of natural form and shows it intensified to us. This quality must always be found in all work, but according to the kind of aesthetic natural to the artist its presence is more or less accentuated, more or less discreetly latent.

At a certain moment Carrière had not a few imitators ; but one and all imitated the outward seeming of his method without bringing to the work the master's knowledge of natural form. Where precisely lay the difference between the imitation and the original ? It lay principally in an exaggeration of the morbid sweeping of line (an imitator invariably imitates and augments whatever tendency to defect the master may have) ; the recurrent curves were never, or were inadequately, brought up by a sudden stiffening where the form runs over some subcutaneous bone, or where a flesh-tension demanded a more male and rigid rendering. Our first impression of such a lithograph as the one here reproduced is that it is entirely made up of curved lines. That this is not so a slight inspection is sufficient to show. In the brush-mark along the nose the sudden determination of the highest light on the bridge where the bone is subcutaneous is at once noticeable. I have spoken of this brush-mark in the singular as it marks out one continuous succession of light. In reality it is composed of several superposed touches ; most evident in the original now before me, they will probably disappear from the reduced reproduction. It is a pity. For it is in such refinements that a master largely shows his hand ; and although the obvious presence may disappear from a reproduction, yet a half-effaced something still remains, unseizable, yet aiding towards the impression that

we have that the original was of worth. Amongst other qualities which I notice in the composite brush-stroke is the way in which its particular element on the bridge comes downwards and seems to clasp the thinner form immediately above the nose-tip just as the forms of the Rembrandt nude successively clasped one another. Again I repeat that this realization of the clasping of one natural form by another seems to be one of the last things realized in drawing ; its sentiment is invariably lacking from inferior work and from that of beginners. Careful examination will show that Carrière has keenly felt its existence in every case ; indeed it is really the basis and justification of his technique, though this was precisely what his imitators failed to see ; they contented themselves with a serpentine handling of the brush on— instead of into—the canvas.

What must be understood before all is that the seeming excessive suppleness of his rendering is really based upon a thorough comprehension first of volume then of plane. Notice how strongly marked is the distinction between the sides and the front of the face ; how from the zygomatic process or cheek-bone the side of the face falls away vertically and in proper foreshortening (see Fig. 97). Notice again how flat the front of the forehead is in spite of the four high lights upon it ; and then at what a faint but definitely marked angle the lateral planes recede from the temples. The better way to appreciate the knowledge displayed in this lithograph will be for the student to refer to it again, when, later on, I treat in more detail the anatomical construction of the head.

Before ending the chapter let me, however, make quite clear my main reason for choosing this portrait as frontispiece. It is difficult to be more fully acquainted with the form both in its anatomical and constructional aesthetic aspects than Carrière was. Had he chosen some highly finished technique such as that of Ingres or Le Poussin, we

should have to assume the existence of this knowledge by a process of reasoning ; we should be obliged to say : The thing would not be so perfect if he had not known so much. Then there steps in another difficulty : a highly-finished technique is to the untrained eye very like the meretriciously smoothed-down surface of the more or less ignorant executor ; to judge accurately in such cases of the absence or presence of expressed knowledge one really has to possess almost as much oneself. This is, of course, the main reason of the errors of judgement that persons only furnished with aesthetic sensitiveness, and not furnished with completed executing power themselves, so often make. Carrière, however, especially in his lithographs, which retain more of the unfinished nature of the sketch than do his oil paintings, has not hidden this knowledge. While thoroughly understanding the shape of each bone or muscle form, he has allowed just so much dislocation between it and the adjacent form to subsist as permits us to estimate his conception of the shape ; he has not so filled in the intervals as to render the result as difficult of analysis as would be the model itself. At the same time this slight dislocation is only used *between* the supple rhythms he employs, at right angles to them. These rhythms are indeed what one might term an artificial exaggeration of the natural rhythm, that is in the direction of continuity—for it is evident that the absolute separation of forms that we meet with in Greek vase work or in the back study by Leonardo (Fig. 72) is just as much a kind of rhythm, of a staccato type, as is the present continuous rhythm. He thus offers us an example, on the one hand, of very complete knowledge, and, on the other, of a very visible way of putting that knowledge into practice. We also see perhaps more clearly in his work than in any other the exact point at which technical method and knowledge of Nature touch one another ; we see just how much of natural coherence is left aside in the interests of

personal technique in one place, and in another just how far natural undulatory rhythm has been magnified. That his work is so easy of analysis, at least in part, is the reproach that one would make to him as an artist ; though it must not be forgotten that we are here leaving almost completely aside the question of the nature and degree of excellence of his emotion, and of his transcription of character in his portraits. These points I forbear to elaborate, for the appreciation of them does not require technical knowledge.

Recapitulation

The hand descends naturally, hence most draughtsmen commence at the top of the drawing. This is by no means necessary. It is advisable in the case of extreme foreshortening to begin with the nearest masses first, and to throw the others into recession behind the nearest. It should be remembered that drawing is never free from foreshortening. Even in drawing a model standing upright and facing you, such parts of the model as the sides of the chest are necessarily foreshortened. Bad draughtsmen always forget this important truth. Leonardo da Vinci insists on the necessity of having a full conception of the round before attempting to draw it. The superficial modelling should be of such a kind that there is a rhythmic connexion between the lowest points of all the hollows between the bosses. An artist such as Michael-Angelo will accentuate anatomical construction ; others, such as Puvis de Chavannes or Degas will, on the contrary, simplify, and show only a part of the anatomical knowledge that their other work proves them to possess. Even in the sketchy study by Degas reproduced in Fig. 74, the essential facts of bony and other construction are noted. This is one of the main differences between the slight study of a master and a very similar sketch by an inferior man. I chose the drawing by Degas without examining it closely. Its worth struck me at once. We now examine why I was struck by its worth. A comparison is made between the Degas drawing and the Leonardo (Fig. 72). The need of carefully terminating lines so as to induce the thought to continue the undrawn form in the right direction is stated, and the indication of the different volumes by their limiting lines is pointed out. The decorative value of the various factors of the drawing is considered, and the reasons of their relative strength or weakness indicated. Artistic manifestations may be very roughly divided into two groups—the Formal and the Informal or Emotional (see *Relation in Art*). The want of form and restraint in Victor Hugo's poetry is discussed, and the nineteenth-century derogation from the French formal ideal is traced to the blind alley of Rodin's sculpture. Leonardo over-estimated the worth of the

then new invention, chiaroscuro. The more plastically valid line of Euphronios is compared with the slightly eloquent line of Rembrandt. The Greek mind was used to thinking in real, tangible masses, clearly limited. It never occurred to the Greeks to lose a part of the reality in mystery. The vision of effect that we have learnt—since the days of Leonardo—to accept, is deleterious to the true architectural spirit. Mural decoration should not ' hollow out ' the wall, should not destroy its surface. Puvis de Chavannes recalls the wall surface to us by certain skilful flattenings in the composition. But flattening must not be the thin aplastic result of plastic incompetence. Formal expression may be said to be a very restrained and particular use of the expressive medium itself, of the very way in which the thing is done, to give to the result an enhanced expressive value. Balance is the basis of all great art. Movement in art never attains to the same heights as repose. Hazlitt failed to understand the ideal of Molière. Molière dealt in types, hence in abstractions. Hazlitt complains that such abstractions are improbable characters. Necessarily ; for abstract art is not imitative. The names of the characters of Molière have entered into the national vocabulary; those of Shakespeare have not. Because the Shakespearean characters are not of universal application, they are individually complex and are not typical as those of Molière. We quote lines from Shakespeare, we quote characters from Molière. Though French Impressionism claimed to be a return to Nature it was really only a new convention. The clean-cut quality of French art is compared with the more complex and even confused thought manifested in Italian art. Toulouse-Lautrec is cited as an example of drawing intermediate between the greater French work and that which is the particular forte of the modern nation—*chic* illustration work. The clever suggestion of modelling in the Toulouse-Lautrec is pointed out. Ingres attains to an admittedly higher level ; though we are not always sure that he immediately conceived his third dimension.

The frontispiece by Eugène Carrière is now examined. He is recognized as a descendant of Rembrandt. Rodin, Carrière, and Degas were probably those who possessed the greatest knowledge of anatomical construction during the first decade of this century. Carrière's acceptation of more modern things is noted. His method of ' correcting ' in class is described ; it consisted of a series of general discourses which took as starting-point some student's error or omission. Though Carrière might have been a great modeller, he would not have been a great sculptor. The nature of the special rhythm that he adopted is discussed, and its fitness to the representation of the suppleness of flesh is brought forward. This rhythm is a direct transcription of the plastic emotion he felt before the model. Manet, on the contrary, was more sensitive to colour rhythm. Delicate modifications of the sweeping rhythms are noticed ; they lend a measure, a reticence, to a technique that would otherwise be too special. But the supple representation is really based on understanding of volumes and planes. This lithograph has been chosen as affording an easily visible distinction between knowledge of Nature and its application in an aesthetic way. His technique may be slightly too evident. The emotional value of his work is not discussed.

IX

CONSTRUCTION OF THE HUMAN FRAME

THE main objection, it will be remembered, that I have to make to the diverse and excellent artistic anatomies which already exist is that they do not permit the student to judge readily the relative importance of the undoubtedly exact facts to be found in them. I might in the present case obviate this difficulty by classing the different facts and exhibiting them in type of different sizes, or by some analogous editorial artifice. But is it worth my while to re-edit during some hundreds of pages what has been already said by my predecessors ? I think not. What a capable figure-draughtsman really retains in his memory is a general knowledge of the more important constructional facts of the body, allied to what one must term an intimate familiarity with its ways ; a familiarity which can neither be written down, nor acquired from the printed word. Such familiarity can only be the child of incessant and long continued contact. Art is an exquisite balance instituted between many factors. In so much as it is an expression of its epoch, and in so much as this epoch is one to which science largely contributes, art cannot be divorced from science. On the other hand, to overburden plastic art with mechanical and anatomical elements is as grievous, or rather a more grievous error than to divorce it entirely from the natural and probable. On this delicate point no laws can be laid down. Each artist must be to himself his own salvation or his own damnation ; the verdict will be pronounced when he and his work have fallen backward into the calm spaces of past history. Familiarity with the human body, I mean with its aspect and not so

much the familiarity with its internal mechanism that is the property of the surgeon, brings with it that unstatable intuitive sense of rightness or wrongness, that sense of the plausibility of shapes which, in its constructive form, is really at the base of the act of draughtsmanship, whether from the model or from *chic*—'out of one's head'. In its critical form only this sense of fitness and of plausibility is possessed by most people. But it remains only in its critical form; it does not become productive. Indeed, when we think of it, the subconscious memory of shapes is extraordinarily developed, not only in persons but also in animals. Between two human faces the differences can be in reality very slight, yet every one is capable by an act of memory (which after all is a plastic souvenir) of deciding to which of the two people he or she is speaking. If one be inclined to suppose—and there would seem to be an element of truth in the supposition —that the human mind more naturally registers details than generalities, one is confronted with the fact that people recognize others at such considerable distances that detail disappears entirely and only general impression remains. One is then obliged to think that it is not so much memory of shapes that distinguishes the artist from the ordinary person, as the power or habit of classifying his impressions, whether consciously or unconsciously, and consequently of being able to draw upon them for productive purposes. The impressions of the ordinary person may be supposed to lie in a kind of latent confusion. Renewed contact with either the model or its simulacrum enables a certain critical advantage to be drawn from them, but before nothing, before emptiness, these unclassified impressions remain unproductive. The known face is recognized or it is realized that a drawing is incorrect, because the face or the drawing affords the real fact on which the critical (but unproductive) power can exercise itself. I myself have but a poor memory for persons, though, of course, my general

plastic memory is fairly well developed, if only from practice ; not however as well as it might be. Though the classification of the relative importance of facts be not so fully carried out in the case of the artist who has no turn for methodical thought as it may be in the case of an artist who has carefully examined his ways of working, yet I am inclined to think that, in the former of the two examples, the classification is fairly complete in reality—though subconsciously so, hence the artist may himself verbally deny its existence. The fact that in his mind the ideas do not arrange themselves in a literary order, or, in other words, do not present themselves to him in a temporal sequence, is no reason why he should not be deeply imbued with a sense of their relations of importance as quite distinct from temporal and spatial associations. In fact, after all, if I classify in writing this book, what has really happened is that I am passing in review and ordering impressions that preside at the rapid execution of one of my own drawings, which execution precedes the examination, and so is obviously not dependent on it. This is, of course, not the whole truth ; some facts that I put forward here have first been, at least in part, learnt as facts statable in words. I have used them in my work, and I now pass them on in much the same condition as that in which they were handed to me. It is especially this series of facts which it is necessary to reduce to a manageable scheme if we wish to present them verbally to another person. Every artist should be capable of finding them out for himself by a combination of intuition and reasoning based on observation. However, much time can be saved for the beginner if he have put before him an already established system. I much regret years wasted through lack of properly based and exact instruction. I think I can safely say that the only verbal instruction to which I am to any serious degree indebted is the comparatively small amount which I owe to Eugène Carrière. Almost

all the rest of the matter included in these pages is the result of prolonged studying of masterpieces, of laborious coordination, of reflection before the living model, of anatomical study, of varied technical experiment with a view to finding out the result of eliminating or of exaggerating such and such an element. I have no hesitation in saying that the greater part of so-called art instruction is worse than useless ; it engages the student in an evil way. The trouble is that it is not even sufficient to be a marked personality in the history of art in order to be a good instructor. I have taken certain ideas concerning drawing from Van Gogh ; I have been myself considerably influenced by his work ; I have, in short, 'learnt' much from him. But can we accept, or rather, could we have accepted Van Gogh as a professor of drawing ? And in the same way Cézanne, who has had such an enormous influence on modern draughtsmanship, could we have counted on him for complete instruction in it ? Such an artist as, for example, Jean Dupas is deeply indebted to his precursor Cézanne ; but he is a student of the Beaux-Arts school, he has introduced into his work many things which I feel sure Cézanne would not have communicated to him. Bearing all these points in mind I have striven in these pages to put forward fundamental facts in as general a way as possible, in such a way as may allow the student to choose any aesthetic direction which he may feel himself justified in taking, or, I should say, in taking up the direction which is natural to him. To what extent have I succeeded ? I have often heard it said that a man is a good professor although he is not a good executing artist. I simply do not believe it. I have often listened to the instructive criticisms of lauded instructors, and have been amazed at the erroneous instruction given. It is generally tidily presented with conviction, and the student not possessing knowledge enough himself to judge the instruction correctly spreads praise of the instructor.

An inadequate artist is one who has not penetrated to the underlying significance of things. All great art is firmly and simply based. He who has never perceived the foundations cannot describe them to us. When once he has perceived them he is already far on the road to great artistry himself. It is evident that perception and execution are not quite interchangeable terms, though I am inclined to think that they are much more closely allied than many unsuccessful executants would fain have us believe. An unsuccessful sketch is always a failure because we have failed to grasp the essential facts of the scene or of the movement of the model. And in spite of the difficulty, of the impossibility of communicating plastic ideas by means of words, it is yet remarkable how much of a sketch *can* be explained verbally ; or, to put it otherwise, how much of it is really the result of judgement in terms of ordinary thought concerning relative importance.

.

Some lines back I said that I might have adopted the method of different-sized type to indicate difference of importance in the relative value of constructional and anatomical facts of the human body, but I decided not to overburden these pages with a re-edition of detailed facts which may be found in any good artistic anatomy. I am therefore limiting myself to the exposition of the most important facts *alone*, and will leave the others to be gathered either from other books or, better still, from a self-disciplined observation of the model detail by detail ; an observation continually aided by self-examination, by asking oneself some such questions as : What is the exact shape of the fold which limits the palm of the hand at its junction with the forearm ? Is the webbing between the fingers placed at right angles to the general direction taken by the first finger-joint, or not ? If not, what is the approximate angle at which it is placed ?

These and ten thousand other facts are more or less sub-consciously stored up in the artist's memory and are used or discarded according to the aesthetic needs of the moment. For one of the most important artistic faculties is that of leaving out apropos. Such studies can be, as I have already mentioned, carried out both on one's own body and on that of the model. Though no absolute line can be drawn dividing these lesser facts from the more important ones, I will try to limit my descriptions, as well as I can, to the latter group.

.

We have already (p. 153 et seqq. and on p. 77 etc.) con-sidered the construction of the pelvis ; we have recognized the importance in the general constructional system of the relative rigidity of the seven points constituted by the three of the sacral triangle and the four of the anterior superior iliac spines and the spines of the pubis. It is superfluous to repeat what has been said. Into this rigid mass of the pelvis are hinged the two femurs. The rounded head of the femur (or thigh-bone) is engaged in the hemispherical hollow of the acetabulum, thus forming a ball-and-socket joint. This arrangement is important and must be carefully studied. First there is a ' neck ' to the thigh-bone ; this neck is more or less horizontal, and becomes more so with increasing age. The drop of the neck towards the horizontal position is one of the causes of the reduced height of aged persons. It is also one of the prettiest examples of natural mechanics, for the internal structure of the bone varies through life so as best to resist the changed direction of the thrust. The neck is short in children, longer in the adult, but shortens anew in the aged. The ball-and-socket joint allows of a certain degree of universal movement, movement which is limited by the muscle and ligament insertions. The rotation of the leg round its own axis takes place largely in the acetabulum, entirely when the knee-joint is straightened out ; when the

knee is flexed a little horizontal movement is possible between the head of the tibia and the condyles of the femur. The pelvis in woman being larger than in man, the femurs slope together more in the female than in the man.

In carrying out sculpture, the head of the trochanter being nearly subcutaneous affords us an admirable point for determining a leg measurement ; for if measuring is to be avoided in studying, it is often advisable, and sometimes even quite necessary, to use it in executing final work, especially when the work is too large to be embraced at one glance or when it is impossible to withdraw far enough from the figure to obtain a fairly normal elevational view of it. Evidently the length of the thigh-bone from the condyles of the knee to the trochanter is a constant length whatever pose be taken by the model. Such constants are of great use in practical work. The head of the trochanter should be felt for, and the measurement taken to the interval between the tibia and the femur if the leg is straight, or to the front of the knee (abstraction made of the knee-cap) when the leg is bent. From there onwards to the outer ankle is another fixed length, that of

FIG. 82. Diagram of leg and thigh construction

the fibula, the head of which may be found lying against the tibia head.

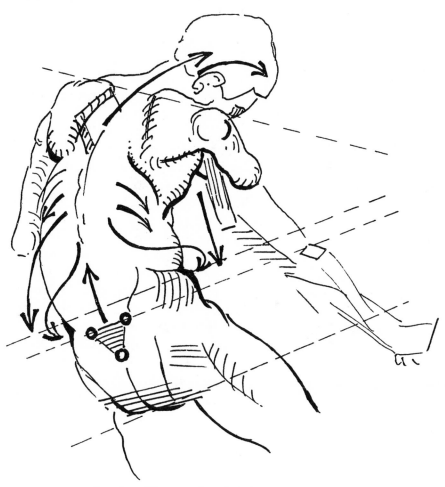

Fig. 83. Diagram of trunk and arm construction.

Perhaps Figs. 82 and 83, taken in conjunction with Figs. 58, 59, 60, and 61, will be more useful than many words in demonstrating the main facts that I carry in my mind as

typical of the construction of the human frame. The arrows indicate the directions, the rhythmical inclinations of which, one against another, I always make a point of noting. Mentally, on this crude and universally applicable foundation, I graft the modifications of the particular case ; now the scheme is thinned down, at another moment it is rendered more lithe ; in a nervous male model the simple surfaces may be broken up by multiplicity of muscular form, in the female the planes are dissimulated beneath a gracious curving in subtle unison ; yet however they may be hidden, however little they may be evident to the untrained eye, these fundamental facts of construction are always there, must always be felt in some way or another in the artistic transcript. Not that it is necessary to include even all the facts shown in these summary schemes ; many of them may remain merely suggested. Yet I think I may safely say that no work in which they are distinctly violated will be found to attain to a considerable aesthetic value. ' The form is never round, its modelling always resolves itself into planes ; ' I forget who said this ; or rather it has been said, and with truth, many times. The subsequent modifications that one adds to the diagrammatic arrangements here depicted should themselves consist, if not of veritable planes, still of curves from which the idea of the plane is never absent. Thus, in Fig. 82, I have indicated the form of the gastrocnemius or calf muscle as a curved ovoid swelling ; however, while tracing it I was thinking of it as a semi-ovoid placed on an imaginary inclined plane underlying it, a plane inclined slightly forward. Thus the idea of a plane was never far from me while I traced the shape. But here, as everywhere else in art, written law cannot exist ; the only use of a law is in its suggestiveness, even in the suggestiveness of the moment at which it becomes needful and excellent to break it. The sweeping line ABC should be noticed as forming the rhythmic union between

the different groups of mass. In reality it represents the edge of an imaginary thin curved surface, superficial on the front of the thigh, lying behind the tibialis anticus mass of the shin, and even passing through the thickness of the tibia itself. This curved surface has no anatomical being ; it is a kind of rhythmic abstraction, a rhythmic law which governs the mass arrangement. Obviously when the knee or the hip-joint is bent, the curve takes on another shape, which may be easily imagined. The necessary things are to point out the existence of such a curve and the need for seeking similar curves of union throughout the whole body. The draughtsman incapable of applying such a doctrine to each particular case is devoid of the essential sense of rhythmic cohesion without which he can never become an artist. I must, however, call special attention to a point already mentioned, namely that such a curve is neither necessarily superficial nor is it necessarily profound, placed inside the body. As we draw by conception of mass-placing in space, and not only by representation of lines or of surfaces, so our governing principles either pass through or over the masses that they order. The rhythm of natural things is of a very complex kind, and cannot be treated as a single type of rhythm bearing a simple, clearly definable, relation to the mass. The sense of such rhythms replaces the need of plumb-line observations and of measurements. The point c must be found in such a place with regard to the points a and b as is demanded by the satisfactory completion of the rhythm already commenced ; this rhythm must be of a kind analogous to all the other rhythms constituting the work of art. It is indeed nothing else than the expression of the artist's mind or message ; it is in the slight modifications of the rhythmic scheme, in the modification of the relations of the different elements of a work of art one to another, that the expression of the artist's personality lies. Pheidias will tend towards a

straightness of rhythmic relation, Michael-Angelo towards a more or less complex curve in his rhythm. Just as the surface ABC continually cuts the surface of the finished drawing, sometimes lying within it, sometimes without, so the planes into which the figure is arbitrarily split, and which figure in the diagrams, repeatedly intersect the real surface of the figure. Thus the projecting angle at the lower part of the buttocks (Fig. 82) would have to be chamfered off, while just above additional volume would have to be superposed on the plane when we come to consider the rhythm of the final surface itself. The dotted line indicates schematically what I mean. Though the surface corresponding to the dotted line is finally quite different from the two planes which it has replaced, it must inherently possess their potentiality ; it must, so to say, start from them, be based upon their conception.

Is it needful to point out all the facts expressed in Fig. 82 ? The projection backwards of the heel, the conjugation of the profiles at c and d which sweep forward in a pre-established harmony that is balanced by precisely the backward thrust of the heel, such facts of equilibrium of mass have already been treated on pp. 144 et seqq. ; to call repeated attention to the existence of such equilibria all over the body would be an endless task. The body is nothing but an indefinite series of such balancings, grading downwards in importance from the great leg-curve we have just been studying, to formal equilibria established among the creases in the skin over the extended knuckles, and even lower to ultimate microscopic degrees. It is the unique business of the artist to seek out such rhythmic equilibria and to turn them to an expressive use once a choice of them has been made.

.

It will of course be noticed that the great planes and masses have but little relation to the anatomical facts. Of this

point I spoke on the opening page of this volume. And it is this lumping together of anatomical facts that is so rarely put forward for the benefit of the student. Thus I have represented as a single plane the whole of the side of the thigh without thereby producing a too shocking or unnatural result. Yet many, very many, anatomical facts join together to make up this singly-conceived plane. First the iliac crest ; then the subcutaneous trochanter plays its part, aided by the group of muscles which converge around it and are attached to it. Then we find the tendon of the tensor fasciae femoris flattening the side of the thigh in the erect position of the model. Half the biceps cruris plays its part in forming the plane we are considering, while the other half accounts for its part of the back of the thigh. Here we see the same muscle split up between two separate constructional facts : the side plane of the thigh and the back plane of the thigh. A little farther down our plane is formed almost entirely by the side of the condyles of the femur and the side of the head of the fibula. But if you look at the usual plate of an artistic anatomy, you will quite fail to detect the existence of this plane. In the plate descriptive of the muscles the bony factors are unperceivable, in the plates devoted to the study of the bones the muscles are lacking, so no indication is given to the student of the existence of this very important constructional fact, *which is necessarily to a certain extent unanatomical*, because (if for no other reason) we have divided the anatomical entity of the biceps cruris into two parts, giving one part of it to the lateral and one to the dorsal constructional plane. It is really of very little use to the artist to know the whole isolated shape of the biceps cruris—or indeed of almost any muscle. It is really quite a piece of useless knowledge for him to know that one of its double heads is attached deep within the pelvic mass to the ischial tuberosity, while the other starts from the linea aspera of the femur.

What is of consequence to know is, first, that it is a powerful flexor of the thigh ; secondly that, stretching from the pelvis to the fibula head, it performs the important office—with other muscles—of solidly joining up the three bony elements of pelvis, thigh, and lower leg. This is a principal fact in the mechanics of the human frame, though even whether the biceps be attached to the head of the fibula or, like the semi-tendinosus, its neighbour, it be attached to the tibia head really does not matter much to us. Here an anatomist will probably hold up his hands in horror. Let me point out that no amount of acquired anatomical knowledge will ever enable you to dispense with the model if you aim at anything beyond a stylization of Nature, I mean if your aim is in any way to produce a plausible portrait of Nature. If you are coming down to such detailed study as that which we see in the 'St. Jean' of Rodin, in which—without verifying my statement —I am sure that the fact of the attaching of the biceps cruris to the fibula head is shown ; if you are coming down to such a degree of accurate transcription of Nature, you must resign yourself to long-drawn-out work from the living model. Then once you have mastered the shapes and general type of the natural forms, and have learnt how among them they weave the beautiful balance of the form, I will even go so far as to say that I am not at all sure if it is necessary to know that the slightly visible tendon starting up from the fibula head becomes the biceps cruris which in time divides and is fixed in the way just indicated. If you are an artist your intuitive sense of the need of balance of form will, aided by your trained powers of observation on the living model, probably enable you to draw or model that fragment of subcutaneous tendon in such a way as will satisfy the most rigorous anatomist, although your knowledge of the muscle may be insufficient to enable you to reply to an examination paper on anatomy.

Now in all this I am not encouraging idleness or reduced study ; I am really only pointing out the danger of mistaking one kind of knowledge for another. On the contrary, an excellent acquaintance with the surgical side of bony and muscular anatomy can be acquired at the cost of a few months' hard work. The way of art is longer and more arduous. I can imagine a student who has arrived at a rough knowledge of the shapes, positions, and insertions of all the muscles and a complete knowledge of their various names, being rendered strong by the praise of his professor of anatomy and so thinking that he has no further knowledge to conquer ; that he is fully equipped as a draughtsman of the nude . . . whereas he has in reality almost everything yet to learn. This is a very real danger. The possibility of possessing considerable anatomical knowledge and almost no knowledge of construction is shown by almost every student's ' anatomized drawing ' on which I have ever set eyes.

.

With a view to making this point quite clear I intended to reproduce two plates from a well-known art student's anatomy ; one a photograph of the back view of a nude model, the other an anatomical diagram made from the photograph. It has been explained to me that the advancement of artistic learning must be subordinated to several other interests such as personal vanity, the sale of books to students, and so on. This is a great pity, for the pointing out of error is one of the best ways to instruct. In lieu of convincing reproduction, I may yet describe one or two of the ways in which such a diagram misleads the student ; though simple description will unfortunately be of less help to him than the visible testimony of the plates.

When I consider the important region of the iliac crest, I notice in the diagram that, although the photograph represents with unusual clearness the rectangular shape (see

Figs. 49, 72, 83A, 111) of the composite mass of the obliques, the author of the diagram completely obscures this fact by bringing down the lower parts of the latissimus dorsi over the upper part of the obliques. The diagram thus belies the appearance of the photograph which it is supposed to explain. More than this, the anatomization is not even correct. The anterior edge of the latissimus dorsi is the only part of the muscle which is of sufficient thickness to modify, in a practical way, the surface modelling. A considerable number of fasciculi ascend from the posterior superior iliac spine to form this anterior border of the muscle. The diagram now before me shows the whole muscle sweeping backwards to an aponeurotic junction with the erector spinae mass ! It is true that in the photograph it is impossible to trace the iliac crest insertion—after all, the posterior portion of the rectangle formed by the obliques and the transversalis is due to the first part of this branch of the latissimus dorsi, which forms the posterior edge of the rectangle. This is but one more example of several anatomical facts combining to make up one constructional fact.

Again, in the costal region of the diagram the latissimus dorsi is represented as a robust mass, under the rotund surface of which all trace of the ribs disappears, though in the photograph their modelling is strongly evident. Because the latissimus dorsi is a superficial muscle, and in the interests of law and order, but not in those of art, it must be shown, even though it dissimulate the shapes which really model the surface. This is the result of allowing professors of anatomy to meddle with artistic instruction. Oscar Wilde told us that : Those who can, do. Those who can't, teach. In every possible case in this book I am reproducing drawings by Michael-Angelo or by Leonardo.

The front view of a leg by Michael-Angelo has already

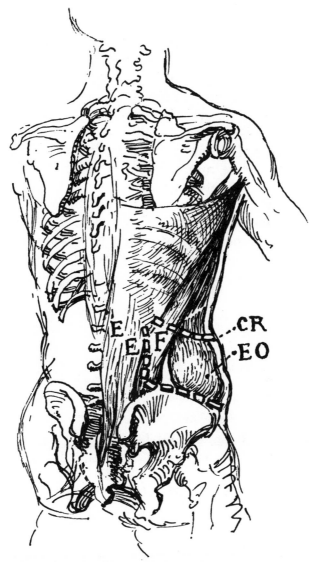

Fig. 83a. Showing constructional rectangular volume (CR) formed by the fasciculi of the latissimus dorsi—which ascend from the superior posterior iliac spine—in conjunction with the obliques and the transversalis (for clearness' sake the external oblique (EO) alone is shown). This volume is distinctly marked on all antique statues; its posterior border is marked by the erector spinae mass (EE).

been reproduced (Fig. 48, p. 151), and to a certain extent discussed. It would be as well though to call attention (Fig. 84) to the long continuity of form which, starting at the hip-bone, comes diagonally forward across the front of the thigh, passes down the inner side of the knee, comes forward again to descend along the inner surface of the shin-bone, caresses the inner ankle-bone, and finally disappears transversely under the sole of the foot towards the little toe. If we were modelling in clay we might follow up such a line with the thumb continuously without once quitting the surface of the work. Carrière did the same with his brush. Michael-Angelo contented himself with placing his masses in such a way as to render evident such co-ordination without insisting upon it. An artist like Maillol will render its existence slightly less evident perhaps, as he wishes to call our attention more especially to an architectural placing of masses. Fundamentally this placing must, however, be governed by the winding movement of the surfaces that limit the masses. If the placing be not so governed it will seem to be false and generally weak. It is precisely this interworking of mass with mass which gives the impression of coherence, of logical sequence, hence of mechanical aptitude, hence, again, of strength. Ungoverned fury does not give the impression of strength. Strength is the outcome of coherence. This is a point missed by most women artists, who generally mistake wild brushwork for strength. A flourish is weak ; it is but an imitation of decision. As a rule you will notice that the weaker the character of an individual is, the more will his signature be surrounded by pen flourishes. In spite of the freedom of execution in the pen-drawing in question (Fig. 48), it should be noticed that none of the lines is a flourished line. The slight trembling and indecision that we notice in, for example, the outer profile of the calf and lower leg show with what comparatively slow and complete intention the line

was drawn. Let us start down from the knee and analyse the work. Immediately below the fibula-head marking, and just inside it, a short line shows the start of the tibia shaft. Then the story is taken up by a line which enables us to place the tibialis anticus. But Michael-Angelo found that he was trending too far inwards for the general rhythm of the limb, so he stops short and takes up again with a fragment of line some sixty-fourth of an inch more to the outer side. The eye now, on looking at the drawing, imagines a rhythmic direction midway between the two, and continues, contented, to follow the subsequent organization. At this point Michael-Angelo harks back, leaves the essential line of bony construction, and, so to speak, hangs to it the projecting mass of the gastrocnemius (in reality the edge of the soleus probably, but the gastrocnemius or great calf muscle, from our point of view, dominates the situation). This projecting mass being a volume that one may isolate and surround, he instinctively feels himself tempted to surround it with an oval movement of the pen, remounting towards the two lines just mentioned. He, however, soon descends again with an uninterrupted motion of the pen and ' writes a statement ' concerning the lower part of the tibialis anticus muscle which again brings him too far over to the left ; so, this muscular volume once sufficiently suggested, he returns to the telling of the shape of the fibula profile, here

Fig. 84. Diagram of plane rhythm down front of leg.

only (or almost only) covered by tendons, though the peronei brevis and tertius have something to say in the matter. It is

just this something which is the cause of the swelling he has marked midway betwixt calf and ankle. Finally, just before the ankle itself the line indicates practically the shape of the fibula hardly influenced by overlying tendons, and then only in the upper part. At the ankle itself the bone becomes quite subcutaneous. What should be remarked is the extent to which one single tracing of the pen, the last that we have been considering, has, by turns, indicated now a bone-form, then a muscular mass, then a tendon profile; all these elements, considered anatomically, are different, and will probably be treated in different parts of a work on anatomy. Michael-Angelo unites them all in the aesthetic element of a single pen line. Not only that, but he makes a choice of which facts he shall represent and which he shall omit. This choice is governed by the exigencies of rhythmic arrangement, as I have twice shown in the above analysis, and might have pointed out a third time by remarking how the segment of our line just above the ankle continues in a perfect way the rhythm instituted just below the fibula head. Certainly the rhythm is based on anatomical facts, and all the anatomy is rhythmical. But as we cannot reproduce the whole complex rhythmic truth of the body, we are obliged to choose certain facts which, combined with others, will make up a coherent simplified and reduced scheme which shall be rhythmical in itself, within itself. This is what the artistic anatomies never tell us. This is what the study of such drawings as the present one does tell us. It is in studying such drawings deeply in the way I have just put forward that I have acquired what knowledge I have of aesthetic construction. I can only say to others : Go and do likewise ; conscientiously ' take this drawing to pieces ', study the meaning, the *raison d'être* of its every line ; trace back the reason of its position, of exactly where it is placed, to some other line in the drawing (as I traced the placing of the segment above the ankle back to the fibula-start just below the knee).

When you have been over the whole body in this way, with an artistic anatomy beside you, you will find yourself possessed already of a very considerable quantity of *aesthetic* knowledge of the constructional facts of the human frame. What you must avoid is to say : Ah ! That is a clever *way* of indicating the toes, I will go and do likewise. There is no ' way ' of doing these things. The ' way ' is invented at the moment of drawing as a representation of the observed organization of the masses . . . which is not at all the same thing. Yet almost all draughtsmen (see p. 168) make this profound error. The hierarchic method of drawing handed on from generation to generation in ancient Egypt or in China belongs to another category of aesthetic. We have no such hierarchy ; our aesthetic aim is different ; I am for the moment speaking to modern European students.

.

In a way the back of the leg and thigh may be looked on as the inverse of the trunk. From the shoulders downwards the most important structural factor is the arrangement of the spinal column.

We see again an example of the compensation system of the body, another manifestation of the eternal equilibrium. In the lower part of the leg, the tibia, being actually sub-cutaneous, gives the structural direction at once ; in the thigh the femur is less evident, yet its inward slope, greater in woman than in man, is still disclosed by the diagonality of the superior mass of the tensor fasciae femoris at one end, and the vastus internus at the other, combined with the actual intermediate shape of the rectus femoris. The sartorius serves to call attention to this diagonal feeling of the mass arrangement. At the back of the leg the principal facts belong to what one might term a secondary order ; they follow suit to a proper establishment of the facts of the front of the leg, though of course modelling should be carried out

as accurately here as elsewhere. In the trunk the case is the opposite ; the facts of the front follow as a corollary to those of the back. The joining up of the two systems, that of the back and that of the front, is elegantly effected by the forward-sloping forms of the external and internal obliques (and the transversalis) and by the special shapes of the gluteus medius and the tensor fasciae femoris, all of which gather round the forward-sloping iliac crest or haunch-bone. The accompanying sketch may aid in showing this, though for a full representation of the facts a clay model would really be necessary in order completely to trace the sequence of forms from back to front over the body. In short, it must be noticed how the forms in the region of the waist can be caressed round and forward and downward from the spinal column just above the sacral triangle over the obliques, and the iliac crest forward into the depression between the thigh and the stomach. This sweeping movement must be felt to exist, however rigidly we oppose geometrically styled mass to mass.

.

The arrangement of the masses at the back and sides of the thighs may be conveniently studied in the annexed Leonardo drawings (Figs. 86, 87, 88, and 89) which hardly need any explanation, unless it be to remark on the tense quality of the drawing showing the pull on the tendons, especially at the back of the knee. In order to render such quality one must feel it keenly ; almost move the pen or pencil over the paper with difficulty as if struggling against a real force. The effort should almost tire the draughtsman, so much must all his energy be concentrated on rendering another display of energy external to him. The way in which the biceps cruris mass descends to find that of the gastrocnemius is particularly clear (Fig. 86, right-hand drawing) ; and it should be noticed how the internal profile of the muscular mass becomes the

actual profile of the limb farther down, first in the tendon and then in the swelling of the calf muscle. To such an artist as Leonardo a profile did not mean the division between the model and the background ; it meant the limit of an aesthetic mass. In the back view of the thigh, one feels how the masses (Fig. 86 right side) of the limb which are in front of the biceps cruris mass swerve both forward and sideways beyond that muscle and into the depths of the paper. The anatomized legs (Figs. 87, 88, and 89) give a presentation of the solid shapes of the various muscles bereft of super-fluous anatomical detail ; they are placed on, or rather themselves constitute, the solidity of the limb. The anatomist's desire to indicate a thin tendon because it ought to be shown is absent, hence the draw-ings are less confusing to the art student, the various parts being pre-sented in about the relative impor-tance they are destined to assume in artistic work. Fig. 89 shows the sartorius in a special position.

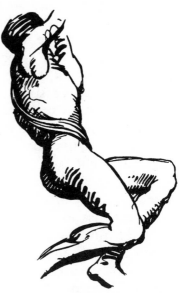

Fig. 85. Diagram of transition of main rhythm from back to front of body.

In the Michael-Angelo drawing (Fig. 48) certain facts concerning the construction of the foot and its conjunction with the leg are well shown. The way in which the inner mass follows on from the tibial or shin line is clearly marked ; the triangle, terminating in the four smaller toes, its apex being at the ankle-joint, serves mainly as a stabilizing system ; the greater part of the effort of holding up the body passes through the arched part of the ridge descending on the great

toe. Here again we meet with the fitting of the triangular or, more exactly, the pyramidal volume of the foot into the clasping form of the ends of the tibia and of the fibula, that is, between the two ankle-bones. The insertion of the foot between the ankle-bones is also clearly shown in Fig. 37, p. 124. The study may easily be caricatured into the accompanying constructional diagram, Fig. 90. It is very useful to notice that the three middle toes form one mass which points in the direction of their arrow ; that the great toe follows its own direction ; and that the rôle of the little toe is, so to speak, to counteract the outward tendency of the middle toes by a distinct inward and closing movement, which I have slightly exaggerated in the diagram in order to make it more evident. Here we notice that three distinct facts, three separate toes, may be included under the heading of a single constructional fact.

The mass of the knee slopes outward, in the descending direction, that of the ankle inward ; again we find the rule of compensation illustrated. These outward and inward slopings must be carefully observed ; it is in such places that much of the feeling of life and truth in a drawing is situated. Any artistic anatomy describes the shapes of the knee and the mechanism of the knee-cap and the patella ligament. I will not linger on such description, I will only note in passing the part that the knee plays in the downward winding mass coming just above it from the vastus internus and continuing just below it into the shin-bone. We must remember that when the knee is bent, the front of the knee is formed by the part of the condyles which is in contact with the head of the tibia and so hidden in the upright position. It is important to understand this fact in connexion with the mechanics of the knee-joint. When the knee is flexed the above arrangement of mass and surface conjugation naturally undergoes modification—modification but not annihilation. The

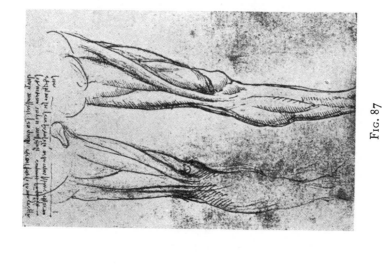

Fig. 87

Fig. 86

STUDIES OF LEGS BY LEONARDO DA VINCI

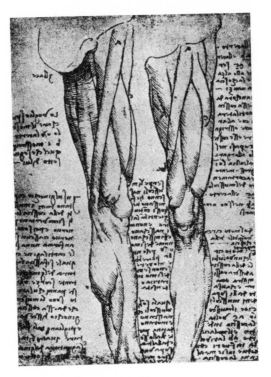

FIG. 88. Studies of legs

By Leonardo da Vinci

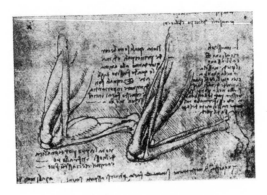

FIG. 89. Leg study, showing sartorius

By Leonardo da Vinci

student must examine for himself the nature of such modifi-
cations ; a letterpress description of three-dimensional changes
would be too cumbersome. The arrangements of the great
planes of the legs are well indicated under their sculptural
aspect by the shading in the pen studies by Michael-Angelo,
Fig. 91. The distinction between front and sides is particu-
larly marked. The special convention
of these studies makes the front of the
shins look behind their proper place.
As a matter of fact the darker edge of
the shading, between the shaded part
and the light, is approximately in its
right place ; but in order to complete
the front of the shins we should have to
build up on this underlying plane, which
is of the nature of those I mentioned on
p. 225, and which assures a firm plane
basis for the superposed modelling of the
shin-bone, tibialis anticus, and so on.
The plane of the knees in the same
way demonstrates the underlying plane
formed by the condyles of the femur
and the head of the tibia, without taking
into count the projection of the knee-

FIG. 90. Diagram of
construction of foot (see
Fig. 37).

cap. This affords quite a good example of the perhaps un-
conscious observation of subjacent planes. As I said before,
their study ensures architectural stability of modelling. In
these two drawings the way in which the stomach forms fit
down into the pelvis—here constructed in a very sculptural
way—is evident. The stomach, or more strictly the intestines,
should be looked on as a soft spherical mass held in the
cup of the pelvis. When modelling in clay, a good method,
and quite rational, is, after modelling fairly correctly and
placing the iliac crest points (see p. 150) quite correctly, to

scoop out the whole of the belly deliberately, then to estimate the size of a clay ball required to replace the intestine volume, and to place such a ball, for the moment hardly modifying its shape, into the scooped out cavity. Smaller pellets of clay can then be introduced into the free spaces. In that way a sense of the spherical mass lying in the pelvic cavity is readily obtained. The form of this spherical mass is easily felt in the right-hand drawing in Fig. 91 ; it lies clasped within the masses of the external oblique. In presence of these sculptural studies, and just after drawing attention to rhythmic sweeps of continuous form, it will be as well to repeat, at the risk of becoming tedious, that drawing consists in a continual balance between the supple sweep and the stable and clean-cut isolated plane which does not fade into the next plane by subtle gradations. According to the solution chosen, the artist is a Carrière or (shall we say ?) a Cézanne. Fig. 92 is just as sculpturally cut, the limits of the forms are just as clearly marked, yet the whole nude exhales a sense of extreme grace and evenly sustained rhythm. This rhythmic sense is obtained by exact juxtaposition of the volumes. Had Carrière been painting the figure he would have realized a similar suppleness by means of brush-marks actually carried on over the different forms. This drawing by Michael-Angelo shows balance of minor volumes among themselves in a more refined and delicate way than the drawing by Rembrandt that we analysed in Chapter VI. The architectural relations are here more completely and more elegantly determined. We see transpiring in the upper part the piercing X-ray-like intuition of the informed draughtsman. The girdle below the breasts traces a real horizontal circle in space. The volume of the upper chest and shoulders immediately above it seems moulded in transparent glass, so well do we seem to see into its thickness. See, too, how it is almost impossible not to believe that the deltoid

FIG. 91. Studies of legs and torsos by Michael-Angelo

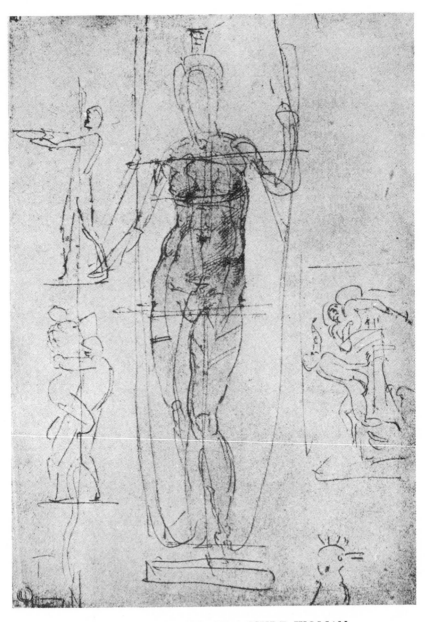

FIG. 92. DRAWING OF A NUDE WOMAN

By Michael-Angelo

masses are not really set back into the paper a considerable distance behind the breasts. How far we are from the flatness of the usual drawing ; and how well this fulfils Leonardo's desideratum : ' The primary object of painting is to show a body in relief. . . .'

While we are examining this part of the drawing we should do well to remark how the horizontal line (traced for I know not what reason) just marks about the limit of the top plane of the torso, a plane set forward at some forty-five degrees with the horizon. It gives the backward and upward trend of the clavicles, which, constructionally and for the moment, we may regard as accidents upon it. From this plane, and squarely set down on it, the neck springs upward in graceful curve, a curve which continues that of the backbone and so shows us once more, in the front of the figure, a reappearance of the great constructional rhythm that swept backwards from the thigh fronts over the haunches to unite in the single line of the spinal column. And on the neck the head is impeccably balanced.

.

Art is a system of varying forms of stating rhythmic relation. A model sets a pose. The pose is not bad, yet we feel irresistibly forced to push that foot a little farther back, to alter the arrangement of this hand. Why ? Because these particular minor volumes do not fall into one of those more or less simple rhythms which it is the province of art to treat. The fact that the model took up the pose that he or she did is in itself a natural phenomenon. As such it forms part of the tremendous rhythm of the universe. But into this rhythm come factors untreatable by art. The existence of such factors may be, *are*, expressed in plastic art, but in an indirect way ; they cannot furnish matter for us to employ directly in drawing, in painting, in carving. What then have we done in changing the positions of the model's foot and

hand ? We have made the placing of their volumes fall into line with the reduced rhythm of that particular little piece of the universe which we have isolated in the shape of our model, and from which we intend extracting a poetic rhythm expressive of universal things, or rather of our conception of them. Placed as they were, the foot and hand constituted verbal errors in our poem, errors in the scheme of prosody we had chosen. A drawing bereft of a single underlying scheme of rhythm is an unmusical poem ; it is a contradiction of itself, a useless thing. The rhythm of the present drawing is that specially indescribable sensation of graceful form, lithe yet stable, that we hold within our minds when the page is turned, when the drawing itself is no longer visible. Into this rhythm must fit all the parts. It is that sense of rhythm which lacks in the English cathedrals ; it is indistinguishable from the sense of the *ensemble* ; indeed the *ensemble* might be defined as the rhythmic relation of parts.

.

In this drawing the slight compression of the thorax on the left of the figure and the elongation on the right about which I spoke on p. 155 can be noted ; as may also be the clean setting of the breasts on the underlying curved form of the ribs and pectoral muscles. The axes of the breasts are at right angles to one another ; they are not directed straight forward as one is often inclined to think. In the female figure, the shoulder mass (see p. 155), which is 'let down' over the conical top of the thorax, includes the breasts ; in fact it is conveniently limited in this drawing by the girdle under them. The way in which the shoulder-masses are anatomically placed over the upper ribs is admirably evident in the two reproductions from Vesalius. This will be a good occasion to deal with these two remarkable anatomical plates.

.

It is more than probable that these plates are the work of

one of Titian's students. Whether this be so or not, we are
in the presence of the drawing of a capable artist, of an artist
determined to show us to the best of his ability the way in
which the human frame is built up. To this effort he brings
an unusually good vision in the third dimension. He gives
us an excellent idea of the solid shapes of the different parts,
and of their spatial relations to one another. Also the admix-
ture of bony and muscular anatomy is very nicely calculated
to show us the relative importance of each in each different
part of the body. The viscera are extracted, thus showing
us, in the front view, the cup of the pelvis which held them.
The four front constructional points, the anterior superior
iliac spines, which stand out into space, and the pubic spines
which are less clearly seen, at once show their importance.
It is perhaps to be regretted that the two Poupart's ligaments
have been eliminated ; they help to give a constructional
signification to the system by marking the furrow of the
groin, that is, in marking the natural limit between the mass
of the thigh and that of the trunk. The rectus femoris having
been removed and the volume of the internal and external
vasti left, their office of carrying the form round from the
front to the back of the body (see p. 287) is now very clearly
seen. Even the pose helps us to realize the way in which the
twisted fusiform mass runs up from the knee, turns round
the side of the pelvis, and continues its way up the muscular
masses of the erector spinae group along the backbone. The
projecting wings of the disengaged pelvis hardly interrupt—by
momentarily cutting across it—this following on of the form,
which is, however, much less evident from the back, where
the shapes tend to run up from the back of the knee and wrap
themselves round the inside of the thigh in an ascending spiral
fashion ; this spiral, as usual, decoratively balances the ex-
terior spiral just mentioned. Again I repeat, such balancings
are at the base of good drawing ; they must be unceasingly

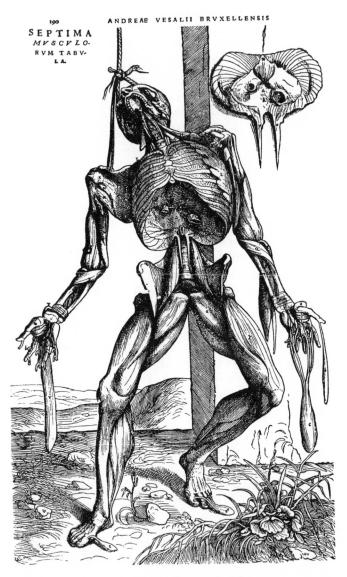

SEPTIMA
MVSCVLO-
RVM TABV-
LA.

ANDREAE VESALII BRVXELLENSIS

Fɪɢ. 93. Vesalius' anatomical figure.

NOTE: Between Fig. 93. (which immediately follows page 293) and Fig. 94. (which immediately precedes page 296) are inserted 28 additional plates from Vesalius of interest to the art student.

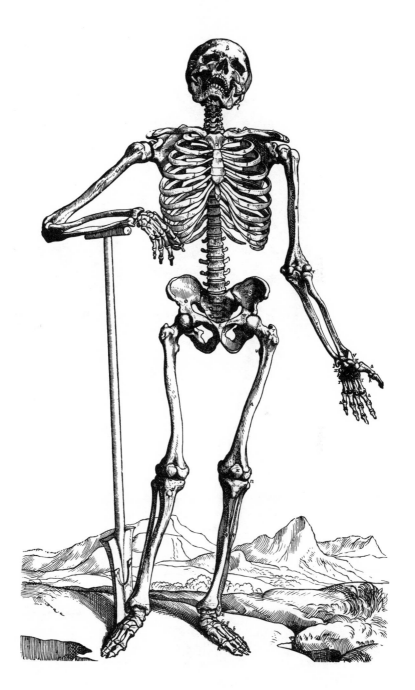

Vesalius' anatomical figure.

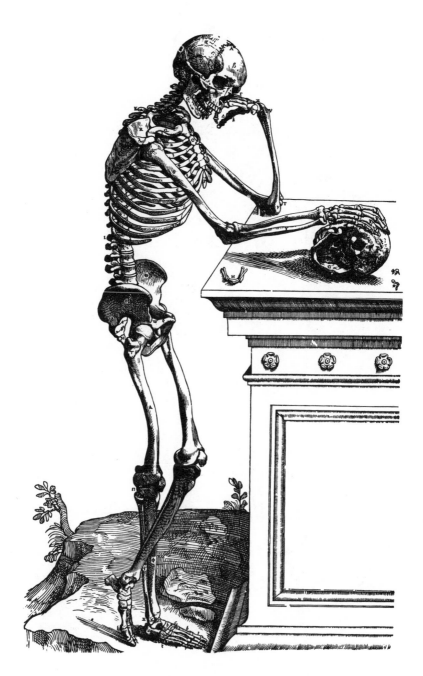

Vesalius' anatomical figure.

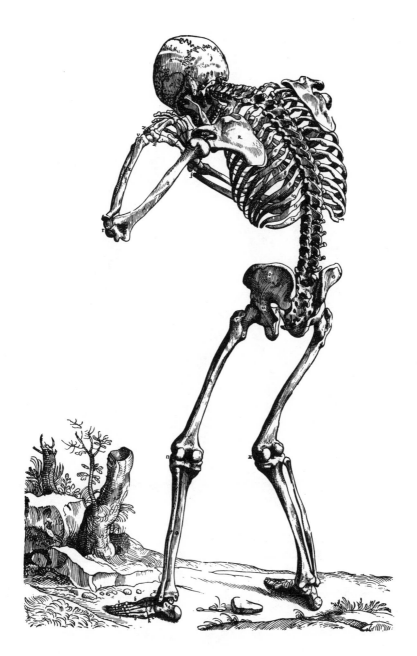

Vesalius' anatomical figure.

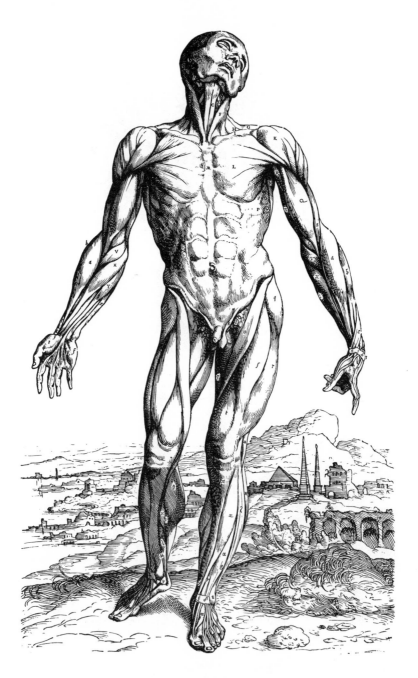

Vesalius' anatomical figure.

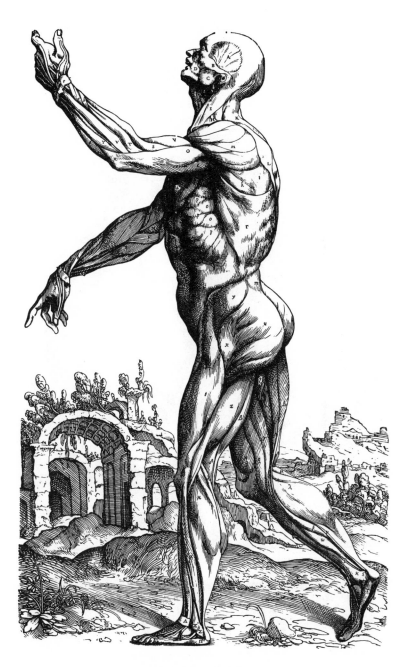

Vesalius' anatomical figure.

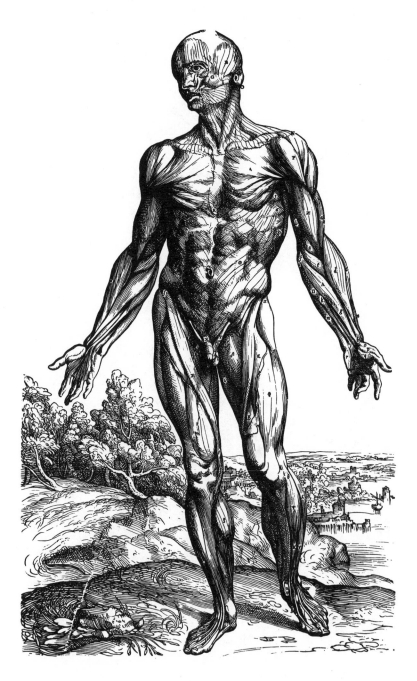

Vesalius' anatomical figure.

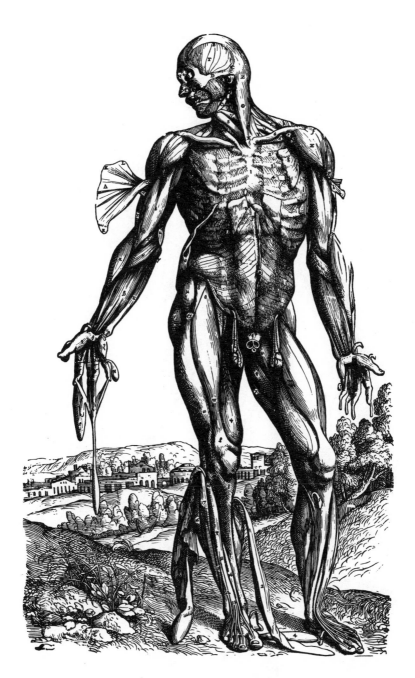

Vesalius' anatomical figure.

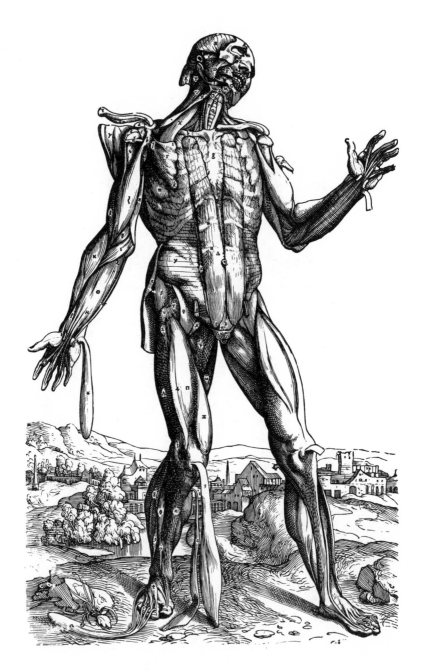

Vesalius' anatomical figure.

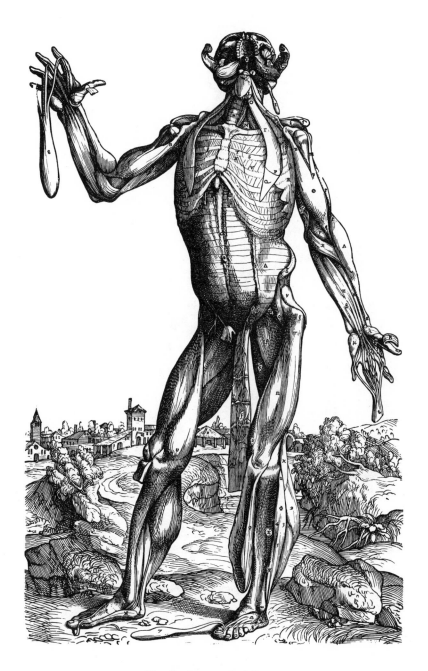

Vesalius' anatomical figure.

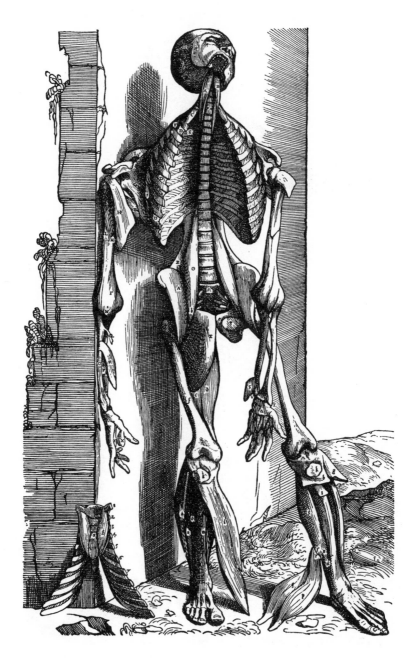

Vesalius' anatomical figure.

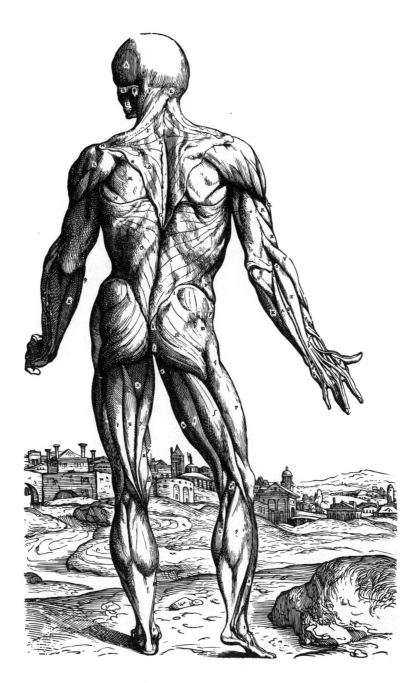

Vesalius' anatomical figure.

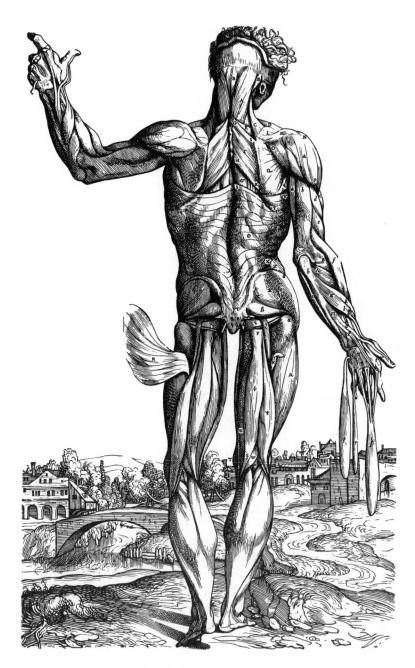

Vesalius' anatomical figure.

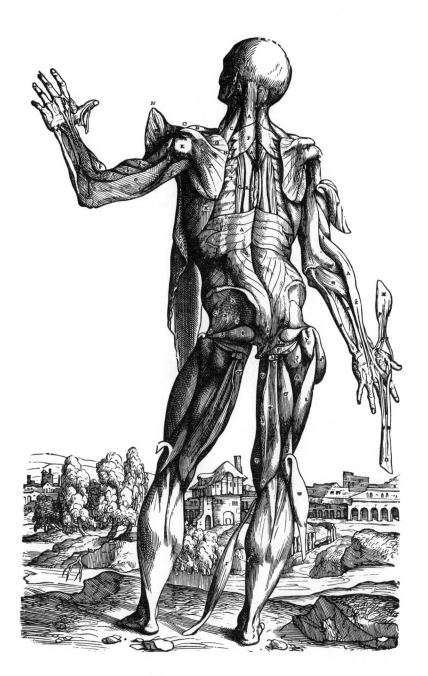

Vesalius' anatomical figure.

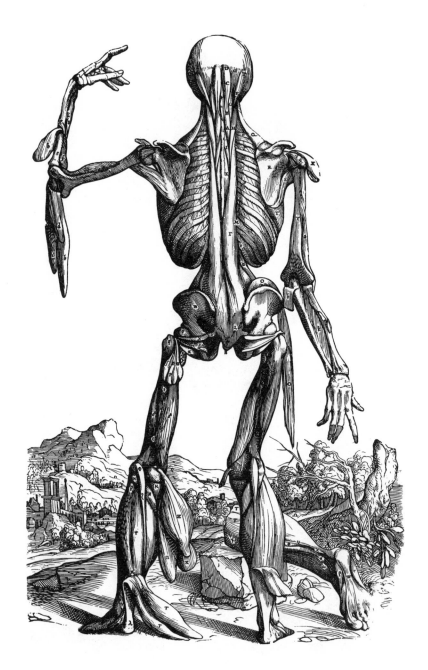

Vesalius' anatomical figure.

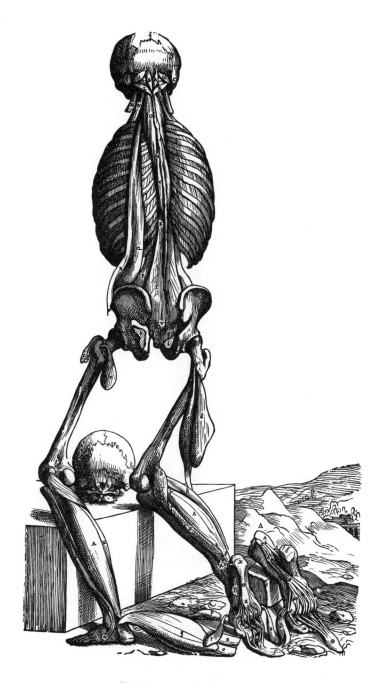

Vesalius' anatomical figure.

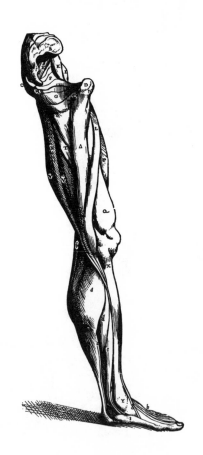

Vesalius' anatomical figure.

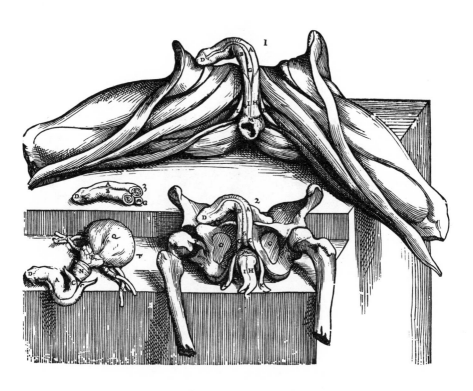

Vesalius' anatomical figure.

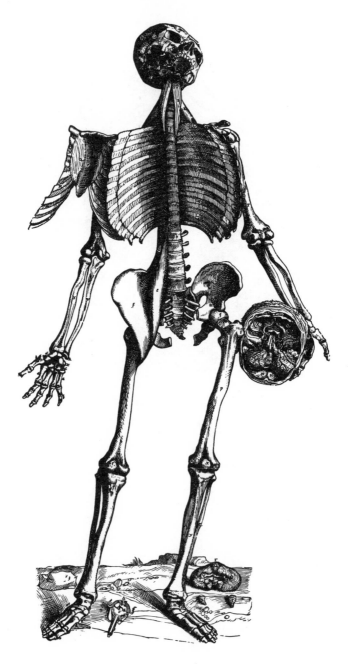

Vesalius' anatomical figure.

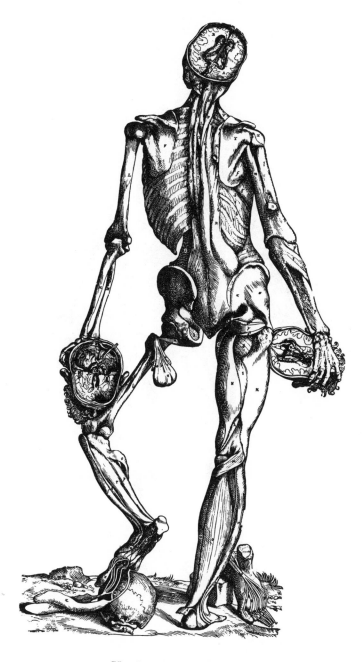

Vesalius' anatomical figure.

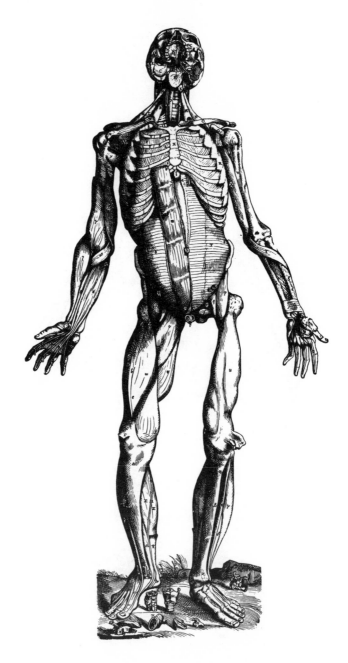

Vesalius' anatomical figure.

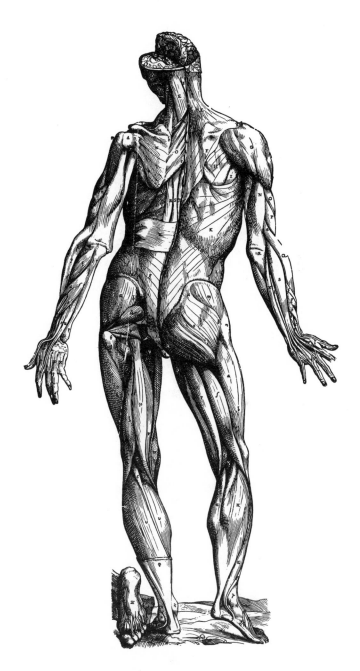

Vesalius' anatomical figure.

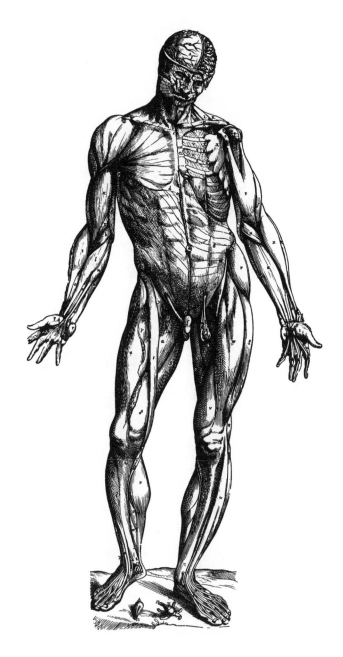

Vesalius' anatomical figure.

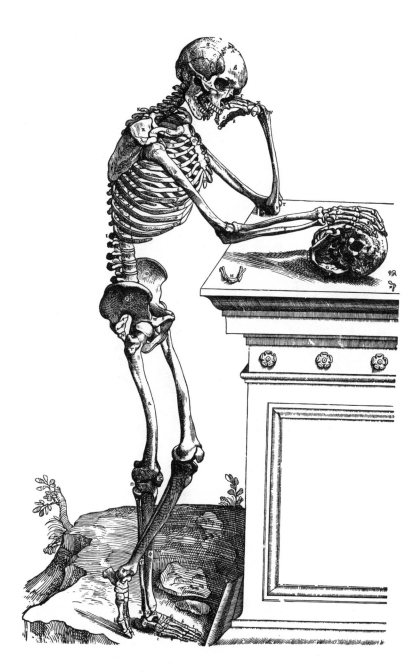

Vesalius' anatomical figure.

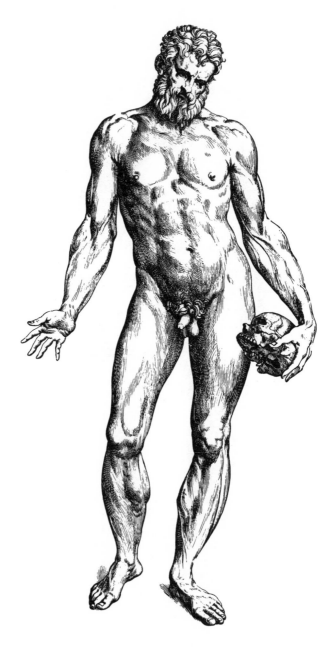

Vesalius' anatomical figure.

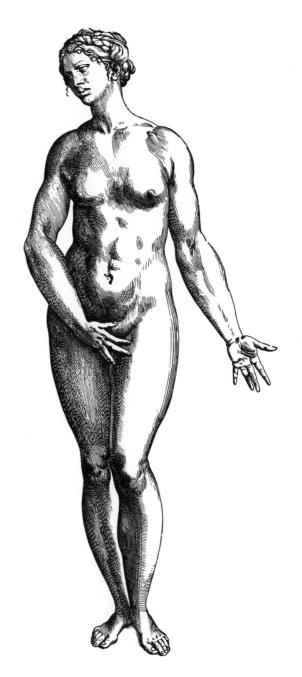

Vesalius' anatomical figure.

Foramina quæ in harum triū chartarum delineatione conſpici poſſunt , ſunt in temporum oſſe auditorius meatus : poſt mamillarem proceſſum vnum , per quod interna iugularis in cerebrum mergit:in facie circa oculorum ſedem quatuor, primum ad frontem, ſecundum ad nares, tertium ad maxillam ſuperiorem, quartum ad temporalem muſculū:duo quoq; in maxilla inferiori. Et per hæc ſingula ramulus tertij paris neruorum excidit.

Obſeruæ dentes,ושן ſcinæim,plurimum triginta duo. תָּחֵ̃ה inciſorij,ושרף mechthchbim, octo : תֵּ̃הוֹתֶ אתר canini, ושלש calbijm quatuor,מלתעת , molares , maxillares, ושרף thochnim viginti. omnes diſparibus radicibus ſuos alueolos ſubeunt.

B Clauicula, κλῶδσʹ, claues,iugula, ושרף tharkuba, Furcula: vtrumꝗ, os literam.ſ.refert, figura inæquabili.

C Ακρωμιον , ſummus humerus,proceſſus ſuperior ſcapulæ , à Galeno in lib.de vſu par.κορακοιν δʹσʹ ad roſtri coruini ſimilitudinem nominatus , ושם של alzegam charton,quaſi appendix cuius principio claues per arthrodian dearticulantur , proprij κιτιαλλῶʹ quaſi ad clauiculas dicitur , R.roſtrum porcinum.

D Proceſſus ſcapulæ interior inferiorq; ab anchoræ ſimilitudine ἀγκυρονδʹσʹ dictus,ꝗ hunc ſæpe κορακονδʹσʹiκ ꝗ ſigmoide Galeno vocant.ꝗרש ꞉ן aijn baccateph , Oculus ſcapulæ .

E Pectoris os , ſigor ושרף bechaſeb , Gaſſor, ſeptem conſtat oſſibus , ſicuti coſtæ que illi alligantur per vnionem potius,quàm per coarticulationem,parte inferiori iunctis:id eb vtroꝗ, latere lunatum eſt .

F Cartilago ſipondʹσʹ, enſiformis ,quo nomine totum os quoque dicitur ,רודה alchangri, Enſifoidis, Malum granatum, Epiglottalis cartilago .

G Βρακίον , brachium,humerus Celſo ꝗ Cæſari, שרף Zeroah , Adiutorium brachij , A ſeth: hoc tibiæ oſſe minus eſt .

H Sinus, humeri caput veluti in duo tubercula diuidens.

I Humeri orbita trochleis ſimilis.

K Cubitus,כן ꝗρ,ושרף bækæneb, Aſaid,quibus nominibus etiam tota hæc pars dicitur ,vlna. Facile maius ,אָה וֹדֵ̃ח ꝗnad eliou . huius acutus proceſſus ad brachiale ϛελονδʹσʹ nominatur

L Radius, κερκίσʹ ꝗρרשʹ-ﬡʹ ꝗnad thachthon, Focile minus brachij.

N Brachiale, κιρπίσʹ,את reſeg, R.aſeta,oſſibus diſparibus octo ꝗ duplici ordine diſtinctis conſtat,in ſuperiori tribus, in inferiori quatuor:hæc ſimul figuram intrinſecus cauam, ꝗ extrinſecus gibbam conſtituunt:iſtorum cum Celſo non incertus numerus eſt.

O Μετακαρπιον , palma , pecten, ꝗרש meſrek , Poſtbrachiale oſſibus quatuor Galeno , non quinque, vt alijs compluribus ,conformatum eſt .

P Δάκτυλος , digiti, אצבעות eboeb,ſinguli ex ternis oſſibus conformantur,priori ſemper interno dio in ſubſequentis ſinum ſubeunte .

Q Μηλε , ἐπιγωνατίσʹ, patella , rotula genu ,מגן הברכ ꝗ magen hercubach , ſcutum genu , Areſfatus: os rotundum breuis ſcuti inſtar .

R Αϛράγαλοσʹ,talus, ꝗרסל karſul,Baliſta: os,Cauilla,Chabab, Alſochi:aliqui malleolum hodie male vertunt .

S Nauiforme, ϛκαφοειδʹσʹ , nauiculare ,ꝗרש zorki .

T τάρσοσʹ,את reſeg,R.aſeta pedis,quatuor oſſibus conſtat,quorum maximum extrinſecus ſitum à cubiſigura dicitur κυβοειδʹσʹ,teſſeræ os , שרף thardij, Exagonon , Grandinoſum, Nerdi.R.eliqua tria nominibus carent,ſed κυλλκρανδʹσʹ nonnullis nominantur.Bis vidimus dextrum pedem vno abundare .

V Planta,plnum , πεδίον , pecten ꝗרש meſrek , oſſibus quinque conſtructum eſt , cui ſuccedunt pedis digiti, X. qui omnes ex ternis internodijs côſtant,magno tantû excepto,qui inter alios ex duplici oſſe conſtructus eſt .

Oſſiculum illud quod ad primum pollicis articulum apparet , vnum ex ſeſaminis oſſibus eſt : ꝗ in illo duntaxat loco duo in vtroꝗ, pede obſeruauimus .

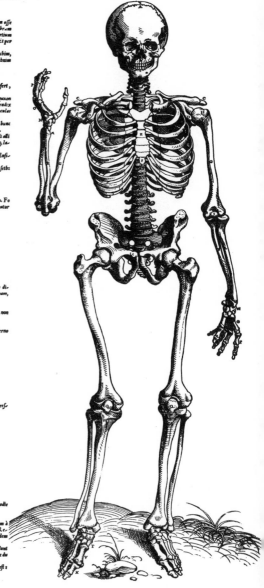

Vesalius' anatomical figure.

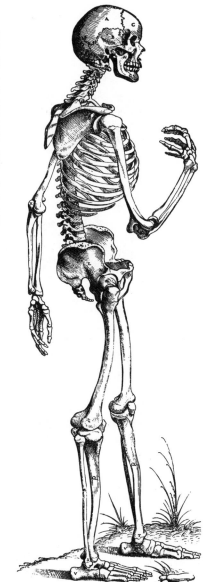

*Offa κρανίου, caluariæ,capitis, offis, ναω ρῖτη kadroth bamuech , Offæ ca-
pitis, Αβαm.*

A *Offa duo βρέγματος, κορυφῶν, fincipitis, verticis, Parietalia. Locus hic apud Auicēnā
in arabico et latino exemplari falfus eft.*

B *Offa duo ut utráᴽ aurem κροταφων, temporum, Aurium: Singulorum βελχρονδ᷒ὸν
id eft ecui, aut tela fimilis et momillaris,et ad os iugale proceffas,partes exiftunt.*

C *Os μιτῶπου , frontis, ναμο ναω ετχεμ baœetzᴽ,Coronale: interdū ob protenfam ad na-
fum ufᴽ rectam futuram, geminum apparet,quod nonulli in omnibus multoribus effe
falfò putarunt.*

D *Os unum iνίου, occipitis, ναω oreᴽ,cuneiforme maximum ineft per quod ſpinalis me-
dulla excidit.*

E *Offa ζυγώματα , iugalia , aut ſυγονᴽ᷒ , να χαᴽ , Partis a utrinque unum ex duorum
offium conftantia proceffibus:quemobrem propria circumferiptione carent.*

F *Os σφηνοειδᴽ᷒, cuneiforme, bafilare,aliquando a multiplici forme πολύμορφος,πυροῡǎ
μῖσᴽὸb bamoach,Colatory, Cauilla,Hoc inter maxilæ ſuperioris offa decimā quintū
numerari confueuit. Sunt enim ſex quæ ad radicem oculorum fuerant:duo maxima
malæ ac molarium dentium alueolos continentia:nerium duo z inciſorios dentes ſuſci-
pientia duo:ad finem palati circa nerium foramina duo,eᴽ ante hæc omnia nuper dictum
os cuneiforme.Niſi ſorteſtis octo,aut ex aliquorum Grϲϲorum ſententia duodϲϲim,hic
offa enumerare mauis, prout ſcilicet exiguas futuras , commiſſuras et harmonias aut
numeras,aut pretevis.*

G *Offa duo maxillæ inferioris,parte anteriori per coalitum firmiſſimϲ annexæ:nec ſat ſcio,
an malϲ cum Celfo in hominibus unum dicere poſſimus , nam quouis etiam decoctione
ſeparari handquaᴽ poſſe obſeruaui,eᴽ ſi ipſa cultro dirimenda ſit,nullis difficilius quā
in medio illaᴽ diuides.*

H *κϲρουιτ ,*
I *Maxillæ inferioris tuberculum eᴽ ceruix : hϲc ſola in omnibus animātibus præterquā
crocodilo mobilis dicitur.*

K *Duo cubiti proceſſus,quorum poſteriorem ώλϲκρανὸν nominant. Hi in medio ſinum ha-
bent antiquæ Grϲϲe literæ C,aut noſtrᴽ C ſimilem.*

*Coſtæ,πλουρǎι ρϲβσῖ tzelaoth, viris eᴽ mulieribus viginti quatuor utráᴽ, latere duodecim.
Ex ijs ſeptem cū metaphreni ſeu thoracis vertebris cuníᴽ offe pϲctoris utrinᴽ coϲunt,
quϲ verϲ eᴽ perfectϲ dicuntur. Cϲterϲ quinque poſteriori parte ſpinϲ duntaxat adne-
ctituv,ex quibus tres priores anticæ parte,ſuis cartilaginibus, veris cohϲrϲt,aliᴽ duϲ inut
cem debiscunt.hϲ ſpuriϲ eᴽ noſtrᴽ eᴽ falfϲ vocantur.ſola autem duodecimæ unica artis-
culatione duodecimæ vertebrᴽ iungitur.*

L *Offa validiſſima,quϲ oſti ſacro cōmittuntur,ιαχιω ναᴽ goſ berus. Superne λαγόνια, iliū
offa. ῖσχίᴽὸb alχα gebha, Anchæ . ad fæmoris ingreſſum iχίον ,coxendicis, ναο ναω
etzem baiarech, Pixis coxϲ, ταχύιβ capϲ baiarech, Althanoret.O Parte anteriori qua
tenuia eᴽ forata imutuᴽque inter ſe per ſynchondroſim connexa ſunt, ῆβαχ, pubis,pϲcti-
nis, alteiᴽα,Penis dicuntur. Totū os,Celfo coxϲ æ, quemadmodum euthori introductо-
rij ſeu medici ιχίον , appellatum eſt. Nonulli falſò putarunt hϲc offa in viris ad pubem
non effe per cartilaginem aligata.*

Q *Tibiϲ,κνάμϲς , ρϲβϲ ρϲβϲ abt zmoth baſϲok,qbus noībus tota hϲc pars nοīatur ῖτατοǎ cane
gadol,Canna maior , Focile cruris maius.Huius pars anterior excarnis eᴽ tenuis crea
nominatur,huic tantummodo quoque fæmur annϲctitur: pretevea facilϲ tibiϲ ſinus qui
bus fϲmoris capita recipit,apparent.*

R *Fibula,ſura,οι minus tibiϲ,κνϲμϲ,ναᴽϲον,ναᴽναω cane katon,Cāna eᴽ arundo minor.Hoc os ti
biϲ craſſitudine admodum cedit,nec ita protenditur , ut genu ipſum contingit: verum
ſupra inſraᴽ, tibiᴽ per ſynarthroſim coarticulatur. Tota hϲc pars Celfo crus no-
minatur.*

S.T *Malleoli,ςφυράι . ρϲαωᴽᴽ arcaboth , Clunicelϲ extremϲ tibiᴽ ſuréᴽque proceſſuum
partes ſunt*

V *Omnium pedis maximum os, ναᴽκρωρϲον pϲϲϲquϲν,calcis os,ναω aϲkeſ.huius pars po-
ſterior tibiᴽ rectitudinem longϲ excedit.*

Vesalius' anatomical figure.

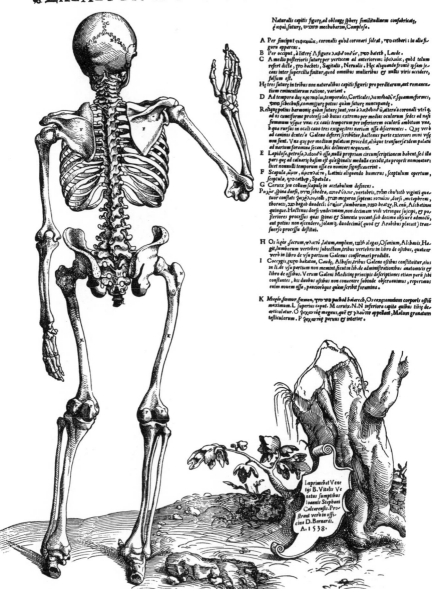

Naturalis capitis figuræ,ad oblongæ sphæræ similitudinem considerata,
ǽ qua,suturæ,ὑπὸ τινῶ mechabenim,Composa.

A Per sinciput εὐφρόνιῳ, coronalis quòd coronari soleat ,ᾳᵒ cetheri : in aliæ fi-
guræ apparens .

B Per occiput ,à litterǽ Λ figure λαμβδοειδὴς ,ᵳᵃ habeth ,Laude .

C A medio posterioris suturǽ per verticem ad anteriorem: ὀβολαίας ,quòd telum
referst dicta ,ᵳᵃ bachets ,Sagitalis ,Nerualis . Hæc aliquando frontè ipsam se-
cans inter supercilia finitur,quod omnibus mulieribus ǽ nullis viris accidere,
falsum est .

Hǽ tres suturæ in tribus non naturalibus capiti figuris pro perditarum,aut remanen-
tium eminentiarum ratione, variant .

D Ad tempora duæ ᾳᵒ τωφίαι,temporales,Corticales,λαμβδοειδ᾽ε,squammæformes,
ᵳᵃᵃ schecbuss,commisjuræ potius quàm suturæ nuncupandæ .

R eliquæ potius hærmoniæ quàm suturǽ sunt, vna à λαμβδωδ᾽ǽ,altera à coronali vtriǽ
ad os cuneiforme protensǽ sub hatus extremo per medias oculorum sedes ad nasi
summum vsque vna: ex cauis temporum per inferiorem oculorum ambitum vna,
ǽ qua rursus in oculi cauo tres exiguæ:tres narium ossa disicernentes . Quæ verò
ad caninos dentes à Galeno deferri scribitur,hactenus parte exterior mini vise
non sunt . Vna quæ per medium palatum procedit,aliáque transfuersǽ eidem palati
ad narium foramina secans,hic delineare nequeunt .

E Lapidosǽ,petrosǽ,λiboνd᾽ǽ ossa,nullà propriam circumscriptionem habent,sed illa
pars quæ ad calvariǽ basim est quipinalis medulla excidit,ita proprie nominatur:
licet nonnulli temporum ossa eo nomine significauerint .

F Scapula ,ὦμος ,ὠμοπλάτη , Latinis aliquando humerus ,scoptulum opertum ,
scoptule, ᵳᵃ scatheẜ, Spatula .

G Ceruix seu colum scapulæ in acetabulum desinens .

P... ᵃᵗ spina dorsi ,ᵒᵐ sehedra ,ᵋᵘᵗᵒΝᾳᵒᵉ ,vertebris ,ᵗᵒᵐ chuᵗioth viginti qua-
tuor constat ᵈᵃᵑᵋλᵒᵘᵗolli ,ᵗᵃᵐ megaron septem: vortuíαv ,dorsi ,mᵗephrem,
thoracis ,ᵳᵃᵃ bageb duodeci: ὀϲᶠᵃᵗορ ,lumborum,ᵳᵃᵃ heatgẜ,Renü,Alchatinu
quinque.Hactenus dorsi vndetimam,non decimam vidi vtrinque suscepi, ǽ po-
steriores processus quas spinæ ǽ Simenia vocant,sub decima obscurè admodǽ,
aut potius non ascendere,solamǽ,duodecima(quod ǽ Arobibus placuit) tran-
suersǽ processǽ destitui.

H Os ἱερὸν ,sacrum,πλατὺ ,latum,amplum, ᵳᵃᵃ aλagẜ, Osanium,Alcauis,Ha-
git,lumborum vertebræ subiectum,tribus vertebris in libro de ossibus, quatuor
verò in libro de vsu partium Galenus conformari produit.

I Coccygis,ᵳᵃᵒᵖᵉ hakaton,Caude, Alboᵊos,tribus Galeno ossibus constituitur,eius
in li.de vsu partium non meminit,sicut in lib.de admisistrationibus anatomicis ǽ
libro de ossibus. Verum Galeni Medicinæ principis descriptiones etiam parǽ sibi
constantes ,bis duobus ossibus non conuenire subinde obseruauimus ,reperimus
enim nouem ossa ,paucioreǽ quàm scribit foramina .

K Μηρὸν femur ,faemen, ᵳᵃᵃ ᵳᵃᵃ pachad hᵃλαrech,Os coxǽ:rotundum corporis ossiǽ
maximum. **L** superius caput. **M** ceruix. **N**.**N** inferiora capita quibus tibiǽ ar-
ticulatur. **O** ᵳᵒχᵃᵗῆς magnus,quǽ ǽ γλουᵗὸν appellant ,Malum granatum
testiculorum. **P** ᵳᵒχᵃᵗῆς paruus ǽ interior .

Imprimebat Vene-
tijs B. Vitalis Ve-
netus sumptibus
Ioannis Stephani
Calcarensis. Pro-
stent verò in offi-
cina D. Bernardi.
A.1538.

Vesalius' anatomical figure.

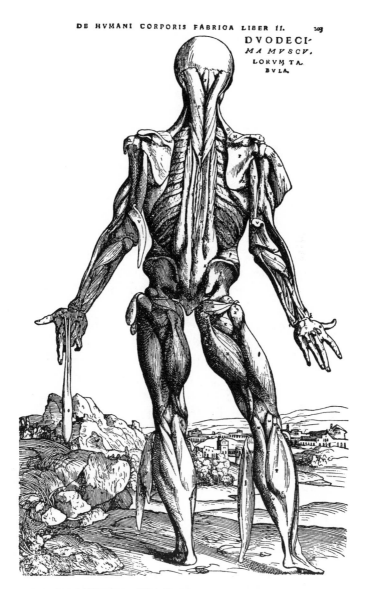

FIG. 94. Vesalius' anatomical figure.

sought. On the forward leg of the front view (Fig. 93) the continuity of the forms is very plain. The two vasti come out from behind the pelvis, slide imperceptibly into the volume of the knee, and then continue down the sub-cutaneous tibia and tibialis anticus to finish over the arch of the instep in the great toe. In the lower part, the forward sweep is counterbalanced by the backward curve of the gastrocnemius (calf muscle), the soleus, and their tendons ; which in turn seem to disappear under the instep, to find, after diagonally crossing the sole of the foot, a last hint of return in the inward tendency of the little toe.

I must refer the reader to special treatises on artistic anatomy for a description of the details of the thoracic cage. These two plates show excellently the way in which the scapulae (shoulder-blades) are applied to the cage, and how in reality the shoulder-blade belongs entirely to the arm and not to the trunk. The collar-bone is very rightly taken away ; the main part of its office is, so to speak, to ' sew ' the shoulder-blade and arm to the trunk, to keep them from falling away as they do in the plate. Evidently this is too simple a way of explaining its functions, otherwise it would be a ligament and not a bone ; its bony rigidity allows it to serve as a part insertion of the pectoral muscle and so on. But I specially wish to avoid dealing with secondary and tertiary facts of construction in order to underline deeply the great facts of the body and to keep them clearly before the student. The arm being put back into its place, and fixed there by replacing the collar-bone, we may almost say that the deltoid is clapped on to finish everything off properly, and as a matter of fact it is inserted into both the collar-bone and the shoulder-blade at the top, and into the humerus at the bottom, thus properly binding the whole together. This clapping on ' of the deltoid is seen in Fig. 61,

Fig. 95. HEAD OF DIADUMENOS

Polycleitan style. *Dresden*

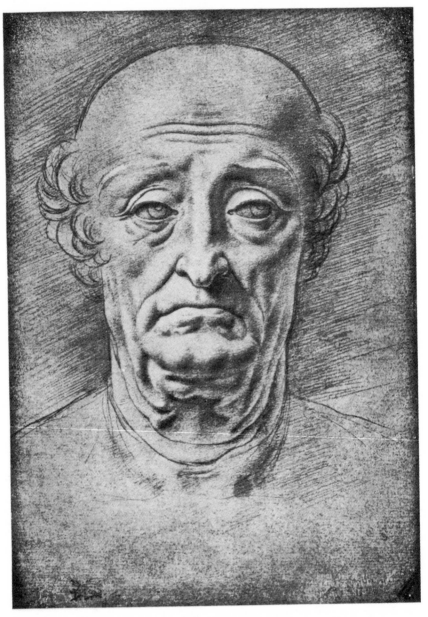

FIG. 96. Old man's head by Leonardo da Vinci

although on that page (156) another analysis of the geo-
metrical mass construction was given. Here, as elsewhere,
the artist must choose for himself a balance between the
geometrical type of constructional analysis and the anatomical
type which we are now studying.

From the top of the shoulder-blade the mass of the
trapezius takes us up into the neck, its forward edge giving
the rear limit of the top plane of the torso. The front limit
of this plane is set by the clavicles or collar-bones. In the
erect figure the plane slopes forward at about 45° with the
horizontal. From it the cylinder of the neck springs forward
continuing the line of the backbone. This is nicely evident
in Fig. 57 where the relation of the cylinder to the front
border of the trapezius may also be conveniently studied, the
junction of the two forms being very clearly marked. All
such junctions take place in the more suave female figure
(see Fig. 92); they are reduced in violence, that is all.
It is more convenient to study them in the drawings of
Michael-Angelo who always tended to exaggerate their im-
portance. We may study them in his work; we are not
obliged, for that reason, to imitate his extremes of contrasted
modelling. The balance of forms in the neck has already
(pp. 157 and 291) been sufficiently discussed, though we
might still remark that while the neck may with reason be
looked on as a cylinder—with its axis slightly convex forward
—the diagonal position of the sterno-cleido-mastoid muscle,
when in tension, so modifies the shape that in the turned head
(Fig. 57) the neck from that view appears almost to be an
inverted truncated cone. The way in which the sterno-
cleido-mastoids embrace the inner volume of the neck is to
be noticed as seen from the three-quarter front view. The
surface of the trachea and Adam's apple slopes upward and
forward governed by the movement of the spinal column,

and anew disclosing the main rhythm of the body to the observer of the anterior neck modelling. This surface, or rather the volume which it limits, seems to spring forward from between the embracing branches of the sterno-cleido-mastoid which seems (Figs. 55 and 56) to tie down the posterior mass of the skull to the front of the body.

.

I have already said that the skull should be looked on as a sphere balanced on the top of the neck, and that the face should be conceived as a triangular (or pyramidal) mass hung from its lower part. Continue, mentally, the circular curve of the skull in Fig. 56. It will represent, very nearly, a ball balanced on the neck. Not quite, because in reality the face is there, and the equilibrium is only complete when the mass of the face is added. It may be noticed in Fig. 56 that the sterno-cleido-mastoid forms nearly a right-angle with the chord that limits the circular part of the skull. In this case the chord passes through the middle of the ear and is a continuation of the line immediately above the ball of the eye. The angle in question, of course, varies according to the backward or forward throw of the head ; but it is always useful to store up in the mind certain normal appearances from which we deviate to the required degree on each special occasion.

As is their wont, the Greeks have evolved a marvellously succinct and yet completely satisfying formula for the treatment of the head. The Polycleitan Diadumenos of Dresden (Fig. 95) gives as good an example of this as any other. Fig. 96 is a reproduction of a well-known head study by Leonardo, and Fig. 98 represents the head of a piece of Japanese sculpture of the Suiko period ; it is interesting to compare these three formulae—the objective and synthetic Greek, the analytic and subjective Leonardo working at the moment of the inception of modern research and scientific curiosity, the idealistic Asiatic who sees in plastic art a mere

language for the statement of abstract ideas, who almost looks on Nature as a drag on his liberty of expression, and who reduces it to a decorative function to as great an extent as is compatible with rendering a sense of life. In two different ways the Greek and the Japanese are intensely sculptural.

Leonardo makes us first specially aware of the dome-shaped upper part of the cranium. This is partly because his model was bald ; but it should also be remarked how that dome dominates the face and recedes behind and over it in the same way as does the fillet-based summit of the Poly-cleitan head. Unfortunately the diadem prevents us from making a comparison with the Eastern figure. The dome-shaped upper part of the head is, of course, our important constructional fact ; its various parts are rigidly related to one another. Where it gives place to the main plane of the face, it flattens to the marked plane of the forehead, a V-shaped form running down to the root of the nose. This is very clearly marked in the old man's head, less so in the two others, though it will be noticed that it is a fundamental fact insisted on both in the West and in the extreme East. From this plane the two side-planes fall away (see also p. 262) until they are limited by another parting line which slopes forward from the front of the old man's hair down by the cheek-bones to each side of the chin. This straightness is also visible in the Greek head, though it is very subtly expressed. In the Japanese face a curved division takes its place. This is in each case the boundary between the front and the sides of the face. From this line swing forward and inward the curved lines of the zygomatic processes and malar or cheek-bones; then from their limits hangs straight down the almost square plane containing the mouth and terminating at the lower line of the chin. The annexed diagram shows the system (Fig. 97). On these main bases the rest of the modelling is executed. Like the stomach, the eyes may be

conceived as cavities filled by the spherical form of the eye-ball, which may be looked on as a subsequent addition to the constructional essentials. The same method of modelling in clay may be adopted for the eyes as for the stomach (see p. 289). Of course the eyebrows form other masses markedly detached from the other planes in the Leonardo, more subtly detached in the pieces of sculpture. In the European heads it will be noticed that the inner corners of the eyes are about vertically over the outsides of the nostrils. Here again there is evidently variation from individual to individual, but the rule may be borne in mind. The eyes will also be seen to be situated about half-way up the head. They are also situated on a curved surface. This is quite visible in the two sculptured heads; it gives the effect of the eyes being 'stroked' backwards; one instinctively 'strokes' the forms in that region backwards with the

FIG. 97. Diagram of volumes and planes of head. The rectangular form of the frontal plane should, however, be borne in mind.

thumbs, on both sides simultaneously, when modelling in clay, backwards and slightly upwards. The whole of the front of the face is curved in form (Fig. 99), the flat planes of which I spoke just now being only first approximations to the finished shape. They must none the less be borne in mind. The thickness of the eyelids must not be forgotten. Notice how very carefully Leonardo draws them in with the complete foreshortening of the *flat* conjunctive

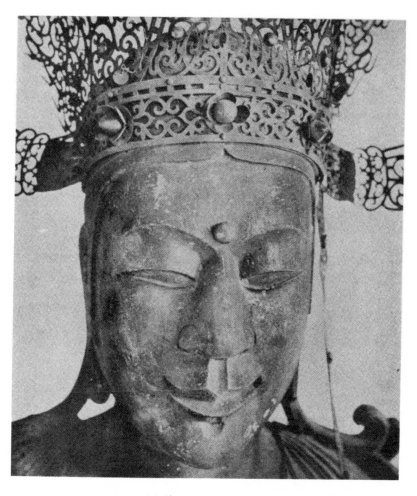

FIG. 98. Head. Japanese sculpture of the Suiko Period

surfaces, flat where they come into contact when the eye is closed. It should also be remembered that the lens of the eye, being slightly in relief on the otherwise spherical surface, slightly pushes up the eyelid at that place, consequently the highest light falls just over the iris. Leonardo's drawing of eyes is remarkable. The different forms should be studied on such a drawing as this or on that of a head of a woman in the Uffizi Gallery in Florence. I remember years ago copying it carefully myself. On the Greek head we see how the forms round the inner lachrymal gland suddenly turn sharply forward. The drawing of an eye is a very delicate affair ; it is nothing but a series of shapes continually presented in the most varying degrees of foreshortening. To describe them in words would take up an undue space ; the student should carefully grasp the solid meaning of every indication in the accompanying Leonardo (Fig. 96), and then tell himself that this complex

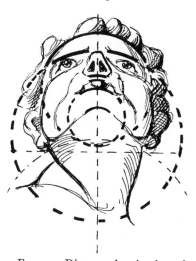

FIG. 99. Diagram showing how the forms of the face are arranged on curves. It should be noticed in this diagram how the superposition of the geometric circles has destroyed all foreshortening illusion. The drawing is quite flat. To have made a genuinely representative diagram, it would have been necessary to adopt some treatment of the circles as bands seen in perspective. This would have unnecessarily confused the drawing.

series of shapes must be thrown into the necessary scheme of perspective. I wonder how many draughtsmen think of foreshortening and perspective schemes while they are drawing the detail of an eye. Not many, I fear, if I may judge from the results. And do not let me be thought to be unnecessarily minute. It is precisely this taking of pains to maintain the solid

illusion throughout the detail which gives life and truth to the result. In a hurried sketch very few of these elements can be introduced, but those which are introduced must be subject to the exigencies of their solid state ; they must not contradict it. If, for example, in rapid painting, only the high light on the lid over the iris can be dealt with, whether the artist is acquainted with all the facts of ocular construction or not ; whether or not he mentally and rapidly subordinates these facts to the perspective view he is taking of the model will make all the difference to the truth and livingness of his result. Thought and knowledge behind the brush-stroke are always evident. Feeling the solid relief of the eyeball he will automatically place his single brush-mark in such a way as rather to exaggerate than to diminish the plastic modelling ; one realizes that, in spite of the summary expression a learned impulse governs the brush. Herein lies almost all the difference between the rapid sketch of the master and that of the amateur or inferior artist. Every one is dimly aware of this difference, but few are critics highly enough trained to place a finger exactly on the reasons of the difference. In my most hurried study it is no exaggeration to say that I use all my knowledge of the form. The fatigue so quickly experienced in this type of work, the fatigue that is so much greater in later life than in student days, comes from the fact that during such short intervals of time, perhaps three or five minutes for a drawing, one is dealing with a very considerable store of knowledge, a store which could not have been handled thirty years before, because it did not then exist.

Mouths, too, are so often drawn flat upon the paper. The different volumes of the lips must be as carefully thrown into perspective, must be as carefully foreshortened as a leg or an arm. Because a form is small the rules of foreshortening are not to be cast overboard ; yet most people do so. Need I

detail the two volumes of the lower lip clearly seen in the Leonardo (Fig. 96), the median upper lip volume and its two accompanying lateral drooping shapes? Need I call attention to the fact that the whole charming cupid-bow design is curved backwards, which, in the case of any three-quarter view, throws all one-half of the mouth into quite violent foreshortening, a foreshortening which makes it necessary to mark out properly the far limit of the upper median mass where it probably hides a small part of the lip surface lying just beyond it? A volume of the lip merits its limiting line just as much as does the shoulder of a mountain which hides from us forms within the hollow lying beyond its mass. How often is this very evident fact realized? Foreshortening is everywhere. The day before I wrote these lines some one said apropos of the accompanying drawing (Fig. 100): 'What a very difficult piece of foreshortening that leg must have been!' As a matter of fact it was not at all difficult to manage. The whole thing was clear and evident, the parts of the forms were frankly hidden or seen. What is difficult to manage—and the almost universal failure to do so is the proof of it—is to treat the continually varying fore-shortening round the spherical surface of the eye, or properly to foreshorten the shapes along the side—shall we say?—of a torso. That is why all great figure-draughtsmen have made so many torso studies, for they realize the need of accurate drawing *within the actual outside profile of the figure*, the drawing between the median line of a normally standing figure and the profile of the side. On quitting the median line there is little or no foreshortening ; then by varying de-grees according to the shape, the ribs, the digitations of the great serratus, perhaps the latissimus dorsi, have to be thrown into ever-increasing perspective. But in the treatment of such spatial delicacies the inexpert eye neither detects errors nor the accompanying illogical lack of homogeneity

in the modelling. As usual the success really difficult of
attaining is passed over, and the obvious and effective is
praised. Look for a moment at the masterly perspective
succession of forms that recede along the cheeks and neck of
the Leonardo head (Fig. 96). How impeccably they retire !
And those under the chin ! Yet how often would the fore-
shortening of this drawing be praised ? And how often would
the exquisite foreshortening of the sides of the eyes be spoken
about, or the way in which ' full on ', the change of direction
between the actual lid and the skin over the lachrymal gland
is marked ? Do you realize that there is in such a drawing
all the third-dimensional information needed to carve a bust ?
Possessing a complete knowledge of the form, Leonardo has
cast each part of it into faultless foreshortening ; ' each part ',
for, after all, what fragment of it is free from some slight
foreshortening ?

.

Fig. 100 may be worth a moment's study. The unusual
pose gives an additional occasion to understand the bony
pelvic mass. The anterior superior iliac spine stands out in
a most marked way. We can easily imagine the position of
the other spine hidden by the model's right thigh—I
imagined it myself when making the drawing a few days
ago—the rectangular ' ground-plan ' of the pelvic volume
when clothed with its muscles is very evident, if we imagine
a line drawn across and tangent to the profile of the buttocks.
The positions of the pubic spines can easily be fixed and their
relations to the superior spines be seen. The line joining the
superior spines and that joining the pubic spines are parallel
to one another and parallel to the line tangent to the buttocks
that we have just mentioned. The way in which the roughly
cylindrical volumes of the thighs come out of the pelvic mass
is obvious, and the whole solid volume of the pelvic mass,
seen from below, is easily understood in this particular

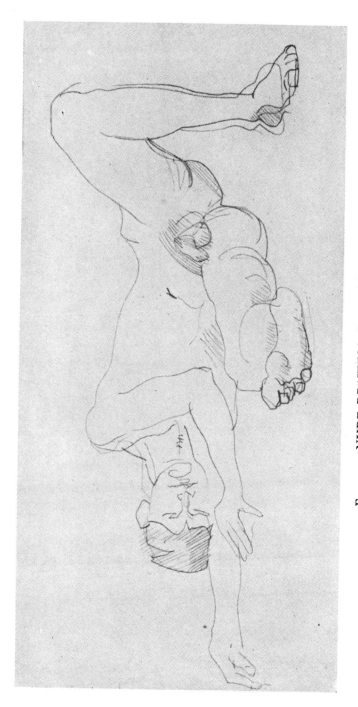

FIG. 100. NUDE DRAWING BY THE AUTHOR

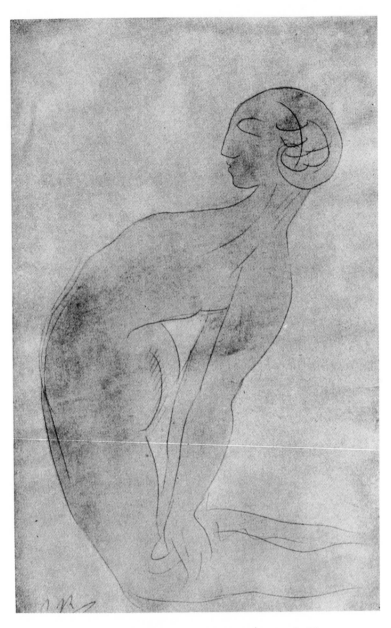

Fig. 101. RAPID DRAWING BY RODIN

drawing. The flexile nature of the abdomen is also very marked ; the superior profile drags away from the iliac spine, which has become in this pose a point of suspension instead of being one of support, as it is in the vertical or sitting position. Following this top profile towards the shoulder, we notice how the first dip is succeeded by a new point, or rather surface, of suspension. We have reached the ribs. But the lowest ribs are ' floating ', and the whole structure of the thorax is flexible, so the climbing of the profile to this new suspension surface is more suave ; it is not brusque and uncompromising as was the change of direction at the totally rigid iliac spine. A new dip marks the limit of the arm system, and the subsequent rise profiles the latissimus dorsi coming forward to its insertion into the humerus in order to play its rôle in partly binding the arm to the body, in being one of the principal agents which prevent the arms from being torn away from the trunk when we are hanging by them from a horizontal bar. The same actual pencil line continues to indicate the deltoid though we are now frankly dealing with the system of the arm, and this portion of the line is coming nearly directly towards the spectator. This is an instance of how it is not at all necessary to respect the classic notions regarding ' intersections '. One and the same profile can perfectly well represent volumes on quite different recessional planes. At the iliac spine I have in this drawing carefully made an intersection which is hardly necessary ; in a second drawing from the same pose, I might just as well have suppressed it, as also the intersection—this time more important, though—between the upper thigh profile and the pelvis. Obviously the only reason for this seeming incoherence is that for the moment I was specially noting the unusual projection of the pelvis ; I had been struck by its prominence, and so insisted on the fact, whereas the deltoid deviation is more normal and less amusing, so I passed it by with a simple

conception of its plastic value. It will be noticed that at the
pelvic spine I did not take my pencil off the paper ; the line
comes into the modelling, makes a sharp-pointed loop,
returns on itself during two-thirds of its length, again makes
an acute angle, and continues to express the fall away of the
flexible forms of the external oblique. The indication of the
iliac spine is really a calligraphic note made about it. Of
course the top profile was drawn as I describe it, from right
to left. The reason for this is the order of representation
chosen, an order partly based on the appearance from the
particular point of view, and partly based on the relative
importance of the real constructional facts. As usual, the
shape and position in space of the pelvic mass is the most im-
portant thing ; but in the present circumstances it is thrown
back to what we may call the third perspective plane, the
first being taken up by the feet and legs, the second by
the thighs, the third by the pelvic mass. The rest of the
body can be classed as falling more or less into a fourth
plane already much less important ; the drawing can be
treated in a more summary way on this fourth plane without
harming the general aesthetic effect. In this particular com-
position the decorative point of interest is the shape of the
pelvic mass.

Because of this placing of the interest, I instinctively
insisted on the amusing calligraphy of the iliac spine. This
handling, compared with the summary treatment of the del-
toid—decoratively less important—affords an example of
change of method adopted in various parts of the same
drawing according to the decorative needs of the particular
spot. We noticed this type of variation when discussing, on
p. 235, the Degas drawing reproduced in Fig. 74. No part
of my drawing (Fig. 100) was elaborated, for it was the work
of five minutes at the 'Académie de la Grande-Chaumière' in
Paris. Slightly more detailed than the rest are the feet,

because they form the foreground of the study. It must not
be concluded that I lay down as an unbreakable law that
foreground objects must be more minutely executed than
those of the rest of the picture. Very far from it. Only, in
this particular case, the mass importance of the feet attracts
special attention to them; the eye must not be disappointed by
finding emptiness of execution. Once the feet and legs were
established, mass was thrust behind mass, as they respectively
receded, my pencil continually ‘ sinking into the paper ’,
until I arrived at the deltoid, when the point began to come
towards me again. I do not remember whether I drew the
model’s left leg from hip to foot or inversely. Probably,
having drawn the right leg lying on the ground I limited the
mass of the left thigh by its ‘ sky-line ’, and then, from its
already suggested mass, drew down the first lines of the leg
and foot, which lines I decided were not exact enough, so
I re-drew the darker and more precise subsequent contours.
The instinctive noting of the foot is somewhat interesting.
I have again made a hitch in the uninterrupted line that
limits the tibialis anticus and the shin-bone, at the base of
the tibia and in order to limit the mass of the instep. In the
first rough lines of the drawing I did not limit the instep
mass ; yet these rapid rhythms, so lacking in photographic
accuracy, indicate the placing of the masses quite efficiently.
In each case I have, however, used the intersection between
the great toe and the heel, and I was so struck with the
separation between the front and back volumes of the foot
that I finally indicated the difference by means of hatching.
That is not the only reason for the hatching. Having hatched
in three or four other places I was obliged to hatch there in
order to preserve a decorative equilibrium in the drawing.
There are always many reasons for any given aesthetic act.
Indeed, the complexity of prompting cause is precisely what
distinguishes work of real import from work executed

according to necessarily simple established rule. This is true of all types of art, plastic or otherwise.

The place of the navel was carefully noted as giving by implication the exact position of the abdominal surface, and the V-shaped form employed in ' calligraphing ' it is by no means fortuitous. It was dictated by the desire to limit, by the right-hand branch of the V, the lower abdominal mass, and by the left-hand branch the forms above the navel. It is easy to notice the suggestion of a dragging rhythm between the right-hand branch of this little V and the iliac spine ; the double curve of this eighth of an inch of line is prompted by this observation. The upper part of the V curves upward to show the drag from the spine, and the lower downward to suggest the fall away of the lower side of the abdomen in the present position, and to determine its rounded form.

The action of gravity on the flaccid muscle forms is also shown in the thigh lying on the ground. The upper profile would be much more convex in its modellings were the muscles in tension or the model erect. Here from the pubis to the knee the general direction becomes a straight line, whereas on the under side there is a slight sagging out of the inactive muscles on the floor.

Arms and head have interested me much less in this drawing (one cannot do everything in five minutes !), they were more normal, and from my place they did not constitute the compositional centre of the arabesque or pattern which lay in the right-hand half of the sheet of paper. The amusing decorative shape was afforded by the triangle made by the legs ; the trunk and head made a secondary mass addition to the main interest. I have given this partial analysis of this rapid drawing in order to show exactly by example how constructional knowledge may be used in actual work. None of the drawings by masters that I have at hand illustrated the point so obviously as the modulations of the directly

traced line which I cultivate myself. In it the noting of the constructional fact is clearly evident . . . unless some unkind and hostile critic contradict me flatly and say that the said modulations are mere accidental phenomena. But even then an examination of a few hundred of my drawings would show an improbable recurrence of the same accident. In drawing from the model we maintain a continuous balance between : first, previously acquired type knowledge; secondly, newly acquired knowledge, acquired at the moment by looking at the model (this new acquisition is in part in the form of recognized difference from type) ; thirdly, an exercise of aesthetic judgement concerning the adjustment between type facts and those particular to the present model —we take into count the modifications due to the particular pose ; fourthly, decision concerning the use of these various facts with reference to (*a*) our general aesthetic intention, (*b*) the exigencies of the decorative arrangement or pattern of the drawing in hand. As we have seen, the use, the way of use, or the entire elimination of a given factor depends largely on this authority of pattern. I know how long I had taken to do this drawing ; I had done it recently enough to remember many of my own impressions while doing it, and so I am able to point without hesitation to their immediate calligraphic transcription, in this case very much better adapted to demonstration than the thick charcoal line of the Degas drawing already examined in this way, to which I will however refer the reader for an analysis of the arm constructional facts. He might look for the expression, in the carelessly drawn arm in my drawing, of the facts that I have pointed out in the Degas. They and many others, very many others, may be traced in the drawings by Michael-Angelo and Leonardo. These comparisons should be carried out by the student. In this way he will be convinced of the recurrence of essentials, and will unconsciously form a list

of them for himself, and will see how often they are absent from the drawings of many contemporaries whose work is vaunted but whom it would be invidious to name. However the commonest failing is that of inferior rhythmic succession. An intense feeling for rhythmic succession is what renders interesting and valuable the most careless and rapid of Rodin's drawings, and is what is invariably lacking from those of his imitators. It is, of course, nothing else which gives life to his modelling, gives the strained effect to a stretched tendon, governs the graceful curve of a slack muscle. This sense of relation of element to element of form becomes large rhythm of line in his most hurried scribbles. It is natural to him. His least correct drawing is, at worst, a statement of rhythm.

From the point of view of ethnic comparison it may be of some interest to compare the drawing by Rodin (Fig. 101) with that by Degas (Fig. 74) and with the two line drawings by me (Figs. 19 and 100). In spite of the thick contour of the Degas we can trace both in it and in the Rodin the same tendency to a kind of round polish of form which is absent from both of my drawings. Degas and Rodin were inferior to no one in capability of reproducing detail; in the case of Degas the curious and exquisite dancer in wax and gauze recently shown in the Paris Exhibition of Decorative Art (1925) would be a proof of this, were one needed. Yet both Frenchmen succeed in abandoning a complex view of the model in favour of a *stylisé* statement of clear and simple line. Comprehension of the detail of the model is one thing, expression of the mind form of the artist is another. At the same time both men belonged to the nineteenth century, so the main tendency of their work is towards a romantic complexity, although, as these two reproductions show, instinctive reversion to national type is in no way eliminated. This quality is by no means confined to the work of distinguished draughtsmen, it is national, I have noticed it

appear in the rapid drawings, not only of inferior artists, but of Frenchmen who made no pretence at all to artistic talent. At the same time it must be carefully distinguished from a certain angular hardness of simplification practised by English and American pen illustrators in chief. On the other hand, on examination of my drawings they will be found to retain a certain sense of nervous complexity, even in the extremely rapid one of the recumbent man. I have failed to generalize to the same extent as Rodin, and all naturalist that Rodin was, he has achieved a *stylisé* and very significant detachment from Nature, quite foreign to my drawing, which one feels to be essentially a transcription from the model carried out by a complex mind type. In short, one may perhaps say that Rodin offers an example of an artist intent on complexity of detail but whose mind type is fundamentally clear and simple, with tendency towards logical and synthetic generalization, whereas I am of a fundamentally complex nature, which nature persists throughout whatever technical simplifications it may please me to adopt as an artist. It will be noticed in my drawing treated in a more simple way (Fig. 19), that this sense of rounded polish which we find in both the Degas and the Rodin is quite lacking. My drawing is simple, is statuesque perhaps. But one can almost say that its simplicity and statuesque qualities are intentional. I had the time, ten minutes, to carry out a deliberate intention. Of the four drawings that we are considering, undoubtedly the Rodin is the most rapid, and probably the Degas the slowest, my own two of five and ten minutes respectively coming, it would seem, between the others. It may almost be said that the less time the Frenchman has to consider the situation, or in other words, the more his work is instinctive, the more it will possess the racial qualities of precise, somewhat in-complete, but perfectly logical generalization. My work shows the arrival at a generalization by means of, so to say,

calculated work. As consequence this generalization is more of, what for lack of a better term I will call, an artificiality, a *vɔulu* result, one that is not spontaneous. The spontaneous effort of my personality is disclosed in the naturalness of the flesh and bone shapes of Figure 100, which very possibly an English critic will prefer as a drawing to the Rodin. The simpler of my two drawings shows solidity of shapes, and masses posed in a fairly architectural way, but compared with the Degas and with the Rodin it is seriously wanting in veritable plastic significance of surface form.

A few words concerning the Rodin drawing may not be out of place. I have chosen it as exhibiting a considerable amount of volume value to which his rapid notes of pose did not always attain. True, the nearer arm is not all that it might be in that respect. The information concerning the advance of the deltoid in front of the neck plane is insufficient, and the same defect continues down the upper part of the thorax. Rodin ' missed ' exact comprehension of the state of things in that part of his drawing. This missing forcibly vitiates the accuracy of the junction between the thorax and the pelvis. On the other hand, the volume of the pelvic mass is admirably felt, and we swing down the thighs to meet with hand and forearm mass values acutely indicated now that the shoulder incompletion is left behind. The scrawl which establishes the plane lying across the two calves is interesting, as is also the hatching indicative of the whole plane lying across the buttocks, seen in rising perspective, hence noted with rising lines. Rodin has attempted to save the thorax by modelling the added wash ; he has indicated the upper light side, but this only remedies in part the defect of want of plastic value in the lower contour. The upper contour is hardly to blame, the inefficiency took its rise in the conception of the shoulder mass and was forcibly continued along the horizontal back line. One feels, however,

the cylindricity of the neck ; and the mass of hair over the ear is just the right degree nearer to us than is the face profile. The eyelid volume is perfectly well indicated and takes its place on the general spherical shape of the head. This is one of the qualities rare to find in drawing. The special attention which Rodin has paid to the contour in the stomach region should be noticed. The base of the ribs, the prominence of the iliac crest, the transition from the pelvic to the thigh volume have all in turn appealed to his knowledge of construction, and, in spite of hasty execution, have reclaimed two or three returns of the pencil, so natural was it to him to realize their importance.

.　.　.　.　.　.　.　.

Has my reader still patience left to follow my repeated changes of direction ? If so, let him turn back and consider, once more, the frontispiece. It is very interesting to compare such an artistic rendering of the human head with the Japanese and Greek heads examined a few pages back. Undoubtedly Carrière had a very personal technique, nevertheless he belonged to the epoch which, *par excellence*, extracted its artistic nutriment directly from Nature, which worked directly from the model and controlled each pencil mark, each stroke of the brush, by a renewed comparison effected between model and picture. The aim was antithetic to that of the Japanese sculptor of the Suiko head ; the one artist strove to represent the literal complexity of Nature ; the other dealt in a schematized system of forms only distantly based on the model. The Greek may be said to have adopted a somewhat intermediate position, but which was capable of becoming commingled with the more modern standpoints which we know. It is difficult to conceive of true junction between the Eastern abstraction and the Western subjectivity. I always have, somehow, in front of the most amazing examples of naturalistic work of Japan, a feeling

that it is not true naturalism, that in spite of inconceivable accuracy of study there is at the last moment the introduction of I know not what artificiality, of I know not what divorce from Nature, of I know not what generalization which dominates the endless and patient detail which is all co-ordinated in some special and human way, a way which is not the large and ever-varying way of Nature herself. It may be that a Japanese critic on looking at European work sees just as much, to him, unjustifiable intrusion of human subjectivity on the natural aspect. It may be so, it almost certainly is so. Yet for our present discussion I think we are justified in considering the Carrière portrait as a more naturalistic production than the Suiko head. In the latter the subtleties lie in the co-ordination, in the joining up, in the exact quality of certain, comparatively few, main conceptions of the human head. True, the line of the eyelid or of the mouth is a very subtle and a very beautiful curve, but it is in each case an artificiality, its beauty is a human invention which has only a distant relation to the extraordinary complexity of Nature, a complexity which possessed an irresistible charm for Leonardo, though he, also, forced it to undergo some exquisite and mental moulding before he transcribed it on the paper. He, too, saw more than the simple appearance of things. Carrière's art, however, owes its rhythms more immediately to Nature ; he merely brings to the natural rhythms an aglyptic exaggeration of sweep. We may thus usefully study them in his work.

The straight noses of the Greek and Japanese heads are in immediate contrast with the contorted forms of the Carrière, and so give the key-note of the whole situation. No form in the Carrière nose is invented, though its importance may be exaggerated (*a*) by increasing undulation, (*b*) by suppressing the modelling between it and the next. So we see how we may use (p. 317) a study by Carrière as

a demonstration in anatomical construction. Of course the planes (cf. Fig. 98) that exist in the other heads are not ignored in the Carrière—they can be by no satisfactory work whether of the West or of the East—yet the complexity of his conception forced him rather to dissimulate their existence than to insist upon it. The change of direction from front to side of the face, so evident in the Leonardo, is still evident in the Carrière, it must be, it is too important a fact. The Japanese artist has reduced it to a sculptural curve, but Carrière has broken it up into at least seven or eight waving modulations all of which are, however, distributed—of necessity—along the same straight line. 'Of necessity', I should add, *if* the European convention of the straight line, and not the far Asiatic convention of the basal curve be adopted. It is instructive also to compare the treatment of this region in the two heads by Carrière and Leonardo. Both being of old men the comparison is easy. The sketchy non-completed nature of each of Carrière's minor forms is very evident when we compare them one by one with the somewhat sculpturally styled forms of Leonardo. Unquestionably the Leonardo offers the better, the more complete, aesthetic schooling. Yet the undefined quality of the Carrière knits it closer to natural things.

The perhaps slightly fastidious equality of high lights (p. 259) in the Carrière, is by no means without use to the student. It calls his attention to the prominent points of bony—and other—construction. The forward sweep of the zygoma and malar bones (cheek-bones) is very evident ; as are also the four main protuberances of the forehead between which lies the square frontal plane. The lower square plane of the face (Fig. 97) is also clearly marked in spite of beard and moustache, and affords us another occasion of noting how several anatomical facts combine to form one general constructional fact. The vertical sides of this square are

composed of several muscular forms : the zygomatici, the
buccinator, the edge of the masseter, and so on. Of these the
zygomatic group is arranged quite diagonally to the vertical
trend of the form governed by the underlying malar bone
that affords a suspension point from which the flesh below
falls. A student of the usual anatomical plate would direct
his form in quite the wrong way here. The constructional
form cuts the direction of the muscles at some 45°. This is
an example of how anatomical plates may be deceptive to
the artist.

.

The touch of high light over the lens of the eye is most
distinct in the Carrière, as is that marking of the subcutaneous
bone of the nose, which is less evident in the very careful
modelling of the Leonardo. In the Carrière it is in more
marked contrast with the fleshy modelling of the nose-tip.
Carrière notes the exact limit of the bone, the cartilaginous
middle part of the nose being of a softer modelling. In the
Leonardo the difference of modelling is hardly perceptible.
It is in such matters of sensitiveness that I find Carrière
a more instructive anatomist than Leonardo.

One thing that should be specially remarked in Carrière
is the masterly way in which he studies the lines of growth of
hair, of beard, of moustache. It is too often forgotten that
there is a strict relation between the trend of the underlying
surface direction and that of the hair which grows from it.
Also it is not remembered often enough that hair tends to
arrange itself in simple decorative masses bounded by surfaces
either plane or curved as the case may be. The beard and
moustache of the Carrière are well worth attentive study from
this point of view. Note with what care the masses are
modelled. They are modelled with almost more attention
than are the flesh forms. A great deal of the character of the
model resides in this meticulous realization. The undulation

of the fine ends of the moustache, on the shadow side, seems
to stand out in space, a minuscle composition of decorative
shapes. And note the sustained movement of form that comes
down the right jaw-bone to swing round into the beard, and
finally turns vertically upward again to the middle of the
mouth. Without imitating the obviousness of all these
unifications of form, it is quite necessary to bear them in
mind ; Carrière employed them as it pleased him to employ
them, another artist might make less evident use of them.
This last movement is to be seen without much difficulty on
the Greek head, only the perfect joining up of the contiguous
modelling—a thing which Carrière somewhat neglected,
especially in his lithographs—renders it less obvious at a first
glance. The difference between artists is constituted by the
different intensity and different slight modifications which
they bring to the same series of natural facts. A complete
series of comparisons should be made between these two
heads so seemingly different. It will be as well to work at
such a series of comparisons with an anatomy open beside
one, and to notice : first, that the discrete oblong eyebrow
swelling in the Greek head, becomes the rather ragged and
ill-defined drooping eyebrow of the Carrière, in which the
upward trend in the middle, so evident in the Leonardo, is
scarcely marked by a horizontal half-tone ; that it is due to
a flat plane on the frontal bone, and not at all to the orbicularis
muscle. Indeed, in the Greek and Leonardo heads we have
no, or next to no, indication of the existence of this muscle—
unless the sagging of the skin under the eye be assumed to
show its lower limit. In the Carrière we may almost discern
a faint desire to show this circular or oval muscle, which
makes such a very evident ring round the eye in all plates
of muscular anatomy. One can trace in the Carrière a
circular brush-movement all round the eye space, whereas
Leonardo seizes—one might almost say—on every occasion

of traversing this circumferential ordering with radially modelled forms. To engender rhythms in an indirect way, to weave them out of contradictory terms, may very well be said to be the appanage of sculptural rather than painting vision. And I feel almost inclined to lay down the seeming paradox : that sculpture is less of an anatomical art than is painting ; for the main glyptic elements of form are more frequently opposed in direction to the anatomical elements than agreeable to them ; though, of course, this statement must not receive the force of absolute law. Anatomical sculpture tends towards the aglyptic (non-sculptural) modelling of Rodin, in which the forms largely follow the anatomical directions. In reality the student should carry out for himself such a reasoned series of comparisons between the works of different artists ; it is but a matter of application to do so, and it is the best way to become acquainted with the essentials of construction, which he will then re-edit according to the promptings of his own spirit. It is really unnecessary for me to continue to carry out such comparisons for every part of the face, and still less to do so for every part of the body. It is hardly an exaggeration to say that the old man's head by Leonardo contains every constructional fact that will ever be required ; when the student has reasoned out the cause of every detail of the modelling he will be more *au fait* with his subject than any amount of verbal description will ever make him. Such research is in no way difficult, it is but tedious ; or, in reality, it should not be so ; if the postulant is a true artist such work will be continually filled with interest for him. The shirkers of study should be eliminated from the ranks of art ; for again I say : artists are both born *and* made.

It is the absence of instinctive comprehension of the so often hostile nature of glyptic construction and anatomical construction that prevents so many comparatively able

artists from becoming sculptors of value. That is why such works as the bronzes of Leighton, quite admirably modelled in their way, remain negligible as sculpture. For the same reason all his ' classicism ' is pseudo-classicism ; he is just about as far from the classic spirit of plastic art as he well can be. His pictures are British illustrations of what a British mind conceives the outside of classic life and mythology possibly to have been. The classic turn of mind that conceived things naturally in a glyptic way was never dreamt of in the philosophy of Leighton. I remember years ago, standing in astonishment in the outer print room in the British Museum, in astonishment at the unhappy neighbouring of drawings by certain Italian masters and of some by Leighton. It was a comparison that the organizers of that exhibition of ' recent acquisitions ', might well have spared the unfortunate British artist. I had never before fully realized the weak indecision of his drawings, not even upheld by the *fougue*, the enthusiasm of such aglyptic artists as Delacroix whose unabsolute and erroneous line one is willing to forgive in return for the impassioned fervour that presided at its birth.

.

It is hardly within the province I have traced out for myself to enter into such questions as the differences between the shapes of the male and of the female form, or between either and that of the child. Books on drawing are often filled up with such evident comparisons. If the seeker of artistic honours, or, shall we say ? leaving the question of honours aside, the student who wishes to model or to paint successfully, if he is not capable of noting such evident facts for himself, he had better devote his attention to a less arduous career than that of the artist, a career far from being the dilettante affair that so many, who rush into its practice and so debase the level of excellence, seem to think it. Art is

an aristocratic appanage ; when practised by the greater
number, it becomes bourgeois, loses distinction, and, so,
dominating magnificence. At least this would seem to be
true of such countries as those of Europe, where art is a thing
more apart from life than it is, for example, in Japan. I had
chosen some reproductions of child-form for inclusion in these
pages ; but on second thoughts I will refer my readers to
the works of those who have preceded me in writing on
figure-drawing. Who does not realize that the head of an
infant is proportionally larger, with reference to the body,
than it is in the adult ? Who does not realize that the cranium
of a newly-born child is proportionally much greater, in
relation to the face, than it is in the grown man ? Who, again,
does not know that an infant's limbs are simpler in surface
form than those of a trained athlete ? Similar remarks may
be made to an indefinite extent ; and, when printed, only
serve to encumber the pages of the book. Such observations
are easy to make and differ essentially from that type of
observation which would seem to be as easy and yet is not ;
the observation, say, of the shape of the frontal plane. Why
it should require a trained artist to observe the main direction
and rhythm of the forms of a thigh, I am at a loss to explain.
Yet it seems that it is so. Therefore I have specially treated
that class of facts in this book.

.

Something still remains to be said concerning the arms and
the hands. Concerning the arm much has been said already
with regard to drawings by Michael-Angelo and by Degas
(pp. 121 et seqq. and 227 et seqq.). I will add here a small
but illuminating study from one of Leonardo's manuscripts.
It gives a good example of the analysis of the relative positions
of the ulna and radius in that particular pose. The mechanism
of the rotation of one bone round the other in supination and
pronation of the hand—movements which do *not* take place

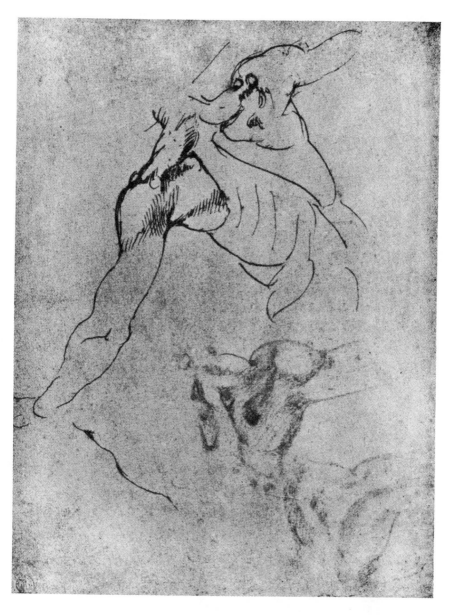

FIG. 102. Study of arms and torso by Michael-Angelo

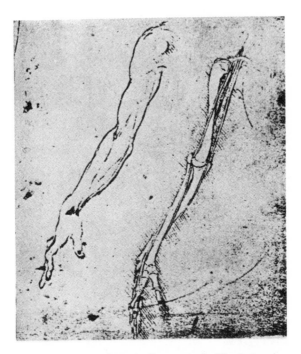

FIG. 103. Study of arm by Leonardo da Vinci, showing
rotation of radius round ulna in pronation of the hand

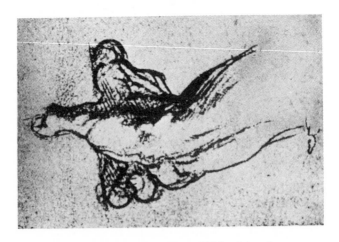

FIG. 104. Hand study by Michael-Angelo

at the wrist but at the elbow-joint (Fig. 103)—is discussed
fully in any good artistic anatomy. I need not repeat the dis-
cussion here. The musculation of the forearm is exceedingly
complex, complicated as it is by the spiral twist normal to
the arrangement of the muscles in any other pose than that
rather unusual one of complete supination with resulting
parallelism of the radius and ulna. As many times as I have
learnt the muscular anatomy of the forearm so many times
I have forgotten it, and I find that at the present moment
I get along very well without that knowledge, although it
may be arguable that to have once acquired knowledge leaves
one in a different position from the man who has never ac-
quired it, even though later the acquisition may seem to be
wholly lost. Here, as usual, I retain in my mind such a
scheme of the arm's construction as I have indicated in
Figs. 52, 54, 75, and 76. If I desire more detailed exactitude
I take my information from the model. Once its mechanism
is fully understood, we can draw a forearm. Perhaps this
thorough understanding of the mechanical theory is only to
be obtained by a detailed study of the muscles, and so we
arrive at the need of making such a study at least once.

Fig. 102 shows the relation of the arm to the trunk un-
usually well. Michael-Angelo was evidently intent on making
a study of the junction of the arm with the torso, so in that
part of the drawing only has he hatched the form (I have
not written shaded, for the hatchings are not indications of
shadow but of plane direction ; some of the darkest touches
being on the upper surfaces, whereas the ' shading ' on the
under sides of the reliefs indicates a top lighting). We see
from this drawing how intensely he realized that the arm does
not leave off at the arm-pit, or somewhere on the deltoid.

I have other reasons for reproducing this study. On
p. 287 I spoke of the sweep of the main rhythmic movement
round to the back. The lowest lines of the drawing may be

used to illustrate this point. One sees the *souci* of this move-
ment of form betrayed in the four or five lines which indicate
the curved shape of the external oblique (just above the hip).
The lower line of the muscle is the continuation of the same
pen-stroke as was used to suggest, possibly, the last floating
rib. Michael-Angelo was so imbued with the continuity of
all the forms up and down and all round the body, that he
found himself irresistibly compelled to continue this pen-
stroke. At first it was the indication of a form in the middle
of the back. It went on in such a way that it became possible
to co-ordinate it with the subsequent shapes of the front of
the body. He is so exercised about them, even while drawing
the middle of the back, that he does not wait to take his pen
off the paper (the hitch in the line corresponding to no
natural form, but simply to the necessity of commencing the
under profile of the external oblique a little lower down)
before proceeding to carry the rhythm forward to where it
necessarily disappears round the front of the figure. The
solitary line below and to the right is a noting of part of the
stable sacral triangle of which I have so often spoken. At
the same time it contains in its lowest part a suggestion of
the gluteal volume, and so a commencement of the pelvic
pose. It should be noticed that in a study of a fragment, like
this by a master, great care is always taken to indicate the
placing in space of the subsequent undrawn mass. In this
drawing the front line of the neck is hooked backwards,
while the right-hand profile, of which hardly an eighth of
an inch exists in the original drawing, is carefully finished
off in such a way that it is quite clear that the undrawn head
is turned to the right almost to its limit of deflection from the
normal position, and that its vertical axis makes an angle of
some 30° with the true perpendicular. The plane of the face
is about parallel with that of the paper. All these data are
to be deduced from the way in which the last lines of the

drawing leave off ; they constitute so many continuations of the system of rhythms already completely determined in the fragment of the drawing that really exists. Pose a model according to this torso study, and you will find that no other pose of the head gives a satisfactory result. That pose alone is the ' logical ' sequence of the system established. In a similar way, at the bottom of the drawing, Michael-Angelo leaves off so that the pose of the pelvic mass is completely indicated. It is also well to notice that in the scarce dozen of lines which indicate thorax and loins the rhythm of the backbone is strenuously marked. The volume of each side of the thorax is placed with reference to it, the near side being seen full on, the far side in foreshortening. It should be fully realized that the sort of spherical triangle which constitutes the far side of the thorax in the present drawing *is* the perspective portrait of the surface which constitutes the near side, on which the three or four rib lines are traced. I insist on this point because it is so seldom recognized ; those few of my readers who do recognize this will forgive my repetition.

A few words must be added concerning the hand. Once more : It must be looked on as part of the arm, and not as a separate object. We are impressed with the continuity of hand and forearm in the powerfully foreshortened study by Michael-Angelo reproduced in Fig. 104. The oval mass of the abductor pollicis—and the opponens pollicis—in the ball of the thumb follows straightway from the strained shape of the tendons of the flexor carpi radialis (the important muscle which, on the side of the radius, flexes the wrist—besides pronating the hand, and helping to bend the elbow-joint) and those of the supinator radii longus, which is one of the principal weight-carrying muscles, and so plays an evident part in moulding the general shape of the arm. One of the

most important features of the hand, the ball of the thumb, is seen to be in direct formal relation with one of the important formal features of the forearm.

The thumb and the ball of the thumb are however exceedingly mobile relatively to the rest of the hand ; that is of course why I drew attention rather to their connexion with muscular forms of the forearm than with the more rigid construction of the skeleton. As the hand and arm are not called upon, in man, to support the weight of the body, this design, lighter and more supple than that of the ankle region fulfils the needs of the situation. The mass of the eight carpal bones—which for our purposes we may look on as one—is shown in the Michael-Angelo studies reproduced in Figure 105 ; especially in the less-shaded study to the right. The carpals—with the heads of the metacarpal bones—are the cause of the oval light extending a little way down the back of the hand from the wrist. This mass of the carpals is in close conjunction with the end of the radius (at the wrist the ulna, the important bone at the elbow, has already dwindled to an almost negligible quantity). It must be understood that only flexure and a limited side-to-side movement take place at the wrist, hence *any turning movement of the hand, of pronation or of supination, of turning the palm downward or upward is necessarily accompanied by complete changes in the modelling of the forearm*, owing to the rotation of the radius round the ulnar, which rotation tends to make or unmake a spiral arrangement of the muscles and tendons. It is these muscles, the extensors and flexors, which govern the movements of the fingers, except those of separating and bringing together which are governed by the small muscles in the body of the hand. We thus see another reason for considering hand and forearm as closely associated. Indeed, the movements of the fingers are the very *raison d'être* of most of the forearm muscles. These fingers are in their simplest expression a

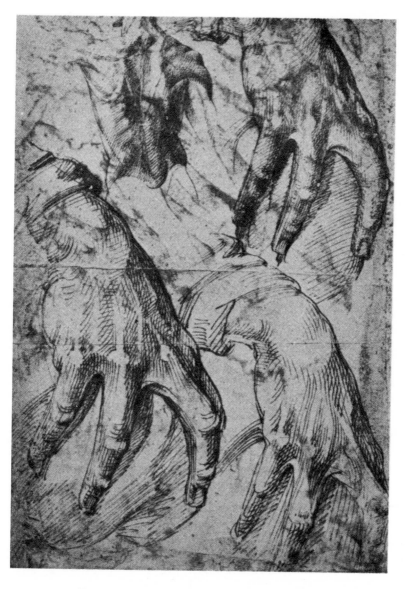

Fig. 105. Hand studies by Michael-Angelo

series of hinged rods with several joints. This fundamental condition of their design should always be kept in view while drawing them. If the palm of the hand is flattened out, the first row of knuckles and the subsequent finger-joints make up a set of simple hinges in rods that may be considered as being square in section. Consequently the axes of all these hinges will be subject to the ordinary laws of linear perspective, as will be readily understood from the diagram (Fig. 106).

To this simple diagrammatic expression may be added the variations which ensue from curvature of the palm, as, for example, in the Michael-Angelo drawings here reproduced. But in any case do not forget that there is no lateral flexibility in an individual finger. The fingers may take up a rather complicated fan-like arrangement, starting mainly from the joints between the metacarpals and the phalangeals; this fan-like distribution may be complicated by various flexures (as in the present

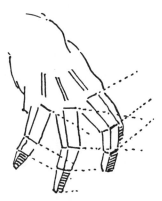

Fig. 106. Diagram of knuckle-joints in perspective.

Michael-Angelo drawings), yet each finger remains strictly rigid laterally, all its three joints fold in the same plane, consequently their axes converge to the same vanishing point. According to whether the palm be flat or curved this vanishing point is either the same for all the fingers or each finger has its own vanishing point proper to its own system of parallel joint axes. It is difficult to exaggerate the squareness of fingers ; it is always well to bear an absolute squareness in mind and, after having resolved the constructional problem by its aid, to bring to such squareness a just amount of needed grace. This way of conceiving the drawing will obviate the multiplication of unconvincing hand drawings

that are, alas ! but too frequent. It is evident that similar remarks may be made concerning the toes.

Rather for their interest than for any clear idea of their instructive utility I am reproducing a page of hand studies from the Mangwa of Hukusai. They are at least suggestive of a field of hand-pose almost unexploited in Europe. Their expressiveness cannot be denied. I trust my readers will not use against me the evident violations on the part of Hukusai of some of the rules concerning finger construction that I have just advanced. In spite of his so-called realism that so provoked the adverse criticism of the Japanese critics, Hukusai had behind him all the tradition of Japanese art, a tradition which consists in a complete plastic system of interworking modifications brought to the natural form, or at least to the natural form as we perceive it. The modifications brought to the finger construction by Hukusai are of the same nature as those brought to all the rest of a Japanese drawing. A Hukusai hand which, as it is, excites our admiration, would appear ludicrous if attached to an arm drawn by Michael-Angelo or Leonardo. The Far Eastern artist deals in a succession of curved surfaces rather than in an arrangement of planes, also his hypotheses concerning perspective are not at all the same as ours (see p. 128). It would thus be unreasonable to apply my statements made on p. 92 to his work, or, inversely, to use the success of his work in order to disprove the truth of my statements made for the use of European students and not for Japanese, to whom I should hesitate to dictate in spite of considerable study of their work, unless it be to cry out against an unfortunate and mistaken tendency that they are displaying to imitate our artistic failures and incompleteness. One thing may be studied from the Hukusai drawings ; a clear marking out of the main volumes ; and a caricatural simplification of the forearm may well be turned to European account, if the necessary modifications

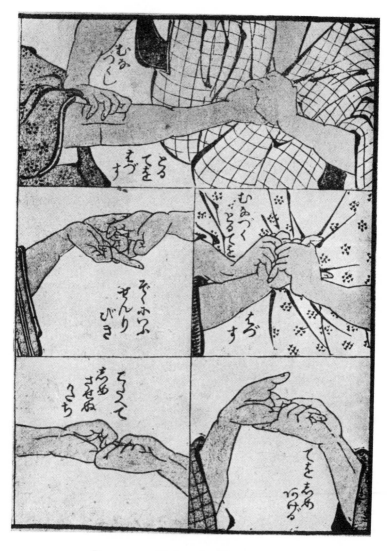

Fig. 107. Hukusai. Hand studies

Mangwa

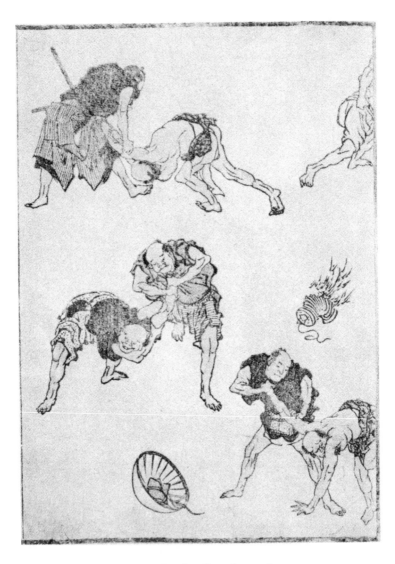

FIG. 108. Studies of wrestlers

Hukusai. Mangwa

be made. Hukusai's arm is quite analogous to my diagrammatic analysis in Fig. 51 of the resolution of the forearm into two parts, the first half down from the elbow full and fleshy, the second straight and thin where the radius and ulna are subcutaneous or only sheathed in tendons.

.

Perhaps more use can accrue to the European student from the study of such whole-figure drawings as are reproduced—also from the Mangwa—in Fig. 108. The top middle figure is very instructive. The twisted volume of the trunk is an example of solid draughtsmanship quite rare among Japanese works, which—with the exception of a few masterpieces—are generally lacking in solid conception. The different volumes of this wrestler's trunk are most clearly inserted one into the other, one feels intensely how the thorax comes out from within the shoulder mass, and in turn, after becoming the abdominal mass, fits down into the forms of the pelvis. The back and sides of the leg are, too, well marked in this figure.

.

We have seen many examples of Michael-Angelo's complete detailed knowledge of the figure. The inevitable fault of the student is to include too much detail. As a palliative to what may be an unhappy influence of such complex work I have given diagrammatic simplifications made by myself of some of the drawings. But, after all, I may not be believed ; it will be better to reproduce one or two drawings by Michael-Angelo himself in which he has limited expression almost entirely to position in four planes : back, sides, and front ; or to a simple line contouring of main masses. It would be a good exercise for the student to apply my statements concerning construction to a careful examination of these drawings (Figs. 109, 110, 111, and 112).

It may be considered curious to include a study of

drapery in a chapter devoted to anatomical construction. But in so doing I am faithful to my creed of uniting, as far as possible, immediately interrelated causes and effects. On p. 305 we have noticed how the external oblique and abdominal forms dragged away from the iliac spine ; the soft forms of the body behaved exactly like so much drapery.

The principal difficulty in drawing drapery is that caused by the frequently large number of folds. We are simply apt to lose our ' place ' in drawing them. Of course one essential of drapery-drawing is to have an intense feeling for the weighty fall of the masses, we must continually bear in mind the advice given on p. 96. This fall is modified by the stiffness more or less great of the material ; modified in a way or in ways long to describe but easy to understand.

I am periodically asked of what use it is to learn to draw the nude if one only means to draw the draped figure. In the first place the reply to this question is implicitly given on p. 164 ; one does not learn to draw one thing or another, one learns to draw, and the best school of draughtsmanship, for the reasons already advanced, is the nude. People who learn to draw one thing only, have not learnt to draw, they have learnt a trick or tricks for doing things ; to them is due in great part the mass of inferior ' art ' by which we are overwhelmed. I personally refuse to have anything to do with them and their clever tricks. To this class belongs the great number of painters who are celebrated for doing something ' so well ' (water, sunsets, Greek drapery, and so on) according to the popular opinion, which simply means that they have specialized in turning out a tidy technique adaptable to that particular subject ; they are specialized workmen, that is all. A genuine artist takes another view of art, of the universe, of the dignity of his attempt, even of the dignity of his failures.

FIG. 109. Nude study by Michael-Angelo

FIG. 110. Nude study by Michael-Angelo

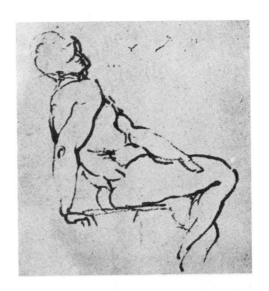

FIG. 111. Nude study by Michael-Angelo

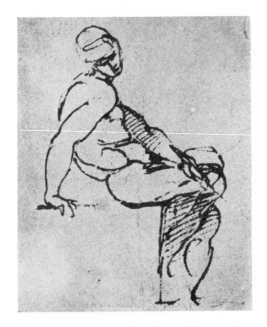

FIG. 112. Nude study by Michael-Angelo

But there is a more evident and cogent reason for the study of the nude before draping it. Drapery hangs free from certain supports. Let us consider a standing figure simply draped with a fairly soft material. The folds will hang free from the shoulders behind to the heels, will hang free unless slightly pushed out by the buttocks. If the figure stoops forward the folds will only hang free from the buttocks to the heels ; along the back the drapery will lie close and very possibly foldless. Now surely it is evident that before we can draw the surfaces of suspension and their edges from which the folds take nascence, we must be able to draw the underlying nude. Not only that, but we must be able carefully to construct the rhythmic relation between the placing of, say, the shoulder surface of suspension and the buttock surface which perhaps pushes out and modifies the direction of the folds. But this means nothing else than knowing how to draw the nude, it is the eternal refrain of this book. When you are a master of plastic rhythmic relation you are a great draughtsman. If you ignore the establishment of rhythmic relationship between the several parts of your work, however little you may deviate from the rhythmic placing that you might have conceived but did not, your work becomes negligible, does not count. Skill or tidiness or both may deceive the ill-advised critic, but will deceive him only ; the clever brush-work of a Sargent will remain clever brush-work, while the painting of Manet remains to be respected in spite of its many shortcomings ; Manet remains as a personality without whom one can no longer write the history of the development of art, because he brought to art a novel study of the fundamental rhythms of natural appearance. Sargent dealt out to us the brush-trickery of an illustrator, fitted out with much superficial theft from the aforesaid Manet. If the surfaces of suspension of your drapery are not carefully co-ordinated in their

placing according to the rhythm you have chosen and conceived, your picture will be artistically valueless and unconvincing.

Examine this drapery study by Michael-Angelo (Fig. 113). The folds fall behind straight from the shoulders. That part is simple. A secondary system of folds falls from the forearm and in part joins up with the back folds. Were the tissue perfectly supple we should have unbroken, nearly pure catenary, curves as a result. (A catenary curve is the curve traced by a flexible cord or chain hanging freely between two points of suspension on the same horizontal line—this gives its simplest form.) As it is, the system is complicated by breaks in the curves due to sudden bending of the material in one place and its resistance to compression stresses elsewhere. It is useless to enter into verbose description of the kinds of rupture of the curves that belong to different types of tissue. They may easily be studied.

As in everything else connected with art, an underlying scheme of simplicity must be sought for in drapery. The multitudinous folds of the Parthenon Fates (?) fall into very simple great plane systems. The appended analysis (Fig. 115) will at once make this evident. There is always a tendency to lose sight of a change of great plane direction while carefully following up the direction of a single fold or of a group of folds. This tendency must continually be counteracted by keeping before the mind the essential movements of the masses. As a general rule simple drapery is more satisfactory in painting on account of the breadth of effect that is obtained by employing it ; the innumerable folds of the drapery of the 'Fates' would seem to be more fitted to use with the more restricted means of expression in sculpture. But, after all, this kind of rule is only made to be violated. In the study attributed to Leonardo (Fig. 116) the arrangement reduces itself to the two-leg volumes, the festoon between the knees,

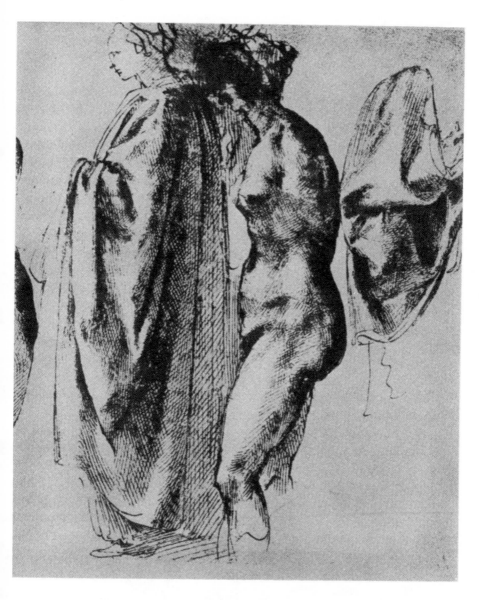

FIG. 113. Study of drapery by Michael-Angelo

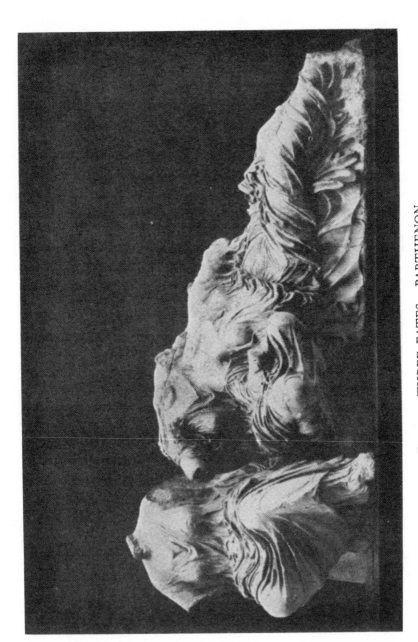

Fig. 114. THREE FATES. PARTHENON
British Museum

and the diagonal from the left knee to the right foot. The rest is variations played on the main theme, to which we must perhaps add the plane lying on the floor. It should be noticed that the forms of the knees are quite evidently suggested, as is the shape of the upper surface of the right thigh (of the model).

The different methods of treating drapery artificially at different periods and in different countries are naturally in harmony with the particular aesthetic convention in vogue at the time and place. I must not go into a comparative

FIG. 115. Diagram of ' Three Fates ' showing main planes on which the arrangement of the drapery is based.

examination of them here, any serious student of art will be able to make the necessary observations for himself during an afternoon's visit to a museum. The utility of practising on drapery studies from still-life arrangements cannot be over-estimated. In working from the living model, haste must be made to get in the general scheme of the folds as quickly as possible; subsequently we may add detail to that scheme. For this reason a small drawing is almost a necessity, a drawing not too big to be completely executed during the immobility of the model. Freedom of line impregnated with the flowing quality of the original is more to be sought perhaps than strict accuracy in this matter.

In the drapery study by Michael-Angelo (Fig. 113) the

way in which he has fitted the features to the curved surface of the face is an interesting demonstration of the fact that he conceived his modelling as so many deviations from the great surfaces, were any additional proof needed.

Recapitulation.

A capable figure-draughtsman retains in his memory a general knowledge of the more important constructional facts of the body, allied to a familiarity with its ways. Art can no longer be divorced from science, but just equilibrium must be maintained between the two. Critical visual memory is fairly general, constructive visual memory is rare. The greater part of art instruction as given is positively harmful. Only the most important anatomical facts are here presented, in order that the student should retain the fact of their importance. Minor facts he can obtain from anatomies, and from observation of the model. Leaving out apropos is an important artistic element. The importance of the pelvic construction is again mentioned. A schematic figure of the main constructional facts is given, and described. Laws in art should never be considered as absolute in their written form ; almost any law may be broken on occasion. Rhythmic curves unite the different parts of the body. The draughtsman incapable of seeing these curves is no artist. Rendered in one or another aesthetic they may tend to the straight or to the curved. Balance of parts is the soul of drawing. The great planes of the body have only a secondary relation to anatomic fact. It is necessary to understand the mechanics of the frame. No amount of anatomical knowledge enables the artist to dispense with the living model when a naturalistic aesthetic is in view. It is possible to possess great anatomical knowledge and no knowledge of construction. The main curves of the surfaces of the leg are traced and applied to a drawing by Michael-Angelo, in which the balance between anatomy and aesthetic rhythm is pointed out. The front of the leg and thigh is the important constructional surface, especially as seen from the side. The back of the trunk is the important constructional surface. The transition from front to back takes place over the obliques. To Leonardo a profile did not mean the division between figure and background, it meant the limit of an aesthetic mass. The pyramidal mass of the foot is inserted between the ankle-bones. More drawings by Michael-Angelo are given showing the clear distinction between back and front. The ' clasping ' of one volume by another is studied. The object of a painting is to show a body in relief . . . (Leonardo). Art is varying forms of stating rhythmic relations. We sometimes change a detail of the pose given by the model in order to complete a simple rhythmic arrangement. A drawing bereft of a single simple underlying scheme of rhythm is an unmusical poem. That sense of co-ordinated rhythm lacks in the English cathedrals. Two

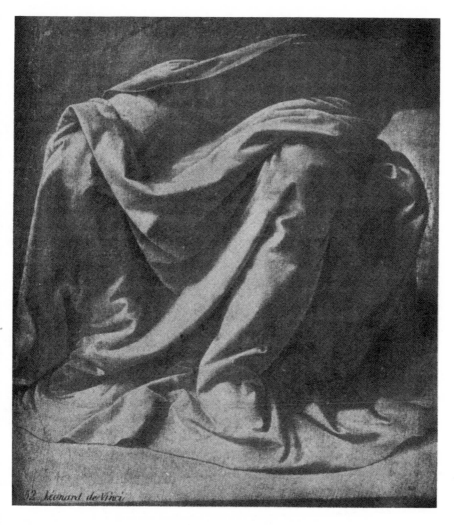

FIG. 116. Study of drapery by Leonardo da Vinci

anatomical plates from Vesalius are reproduced. They show the solid shapes of the different parts. The arm system includes the shoulder-blade and the collar-bone. We may study Michael-Angelo without imitating his formula of violent contrast. The cylindrical neck appears conical from one view. The skull is a sphere balanced on the spinal column. The face is an addition. Greek, Italian, and Japanese formulae of face representation are compared. The Greek formula was very succinct yet naturally satisfying. The Japanese was ideally (but less naturally) satisfying. The Leonardo exceedingly detailed. The scheme of construction by mass of the face is given, and discussed. It is essential to throw all parts—even the smallest—of a drawing into perspective. Mouths and eyes are too often drawn ' flat ', without perspective. Evident foreshortening is comparatively easy, in spite of the common belief. It is very difficult to render the subtle foreshortening of the ' interior ' modelling. One of the author's drawings is analysed in the light of anatomical construction, and reasons given for modifications in the line. The author's direct line shows clearly the exact working of his thought and emotion. In drawing we maintain a continuous balance between : (a) type knowledge ; (b) knowledge acquired at the moment ; (c) aesthetic judgement concerning modification to be brought, here, to type ; (d) use of results of those three in light of aesthetic aim and decorative exigencies. Drawings of masters should be carefully analysed from constructional point of view. Rhythm is the success of Rodin's drawings. The frontispiece by Carrière is discussed ; it is naturalistic though very personal in technique. The rhythms are very natural ones exaggerated, they are not those of Japan. The old man by Leonardo is compared with the Puvis de Chavannes by Carrière, who was less preoccupied with glyptic notions than was Leonardo. Leighton failed to recognize glyptic construction, his ' sculpture ' is unsculptural. The hatching of many of the Renaissance drawings is not shading but indication of plane direction. The continuity of formal rhythm from back to front is well shown in the Michael-Angelo reproduced. It is necessary when making an incomplete study to indicate the direction of the subsequent masses not drawn. Pronation and supination of the hand change the forms of the forearm. The knuckles must lie in linear perspective. Some hand studies by Hukusai are reproduced, in them the main volumes are clearly marked. Some slight studies by Michael-Angelo are reproduced to show how simple was the basal conception to which he super-added complexity. Draped figures cannot be satisfactorily drawn without complete knowledge of the nude. The artist who only learns ' just enough ', who spares his pains, is no artist. An underlying scheme of simplicity must be sought in drapery. The most multiple folds are conceived on a relatively simple scheme. Freedom of line is important in drapery. Drapery falls from determined surfaces and points of suspension.

X

LANDSCAPE-DRAWING

IN the opening pages of this book I stated that the best
school for every kind of drawing is the nude. Manifestly
one could write a whole volume on the special branch of
landscape-drawing. Matter is by no means wanting. Com-
parisons can be instituted between the multiple technical
modifications ; pages may be filled by describing the differ-
ences of form between elm and beech, granite and sandstone ;
' recipes ' can be and generally are given for ' doing ' trees,
water, and so on. Needless to say I eschew all these last.
Detailed treatment of rock, tree, and plant construction,
of cloud and of river, of the restless sea must, for the
moment, be left aside. The history of landscape-paint-
ing is not my present aim, and besides, the separation of
landscape-drawing from figure-drawing is a seductive but
quite false classificatory distinction. At any period the
methods of treating landscape and figure are necessarily
analogous one to the other. The really great landscapists
have dealt with the figure as well. Figure-paintings by Turner
are not lacking. Was Le Poussin—who potentially contained
Corot—a figure painter or a landscape painter ? And Corot
himself has left figure-work as charming and distinctly his
own as was his landscape. What a considerable part figures
play in the landscapes of Claude ! Who will undertake to
divide the work of J.-F. Millet into such separate portions ?
Hukusai, Godoshi, all the Chinese and Japanese worked as
readily in one as in the other. One is inclined to fancy
that the distinction is encouraged by those people who are

incapable of satisfying the severer exigence of figure-work, and who are inclined to claim as a praiseworthy quality their own incapacity. Remark that all this is not a denial of the fact that a man may be so constituted that his best aesthetic expression lies in the field of landscape art. Turner was quite right to devote himself to landscape-painting ; his gift was to trace on paper and on canvas the endless wonder of mist and light, of night yielding place to the prepotency of day, of the steadfast pausing of the Alps. The narrower horizon of figure-painting would have cramped the motion of his spirit. But Turner had passed through the academy schools, and Turner could draw very excellent studies from the nude ; one, in the national collection, of a man lying on his back, one leg in the air and strongly foreshortened, I specially remember. I think you will find rendered in it all the constructional facts with which I have dealt in these pages. But then Turner was a landscape artist, so no remark is made about a drawing which would attract considerable attention did it bear the signature of, say, Titian. The world thrusts artists into pigeon-holes properly labelled. 'He can do one thing ; ergo he cannot do the other,' is the popular logical form. Unless the right thing to do—i. e. what everybody does —be to stand in mute admiration before the universality of the genius of a Leonardo. Then the very mediocre science of Leonardo is artificially bolstered up to the level of his incomparable artistic gift. So consequent is humanity !

I have known artists (?) who obtained a seemingly better result from figure-work than from landscape ; their landscape being what is known in British artistic circles as ' tight '; that is, not possessing a suggestive looseness of treatment that satisfactorily rendered the multiple aspect of leafy trees and rippling water. The explanation is simple ; instead of having learnt how to draw, such an ' artist ' had learnt how to make a drawing from the human figure ; and the method that was

sufficiently adaptable to the apparently less complex human figure did not adapt itself to landscape work. That is the inconvenience of learning how to make a drawing instead of learning how to draw.

.

Some of the most remarkable European landscape-drawings we possess are by a man who is classified as a figure painter. This is annoying. His name is Rembrandt. Had he, being a figure artist, the right to produce remarkable landscapes ? I do not venture to decide.

My special reason for reproducing this drawing by Rembrandt (Fig. 117) is that it is the only example I remember which has a curious bas-relief quality in the drawing of the trees. In the trees on the left each mass of foliage is distinctly isolated and then, so to speak, flattened as it would be in a bas-relief in stone. This effect is due technically to the thick line on the shadow side of the mass, and the thin line on the light side, and also in part to the probably accidental doubling of the profile on the light side. Probably, also, the result itself was unconsciously obtained, and in that sense unintentional. I find it far from displeasing, it lends to the forms a feeling of architectural stability and decorative value by suggesting—in a way analogous to the compositional methods of Puvis de Chavannes (pp. 93 et seqq., 244)—the existence of the volume in the round without at the same time destroying the sense of the surface of the picture. It is usual in decorative work, such as that of posters, either to work quite flat, or to deal in an aplastic pseudo-modelling obtained by a use of light and shade which has no reference to the surroundings, often a plain flat tint. The suggestive comprehension, by means of the plastically eloquent outline, of the Greek vase is not understood, on account of the absence of the plastic sense of conception (p. 87) ; nor is the non-effect modelling of the Italian drawings—Fig. 72, for

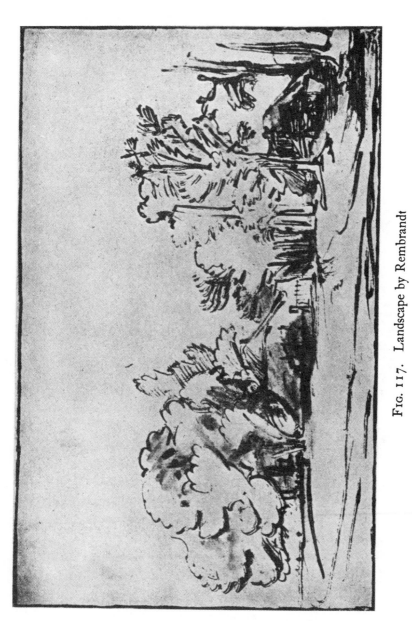

FIG. 117. Landscape by Rembrandt

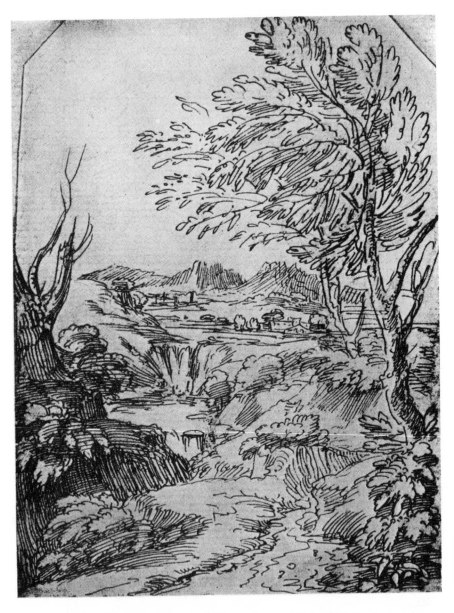

Fig 118. Italian landscape. Pen drawing

example—turned to account in such work. There is every room for improvement in poster work, but I cannot treat of it here.

Few draughtsmen have better rendered than Rembrandt and Cézanne (see p. 288, *Relation in Art*, and pp. 28, 46, and 102, *Way to Sketch*) the stable planting of a tree in the ground, the columnar nature of the trunk solidly fixed to the earth. This is specially remarkable in the present drawing. Fig. 118, a landscape of the Italian school, is by no means negligible as work, but notice how undecided and floating is the union between tree-trunk and soil, how devoid of weight and stability the tree-trunks are here, when compared with those of Cézanne and Rembrandt.[1] Even the great Turner does not leave one fully satisfied on this score. It is true, though, that his method of rendering solidity amounted rather to a complete suggestion of its possibility, a possibility so often shrouded in aerial doubt. To this dream quality the absolute materialism of Cézannian technique would probably prove harmful. A delicate equilibrium is needed between reality and the unreal. In the 'Schaffhausen' reproduced there is no question about the successful rendering of the various shapes of hill-side, buildings, and receding river ; yet at the same time the line which indicates all these things is uninteresting, is really a scribble. Turner was not a formal artist ; he was not interested in the way itself of expressing shapes. So long as they were expressed it mattered little to him how it was done ; any line was good enough for his purpose. In some of the 'Liber Studiorum' plates a pure and careful line is used with much address, in, for example, a certain classic view of ruins with a peacock perched on a fallen fragment of frieze in the foreground ; but the line is excellent, descriptive, yet not lyric. In the 'Schaffhausen' we see how useful this indecision of line is in reproducing the unlimited detail of Nature, or, I should say, the suggestion of

[1] See Fig. 117 of present volume, and plate facing p. 288 in *Relation in Art*.

it. Everything in the drawing conspires to that end, the very dragging of the water-colour washes adds a feeling of complexity due to the ragged edges. Hardly any line is clean and sharp, it is broken in its course by saw-like jagging, by the interrupted rendering of dots. Nature, to Turner, was an immense congeries of parts ; he was far from imposing on her any reduction of her opulence to a scheme that should impoverish her wealth. Painting without scheme is impossible. Some scheme Turner had to find ; he took refuge in that most flexible of arrangements, a curving colour modulation ; the scheme itself was suggestive of unlimited extent of ever-subsequent detail.

For Turner the geometric doctrine of Cézanne would have been almost unmeaning ; what had Turner to do with geometric stability, he whose philosophy craved the flowing, the sequent, the unseizable, the ever strange and new ? The bridge across the Rhine is a very apology of a bridge, mechanically impossible ; Turner does not wish us to remain in the faintest degree interested in it ; its only rôle is to offer the slightest of obstacles—as quickly traversed as perceived—to imagination's flight along the curving river away to one knows not what promised regions, filled with veiled and mystic light, beyond the distant hills. Indeed the half-real solidity of all the scene is but an arrangement, but a succession of slightest obstacles without which we should have no interval to traverse, without which he would be unable to paint his idea of indefinite extent wrought through and through with lucent tint. Not so Cézanne. His bridge is a solidly planted and established affair ; it is the reality which he paints.

From this bridge we may learn one of the best lessons that Cézanne can teach us ; we may learn the precise choice of the important note in solid rendering. This he made with unerring instinct. Whatever else failed him, *that* did not. It is due to the insensitiveness to plastic values which persists

in the modern world that people in general see no worth in Cézanne's work. Cézanne treats almost uniquely of the solid factors of appearance, and it is precisely those solid factors which are not appreciated by the average vision. Cézanne eliminates the amusing detail which is all in all to the other critic, hence the latter turns away in jeering reproof from a statement of facts to the existence of which he is blind (see p. 320). It would be astonishing were things otherwise. The tow-path is simply white paper, yet its surface exists, exists on account of the relations established between all the forms which neighbour it, and which are, themselves, determined with amazing parsimony ; the shadow of the gangway on the barge side is all that indicates it, though the cast shadow must be taken into consideration with the dark above the middle of the gangway, with the just-indicated thickness of the side of the barge itself, with indeed everything else, going on from one detail to another, in the drawing. Everything takes on reality by reason of everything else. It is a triumph of suggestion by relation. And not a small part of the relation is the decorative value of the placing of the different elements of the picture. The thing, as it is, forms an excellent pattern. Make a copy of it and then continue some part of it chosen at hazard. Put some detail into the tow-path, draw out the arches of the bridge completely ; you will spoil the picture. As it is, a perfect equilibrium has been established between all its parts. To continue the drawing, as much care must be brought to the choice of the next element handled as Cézanne has himself displayed to bring it up to its present state. It is for a clear and definite decorative reason that he has left the top of the left-hand arch blank, while accentuating the line of smaller arcs of circles just above it. Pass to the next arch, that in the middle ; two dark accents now climb towards the middle but as yet do not join. Finally, in the right-hand arch the

black accent is placed at the summit of the curve. A lesser artist would probably have treated all three arches in the same manner and would have deprived us of the plastic eloquence of this delicate decorative arrangement. Evidently such subtleties of intention cannot be enmeshed in a web of words ; translated into another medium the fine cause of their being is lost, the unerring judgement of equilibrium between decorative intention and solid suggestivity, the consequent choice of pencil-stroke or wash of colour, is no longer to be divined. Cézanne himself told us : ' L'effet constitue le tableau, il l'unifie et le concentre ; c'est sur l'existence d'une tache dominante qu'il faut l'établir.' (Effect constitutes the picture, unifies it, constitutes it ; a picture must be established upon the existence of a dominant *tache*—or area of colour or value.) We see from these lines how intensely he was preoccupied with the decorative foundation of the picture ; it was for this reason that he was, in spite of his keen sense of the solidity of things, a true painter and not a sculptor. From one *tache*, the principal one, another follows as a decorative necessity, a decorative necessity closely linked to the solidity in which the appearance in value and colour finds its origin. Perhaps the great aesthetic significance of Cézanne's work lies exactly in this very close co-ordination of reality and effect, a kind of placing of them on an equal footing, whereas one may almost say that to Turner reality was a necessary evil. After a condemnation of aesthetic discussion Cézanne says : ' Le littérateur s'exprime avec des abstractions, tandis que le peintre concrète, au moyen du dessin et de la couleur, ses sensations.' (The writer expresses himself by means of abstractions, while the painter renders his sensations concrete, by means of drawing and colour.) Effect, playing upon mass, generates the painter's decorative design and so creates sensations in the artist ; this decorative design—which origi-

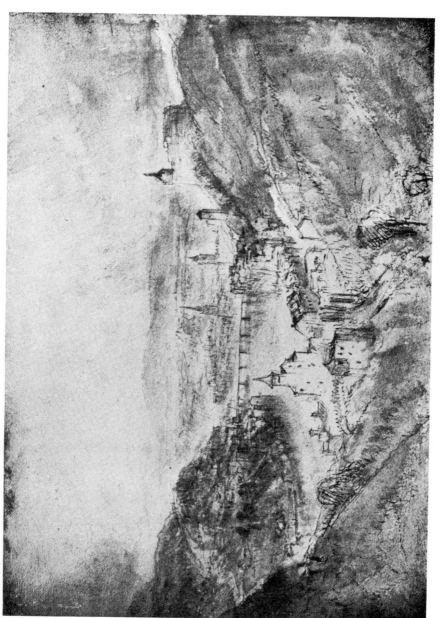

Fig. 119. Schaffhausen. Turner

FIG. 120. Bridge. *Cézanne*

nated in the mass placing—is what Cézanne transfers to the
paper with scrupulous regard to its continued integrity.
Had there been no decorative design before him, he would
have had no sensation to render concrete. This makes
understandable his phrase : ' Tout se résume en ceci : avoir
des sensations et lire la nature.' (Everything reduces itself
to this : Have sensations and read Nature.)

.

This saying is in curiously close relation with the Japanese
claim for the admixture of artistic unreality with inartistic
reality ; though the Asiatic love of abstract thought carried
examination of the matter much farther than ever Cézanne
did. Some of the Laoistic beliefs have already been briefly
sketched (pp. 11 et seqq.), but other forms of intention, other
but all ultimately bound together into one homogeneous
aesthetic, permeate the art of Japan. The Japanese artist
will see such symbolism in the painting of an orchid as the
' cloud longing ', the skyward aspiration of the blade-like
leaves in spite of their drooping earthwards, a symbol of the
heavenly tendency of earthly things. Thus while a European
painter simply strives to reproduce the precise falling curve of
the leaf, the Japanese is dealing with form which should be
in itself a poetic rendering of the struggle between the lower
and the higher ideal. Then his craving for concealed meaning
will lead him still farther to see in the unusual form of an
orchid's flower the tracing of the Chinese character for
' heart ', and so he will bring to bear upon the natural form
such delicate pressures in his transcription as will unveil still
more this imaginary resemblance.

Again he will attempt to find everywhere hints of a
mystic trinity : *ten, chi, jin*, heaven, earth, man. Thus he
will see in the tree-form three types of branch, which he will
of course draw in the given order. The *ten* is the thickest,
chi follows as intermediate, while the *jin* branches are the

final twigs that bear the leaves. Then again the active and passive elements (see p. 351) will be symbolized by light and shade ; so what we take for an amusing design is to the informed critic a complex series of interwoven symbols balanced among themselves by the eternal laws of plastic equilibrium ; symbolic intention and beauty of form and tint go hand in hand. And what a lesson in the sole saying : If the spirit of the artist be not alert, the result is failure (It ten ichi boku ni chiu o su beki) !

　　·　　　·　　　·　　　·　　　·　　　·　　　·　　　·

Japan seeks an imaginary symbolistic unity in the unity of form which in reality joins up the sequence of branch springing from greater branch. Again we are in touch with the fundamental truth of basal rhythm. In *The Way to Sketch* I have spoken of the need of noting carefully how successive branches come out of one another and out of the main trunk ; it is unnecessary to repeat here what I have already put forward in the earlier book. There I have described the state of balance which results between the upward growth of a tree or plant and the ever-acting drag of gravity upon it towards the earth. The forms of a tree are the natural result of such combinations of force and tendency ; the vital force of the tree strives against the hostile pressure of wind, and triumphs or fails according to its strength or its flexibility. Our trees must inhabit a livable world where gravity acts, where winds blow ; and while our pencil traces the shapes due to these divers causes we must keep our minds full of the facts, full of the natural effects of such causes. Our spirit must make our hand its servitor, our hand must respond to each behest of our spirit, the Japanese tell us. That is why it is held to be necessary to feel savage, cruel, and feline at the moment at which one dots in the gleam of light in a tiger's eye. When we draw rocks they must be drawn with apprehension of their nature, whether sedimentary or volcanic ; if

stratified, their stratification must at least be hinted at by the form we trace. If they are volcanic the shapes they assume are governed by certain laws of erosion ; rather exaggerate than suppress these facts.

Art in the Farther East is terribly codified ; as I have said before, we must beware of taking from a system qualities which are only admirable because they are a part of a complete system ; such a page of methods of treating trees as that reproduced in Fig. 121 can be but of little use to the European student ; in his hands, and bereft of the thousand abstract intentions of Japanese work, its teachings can only descend to the level of unjustified method, unless he use them as mere suggestions of treatment which he entirely edits anew. What it is instructive to see in these ways of drawing half a dozen different species of tree, is the use of an artificial parallel, so to speak, to Nature ; artistic unreality is mixed with inartistic reality. The inartistic reality is, first, the unmanageable multitude of detailed facts ; secondly, the indifference of Nature to our limited ideas of decorative validity, although these ideas are based on a part of her immense system. The artistic unreality is : first, the conception of certain laws which impose an order on Nature, an order which is sufficiently simplified in kind to be grasped by us ; secondly, a choice of what, according to these laws, seems to us to be the most important factors of the situation ; thirdly, the invention of quite artificial methods of suggesting the existence of these factors to the spectator (in the accompanying figure we may study a few, a very few, of the technical artificialities which Japan has chosen to adopt for this suggestive purpose) ; fourthly, a symbolism which is again superposed on the method of line, dot, or wash employed ; a symbolism which generally attaches the painting method to the written character, as for example that just cited ; the treatment of an orchid flower in such a way as

to recall the shape of the Chinese character *sin* (𢙢) the heart, with the accompanying suggestiveness of the meaning of the character ; fifthly, it is perhaps allowable to add the very choice made of the object represented—such a choice is indeed ' an artistic unreality '—the pine symbolizing longevity, the bamboo rectitude, the plum-blossom fragrance and grace, the stork and the tortoise again long life, and so on through a formidable symbolistic list. That then is the use to the Japanese artist of such ' copybooks ' of painting methods. He, unlike us, sets out to deal with a very complete science of the language of drawing, a language of which he has to learn both vocabulary and syntax to avoid seeming absurd to people capable of reading it ; there must be an intentional fitting together of all the parts, otherwise his work will bear a dangerous resemblance to the poetic message of : ' The owl and the pussy-cat went to sea in a beautiful pea-green boat ; ' or to the intense meaning of the coherence concerning (or not concerning) ' the great Panjandrum with the little round button atop ' ; it will seem nearly as ridiculous as do those imitation Chinese characters that some enterprising European shopkeeper has had drawn for him by a European artist in order to affix them to packets of tea. An uninformed theft of fragments of Japanese or Chinese technique with a view to engrafting them into European work is just about as dangerous an experiment. Their artificialities have, in their native lands, a secular justification in the innumerable threads which bind them to a symbolism which is one with the philosophical and religious creeds. Exiled to Europe, torn from these associations which are natural to them and are the very causes of their inception, they become meaningless affectations, more or less amusing to the eye, but which more or less shock our desire of naturalism fundamentally dear to us but which it is the special aim of the Japanese to avoid as far as possible.

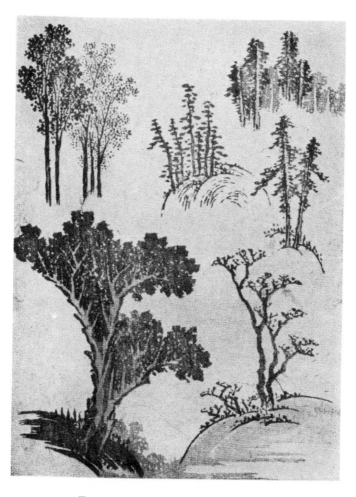

FIG. 121. Japanese tree formulae

Hukusai. Mangwa

In Fig. 121 we have a sample of some of the ingenious ways in which the Japanese have succeeded in codifying certain appearances of trees, reserving to each codification particular handlings of the brush subtly related to the perception of natural shapes which it is *not* the aim to *reproduce*, but of which it is the intention to *suggest* the existence, and at the same time to suggest the relations of these perceptions to the other perceptions of the universe. The danger of isolating one such method and introducing it into European plastic surroundings may at once be seen if we consider for a moment the top right-hand stylization of fir-trees. It will be noticed that all the white (!) trunks are entirely visible, in other words, the artist has completely suppressed all the branches on our side of the trunks! Such an amazing liberty taken with Nature can only be justified by accompanying it by similar conventions throughout the picture. The reason of the suppression is evident ; the fragment of drawing is not an imitation of Nature, but practically a calligraphic assertion of the fact that fir-trunks are straight and vertical, and that, in this particular species, branches come out from them nearly horizontally. The fact that branches come out horizontally towards us as well as laterally is voluntarily suppressed, because if they were represented they would hide the more important fact of the uninterrupted verticality of the main trunk. The drawing is almost a diagram from which certain parts of the original object are left out in order to make others more clear. We evidently cannot play that kind of trick in a picture based on an aesthetic which attaches vast importance to faithful following of Nature. One may almost term the Eastern picture an aesthetic theorem. That it is such a complex abstraction is the reason of its ultimate attraction for the lover of the abstract, for the true worshipper at the shrine of the highest artistic ideals. The imitative art of Europe seems child-like and empty beside

the unlimited purpose and suggestivity of the other ; the
ambition of ' getting things like ' seems such an unworthy
end, so elementary. Yet it is into such a fettered state that
the European artist is born. Unfortunately the greater part
of the teaching of this book may be reduced to instruction
in ' getting things like ', though in palliation of my crime
I will say that much of the matter incorporated has been
learnt from non-naturalistic Asiatic work, and from Asiatic
philosophical speculations. The painting and sculptural
methods of the East are finally founded on the structural
system of Nature, as we conceive it, as both we and the
Chinese conceive it, for both the Chinese and the European
brains are human and only differ in their concepts in, so to
speak, the second degree—thus the European may prefer to
approximate the essence of a perceived structural fact to the
cube while the Asiatic prefers to approximate it to the
sphere ; but the perception itself of the structural fact
remains one identical phenomenon. So the greater number
of the propositions which compose this book are in reality
fundamental ; the artist is free to turn them either to an
imitative use, or, by modifying their presentation as it may
please him, to employ them as symbols of abstract ideas.
That is his business and not mine ; I have often enough
called attention to the different types of modification brought
to the same underlying fact according to whether it is
presented by one mind-type or another.

.

The Italian drawing, Fig. 118, may be looked on as an
honest but uninspired example of pen-drawing. The artist
has very carefully indicated the shape of the ground but has
quite failed to show us the modelling of the foliage. Compare
it with the Rembrandt, compare it with any Claude. The
skilfully drawn festoons of pen-work lie quite flat on the
paper, there is not the slightest trace of recession between the

different masses of branch and leaf. This is the cause of an insipidity that seems to permeate the drawing. The top left-hand quarter of the picture possesses no plastic reality, no backward and forward volume composition has been imagined by the artist, he has filled up his space with pen-lines only endowed with two-dimensional intention. In the Rembrandt the only intention is one of volumes ; I exaggerate of course, all the forms are organically arranged in orders resulting from the essential fan-shaped radiation of growth.

The Japanese fir-tree just dealt with was flattened also, if only from suppression of the nearest branches ; but this flattening could be traced to a complex aesthetic cause. No such aesthetic cause can be found for the flattening in the Italian drawing, it is simply weak. In certain more or less decorative arrangements it may be justifiable to suppress the third dimension suddenly, while treating it elsewhere in the canvas (I have oft-times done so myself of malice pre-pense). But there is no such decorative or abstract intention in this drawing, which really aims at giving an impression of Nature, an impression slightly robed in the technique fashionable at that period. The artist sets out to give us quite a proper account of the recessional shapes of the ground bordering the stream, and he succeeds fairly well, or rather he succeeds in each division of the subject ; yet a comparison with a drawing by Claude will at once show how curiously he fails to give us the *whole* recession of the whole subject. We are in presence of the eternal failing of the inadequate mind to conserve the conception of the whole, of the *en-semble*, while it is dealing with the particular ; the particular shape of a portion of the foreground is understood and carried out, but its relation to the distance, to the rest of the picture, is forgotten, hence the impression of weakness which we get. Many people think that by more violent means, by darker, heavier lines, strength can be obtained ; this has nothing to

do with the matter, such methods only deceive the critic who, as incapable as the ' artist ', and not feeling the need of *ensemble* himself, does not notice the absence of it in the painting. The corner-stone of the edifice of art is total co-ordinate rhythmic relation of all parts. In the present drawing the distant mountains are almost as ' near ' as much of the foreground. When we try to ' go back ' into the picture, as into a Claude or into a Turner, surprising is the difficulty experienced. We cannot pass onward from mass to mass in easy recession. On the other hand, with what facility can we penetrate into the beautiful drawing, ' The Fisherman ', by Claude (Fig. 122) ! Let it not be thought that this difference lies in the fact that Claude has combined wash with his pen-drawing. The difference lies wholly in the conceptive grasp of the artist. Consider for a moment the way in which Claude has carefully split his subject into about eight groups of recessional ' planes '. First the foreground ; then the tree-group on the other side of the river ; after that the bank of the river just after the first bend ; afterwards again comes the river-bank beyond the second bend, and with it may be included the distant bridge (pretty solidly constructed, not a mere suggestion of a bridge's existence as in the Turner (Fig. 119) ; but a bridge realized in a way which would not displease Cézanne) ; the nearer mountain masses then succeed on each side of the drawing ; and then, finally, the distant peak. Each of these separate systems is complete in its own modelling ; each is at the same time clearly detached from, and subtly co-ordinated with the others, both by ingeniously invented transitions and by the decorative relative arrangement of the various groups over the surface of the paper, which forms a foundation on which is built the decorative scheme. The decorative scheme of the other drawing (Fig. 118) was insufficiently thought out ; the various parts, often well enough treated each on its own

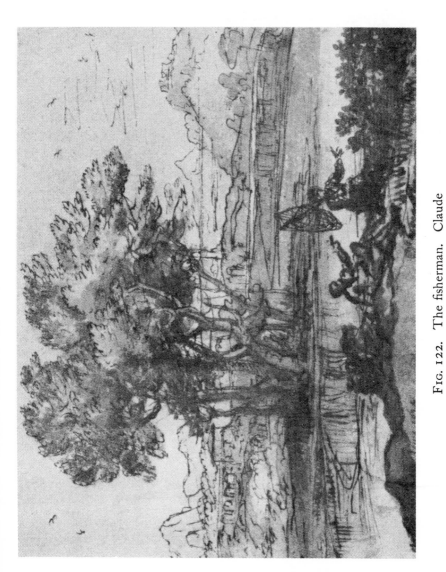

FIG. 122. The fisherman. Claude

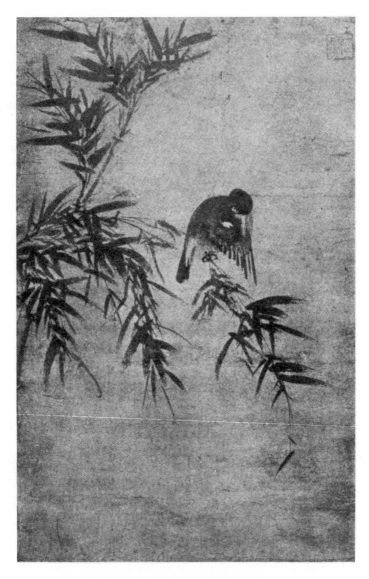

FIG. 123. Bird on bamboo-stalk
Su Kuo

account, were not properly co-ordinated in the artist's mind ;
he only, now and then, and in a half-hearted kind of way,
bothered about recessional composition. Look, on the other
hand, at the magnificent display of third-dimensional compo-
sition in the foliage of the trees in the Claude. Compare it
with the total absence of recessional foliage-composition in
the Italian drawing ; it is only by a difference of handling
that we are able to distinguish between the foliage of the
nearer and the farther tree ; if anything, the farther foliage
sprays appear to be even nearer than those of the nearer
tree. This is flat calligraphic work. In the Claude group
of trees not a single spray is out of its just position ; one
passes from mass to mass in regular progression. Not only
is the spreading fan-like arrangement indicated in the lateral
direction, it is also clearly shown in the direction to and from
us. The trees spread as satisfactorily towards us as they do
laterally.

The Italian work is not wholly without good intention.
The draughtsman has used his pen-strokes to indicate plane
directions, but he has used them in an uncertain way. Take,
for example, the distant mountain nearest to the two trees ;
the outlines indicate one shape of crag while the hatching
contradicts, instead of upholding the forms indicated. He
would have done better either to have left the outline to do
the work alone, as Claude has done, or to have hatched with
greater care. Below the mountain is a group of buildings,
and below that again a bush form. I feel an irresistible desire
to change the hatch from its nearly horizontal direction to
one nearly vertical. The present hatching does not seem to
me to be in harmony with the shape suggested by the outline.
Such uncertain rendering of volume shape is more evident
in figure-work than in landscape, for the least expert critic
can generally see that ' it does not look right ', that a fore-
shortened arm does not appear to be long enough ; that is

why—or at least is one of the reasons why—I have upheld
the nude as being the best school for landscape-drawing ; for
we have just seen that many of the important weaknesses of
the Italian drawing are of a kind that figure-drawing will
help us to avoid. It may be objected that probably the
Italian in question had been through a course of figure-
drawing ; almost certainly, at that epoch, he had. Alas !
attending a life-school is not enough to make an artist ;
innate disposition, and great comprehension must also enter
into account. In the life-class it is the rarest thing to see
solid work.

.

I yield to the temptation to terminate these inadequate
analyses of the various parts of the art and craft of drawing
on the note of infinitely subtle China. A branch of bamboo,
a bird perched thereon, is what Su Kuo chose from landscape,
from the inexhaustible reservoir of Nature, in order to trans-
mute his impression of it ; and so he gives us a precious thing
which has come down to us across the ages. A landscape ? . . .
hardly. Yet it is an arrangement isolated from the sur-
roundings, which, if they were there, would indubitably con-
vert to a landscape what we now fain would call but a decora-
tive design. A decorative design ? Again it is scarcely that
either, for an irresistible breath of sketched reality floats
among the brush-strokes of the leaves. Can they be said to
be decoratively treated ? In so much as their arrangement is
faultlessly subservient to rhythmic laws, yes. But the con-
vention of the technique is, when all is said, most naturalistic.
Unquestionably the single rapid brush-mark constitutes a
conventional method of treating the bamboo-leaf, yet it is
hardly one which we associate with the idea of stylization ;
at that rate every rapid sketch must be classed as a stylization.
It simply amounts to reducing by a word our already too
narrow aesthetic vocabulary, if we confuse the ideas of rapid

technique with those connected with the intentional decorative, and to a certain degree geometric, modification of 'natural' form. Decoration or naturalism? Landscape or study of detail? This last assuredly, No; for we have before us not a study but a completed, a perfected work of art, one that has been deemed worthy by tens of generations of able critics. So we see how faulty are the usual classifications of practical Europe. What completes, what renders intensely valid, these few draggings of Chinese ink, these few dozens of brush-marks on an unworked ground? We are forced to fall back on their esoteric value, on their infinite suggestiveness, their masterly rhythm, as our sole means of dealing with their worth. Is there, can there be, any other means of classing, of judging, works of art?

.

Technical study tends to lose sight of subject-matter, but the subject of a landscape is no negligible quantity. The Chinese replace our general term 'landscape' by a more limiting combination of the characters *Shan* (山) and *Shui* (水), 'mountain' and 'water'. According to their racial and Taoist postulate, the universe took on shape and being only at the disjunction of the two primeval forces of the *Yang* (陽) and the *Yin* (陰), the Male and the Female, Action and Repose. The mist-shrouded mountain, the immobility of rocks contracted with the fluid rushing of water are among the most frequent symbols of this Taoist belief on which Zenism grafted another and secondary symbolism too complex to be dealt with here. With the rock the teaching of Zen compares dominating will and resistance, vanquished finally, however, by the supple but unceasing flow of water. Has Wang Wei forecast this thought in his splendid painting of the waterfall (Fig. 9)? Or, by that curiously rigid curve imbued with sweeping motion, has he attempted a symbolization of the thought of Heraclitus : ' We descend and descend

not in the same river, we are and we are not.' Let us not forget that a like stationary suggestion of movement inspires the greatest Greek statuary. Oft recurring in this Far Eastern painting, so different from ours, is a torrent which bursts, impetuous, from a rocky gorge, to pause awhile in widespread stillness at the mountain's foot ; or the same symbolism may assume the form of a lake's immense extent (Fig. 43), stretching to distant and to mist-veiled hills ; again, elsewhere, an unquiet sea will strive against the rocks. These and like symbols form the soul and very animating force of extreme Asian art.

Yet though we have never formulated, Easternwise, such symbolic precision, still a certain frequent choice of subject, the satisfaction which we gain from pictorial combinations of land and river, of sea and rock, of torrent and crag-bound mountain-side, would seem to show some shadowing forth of this underlying sense, common to the human race, of the opposition of two principles. But is all art ultimately other than union of interrelation and antithesis, is it other than an impotent question thrust forth, helpless, in view of the unanswerable ?

Recapitulation

The nude is the best school for landscape-drawing ; the separation into figure and landscape-drawing is seductive but misleading. At all periods figure and landscape-drawing methods are analogous. Great landscape painters dealt in the figure. It is a mistake to suppose that because a man excels in one direction, his achievements in another must be necessarily negligible. Often ' artists ' are successful in one branch, not because they have mastered the difficulties of the subject, but because they have worked out a way of ' doing it '. Rembrandt, a figure painter, was a great landscape artist. In the Rembrandt reproduced, a curious ' bas-relief ' effect is obtained ; this is discussed. Stability is necessary in landscape. A comparison is made between the ' dream ' technique of the later Turners, and the realistic and material technique of Cézanne. The aim of Turner was to reproduce infinite complexity. To this the geometric doctrine of Cézanne would have been harmful. Cézanne's choice of the important plastic note, which renders solidity, is extolled, and a slight

examination of the reproduction is made. The relations between its parts are pointed out. Quotations of Cézanne's condemnations of aesthetic controversy are given. The abstract symbolic intentions of Japanese painting are touched on ; the desire to find everywhere analogies with the stated trinity of Heaven, Earth, and Man. Attention is called to the influence of place and wind on tree-shapes. The Japanese consider that for the moment we must take on the personality of the subject we are drawing. We must be careful of taking isolated fragments from a complete system such as Japanese Art. Artistic unreality is mixed with inartistic reality. The aims of Japanese art are classified. The reason of one of the Japanese conventions is given. The abstract nature of Eastern art attracts the advanced aesthete to whom the European ideal seems severely limited. Lack of third-dimensional composition is given as the reason for the inefficiency of an Italian drawing which is reproduced. Total co-ordinate rhythmic relation is the corner-stone of art. The arrangement of the planes in a Claude drawing is analysed, they are about eight in number, separate yet co-ordinate. Claude showed remarkable appreciation of recessional foliage mass. Errors are less evident in landscape-drawing than in figure-work, but none the less deny a first place to the work. It is difficult to class a drawing of a bird on a bamboo-stalk executed by Su Kuo as decoration or as landscape. We see the inutility of trying to define ' stylization ' in technique, for, while being supremely decorative, this drawing is intensely naturalistic in handling. We are obliged to fall back on abstract and esoteric methods of classing works of art. All others fail in practice. Perhaps at the base of the so often expressed approval of combinations of water and steady land, may lie some uncodified sense of the Taoist opposition of the cosmic principles of *Yang* and *Yin*. Is not Art a union of inter-relation and antithesis ?

XI

'PRIMITIVE' DRAWING

A SERIOUS lacuna in *Relation in Art* is caused by my omission to deal with the arts of savage and 'primitive' peoples in a sufficient way, in a way which they merit, considering the vast mass of material which exists, and the very different outlook which primitive peoples have on the whole of the phenomenal world. I will try to remedy this omission here and now, at least to some extent.

The whole subject is exceedingly difficult and obscure. In his admirable works on the subject, Monsieur Lévy-Bruhl convinces us of the tremendous divergence which separates the conceptions of such mentalities from our own. I believe that no one has as yet ventured on any serious examination of the plastic arts of primitive peoples taken in consideration with the form of mentality which inspires and judges them. May these pages which are almost entirely reproduced from the able book on Ashanti by Captain Rattray [1] (for which I first wrote them) be at least a commencement of attack on the very obscure problems which an examination of the matter at once poses.

For the reasons which led M. Lévy-Bruhl to arrive at his two main conclusions, I must, of course, refer the reader to the original works : *Les Fonctions Mentales dans les Sociétés Inférieures* and *La Mentalité Primitive.* [2] The conclusions themselves are as follows :

(1) Institutions, practices, beliefs of primitive societies

[1] *Religion and Art in Ashanti.* Clarendon Press, 1927.

[2] These two volumes have appeared in English form published by Messrs. Allen & Unwin.

imply a form of mentality which is ' prelogical ' and mystic, and which is directed quite otherwise than is ours.

(2) Collective representations and the co-ordinations or connexions of these representations which constitute this mentality are governed by the law of participation, and so being, are indifferent to the logical law of contradiction.

As a result of this government by the law of participation, instead of by that of contradiction, the primitive mentality finds no difficulty whatever in accepting such contradictions as the conception of simultaneous existence in two places, metamorphoses, distant action, unusual generation or generation devoid of cause, and a thousand other contradictions which are inacceptable to the logically determined mind. Totemism obviously inclines to a belief in the possibility of a woman bearing an animal in place of a human child, or in that of a human being changing himself into the animal with which he is not only in close mystic relation, but perhaps with which he is already identical.

By the law of participation is meant that faculty which phenomena, things animate or inanimate, possess of being at the same time themselves and something different. But as soon as such a concise formula is established we realize that it is far from expressing, even approximately, the conditioning of minds capable of such conceptions and beliefs as are reported to exist by travellers and ethnologists. We must add to our definition that such a mind-form comports a simple indifference to antithetical propositions. It neither seeks nor avoids them. It may be convinced or not by them, according to other circumstances ; whereas we are convinced of the impossibility of a statement when once its incompatibility with accepted natural fact is demonstrated.

Is this quite exact ? In so far as categoric thinking, as ratiocination, in the ordinarily accepted meaning of the term, is concerned, yes. But there remains over a very considerable

residue of thought type which is far from being eliminated even from the most highly ' civilized ' levels. Need I say that I refer to religious belief and to art?

Faith and Mysticism are essentials to religion; their beliefs do not bow to the rulings of logical concatenated thought. Just as the ' prelogical ' mind neither seeks nor avoids statement of contradiction, just as the fact of contradiction leaves it almost completely indifferent, so religious belief remains indifferent to logical contradiction. But we must not confuse antagonism and contradiction. The ' prelogical ' mind lives in the midst of ceaseless warfare of opposed forces. The spirit of a salutary plant is stronger than the spirit of a disease; so the spirit of the plant thrusts out, by its superior force, the spirit of the disease. So in the case of religions we encounter almost without exception the idea of struggle between a good and an evil spirit or between good and evil spirits. The Greek pantheon, itself subordinate to a single ruling destiny, might be put forward as an exception to this rule of predominance of antagonism. Yet even if it be an exception at base, its mythology hastened to introduce the notion of struggle in the endless disputes and ' sidetakings ', favouritisms of the individual gods themselves. Perhaps the purer forms of Brahministic belief might also be adduced as an example of ultimate non-antagonism. But here is matter for much careful analytical examination; it must be left aside.

There remains the second form of non-logical activity which persists among the higher mentalities: Art.

Even among the most elaborated ' logical ' peoples, art still conserves its ancient prerogative of franchise from logical bonds. It retains this right not only in its methods of conception and execution, but also in its reception by the spectator. Only to a certain degree is the European artist bound by natural possibility; and even a most uncompromising

anatomist may be found who will restrain his ire before the 'Harpy Tomb'. It is on such elements of our own personalities that we call, when we wish to appreciate the value of 'primitive' art, outcome of 'prelogical' mentality.

If, when studying 'primitive' mentality, we are not certainly in presence of the childhood of our own thought, it is all the same quite probable that our ancestors, at some period of their history, were in a very similar mental state ; indeed the inveterate survival of many superstitions even to-day would almost force us to believe in their extended supremacy in former times. On the other hand, I have written in *Relation in Art* (p. 318) : 'Palaeolithic art seems to have been, like the philosophical conceptions of Tahiti, an art developed to its full ; one not, indeed, destined to achieve a high level of technical complexity, but within its own frontiers complete and " fully orbed ".' By these words I meant to imply that I did not look on so-called primitive arts as being a simple stage in one universal sequence of evolutionary development. I look on such an art as that of Tahiti as being an old-established art which has reached long ago its ultimate point of development beyond which Tahitian mind type was not destined to continue. In other words, that we are dealing not with a primitive art but with the late manifestation of a fully determined effort.

Such a drawing as that of the Altamira Boar reproduced in Fig. 25 leaves us in considerable doubt as to its classification. Can we strictly look upon it as a primitive drawing ? When I examine it I feel curiously satisfied by its aesthetic. Still it is the work of a man not so far advanced in what we understand as civilized conditions as to be acquainted with baked pottery ! This palaeolithic art recedes along the scale of ages to an unknown degree. After it, probably long after it, on the same sites, succeeded the negligible and childlike aesthetic efforts of neolithic peoples, who, at least at first,

did not surpass the stage of expression by means of crude decorative shapes. At best, of their work we have but a few deformed and inadequate attempts at reproduction of the human body, a few vague clay or soft stone statuettes,[1] if we may dignify them by such name. The neolithic peoples passed on into the ages of bronze and iron before their art became valuable, worthy of consideration. Yet they polished stone, they baked pottery, badly it is true, and would seem to have been in many ways better informed than their palaeolithic predecessors, who disappeared without having achieved knowledge of the metals. Art would not, then, seem to be a function of the sum of knowledge possessed by a people, but to be the outcome of mind-conformation which may be attained even though the absolute stock of knowledge be extremely limited.

It is perhaps not sufficiently understood that the doctrine of evolution does not necessitate a passage by similar stages towards a necessarily similar end. A glance at the diagram given in the chapter on Natural Selection, in *The Origin of Species*, will render my meaning evident. It is both possible to arrive at a similar level by different routes while starting from the same point, and to come to an abrupt stop at some given point of evolution, the duration of predestined course— if predestined it be—having come to a close. One would be inclined to see in the Altamira drawings, as one sees in Tahitian art, the final and perfect blossom of aesthetic expression of a mentality which had attained its apogee, an apogee circumscribed and limited in many ways, even in the extent of its capacity for artistic expression. But though the *extent* of this capacity was limited its *quality* was strangely fine. What more *savant* distribution of accents, both from constructional and decorative view-points, could one desire than that of the Boar? With what exact aesthetic skill the

[1] Cf. also the Monte Bego figures of doubtful period. See p. 371.

calcanea are accentuated ! How the fleshy line of the abdo-
men is left as a finely traced but, this time, unaccented curve !
With what address are the accents placed along the tremen-
dous rhythm of the spine, and how they remind one of the
deft handling of some great Chinese master of the brush !
No, it is difficult indeed to relegate such work to the naïve
realms of primitivism (though see note p. 104).

I have already drawn attention to the incomplete per-
spective conception of the drawing, but if the need of
precisely imitative art had not yet dawned upon the world,
why seek for the compromise of perspective, for faulty
means of rendering the appearance, to the artist, and from
one view-point, of various objects in their relational inter-
dependence ? Drawn upon a rock wall, the Altamira boar
seems, even to modern me, better to fulfil the exigencies of
mural decoration than, if you will, the splendid perspective
science of the Sistine Chapel.

What is there so 'primitive' in the poetic myths of
Tahiti ? The language is figurative ; but so is that of poetry
written to-day. However seductive be the task, I must not
linger over a detailed exposition of this so little known
mythology of the Pacific. Some few words only will I write
to uphold my thesis. In the beginning was Taaroa born
from the Night and Chaos. He was not made by any other
god. After innumerable seasons, he cast his shell or body as
birds cast their feathers or as serpents their skins ; but this
body was invisible to mortals. In the *reva,* or highest
heaven, he dwelt alone. His first act was to create Hina.
Countless ages passed. Then Taaroa and Hina made the
heavens, the earth, and the sea, and cast the foundations of
the world upon a solid rock which Taaroa sustained by his
invisible power. Then the power of the arm of Taaroa
shook over Hina the shadow of a bread-fruit leaf and she
became the mother of Oro. And Oro in turn was the

connecting link between the beings of earth and those of heaven.

Who shall affirm or who shall deny that the men of Altamira did not believe some such beautiful mythology ? All that remains to us of their creeds, their mental attitudes, are the now fast fleeting rhythms of the cave wall-drawings. Had the Tahitians disappeared, unknown, long ages ago, less still would have remained across the revolving years to tell us that once they too had conceived a mythology of so fine a grade.

.

We may succeed in understanding the phenomena due, in the realm of thought, to a prelogical mentality ; we may by study arrive at an external comprehension of the ' participation ' which plays such a considerable rôle in the production of these phenomena, but, in so far as are concerned those acts and methods of thought which belong to the non-artistic or non-mystically religious sides of existence, it is quite impossible for us to feel ourselves to be even in the very smallest degree in sympathy with the results of such thought mechanism. In the case of art, however, this difficulty disappears, if not entirely, at least in part. We remain perplexed when confronted with the idea that a dancer disguised as a bird can at the same time consider himself to be himself, to be a bird, and to be some remote ancestor, can consider himself not to be playing the part but to *be* in the narrowest sense of the word all these three mutually exclusive things, yet we quite readily bring ourselves to accept the ' beauty ' of the works of art which the same mentality has produced.

Are we not then justified in asking ourselves if in the analysis of such works of art we may not find a method of at least partly bridging the gulf which is hollowed out between the primitive mentality and our own ?

The logical method of thought which Europe has in-

herited from Greece, and which would seem to be destined to furnish, ultimately, the thought-form of the future, has not yet by any means attained that end. The thought methods of India, of China, though they can in no way be termed ' primitive ' do not belong to the same category. This is not the place to enter into an examination of the divergence of such methods from our logical forms ; it will be enough to say that analogy there takes on a much greater importance than it does with us. And perhaps analogy and participation are not very hostile to one another in some of their aspects.

There would seem to be little doubt that logical and categoric thought (in the ordinarily accepted sense of the term) is not the thought type which is the best adapted to the production of works of art. The sculpture of Greece will at once be put forward to confute this last statement. Undoubtedly the sculpture of the Parthenon is ' perfect ', if, as we are naturally inclined to do, we adopt to judge it the point of view which, however much it may have been modified during the ensuing centuries, at least in the beginning was identical with that which presided at the construction of the Parthenon and at the carving of its sculpture.

But this is not the only point of view open to the aesthetic appreciator. Let us adopt another, from which we may quite easily find ourselves saying with Browning that there is something too coldly perfect, something too purposely abstracted on certain postulated lines, something too slightly human which hangs about the Olympian tranquillity of Grecian marble. Browning implores us instead to exclude from our art this worship of ' perfection ' and to replace it by study of the very imperfections themselves of mankind. Reflect again one moment. What are we now asked to do ? Instead of using a magnificent external representation of typified form of the body as the almost unique base of the rhythms which we are to use in our work of art, we are told

to portray the personality of the man. We are still told to portray. And portraiture, likeness to the model, continually occurs as the principal motive force in the arts which spring from the mentality which is produced by logical culture. Why do we object to the idea of the possibility of our occupying at one and the same time two different positions in space ? Because such an idea is contrary to all the laws which a long examination of the ways of the physical universe has enabled us to establish. In other words, such a state of things is not 'like' Nature. We have observed, analysed, and then induced natural laws. To these laws we are slaves, not only when we are dealing with scientific facts, but also when we are producing or appreciating works of art. Of course in the interests of clear exposition I am exaggerating the condition of things. Were what I have just said exactly true, art would necessarily become a kind of scientific photography and would *ipso facto* cease to be what we know as art. None the less there is a very considerable parcel of truth in what I have just advanced ; and if the idea of imitation is not wholly responsible as a cause of European Art, it cannot be denied that the line of approach to the aesthetic problem is always strongly influenced by it ; unless, it may be, when music is in question.

I have already indicated that among the peoples of the Far East, who constitute the only races which have completed a conscious and applied aesthetic theory, imitation is looked upon as a low and negligible artistic ideal. True, in the plastic arts, once we leave behind arabesque methods of decorative art, one is obliged to deal to a certain degree in the imitation of natural forms. But this imitation is in no way sought for its own sake ; we may almost say that it is tolerated as a necessary evil, without which abstract expression becomes impossible to the plastic arts. We have already seen to some degree (p. 130) to what extent the complex symbolism and

the plastically expressive elements of a Chinese or a Japanese painting are prized in its native land to the almost complete exclusion of its imitative qualities.

Among those singularly aesthetic peoples we have seen that the inspiring force of art must be sought in the beliefs of Taoism or in those of the Zen Buddhism. Laoism had directed towards an intellectual conditioning every sentimental element of the human being. Buddhism brought to this conditioning an added element of charity, which should envelop the totality of the beings of the universe. In each case the physical reality, the outward appearance, tends to disappear as a superfluous shell, which is at best but the manifestation of a universal spirit. If the aspect of this shell is rendered in a painting, it is only rendered as being the single means at the artist's disposal by which he may suggest the existence of the inward spirit which governs all appearance. Hence he will only insist on such elements of this appearance as he considers necessary for this suggestion. We have seen the explanation of the marvellous parsimony of expression of many Far Eastern masterpieces in monochrome wash.

The aim of this art is in many ways distinct from ours ; yet though our aims are not so distinctly codified, or even perhaps realized with any degree of clarity, the Chinese position with regard to the aesthetic problem is not up to this point so hopelessly differentiated from our own as to be incomprehensible to us. However, in China the matter does not cease here. We never lose sight of the fact that a work of art is a work of art ; although we talk about ' creating ' a work of art, with us it is the work of art which is ' created ' and nothing more. In China there is a tendency to look upon the artist as a creator in a much more literal way. Hence the stories, to which I have referred, of dragons taking flight from the paper, on which they have just been

traced, and disappearing among the clouds. If the sense of the Tao has been truly rendered, there is real creation as adequate in this form as in any other. This is a belief that the non-idealistic Occidentals find with great difficulty acceptable.

On the one side the Chinese aesthetic creed presents an aspect in no way displeasing to our mind type, on the other it recedes from our comprehension ; and though in reality its very perfected and co-ordinated beliefs differ fundamentally from the prelogical tenets of primitive life, yet this confusion, shall I say ? which takes place between the work of art and the reality, prepares us in a certain way for the view, so completely different from ours, which primitive peoples seem to take of art.

.

To us a drawing is only a drawing, and (question of decorative arabesque apart) is mainly valuable according to the degree of excellence of representation or of suggestion of natural objects. Whether this drawing be here or there, made on one piece of paper or on another, are matters which leave us completely indifferent. The drawing is self-contained and its qualities are its visible ones. Quite the opposite would seem to be the case when it is question of the angle of approach of a ' primitive ' mind to a drawing. Parkinson tells us, speaking of this problem : 'We are here in presence of a difficult enigma. The Mittheilungen looks on the drawings as being drawings of serpents ; and, effectively, one can believe that one recognizes in one a serpent's head and body ; but the Bainings affirm that it is a pig. . . . The figure which follows could, *à la rigueur*, pass for a face ; but according to the natives it represents a club, although it has not the slightest resemblance to that object ! Certainly no one even in most fantastic mood would ever have hit on this explanation. . . . I was inclined to look on the next three circular

figures as being eyes. The natives at once bereft me of that illusion, and added that it is impossible to reproduce [1] eyes. . . .

‘ The ornaments were explained to me by the Bainings themselves, so there cannot be the least possible doubt that those who execute drawings associate them with a determined idea, although the relation between drawing and idea remains almost always hidden from us, as the drawing offers no kind of resemblance to the object in question. Thus one sees the danger of interpreting the ornaments of a primitive people according to a resemblance which the drawing might bear to an object which we know.

‘ The Bainings see in these traditional drawings a shell, a certain leaf, a human figure, and so on. This representation is so profoundly anchored in their minds that one remarks their stupefied expression when one asks them what the drawings mean ; they cannot understand how it can be that every one does not grasp the meanings of the drawings at once.’

.

These remarks are more than enough to indicate that we are here in presence of a symbolism carried to such a degree that it far surpasses anything which we conceive as justifiable in that direction. In many ways the child’s mind and the mind of the primitive are allied, though we must be careful not to carry such an analogy too far. To the child at play often the vaguest indication of a line traced on the ground will serve as the, to him, really existing wall of his house. The tunnel three inches high through a sand heap is to him no model of a tunnel, but a real tunnel into which, in imagination, aided by the real introduction of his hand and arm, he

[1] Is this reported correctly? Very possibly. The use of the idea of reproduction would then seem not quite foreign. As usual there would be an undefined intermingling of the reproductive and of the simply ‘ indicative ’ method. It is generally useless to apply our categoric precisions to ‘ primitive ’ ideas.

really penetrates. But this is only one side of the primitive question. There are others.

In the civilized child we can, even at an early stage, only trace rudimentary remains of the primitive qualities of ' participation '. At times the child certainly ' participates ', if not with the universe in general at least with his companions. Léon Frappié paints for us a momentary picture of the infant playground in *La Maternelle* : ' . . . je restai . . . saisie par un spectacle de foule. Dix fois, des poursuivants hurleurs étaient passés, dédaignés, près d'un groupe de " moyens " affairés à échanger des bons points ; soudain, comme par l'effet d'une onde électrique, tout le groupe se précipita, braillant avec les camarades, sans signification, sans motif ; alors d'autres groupes frôlés se joignirent, des grands en-traînèrent leurs petits frères, des causeurs tranquilles sautèrent, brusquement emballés, plus éperdus, plus frénétiques, cla-mant plus fort que les premiers, et ce fut une nuée d'élément, un haro unanime, un emportement destructeur et oppresseur : panique, assaut, joie brute. Puis brusquement encore et sans cause encore, il y eut baisse et discordance des cris, éparpille-ment du nombre. Le mal que l'on pourchassait était-il censément puni ? Ou bien le fléau que l'on fuyait était-il évité ? Impossible de savoir, c'était la foule.'

There is little doubt that such phenomena are attached to the elementary springs of human action. In the civilized child the effects rapidly disappear more or less on account of his environment. He falls into line with the individualism which is the necessary concomitant of antithetical logical rationalism. But in the case of primitive societies the condi-tions are other. This very participation, being due to one of the earliest mental conditions, is raised to the position of becoming the very soul itself of the mode of thought, it is the controlling and organized motif of judgement and under-standing, which only by slow degrees grudgingly yields place

to the antithetic position which ultimately becomes our logic of antithesis.

That this antithetic position dates almost, if not quite, in its rudimentary forms from the beginning is evident when we consider that even animals realize that the presence of two objects eliminates the possibility of their being only one. This really constitutes a very elementary form, if not of antithetical reasoning, at least of antithetical perception. It is the first step in the series which will ultimately lead to the amazing erection of our ultimate mathematical and philosophical systems. But the sense of participation would seem to be the first and most rapidly developed at the expense of the antithetic sense destined later on to gain complete precedence, ousting the other almost entirely, save on certain rare occasions of battle or of love.

Even among a people so sensitive to antithesis as the Greeks, we still find lingering on such remnants of participation as are disclosed by the beliefs not only in a certain unity between the carved statue and the god it represents, and of whom it is, in an unexplained way, the abode, but also in the admission of different varieties of the same god whose different personalities are revealed by the distinguishing place-name attached to the general one of Zeus or Hephaistos. The conception of a Zeus who shall be at once unique and many is obviously incompatible with antithetic reasoning, though it offers no difficulty to the ' participant ' thinker.

.

It may be upheld with considerable justification that one aspect of art is necessarily constituted by a type of relation which comports an almost antithetical quality. Light in recent painting is light on account of its opposition with shade, one tint is valid by contrast with another. I need not extend the list of evident examples ; I have dealt somewhat with this point elsewhere. Perhaps we might be justified in

seeing in primitive arts an embryonic use of the antithetic element which, later, we see carried to a much higher and *voulu* degree in the painting of the last half-century, an epoch which has seen the conscious introduction of semi-scientific reasoning—concerning complementary colours and the like —carried to an extreme degree. This same tendency to theorize upon technique has inevitably brought with it a negligence of the signification of the picture, an allegorical representation of spring has yielded before a problem in placing of red and green, or a geometric equilibrium of planes and masses, destined, so we are told, to suggest the type of ' plastic emotion ' engendered in the artist by his perception of underlying constructional facts. These same artistic rationalists of emotion admire the naïve wood-carvings of West Africa. We may wonder to what exact degree they are justified in so doing.

.

There would seem to be little doubt, on the contrary, that to ' primitives ' the really appreciated part of their artistic effort is its representation ; not perhaps quite as we recognize representation, that is, to a considerable extent, by estimating its value according to its degree of photographic ' likeness ', but simply as being a kind of fixation of the idea. An Ashanti stool is not supposed to be *like* a soul ; it is only an abiding place for the soul. The designs or ornaments of these stools had some primitive meaning, which, as we have seen above, can never, or only rarely, be guessed from any resemblance to natural forms which we might believe that we find. To the most primitive forms of mentality there is no difficulty in accepting that the same drawing can represent two totally different objects. Messrs. Spencer and Gillen tell us that to the mind of the central Australian the same drawing, a spiral or a series of concentric circles can, on one ' sacred perch ', represent a gum-tree,

while on another it represents a frog ! The important point —and the one which according to the Australian should be evident to every one—is not what the drawing looks like, but what the participation, the consecration, the dedication (or whatever term we care to employ) is of the surface on which the drawing is made. If the drawing is executed on any ordinary surface, the draughtsman will tell you that it means nothing, that he has only done it for fun ; but the moment the surface is in some way consecrated, the drawing has an immediate and definite signification. We see again how very careful we must be in applying our modes of thought to the appreciation of primitive art.

On p. 173, vol. i, *Ashanti*,[1] Captain Rattray tells us that he was told that the ornamentation on the most elaborate temple he had seen in Ashanti had no particular signification. That such decoration never had a significance seems to me— as to Captain Rattray—very improbable. But it must be remembered that the Ashanti offer what may be termed a very high example of primitivism, that they have been for long in contact with more advanced peoples ; so it is quite possible that not only has the original signification of such drawings been forgotten, but that, in the forgetfulness of their meaning, the idea alone of the need of making drawings on a temple has survived, and so to-day the builder makes any kind of drawing on the temple. Thus the drawings have, as was told to Captain Rattray, no signification, and we see in them only the elementary efforts of an incapable artist at pictorial representation or childish decoration.

.

The juxtaposition of the words ' childish ' and ' decoration ' reminds one of the seeming historic precedence of decoration over representation, or at least of decoration over ' photographic ' representation. It is evidently easier to trace

[1] *Ashanti*, Clarendon Press, 1923.

a decorative waving line round a neolithic vase, than it is to execute a fairly good likeness of a natural object. On the other hand, it becomes very doubtful which is the higher artistic effort : to produce a satisfactory vase shape ; or to draw the wall figures of Val Fontanalba and the foot of Monte Bego in the Italian Maritime Alps, with their infantile and distorted grotesque.[1] It seems possible that the desire of real likeness to objects is a thing only sought for after considerable rise in the intellectual scale. By ' rise ' I mean emancipation from the ' participation ' state, which obviously renders likeness unnecessary. Given the conditions of ' consecration ', there may even be absolute identity between the spirit of the thing in question and the drawing or carving, which though it is a simple statement that the object is in question, yet may participate in the object itself, or at least furnish a habitat for it. Captain Rattray tells us that a carver under his direction was twitted by onlookers for having made a mistake in the design of the stool on which a figure of a Queen Mother was seated, the stool not being a woman's stool. I think we should be careful, perhaps not to confuse, this desire of accuracy of ritualistic detail with accuracy of ' artistic ' detail. And I am inclined to think that, in any form of primitive religious art the moment that an almost symbolic statement of attributes and so on is made both artist and public are content ; likeness to life is not considered at all, or to a negligible degree. It is evidently foolish to quarrel with an artist for not having put into his work that which he has never sought to put there, and which his national aesthetic does not demand.

.

[1] See Déchelette, *Manuel d'Archéologie Préhistorique Céltique et Gallo-romaine*, Paris 1910, Tom. ii, pp. 492–3. Mr. Clarence Bicknell has also studied these curious petroglyphics of an uninhabited region at 2,600 metres (nearly 8,000 feet) above the sea, near the Col de Tende to the north of Ventimiglia. See *A Guide to the Prehistoric Rock Engravings in the Italian Maritime Alps*, Bordighera, Giuseppe Bessone, 1913.

The actual existence of sculpture eliminates the difficulty of point of view and of perspective, which we have now come to consider as an inherent necessity of artistic representation in the graphic arts. In the earlier forms of art in Egypt, in Assyria, in China, we have seen that perspective, as we practice it, is not observed. May this not be less on account of insufficient intelligence on the part of primitive artists, than on account of a lack of desire to reproduce a *scene as it appears* when looked at from one point of view and in one direction ? In reality, as I have already pointed out, our convention in this respect is possibly much more absurd than a convention which would demand a kind of composite rendering of many aspects.

A drawing by a little boy represents his impression of the interior of a theatre. But he has not yielded in the faintest degree to a desire to establish a perspective scheme. His drawing *describes* a theatre, it does not tell us what a theatre *looks* like. The drawing is a compound of plan and elevation. He noted as one or the other, according to whether he realized the fact which he observed as being a ground-plan fact, such as the curve of the dress-circle, or as an elevation fact, such as the proscenium. The drawing is an accumulation of statements about a series of observations which he made during his sojourn in the theatre.

But if ' photographic ' representation is not a universal aim in art, decorative rhythm is. Our little boy had succeeded in organizing his various ' statements ' into a not at all displeasing rhythmic decoration. And that is his drawing's chief claim to artistic value and interest. Its chief claim ? Better say its only claim. Rhythmic relation of parts is the real essential of art. In the case of music we admit pure rhythmic relation as sufficient. Reproduction of natural sounds, of natural arrangements of sound may be said to be almost non-existent. Why in the case of the plastic arts

should we so anxiously demand resemblance to natural shapes ? The affair is one of ingrained habit. The more an artist is capable, the more he will attach greater importance to rhythm, of one kind or another, and less importance to ' photographic ' likeness. He will be content with a few amazing brush-marks by Ying Yu-chien.

An Assyrian bas-relief (Fig. 41) is the account of the victory of a king. The artist did not wish to give us (it never occurred to him that it might be necessary to give us) a photograph of the battlefield *taken from* an avion. He simply states facts concerning the battle. But he has this in common both with our little boy and with a Grecian *aoidos* chanting the *Iliad* ; both treat their subjects rhythmically. So when an Australian wishes to state a frog on a *churinga*, he makes rhythmic marks on a *churinga already dedicated to the frog*. The dedication renders likeness to a frog unnecessary. Remains the statement that he calls your attention to the idea, ' frog ', which statement he makes rhythmically, as all human beings always have done until the habit of antithetic logic and methodic doubt had warred against superfluous rhythm and elevated to its throne concise and ' accurate ' statement of uncompromising fact.

.

The seeming paradox of calling a savage a better artist than Pheidias might even be upheld. We might say that the savage ideal was further removed from contamination by the inaesthetic desire to copy.

Yet even here we are not consequent with ourselves. In the design of a carpet we at once admit the validity of rhythmic arabesques which are ' like ' nothing at all. After all, they are stylizations of I know not what creeper or other natural forms. Yet if the same degree of stylization be carried out on, say, the human figure, we announce ourselves offended. It would really be very difficult to run fairly to

FIG. 124. 'Sasabonsam' *Ashanti*

ground current and inexpert European belief on this matter. A statuette of the ' Sasabonsam ' (Fig. 124) will have its feet turned both ways. A moment's reflection will show us two things : first, that such a derogation from anatomic possibility is not the artist's ' fault ', he is simply making a statement concerning an already firmly established mythological personage ; secondly, that there is nothing really more absurd about any such anatomical modifications than there is about the classic centaur, only as we have always been accustomed to the centaur we are quite prepared to accept him, especially when he is served up to us with an anatomical torso and an accurate transcription of a horse's body and legs. In reality the position only becomes more absurd proportionally to the ' naturalness ' of the representation. Executed as a mere plastic symbol of a literary figment—the combination of the qualities of strength and fleetness of the horse with certain human qualities—that is, as a symbol only bearing the strictest minimum of imitation in order to suggest the idea, such a figure seems to me more acceptable than in its more anatomical (? !) conditioning. Our Ashanti artist makes statements concerning the ' Sasabonsam '—that its feet are turned both ways, and so on—and makes this statement rhythmically. From the aesthetical point of view it is only this rhythm which interests us, and, given the mental conditions, we are quite in error if we bring to our estimation of its value any judgement concerning its degree of ' likeness ' to the natural rhythms and arrangements of parts of the body. The moment that the rhythms are balanced among themselves, this balance may at once become the medium of transmission of plastic thought,[1] it may be aesthetically valid.

The difference between an excellent and an evil drawing is to be measured by the nature, the quality of the mind of the artist of which it is in a way the mirror. The work of the

[1] See *Relation in Art*, pp. 33 and 124.

inferior artist, the ' illustrator ', the man who, fitted out with a mediocre mind, has learnt to make a ' correct ' drawing, as he might have learnt to make a ' correct ' table, lacks in interest for us very possibly because, having met it many times and oft, that type of mind has no novelty with which to hold our attention. When it comes to ethnological study and its comparative psychology, perhaps even the transcription of the most commonplace example of the type may not be devoid of interest, for it is tremendously removed from our own type. If this be at all true it becomes still more difficult to establish an absolute scheme of artistic excellence. Such estimation will become strictly a question of relation not only among the elements of the work of art, but one of relation between the work of art and the spectator.[1] The judgement of the spectator will be considerably influenced by the intellectual interest which he may take in the type of mentality portrayed, by the plastic mode of thought manifested in the work, and he will be tempted to pay insufficient attention to what may be termed the absolute value of the artist's aesthetic outlook. This absolute value is, of course, gauged by reference to a general balancing up of all the aesthetic outlooks ; much in the same way as there is a worldwide standard of par exchange, although perhaps the exchange value of no actual currency is exactly at par. To this intellectual appreciation must be brought the necessary emotional modification, that subconscious movement of the spirit without which neither artistic execution nor artistic criticism is valid.

In *Relation in Art* I have put forward the thesis that there is a ' plastic ' form of reasoning which cannot be adequately translated into verbal forms of logic. I will continue to assume, in the present case, the validity of such an hypothesis.

[1] *Relation in Art*, pp. 42 et seqq.

I have already supposed that there is a coherence of nature in any type of personality, that is, if we find one type of reasoning to be in use in verbal ratiocination, we must expect an analogous type of mental action to govern plastic conceptions. In Europe we reason by means of logical concatenation, our art is in the main logical and ' like ' natural physical orderings. In the East and in Africa, logical concatenation yields place to apt quotation of some ancient saying or wise saw which appeals to the hearer as a definite and applicable summing up of the situation. That we find a sort of ' plastic ' concatenation different from ours among such peoples, is only to be expected. What violates a sense of logical sequence does not necessarily violate a sense of imprecisely established analogy ; so we should be in no way surprised to encounter in the art of ' primitives ' a certain disdain of what we consider to be fundamental co-ordinations of proportion, or of volume, or of plane. The whole critical difficulty would seem to be enclosed in the question : Do we consider that a work of art should or should not be inspired by, be a transcription of its author's mental form ? This admitted affirmatively, if we are inclined to condemn transcriptions of mental forms other than our own, we evidently declare : My own mental form is the only one worthy of a moment's attention. Or, of course, we may say that the work of art has no relation to the mental type of the artist. I must admit that I do not see quite where such a tenet will lead us.

.

The European art lover will, I think, experience little difficulty in admiring many aspects of ' primitive ' art. Textile fabrics, ornament in general, possess for us a charm. Though their qualities seem to us to be easy of appreciation we should be very wary lest our appreciation be based on such resemblance as they may bear to our own work. It

is not by any means certain that another mentality when it admires a work of art admires it for its most important qualities. In *Relation in Art* I report an admiration of the Elgin Marbles for the excellence of their light and shade! Which light and shade is only, so to speak, a by-product of their fundamental excellences. What should put us on our guard is that we are inclined to smile at certain 'primitive' renderings of the human shape while we admire other 'primitive' balancings of colour and form. Just as the rhythm of African music is totally different from ours, so is the plastic rhythm quite different. It may be that we only admire when there is a chance similitude to, a chance coincidence with our own ideals. This chance coincidence may not really be a coincidence at all, any more than there is any relation between the French word *lait* and the English word 'lay', although there is considerable similarity between the two phonetic values. My tiresome insistence on this point is owing to the extreme difficulty which the most careful comparative aesthetician experiences in freeing himself from his own point of view. In a certain way art may be looked on as being the concise expression of a type of mentality, an expression devoid of confusing detail and possibly misunderstood 'explanations', in short, a quinessentialized and integral presentation of mind quality, precisely those parts of 'primitive' work which annoy us may be those which render best the 'primitive' mind so made up of sides to us incomprehensible and exasperating. But why should a successful rendering of a racial mind type be considered to be bad art? Why should we arrogate to ourselves the post of judge in the matter of estimating masterpieces?

.

The reader may be inclined to think that I am attaching too much importance to the question of participation when applied to an appreciation of aesthetic values among primi-

tives. Captain Rattray was allowed to photograph, that is to make a reproduction of one of two little girls in Ashanti, but permission to photograph her little sister was denied to him, because the spirit of the child was too delicate to run the risk of any of it being taken away in the portrait! This is surprising as it implies subtraction of part of the child's personality. As a rule participation does not imply subtraction. Possibly the child was not strong enough to resist the various journeys and changes to which the photograph in which she participated would be submitted. Again, Captain Rattray was asked to see that certain carved wooden figures of ' fairies ' were given monkey-nuts, palm-kernels, and sugar from time to time ; from which it is quite evident that the executed work of art really becomes the residence of the spirit.

It would seem that, according to the ' primitive ' idea, likeness to the original would have little or no weight in determining the worth of a drawing or statue ; for we can hardly assume that the greater the likeness the more the spirit (either of the living person, or of the god, or whatever the figure may represent) would enter into, would participate in the representation. Consequently we are not at all justified in bringing a ' likeness ' criticism to bear on such works. This at once raises the questions : What critical criterium of aesthetic values would really be applied by a ' primitive ' to the productions of his own people ? What is his real opinion concerning the successfully imitative pictures or photographs produced by the ' civilized ' man. It is much to be desired that ethnic investigators should strive to elucidate this obscure and delicate point as far as possible. Such questioning is very difficult, an elementary mind generally fails completely to deal with abstract questions, and such forms of criticism are necessarily of that nature. However intelligent, sympathetic, and co-ordinate questioning

might enlighten a little the questioner in the long run. The position would seem to be this : Primarily there is no need at all to make a drawing or a statue resemble the object intended, even in the remotest way, as the same drawing can represent two totally different objects. The only thing needful is that the intention should be there, and the consecrating rites should be carried out on the material on which the drawing is made or from which the statue is carved. Then we may suppose that with a rise of civilization and an increased cleverness of workmen, some proportion of ' likeness ' is introduced, and the figure ceases to be a mere ornamented block, it begins to possess two legs, two arms, a head, and a body. But to the ' primitive ' mind this is quite enough. The idea that imitative approach to likeness to Nature should either be possible or even desirable never occurs to our ' primitive ' for a moment. Why should it ? The important part to a mentality which exists in a world permeated with spirits is that the statue or drawing should ' participate ' in the spirit intended, or, perhaps one should say, that the spirit ' participates ' in the statue. But this end is already attained by the rites. The effectiveness of the rites depends not on the appearance or other quality of the object over which they are performed, but on the accuracy of their execution. Why then strive after likeness ? On account of the tremendous memory of ' primitives ', every one knows or remembers to what spirit such and such a place or object is consecrated, hence there is no need of a likeness on the part of the drawing in order to inform the spectator what it is ' meant to be '.

No absolute division can be traced between the ' primitive ', ' prelogical ' mental conditioning and the conditioning of the minds of more elaborated social groups. Still it should be possible—and surely it would be interesting—to find out examples which should determine just when the ' participa-

tion ' idea ceases to be, at least pre-eminent, in aesthetic matters. But we must be cautious in carrying out such investigations. Analogous beliefs concerning the efficiency of pin-sticking into wax figures still exist to a degree greater than is often believed among the less enlightened inhabitants even of western Europe.

As the address of the workmen increases we can easily understand that the statement concerning two arms and two legs develops without any fixed intention on the part of the artist from its first merely cylindrical state (already far in advance of the Easter Island monoliths) towards indication of knee, elbow, and other ' scientific ', other ' logical ' statements ; and indeed it may be that this plastic manifestation of logical mind conditioning might be found to correspond in its development with the other manifestations of mental ' logicality '. This again is matter for experimental research. It may be that it is possible to construct an ethnological scale of progression on the one hand from early prelogical, participant to logico-scientific mind type, and on the other to parallel this progression by an advance from the purely indicative symbolic ornament through the intermediate stage, say, of Byzantine religious representation up to the accurate representation of imitative painting or photography. The first part of this research it is urgent to carry out while we still have with us truly primitive types. The latter parts of the scale can be filled in at leisure, for we have always with us the written records of the modes of thought of the higher forms of mentality.

But when we arrive at the purely imitative condition of painting, we are surprised to find that the result has ceased to possess, in an appreciable degree, aesthetic excellence ; it has become a scientific document. Is this to say that a piece of primitive rhythmic decoration which constitutes the fixation of some ' spirit ' is a finer work of art than a piece

of 'photographic' painting? I am rather inclined to say that it is, or rather that it may be. 'Likeness' to appearance is too definite, too simple an aim to lie at the base of aesthetic effort. Indeed, as I have already pointed out in *Relation in Art*, the more one studies the problem of aesthetic validity the less importance is one inclined to attach to the 'resemblance factor' and the greater importance one finds oneself attributing to those connected with rhythmic balance, established among tints and shapes which may only have a remote relationship to natural shapes and tints. It seems to me that it is perfectly futile to establish an absolute scale of aesthetic excellence. The correct presentation of the problem is the examination of so many complexes of work of art plus spectator. If there be good and complete coherence of kind within such a complexus as an Ashanti and a piece of Ashanti sculpture, I see no reason why the aesthetic value of the work should not be classed highly. That there is no sympathy between an Englishman and a piece of such sculpture seems to me to have little or nothing to do with the matter. When the Englishman tells us that he does not like such work (he will probably say in reality that it is bad and defective, but I submit that he ought to say simply that he does not like it) he is much rather telling us something about himself, about his own mind-conditioning, than about the carving. He is saying: 'My mind has not got a side like that to it.' If, all modern European that he be, he is additionally an artist, he may be inclined to look rather upon the nature and the excellence of the rhythmic equilibria established than upon the imitative qualities or defects of the object. In which case his reply is much more likely to be of this type—if as well he be a careful thinker: 'Many points about this statue I feel to be inharmonious with my own mind form, my own convictions, my own prejudices. But at the same time I realize that the artist has used types of plastic equilibrium in

his work, which, if they are not exactly those which I should have used myself—and how can they be if they are to express a mind form different from my own ?—still they are far from meaningless, and are even interesting and sympathetic to me. Because these rhythmic arrangements disclose a governing mind form which may even be displeasing to me as an individual, used to certain social conventions and to certain modes of thought, I, as an artist, must not declare the aesthetic expression, these rhythmic arrangements, bad on account of the nature of the story which they tell or suggest.'

 · · · · · · · ·

The main tendency of recent art has been the abandonment of imitative execution in favour of representing, by means of more or less conventional rhythms, the mind-state occasioned in the artist by contemplation of Nature. This may be termed a conscious attempt to realize what the ' primitive' possibly does unconsciously. However, it would seem that the extreme separation between natural and imagined shapes, in which the most advanced Cubists dealt, is fundamentally objectionable to the European mind, too deeply attached to its logical nature to admit form so arbitrary when it is still question of representable shapes, and not one of mere artificial and decorative arabesque; in the latter case the ' logical ' sense is not shocked. But in the case of the ' prelogical primitive ' this ' shocking ' does not take place. It would be very interesting to carry out a series of experiments with a view to finding out which is preferred by an Ashanti : a photograph or a piece of imitative art on the one hand ; and Ashanti production on the other ; careful questioning might lead to useful hints. The shock is in our own case evident from the recent return from Cubistical eccentricities to styled but still recognizable shapes, a solution which, from our point of view, would seem to lie in the desirable intermediate position between inaesthetic imitation

and exaggerated styling which shocks the logical factors of our personality. The justification of the avowed admiration of the period between, say, 1912 and 1920 for West African sculpture, may be found in the fact that neither the ' advanced' European school nor the ' primitive' attached importance to mere imitation ; hence they found common standing in the treatment of rhythm untrammelled by serious reference to natural shape. In reality the two arts were far apart, for the European only sought—with more or less sincerity—to express rhythmically his own personal emotions before Nature and to express them by means of the result of carefully studied ' logical' analyses. Whereas the ' primitive' unconsciously expresses his personality in rhythm because he cannot help it ; he is really only taken up with the ' participation' aspect of art and does not purposely avoid ' likeness' ; it has simply never occurred to him that it might be desirable.

The artist who lives continuously in a ' spiritual' atmosphere, by which I mean one in which unseen qualities, significations of unseen things, take great preponderance over the visible qualities of the world, can hardly be expected to take as much interest in the outward conformation of objects as would a Velasquez. An Ashanti wood-carver produces the deformed dwarf that Velasquez may have taken a certain delight in painting ; but the motives of reproduction are very distinct from each other. Velasquez is filled with a passionate desire to transcribe Nature even in her grotesque moments. I am inclined to think that the Ashanti does not even notice that his sculpture is deformed. This again is a point which should be carefully investigated. It will be remarked in the accompanying reproductions that the practically universal deformity consists in great oversize of the head. The distinguishing part of the human being is his

face, on which we read expression. We either make full or
half-length portraits of people, or we content ourselves with
the single representation of the head. No one ever makes
a portrait of the sitter's legs ! though we add them occa-
sionally as further information concerning the rest of the
body attached to the head. In many primitive arts this over-
powering of the rest by the head may be noticed ; Margari-
tone of Arezzo may be instanced as an Italian example.
Why should it not be so ? The personality is sufficiently
indicated by the head alone (we ourselves admit it), the
larger proportion of attention, hence of volume, is attributed
to that part of the body. When we add arms, legs, and so on,
we keep them in their proper proportions because of the
logico-scientific background and representational tendency
of our thought form. But the Ashanti, not at all interested
in exact representation of real appearance, contents himself
with saying : Here follow 'arms, legs, and so on to taste.
Not quite ' to taste ', however, because these addenda must
fall in with the rhythm of the whole, so after all they are
added to the taste—in the matter of rhythm—of the artist ;
not to that of any one who may come along. As he has
derogated from natural proportions, for the sake of insistence
on the importance of the head, the real rhythmic proportions
are thrown overboard completely and for them he sub-
stitutes an artificial African rhythm, which discloses to us the
conditioning of his mind rather than that of natural rhythmic
shapes.

I have said that interest centres on the face on account
of its expression. So it may do. But to the non-representa-
tional artist the reproduction of expression is evidently no
more interesting than the reproduction of anything else.
Hence in the *Akua mma* (Figs. 125, 126, 127) [1] we find a simple
decorative arrangement of eyes and nose in a vast circle, while

[1] Figures carried to promote child-birth.

the body only plays the part of support to the symbol of the face, hence of the individual. There is even no thickness to the head. Why should there be? The possibility of the future child is quite sufficiently evoked without it.[1] One might say that a headless torso study by Rodin is at the aesthetic antipodes from the Ashanti statuette, Rodin being interested above all in reproducing appearances of parts of Nature.

This neglect of the imitative side of art renders it particularly difficult for us to estimate the rhythmic worth of such statuettes. Troubled by their lack of veracity we fail to be able to judge, without prejudice, their value as plastic rhythms, the more so that the idea type expressed by the rhythm is so very different from our own. When we come to consider such objects as Ashanti stools which have no pretence to imitation we feel ourselves to be less biased judges. It is perhaps worthy of notice that we find the same squat feeling about the stools as we felt about the figures. Is this due to an inherent quality of the Ashanti mind? Is it due possibly to the habit of making the head more important than the rest in figure-work? Is it due to the squatting habit of savage races? For the moment, an insoluble question. We must leave it there. All that we can say is that it creates a special and peculiar sensation very difficult to define, of a certain complication and lack of sequent thought on the part of the artist. The stools seem to offer repetitions of the stubby and generally bent legs of the statuettes. We are evidently in presence of a fundamental factor of Ashanti plastic expression.

I cannot prevent myself, every time I look at these stool designs, from immediately remembering certain sides of Chinese Art. We seem to be in touch with something—mental power of co-ordination apart—analogous to the

[1] If this be the idea, which I doubt.

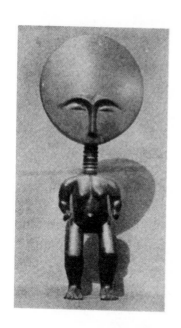
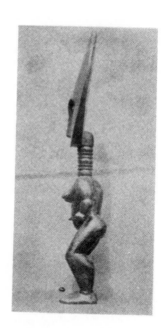
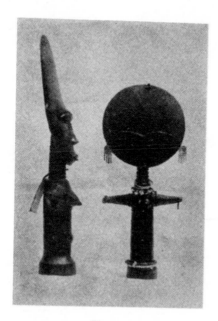

FIG. 127

'AKUA MMA' STATUETTES. *Ashanti*

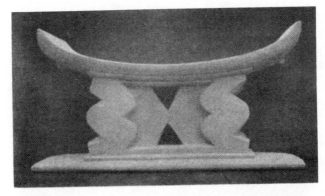

Fig. 128

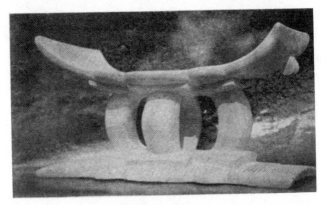

Fig. 129

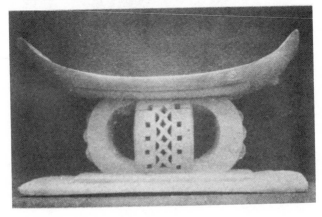

Fig. 130

ASHANTI STOOLS

curved aesthetic of China. The greater number perhaps of the designs might almost pass for having a Chinese origin. What can this signify, this common use of a ' curved formula ' in such marked opposition with the Græco-European straight tendency ? Can we set up as an axiom that the straight line corresponds with the logico-scientific thought and the specially flexed curve, which we find here and in China, with the tendency to people the seen world with unseen things, with the *Feng-shui*, with the omnipresent spirits of ancestors, with ' participation ' beliefs, with all that so divides the mentalities in question from ours ? I should be inclined to be wary of such an encitingly simple supposition ; yet it may be worth meditating upon. At the same time we should remember how very different from the Chinese is that other curved-line companion of the philosophies of the Indian religions.

.

It would seem certain that the primitive mind has not precisely the same conception of time as we have. We conceive of time as a kind of continued linear extent which is unlimited both before and after the present moment. But it would appear that to minds not given to abstract reflection discrimination between past, present, and future does not take place with anything like the same precision as with us. For them life is a vague intermingling of the human and the spiritual, past things are still present to-day ; on the future they reflect but little. The scheme of causality, which is to us so evident, is to them almost non-existent. The ' primitive' but rarely seeks the cause of a phenomenon, the cause is always to him evident—the intervention of spirits, whether it be in the matter of cutting his finger or in a wished-for rainfall. The ideas of cause and effect sequence are strictly bound up with those of the sequence of time. The cause and effect sequence has little or no *raison d'être* when the cause

is spiritual. The confusion which so often occurs in their minds in the case of dreams foretelling the future which is, in a way, already assumed to have happened, is one of the several examples of this vagueness concerning the conception of time sequence. On pp. 122 and 123 of *Relation in Art* I have mentioned a possible future European position not totally alienated in some ways from this non-causal and non-temporal mind condition of the ' primitives '. It seems to me to be one, *ceteris paribus*, particularly favourable to the plastic arts. Though I have not employed this particular phrase in that book, the whole point of view adopted points to such a meaning with sufficient clearness.

Discursive and abstract thought, as we generally practise them, depend upon this concatenation of cause and effect. It is not then astonishing that although the primitive mind is capable of well-conditioned thought of a kind which interests it, and in which close contact is continuously preserved with ' tangible ' fact, it is not then astonishing to find that its attention flags as soon as the subject ceases to have a practical interest, or as soon as immediate contact with fact ceases. Extended excursions into the regions of continued abstract thought are thus impossible to it. But to the execution of the plastic arts this failing is in no way hostile. In fact one may almost say that the more immediate is the contact between observed fact and artistic generation the better will that generation be ; though this is advanced without prejudice to the statement made on p. 205 of *Relation in Art* that a studied drawing may be more synthetic, more statuesque, more architectural than the swift rapture of a moment. Yet in the case of arts possessed of such moderate ambition as that of Ashanti, the lack of sustained and coherent reflection as a background to conception and execution is in no way detrimental.

The act and thought, practically inseparable, of the plastic artist are his work. This is, of course, the explanation of the legendary want of practicality in the ordinary affairs of life displayed so often by artists. An artist's powers are concentrated on the production of his painting, that production is what interests him. Once the canvas completed he has attained his goal, the matter loses interest for him. Selling the canvas is the affair of the man who makes money-getting his aim. Now the artist, while producing, keeps his thought, so to speak, in uninterrupted contact with the tangible object he is producing, and perhaps (when working from Nature) with the tangible model. In any case no discursive thought is needed, even if he be the most abstract of painters, for all his abstract thinking has been done beforehand and it is only the ineffaceable traces, that such thinking has left upon his generating personality, which endure to influence the quality of his work. Thus the defect of the primitive mind, its incapability of following prolonged discursion, is scarcely a defect from the artistic point of view. Indeed, the universal distribution of the artistic sense which we find among pre-logical peoples is most certainly due in part to this immediateness of contact between thought and tangible object. The gift of abstract thought, especially of a logico-scientific nature, would seem to be adverse to the realization of plastic art, in any case it tends to reduce art to imitation. The lack of artistic sensibility found in the ranks of the people in Europe is easily understood when we remember that, thanks to this determining in a direction of reproduction and imitation, art has become to their eyes imitation and nothing more ; the abstract side of this ' scientific ' art being far beyond their comprehension. The ' reproduction ' ideal, the ' getting it like ', being the only artistic factor [1] left to their understanding, naturally there remains no popular aesthetic tradition

[1] Combined with acquired erroneous taste in decoration.

within their reach. In the Middle Ages art was much more popularly distributed precisely on account of the more 'mystic' and less 'logical' state of the mass, who had not yet been taught to confound art and photographic production, and to whom the unnatural shape of a Chartres figure was not yet a matter for ridicule, likeness not having yet displaced symbolic suggestion. A figure on Chartres Cathedral may in a way be said to come intermediately between the spiral traced by the Australian on the *churinga* consecrated to the frog—and so indicating a frog—and the completely representational painting of Velasquez. The Chartres figure is partly 'like', and partly a decorative indication intended to bring to mind some known fact connected with the religion to which the Cathedral is consecrated. Rhythm and suggestion are all that a mind as yet primitive and not yet expecting photographic accuracy demands from art, and curiously enough it is precisely to those rudimental terms that prolonged study of aesthetics tends to bring us back, after we have traversed the unprofitable stretch of imitative art.

The more I reflect on the correlation between primitive art and the 'pre-logical' mentality which inspires it, the more I am led to wonder whether it may not possess some shadowy indications of what may possibly await us in the future. If this be so it will be but a renewed example of that pendulum-swing which seems so often to govern, and to compensate for, any too definitely marked phenomenal trend. What will be the thought form of the future? I think that there can be little doubt but that it will be relative in nature. Here I must venture upon delicate and suppositional ground. Let us for a moment consider the Einsteinian explanation of gravity. It is the first ever put forward. It would seem that far from being an absolute phenomena

(absolute by reference to what? by the by) it would take on dimensions, nay existence even, simply with regard to a frame of reference, while with regard to another reference frame it can even be non-existent or at least have another measure. Surely this, if we reflect, is coming dangerously near to an admission, all akin to that of our ' primitives ', of the possibility of a phenomenon both having and being deprived of existence at one and the same time, of both ' being ' and ' not being ' simultaneously.

Then again the very word ' simultaneously ' loses its till now accepted significance. Superpose this consideration upon that just advanced and reflect upon the curious mental position that such concepts engender.

Inevitably one asks oneself if there may not be an occult coherence between the interest taken of recent years in ' primitive ' arts—not to speak of the evident effect of their study on modern artistic production—and the relative concepts which have seen their birth during the same chronological decade. I am yet to be convinced that the Principle of Relativity does not necessarily carry with it the ruin of Occidental logic based upon antithesis, upon the impossibility of a thing both ' being ' and ' not being '. It would seem that we must add to this fundamental postulate some modifying phrase which shall make of the absolute statement a relative one, one which shall say that : To a given observer placed in certain conditions, and taking into count his own personality alone, at the same moment of the Time which is attached to those conditions, it is impossible that a phenomenon should both occur and not occur. This after all only really amounts to a definition in part of the personality as being a thing which does not conceive of such a possibility in the above conditions.

We thus find ourselves in presence of an onslaught upon the judicial value of the isolated personality, and so arrive

at contact, by an unusual route, with the underlying metaphysical difficulty. We, at the present day, seem to be tending towards a diminution of the value of the personal observation by freeing physical science from the subjective element ; the ' primitives ' diminished the personal value by their tendencies towards ' participation '. Certainly the two methods of approach are very different, yet it is not inconceivable that they may lead to a slight similarity of result, all proportions kept of course. An art in close connexion with a scientific past can hardly be conceived as being devoid of representational qualities after so many centuries of examinative observation.

.

I have written the foregoing words for whatever suggestive value they may possess. To estimate exactly what value they may have it is as yet far too early, for we are still in no way sufficiently enlightened as to the real import of the Principle of Relativity. These thoughts concerning the future before our mental position, before our art, have, at least, been suggested to me by my reflections on the nature of ' primitive ' art and of ' primitive ' mentality, and of their correlation. It must not be supposed for a moment that I wish to propose any real degree of immediate parentage between the mind type which may result from the extreme efforts of imaginative physical science and the mind type of the ' Primitive '. A rapid drawing by Rodin may have a certain outward resemblance to the erroneous scribble of a child, yet the two are divided by all the anatomical and other knowledge of the sculptor. At the same time *one part* of the nature of Rodin's hurried note may quite well be analogous to the intention of the naïve drawing, and from comparison between the two may arise some new hint or suggestion. The consideration of the philosophy of Heraclitus of Ephesus may just possibly be of suggestive use to

a modern physicist at some particular point in his reflections. This is all I mean. But the possible weakening of the value of the antithetic element in future reasoning must not be too hastily assumed to be identical with the neglect of it in 'prelogical' thought.

At the close of this volume I am particularly anxious to draw attention to this but little realized aspect of primitive art : the minor interest displayed in likeness to the object depicted .; and the major, or rather unique, importance attached from the very first to the rhythmic element. The more so am I inclined to insist upon this point because it is not a question here of some 'advanced' tenet of a Montparnasse studio, but is the point of view adopted towards art by an immense portion of mankind, and one of the widest possible distribution. The more modern comparative ethno logical research pursues its way, the more it becomes clear that a wonderful similarity is found to exist between the 'primitives' the whole world over, from the Esquimaux to the natives of Uganda, from the Papuans to the dwellers in the Queen Charlotte Islands. Evidently there are large differences of development within the 'prelogical' class itself ; yet the outlook upon art which necessarily accompanies the 'prelogical' and 'participative' mind, would seem to be so widely separated from ours as to allow us to sink the differences, and to combine all 'prelogical' outlooks, even of various grades of primitivism, into one general class very distinct from our own ; although, as usual, when we come to frontier types there is a sliding scale which permits passage from one class to the other without undue shock. The human personality is so complex, so many sided, that this fading of type into type should not astonish us. In the advancement of our 'logical' civilization we have made of art something very different from what it was in its earliest manifestations, which, in spite of its apparent superfluity, seem to stretch back

away to the earliest being of our race. What we realize with so much difficulty is that ' primitive ' art is a very real thing ; that it is not only palaeolithic, but that it is the artistic manifestation of many millions of human beings alive at the present moment. The Paris Salons, the London picture shows are by no manner of means representative of the total human desire for beauty, for aesthetic expression. By what right does the aesthetician ignore a branch of his subject which has persisted on firmly-established lines for thousands of years, and which may be looked on as often having attained to the culminating point of its development ?

Recapitulation

In the consideration of art it is a grave omission to leave out an examination of the art of ' primitive ' peoples. The mentality of such peoples, while being strangely similar all over the world, is very different from our own. Our own may have preceded from a same source as that which we can study to-day among ' primitive ' tribes. On the other hand, we can easily conceive that some ' primitive ' civilizations have reached their apogee beyond which they can proceed no farther. Further ' civilization ' can only mean introduction of European methods to the extinction of the existing mentality and its results. Hence the word ' primitive ' would seem to be an unfit term to use in order to define a condition which has long since attained its limit term. Monsieur Lévy-Bruhl shows that the ' primitive ' mind is ' prelogical ', mystic, follows other paths than ours, is indifferent to the law of contradiction, which lies at base of our reasoning, is ' participative ', that is, it admits that an object can be at the same time itself and something different, and that the personality of the individual is by no means as distinct an entity as we like to think. The ' primitive ' lives in an uninterrupted spiritual atmosphere, every event is the result of spiritual intervention. Hence cause and effect sequence is not sought by him. Probably all idea of ' imitation ' is absent from ' primitive ' art. It is entirely replaced by rhythmic symbolism, or often by a mere statement that it is now question of a certain object. This statement is often—or perhaps always—doubled by a ritual consecration, by which the work of art becomes the *real* dwelling place of the spirit. Any unconsecrated work of art is not one, it does not ' count '. In all this, resemblance would hardly seem to play any part at all. In accordance with our ' logical ' view of the physical universe we seek for resemblance. Perhaps in ' primitive ' art we may see an unconscious

beginning of the 'antithetic' type of mentality in the necessary oppositions of art. Children's drawings often show the same negligence of 'appearance' as we find in 'primitive' drawings. The child's drawing is often a statement of fact rather than of appearance. In the matter of imitation we are not consequent with ourselves, we admit non-imitative rhythm in decorative art. What may be the real criterium of artistic worth ? Should it not be estimated by the degree of homogeneity within the complex : work of art plus observer ? It is possible that we may admire primitive art for its points of resemblance with our own, and not for its real successes. The 'resemblance factor' is probably slowly introduced—unintentionally—with the increasing skill of the workmen. It may be of interest to compare the possibly less rigidly logical outlook which seems to be in store for us with the 'prelogical' point of view of the 'primitives'. In any case we are not justified in ignoring a whole side of art which has persisted for many thousands of years.

XII

CONCLUSION

WHAT have I written? Considerably more than
a hundred thousand words concerning the art of
drawing; I have tried to explain in words ideas
which are an integral part of the forms which represent them.
Each art exists because the ideas special to it cannot be
transmitted otherwise than by its medium. To talk about
drawing is to doom oneself from the outset to partial failure.
The plastic arts have a logic, a rationality of their own,
which cannot be transmuted into the terms of verbal ratio-
cination, nor even into a form of non-verbal reasoning,
applicable to other types of mental activity. All the types
of mental activity are products of the human brain, hence
all the types have some common factors, or are of com-
parable nature. On account of this we may make attempts
at rendering or describing one of the systems in terms of
another. This is what I have attempted to do . . . with
what success? The fact that seems to one's plastic sense
of fitness, of rationality, to be clear, simple, beyond all
argument, becomes almost impossible to seize and bind down
in words. The phrase always seems, when written, to mean
something quite different from the intended idea. The co-
ordinations which are natural to the plastic scheme are not
foreseen in the vocabulary, in the syntax, of a language. The
literary term supposes another grouping of ideas. What is
clarity itself to the draughtsman becomes doubtful, and only
partly exact, when couched in the written word, which either
embraces too large a field, or shows itself poor in vocabulary,
incapable of necessary differentiation. To this cause as many

aesthetic disputes may be traced as are caused by veritable difference of opinion.

I have found it exceedingly difficult to estimate the exact degree to which I should treat detail, to what extent I should speak of special examples, within what limits I should examine the draughtsmanship of different peoples. I had originally intended to speak more fully of drawing in Egypt, in Mexico, in India, and elsewhere ; but fear of unwieldiness and additional cost of illustration have restrained my ambition. After all the study of comparative art is one apart ; it is a field which has been but little explored. Histories of the world's art have often appeared, but they are not what I mean. Histories generally content themselves with describing the works of art of the particular period or people, they do not as a rule deal with the technical analysis of the method of expression considered in relation to mind cast. This, doubtless, is due to the fact that such histories are written by literary men who are necessarily wanting in that intimate knowledge of technique which can only be the appanage of the professional artist. Professional artists who take a wide interest in general culture are rare. My own case is particular. Not obliged, until recently, to earn my living, I have been able to continue from the vanquishing of one difficulty to the vanquishing of another. I have been able to devote all the time necessary to experiment. The man who is obliged to convert his knowledge into saleable work has little or no time to give to increasing his store of it. Experiment spells failure ; many failures precede a successful overcoming of a new difficulty ; failures are not saleable.

Comparative study of the world's arts demands much research, much ethnological and philosophical reading before we arrive at any just comprehension of the subject. And I believe that a really useful degree of understanding of the ideals of another people demands a sojourn amongst them,

and a considerable acquaintance with their language. The tourist's view obtainable during a summer holiday of a month is of but little use. The greater part of my life I have lived out of my native land ; it would scarcely be an exaggeration to say that I have lived the whole of my observant life away, for I quitted England before the age of twenty. Putting Eastern travelling aside, I have passed my time in France and Italy, some eight years in the latter country. When one has lived for extended periods among peoples animated by very different ideals, unless one be girt about with that shield and buckler of the Anglo-Saxon, impenetrability to his surroundings, one is obliged to admit that opinions and points of view are many ; and not only this, but that comparison of their relative worth is difficult, is almost impossible. Each people constructs its own system of inviolable beliefs, its own philosophy, its own religion, its own scheme of morality. Even in the same country all these hypotheses change with time. The aristocrat of to-day would reprehend the thieving acts that his ancestor of the Middle Ages executed openly. The arts of a country are a changing transcript of this changing scheme ; they also reply to the particular desires of the people who invented their methods. As these desires are not exactly common to the inhabitants of different countries, it cannot be expected that the work of art which satisfies the inhabitant of one country, the work in which he sees the type of his own mentality reflected, will prove to be pleasing to a foreigner. Though there is a singular underlying series of common factors in the plastic arts (and it is this series that I have endeavoured to describe) yet the ' editing ' of them, the proportional use of them, differ markedly from one country to another. One people ' cannot understand ' why another insists on the considerable use of a certain ingredient in the compounding of works of art. A nation's canon of taste is founded on its own desires, it too often accuses the other

nation either of unintelligence or of lack of taste, of which quality, by the by, it always shirks the definition.

Draughtsmanship is not a national gift in England ; none of the formal arts are practised with success in the British Isles. I am writing about drawing, not about English drawing. Why should I write only about English drawing when the British Museum contains its magnificent collection of drawings of all periods, and by all peoples, from the palaeolithic engraving of a reindeer on a fragment of bone brought from La Madeleine (how many people know that the British Museum possesses the original of one of the most triumphant fragments of palaeolithic sculpture : the point of a mammoth tusk carved with Reindeer from Montastruc over the Aveyron ?) to a recent drawing by Degas ; from the remarkable series of Greek vase drawings to the ever-growing numbers of paintings in colour or in monochrome from the countries of the Farthest East ? Consciously I review, unconsciously I submit to the influence of this enormous mass of human artistic production. Once more it seems to me that the impassive figures of Abu Simbel, waiting through the long-drawn ages, gaze fixedly at the desert there across the Nile. Yet again it seems that I have just climbed the causeway, half path, half stair, that leads upwards to an inner temple shrine. The darkness within is a darkness laid over vermilion and gold, rich and silent, fraught with leavings from the tremendous past of Asia. Outside, a squandering of tropic light. Then, as my eyes become accustomed to the gloom, I make out dimly the presidence of three great figures carved in wood ; wood this time, no longer the granite of Abu Simbel. And the wood is black, polished, discreetly gleaming here and there. A curved and subtle simplicity of form grows slowly from out the mysterious obscurity ; is it symbolic of the primal unity of Buddhistic faith? symbolic of that single permeating spirit, that ineffable

essence, from which the universe unfolds? This still remains
the mightiest theme of art, towards its telling tend the
rhythms of the Eastern line, avid of abstraction, spurning
the particular.

.

Yet it is to this particular that Europe clings. The most
general of Western arts, the Greek, was yet wrought from the
measure of man. ' L'Hellène . . . conçut toute chose à sa
mesure et donna à ses temples des proportions parfaites :
tout y était grâce, harmonie, mesure et sagesse.' [1] For when
he raised his eyes to heaven he found there anew his own
image, his own beauty ; and from his own beauty he con-
ceived his gods, conceived them by shores of this same violet
sea, beyond the plain, almost visible from where I write. He,
too, the Greek, lived here ; and now and again some trace of
his ancient sojourning appears ; I pick up from the village
dust a coin, struck with the fairness of the face of Artemis.

But this keen love of beautiful things was a creed too fine
and free, a creed still too remote, too aristocratic, to subsist ;
it dwindled and almost died amid the heavier splendour
of Rome ; it stayed but as the faintest memory, when the
uncouth horde, fathers of future dominators of the globe,
swept down upon the classic world. What had the hard-headed
practice of Germanic peoples to do with abstractions of belief,
with intangible harmonies of form ? Art sank towards the
naïvetés of Byzantium.

.

No people can exist without, at least, the simulacrum of an
art. The new religion of Christ spread among the northern
barbarians, spread among the peoples of the Mediterranean, for
the splendid essay of Greece had passed away. Europe seized

[1] The Hellene . . . conceived all things in measure of himself and endowed his
temples with perfect proportions : all therein was grace, harmony, restraint, and
wisdom.—*La Révolte des Anges*, Anatole France.

upon a creed which taught the eternal conservation of the personality, the eternal reward or punishment for acts easily judged on the basis of a moral code. In this belief the newer art found source and inspiration. Earthly suffering was to buy eternal blessedness ; Fra Angelico dealt in psychology almost pathological ; emaciation replaced the abounding health of Greece. True, magnificent life is broadcast over the Sistine vault, but it is unquiet, distraught, contorted ; the godlike Hellene calm has passed away forever. First, the spirit of practical Rome, then the genius of the German races, empire making, restless in kind, have made it henceforth impossible. Reflection, personal reflection there may be, Rembrandt has ofttimes painted it ; but his pictures are the consecration of the personality of the individual. Even such an art as Turner's does not generalize, it remains confused, treats of the complexity of the universe, not of the unity of its essence.

.

Till the end of the nineteenth century such was the aim of art. But with the opening of this newer age there seems to have taken place a novel seeking in aesthetic things. Much has ensued, consciously or subconsciously, from ever-increasing contact with the distant East. Asiatic philosophies have been examined, Eastern art has been considered with a more and more understanding eye. As yet the steps towards an abstract art are halting, the successes not worthy of the name, less worthy still of the ideal.

The circumstances of life have changed, are changing rapidly, with a rapidity never before thought possible. War, the advances of applicable science, the invention of the automobile, of the aeroplane, a thousand other modifications of existence, have rendered new outlooks normal to the younger generations. The art that seemed wilfully extraordinary to their fathers seems natural to them. The aesthetic position

must be examined anew from its lowest strata. A new series of forms, due chiefly to the engineers, has imposed itself surely, though scarce perceived, upon us. The shape of the motor-car is permanently recognized. Building will suffer in the near future still greater modifications than it has yet undergone. The problem of construction has changed entirely. Till now, speaking broadly, the aim of the constructor has always been to convert all stresses into thrusts, for the quality of brick and stone arrangements permitted resistance to compression and next to none to tension. Now all is contradicted ; a steel armature resists tension with less risk of deformation. A constructor in reinforced concrete seeks to convert all his stresses to tensions. It is obvious that rational building design must take on quite another aspect.

We are surrounded by the results of these novel types of production ; insensibly the eye gets used to their appearances, finds pleasure in contemplating them, desires to meet with similar impressions elsewhere. The sculptor, the figure-painter, are constrained to fall into line ; or rather, the newer generation of artists is not constrained, for the line of march is natural to it. Drawing of all kinds receives a new orientation. I hope in a future volume to discuss more definitely this art in the making ; in the present pages I have preferred to remain as nearly as possible within the limits of ground already fully conquered in the past, whether it have been conquered on the Eastern confines of Asia, on the Nile banks, in Athens, in Florence, or in Paris. In any case I doubt if the conclusions, to which I have arrived, and which I have put forward here, will be absolutely invalidated by future change, the more so that though I have not—or have hardly—spoken of recent art, yet all my tenets are tempered by its presence. I have, in the past, successfully foreseen many minor modifications in the tendency of the artistic

current ; my expectations have been fulfilled. Art is now turning in the direction which I foresaw during the first decade of the century and for which I prepared myself. My views cannot have been quite erroneous.

.

Many may be surprised that I have made so slight a mention of those works among which delightful days of my later youth were spent, so slight a mention of those works which did so much to model my ideas, my own artistic production. I speak of the quattro and cinque centisti of Italy, in the main of Florence. This omission of work by no means negligible in drawing quality, and from which I myself have learnt so much, has come about unintentionally, automatically ; and now, for the first time I ask myself the reason of this oversight. I think the reason of my unconscious act is this : that the plastic qualities, the aesthetic theory—shall we say ?—of Giotto's drawing, of Filippo Lippi's, of Signorelli's, of all the others, is, so to speak, a transition from the resuscitated inheritance of classic things to the full arts of Leonardo and Michael-Angelo complete with the new additions of romantic emotion, with perspective, and with light and shade. Far be it from me to suggest that I do not delight in a Paolo Uccello, indeed it is perhaps from that school and period of Tuscany that I take my chiefest joy in post-Christian Europe. But the matter of this book is not dithyrambic appreciation—were it, how much more would I have dilated upon the Chiostro Verde, upon the gracious visions of Botticelli, upon the strange frescoes of Orvieto ! When one has spoken of the draughtsmanship of a Greek vase on the one hand, and of the drawing of Leonardo on the other, one feels that one has somehow little that would be new to say about the technique employed by that brilliant constellation that came as a new wonder to Florence and the world six or seven centuries ago. From the first the orientation was apparent ;

naïve as was the line, it was already emotional. Unlike that of the Greek vase, which we may take to be at its apogee in the fifth century before Christ, we can fix on no definite style of technique as being early Tuscan. A continual change takes place from primitive Giotto or Cimabue to complex Leonardo or Michael-Angelo. What wordy warfare might rage around the question whether Michael-Angelo is or is not the ultimate perfection of the ideal which Cimabue created ! (And did he create it ? Such was the hasty belief of the middle nineteenth century. But what shall we say of the mass of ' Byzantine ' work from the eleventh and twelfth centuries, and indeed in really uninterrupted succession from classic times, work which modern research and classification have unearthed, and which is often even more ' naturalist ' than Duccio or Cimabue ?) Shall we fix upon Taddeo Gaddi as our type of draughtsman to examine ? . . . No, rather upon Piero della Francesca ; but then there is Masaccio, with his introduction of naturalism in still larger doses . . . our examination resolves itself into a critical and historical study of the development of drawing in Renaissance Italy ; a vast subject by itself. As a method of drawing, that of the period may be looked on as a transition by imperceptible degrees from an ideal already detached from the pure and plastic ideal of Greece—yet imbued with memories of it—towards the fully emotional ideal of the European Art which followed on the decline of Florence ; from a simple, and often charmingly *gauche* sense of volume values and their rendering, to the completed *gamme* of anatomical ' truth ' of fifteen hundred. In these pages I have treated of the essential aesthetic components of this art ; to study in detail the transition from one to the other is outside my province. Hence I have written little about the wonderful school which really founded modern art. To such paradoxes we are sometimes led.

.

I have found myself also unable to treat of the very wide subject of decorative design. However, a little reflection allows us to see that although very little explicit mention has been made of design, still the general observations are applicable to that special branch of art. Indeed, the painting of pictures has grown slowly from a savage desire for rhythmic design, from the waving line which surrounds the great neolithic vase standing at this moment in the entrance passage of this house. Little by little minor articles of the now great code have been added. Little by little the lumps of red ochre, which I found in the cave from which came the vase, have been replaced by a range of natural and artificial tints of very considerable extent. In a picture we generally try to avoid repetition ; often, in decorative work, we utilize approximate repetition intentionally. I say 'approximate' repetition, for I am inclined to think that all absolute repetition, all stencil work, is a low form of art. The Greek and Egyptian 'keys' and palmate frieze patterns were always executed free-hand, hence with the inevitable variations. A modern bourgeois love of tidiness is responsible for the fatiguing monotony of much modern decoration. (Machine production of course is also responsible.) Some degree of repetition, of symmetry is perhaps necessary in decorative design, which is generally destined to assume a secondary place as a background or addition of some kind to the main interest, whether that main interest be the furniture and people in a room, the title of a book, or the name of some article advertised by a poster. Repetition adroitly managed utilizes similitude of impression to amuse the eye, without tempting it to undue attention. The changes that decorative arts have undergone have naturally always exhibited a strict relationship with the changes in figure and other artistic work, at least since the more elaborated arts have existed. But to deal with decorative design and such special applications of the

general definitions already advanced would call for a volume apart.

It is difficult to write didactically and to avoid pedantry. Art is, so to speak, the materialization of a figment of the mind, of a subtlety whose very presence so often escapes the perception of all but the elect. Pedantry and art are antitheses. May I not have touched with too brutal a hand that fairest flowering of human things ; a flowering which ever seems to blossom beyond our narrow ken.

INDEX

(For anatomical terms see special index.)

The principal references are printed in Clarendon type.

ANATOMICAL INDEX

The principal references are printed in Clarendon type.